IMAGES OF EDEN

IMAGES OF EDEN

An Enquiry into the Psychology of Aesthetics

ARTHUR EDWARDS

The Skylark Press

Copyright © Arthur Edwards 2003
First published in 2003 by The Skylark Press
6 The Hazels, Lower Green
Tewin, Welwyn
Herts AL6 0HZ

Distributed by Gazelle Book Services Limited
Hightown, White Cross Mills, Lancaster, England LA1 4XS

The right of Arthur Edwards to be identified as the author of the work has been asserted herein in accordance with the Copyright, Designs and Patents Act 1988.

All rights reserved. This book is sold subject to the condition that it shall not, by way of trade or otherwise, be lent, resold, hired out or otherwise circulated without the publisher's prior consent in any form of binding or cover other than that in which it is published and without a similar condition including this condition being imposed on the subsequent purchaser.

British Library Cataloguing in Publication Data
A catalogue record for this book is available from the British Library

ISBN 0-9536116-0-4

Typeset by Amolibros, Milverton, Somerset
This book production has been managed by Amolibros
Printed and bound by T J International Ltd, Padstow, Cornwall, UK

This book is dedicated to Peter who begat it, to Betty who made it possible, and to the abiding memory of Christine.

By the same author:

The Design of Suburbia, a critical study in environmental history

Contents

List of Illustrations	xi
Acknowledgements	xvii
Preface	xxvii
FOREWORD	1
PART ONE: COMMUNICATION AND THE VISUAL ARTS	3
Introduction	5
Chapter One: The Visual Arts and the Theory of Signs	7
Some Definitions	7
Communication: Where Our Subject Lies	8
Peirce's Theory of Signs	10
A Tool	13
Conventions	15
Symbols	18
Icons	21
Indexes	21
A Name	28
Chapter Two: Some Problems of Indexical Aesthetic Communication	31
Iconography and Iconology	31
Indexical Aesthetic Communication and the Unconscious Mind	35
A Universal System?	44
A Conclusion	50

Chapter Three: Some Models of the Mind: Their Relevance to Indexical Aesthetic Communication 53

 The Standard Social Science Model 53
 Interlude: the Question of Innateness 56
 Freud 60
 Jung 69

PART TWO: PLUGGING THE HOLES IN JUNG'S ARGUMENT 83

 Introduction 85

Chapter Four: A Definition and a Context 87

 The Archetype, Some Definitions 87
 Some Aspects of Evolution 90

Chapter Five: the Evolution of the Human Mind with Jung's Archetypes and the Collective Unconscious 101

 The Timescale of Human Evolution 101
 The Pre-requisites of Hominid Survival 109
 The Three Capacities, Cognition and Genetic Theory together with the Collective Unconscious and its Archetypes 117

PART THREE: THROUGH NATURE'S LOOKING-GLASS 135

 Introduction 137

Chapter Six: Sundry Archetypal Images 139

 A Few Preliminaries 139
 Representational Art 143
 Profiles 145
 Serpents 152

A Problem: the Basilical Section	156
Sex	164
Texture	168
Space	171
Scale	180
Pleasing Decay	185

Chapter Seven: Archetypes and the Mathematics of Form and Space 189

Symmetries	189
Rhythm	205
Fitting Together	206
Mathematical Consistency, the Module	214
Proportion	221
A Puzzle: the Golden Ratio	224
The Yin Yang Symbol	259

Chapter Eight: Unity in Diversity 265

Unity in Diversity in Nature, Some Examples	266
Conclusion	273

PART FOUR: THIS SIDE OF THE LOOKING-GLASS 277

Introduction 279

Chapter Nine: the Beauties and Uglies of Nature 281

The Beauties	281
The Uglies	284
A Bonfire	284

AFTERWORD 285

APPENDICES 287

 Appendix One: Wissler's Culture Scheme 289
 Appendix Two: Murdock's Universal Culture Pattern 291
 Appendix Three: The Activities of Brown's 'Universal People'
 an Abbreviated Version 293
 Appendix Four: The Activities of Brown's 'Universal People'
 with the Three Capacities, Certain Instincts and Belief in
 the Supernatural 299
 Appendix Five: Toynbee, Consciousness and Cognition 309
 Appendix Six: Spiral Phyllotaxis 311

Bibliography 315
Index 331

List of Illustrations

PLATES

Facing page 18

Plate 1 Manet: *Olympia*.
Plate 2 Hieronymous Bosch: *The Marriage at Cana*.
Plate 3 A vintage scene: Egyptian, XVIII dynasty.
Plate 4 Fan K'uan (c 950-1050): *Travelling amid Mountains and Gorges*.
Plate 5 Constable: *The Cornfield*.
Plate 6 Grünewald: *Crucifixion from the Isenheim altarpiece*, detail.
Plate 7 Renoir: *Sleeping Woman*.
Plate 8 Goya: *Charles IV of Spain and his family*, detail.

BLACK AND WHITE ILLUSTRATIONS

1	T A Greeves: No title.	4
2	A crescent.	13
3	The weathervane at Lord's cricket ground.	14
4	H W Inwood: St Pancras Church.	16
5	Donatello: *David*.	20
6	Rembrandt: *The Three Trees*.	25
7	Grünewald: *Crucifixion from the Isenheim altarpiece*.	26
8	Rubens: *The Horrors of War*.	33
9	A stag: from Lascaux, between 17,000 and 19,000 years ago.	45
10	A bronze head of a queen mother: Benin, probably sixteenth century.	45
11	Anthony Stevens: Diagram of Jung's model of the psyche.	72

XI

List of Illustrations

12	Picasso: *Les Demoiselles d'Avignon*.	78
13	A diagram showing genetic drift in a small population of birds.	97
14	Seeing and perceiving	118
15	The conservatism of hand-axe design.	122
16	Paul Klee: *They're Biting*.	143
17	An Atlantaean column: Tula, Mexico.	144
18	Egid Qurin Asam: *The Assumption of the Virgin*, Rohr, Bavaria.	144
19	A Royal Lion Hunt, Assyrian seventh century BC.	145
20	The Bull Ritual, Minoan, about 1500 BC.	146
21	Texcatlipoca, the Aztec sky god, sixteenth century.	147
22	A Sacred Procession, from Persepolis, Persian, sixth and fifth centuries, BC.	148
23	Herakles and Cerberus, Greek vase painting, fifth century BC.	149
24	A Girl Playing The Bagpipes With A Herd Of Deer, Indian (Rajput) nineteenth century.	150
25	Giotto: *The Entry into Jerusalem*, the Scrovegni Chapel, Padua.	151
26	An Egyptian cobra deity.	153
27	A stone rattlesnake, Aztec.	154
28	A poisonous water snake: Sarawak.	154
29	A diamond python, English, nineteenth century.	155
30	An uroboros, Chinese twelfth or eleventh century BC.	156
31	S Apollinare in Classe Ravenna: Plan and section showing the interior.	157
32	San Zeno, Verona.	157
33	Wells Cathedral.	159
34	Peterborough Cathedral.	159
35	The Certosa di Pavia.	159
36	Amiens Cathedral.	160
37	Johann Michael Fischer: Church, Benedictine Abbey, Ottobeuren, Bavaria.	160
38	Saint Andrew's, Heckington, Lincolnshire.	161
39	Andrea Palladio: San Giorgio Maggiore, Venice.	161

40	Leon Battista Alberti, S Maria Novella, Florence.	162
41	The African flesh fly.	163
42	Boucher, *Miss O' Murphy*.	165
43	Hokusai, *Festive Lovers*.	165
44	A pottery jug, Chinese, c 2000-1500 BC.	166
45	The entrance, the temple of Horus, Edfu, Egypt.	166
46	'Islands in the sea', raked gravel in a dry landscape garden, the Abbot's quarters at Daisen-in, Daikoko-ji, Kyoto, Japan.	166
47	Two nineteenth-century silver tea-pots, English.	167
48	Part of the garden, the Imperial Villa, Katsura, Japan.	169
49	van Gogh, *Willowwood and Shepherd*.	170
50	A prospect: a loch on the west coast of Scotland.	173
51	A view from cover: the Pantheon, Stourhead Wiltshire.	174
52	A primary refuge: a tropical rainforest, Brunei.	175
53	Venice: The Piazza San Marco and the Piazzetta, air photograph.	178
54	A Venetian alleyway.	178
55	Venice: the Piazza San Marco.	179
56	The Venetian Lagoon from the Piazetta.	179
57	Gainsbrough: *Mr and Mrs Andrews*.	181
58	van Dyke: *The Five Eldest Children of Charles I*.	181
59	W H Barlow and R M Ordish: St Pancras Station.	182
60	Chartres Cathedral: plan and interior.	183
61	Leonardo da Vinci: *The proportions of the human figure*.	190
62	A painted skin tunic: Sitka, Alaska.	191
63	St John Chrysostom, Mosaic in the church of Saint Luke, Mount Athos, Greece.	191
64	Dürer: *Adam and Eve*.	192
65	The 'Venus of Willendorf'.	192
66	Picasso, *A Bull's Head*.	193
67	The Buddha Fasting, Gandhara, borderlands of Afghanistan and Pakistan.	193
68	The Chehil Situn pavilion, Isfahan.	194
69	The garden, Marly, near Versailles (now destroyed).	194

70	The three great halls of the Imperial Palace, Peking.	195
71	The Place Royale, Nancy.	195
72	The North Acropolis, Tikal, Guatemala.	196
73	Temple 1, Tikal, Guatemala.	196
74	Gateway, the Varadarjaswamy Temple, Kanchpuram, near Madras, India.	197
75	Joseph Paxton: the Crystal Palace.	197
76	A rug in the medallion and corner design, Persian.	198
77	King's College Chapel, Cambridge, south side.	201
78	Mosaic wall-tiling, the Alhambra, Granada.	203
79	Girls playing in a gamelin band, stone rubbing, Indonesian.	203
80	Part of the border of a Persian embroidery.	205
81	The Dome in the Hall of the Two Sisters, the Alhambra, Granada.	207
82	Wren's favourite design for St Paul's, the 'Great Model': the portico.	211
83	Wren's favourite design for St Paul's. Plan.	212
84	Wren's favourite design for St Paul's, the 'Great Model': three views of the interior.	212, 213
85	The Erectheion, Athens: the Ionic order.	215
86	The Imperial Villa, Katsura, Japan: plan.	218
87	Tahir Zadeh Bihzad: A motive of Persian carpet design.	219
88	T Medland, *The Panshanger Oak,* near Tewin, Hertfordshire, 1814.	220
89	Oak leaves, flowers, acorns and a twig.	221
90	The mortuary temple adjoining the pyramid of Chephren, Egypt: plan and analysis.	230
91	The Parthenon, an analysis of the façade.	231
92	The Dome of the Rock, Jerusalem: axonometric projection, and elevation of the octagon.	234
93	The Alhambra, Granada: plan.	236
94	The Alhambra, Granada: the west pavilion in the Court of the Lions.	237
95	The Brahmeshvara temple at Bhuvaneshvar, India: elevation, section and plan.	240

96	The temple-city of Srirangam, India: plan.	241
97	Teotehuacan, Mexico: the sacred complex: plan.	242
98	Hokusai: *Farmers Crossing a Suspension Bridge*.	244
99	Piero della Francesca: *The Baptism of Christ*.	246
100	Michelangelo: *The Creation of Man*.	247
101	Rembrandt: *The Night Watch*.	249
102	Gustav Fechner: Graph showing people's preferences for various rectangles.	251
103	A man, a woman and the golden cut.	252
104	Le Corbusier: *The Modulor*.	254
105	The Yin-Yang symbol.	260
106	Unity in diversity in an ecosystem.	273
107	The Matterhorn.	282
108	A diagram of a sneezewort.	312
109	A diagram of spiral phyllotaxis.	312
110	A diagram of a sunflower's florets.	312
111	A pineapple.	313
112	A daisy.	313

Acknowledgements

I have to thank the following individuals and organizations for their kind permission to quote material or to reproduce illustrations for which they hold the copyright.

QUOTATIONS IN THE TEXT

Academy Editions
Rudolf Wittkower, *Architectural Principles in the Age of Humanism*

American Association for the Advancement of Science
Science, Vol 250, 1990, Contribution by Thomas J Bouchard Jnr et al, "Sources of Human Psychological Differences: The Minnesota Study of Twins Reared Apart" and Vol 264, 1994, Contribution by Thomas J Bouchard Jnr, "Genes, Environment and Personality"

Laurence Bicknell
Peter Bicknell, *British Hills and Mountains*

Blackwell Science Ltd and Roger Lewin
Roger Lewin, *Principles of Human Evolution, A Core Textbook*, 4th edition

Cambridge University Press
Steve Jones, Robert Martin and David Pilbeam, eds, *The Cambridge Encyclopedia of Human Evolution*, Contribution by Shahin Rouhani and Steve Jones, "Bottlenecks in Human Evolution"
d'Arcy Wentworth Thompson, *On Growth and Form*
P H Schofield, *The Theory of Proportion in Architecture*

ACKNOWLEDGEMENTS

Columbia University Press
Ralph Linton ed, *The Science of Man in the World Crisis*, Contribution by George Peter Murdock, "The Common Denominator of Cultures"

Faber and Faber
Rudolf Arnheim, *Towards a Psychology of Art*
Robin Dunbar, *Grooming, Gossip and the Evolution of Language*
J L Martin, Ben Nicholson and N Gabo eds *Circle, International Review of Constructive Arts*, Contribution by J D Bernal, "Art and the Scientist"
Hugh Brody, *Living Arctic, Hunters of the Canadian North*

Ginn and Co
D E Smith, *A History of Mathematics, Vol 1*

Sir Ernst Gombrich OM
"Freud's Aesthetics", *Encounter*, January 1966

The *Guardian*
Tim Radford, Article: "The excavation of Boxgrove", September 14th 1995

Harvard University Press
C S Peirce, *Peirce, Collected Papers 1931-58*,
Charles Lumsden and E O Wilson, *Promethian Fire*

The Hogarth Press
Sigmund Freud, *Complete Psychological Works, Standard Edition, Vols 13 and 23*
Laurence van der Post, *The Lost World of the Kalahari*

Icon Books
Steve Jones, *Genetics for Beginners*

Indiana University Press
Umberto Eco, *A Theory of Semiotics*,

ITPS published by
(i) Allen and Unwin
Emile Durkheim, *The Elementary Forms of the Religious Life*
(ii) Harper Collins, including Collins, Fontana and Fontana Collins
Steve Jones, *The Language of the Genes*
Alan Bullock, Oliver Stallybrass and Stephen Trombley eds, *The Fontana Dictionary of Modern Thought*, second edition, Contributions by Peter Burke, "Communications", Martin Seymour-Smith, "Semiology", and David Crystal, "Semiotics"

(iii) Routledge, including Routledge and Kegan Paul
Pierre Bourdieu, *Distinction, a Social Critique of the Judgement of Taste*, Trans Richard Nice
Anthony Stevens, *Archetype, a Natural History of the Self*
C G Jung, *The Archetypes and the Collective Unconscious*, 2nd edition 1968 and *Memories, Dreams and Reflections*

(iv) Tavistock Publications
Lancelot Law Whyte, *The Unconscious Before Freud*

Jonathan Cape
Chris Stringer and Robin McKie, *African Exodus*
Colin Tudge, *The Day Before Yesterday*

Journal of the Royal Anthropological Institute of Great Britain and Ireland
Vol 76, part 2, 1946, Contribution by D F Thompson, "Names and Naming in the Wik Munkam Tribes"
Vol 101, 1971, Contribution by George Peter Murdock, "Anthropology's Mythology"
Man 1976, Contribution by G Reichel Dolmatoff, "Cosmology as Ecological Analysis, A View from the Rain Forest"

Journal of the Royal Institute of British Architects
October 1959, Contribution by Christopher Alexander, "Perception and Modular Coordination"

Acknowledgements

Kegan Paul International
Justus Buckler, editor, *The Philosophy of Peirce, Selected Writings*
C G Jung, *Collected Works*, Vols 7, 8, and 9
Little Brown
Walter Bodmer and Robin McKie, *The Book of Man*
Philip James, *Henry Moore on Sculpture*
Peter S Stevens, *Patterns in Nature*

McGraw-Hill
Donald E Brown, *Human Universals*

John Murray
Kenneth Clark, *The Nude*

W W Norton
Rudolf Wittkower, *Architectural Principles in the Age of Humanism*
S M Kosslyn, *Ghosts in the Mind's Machine, Creating and Using Images in the Brain*

Oxford University Press
Anthony Storr, *Freud*
Richard Dawkins, *The Selfish Gene*
R L Gregory ed *The Oxford Companion to the Mind*, Contribution s by O L Zangwill, "Freud and Mental Structure": Daniel C Dennet, "Consciousness"(quoting E R John): Horace B Barlow, "The Art of Good Guesswork": and, unattributed, "Cognition"
Jerome H Barkow, Leda Cosmides and John Tooby, eds *The Adapted Mind, Evolutionary Psychology and the Generation of Culture*: Introduction by Leda Cosmides and John Tooby
Arnold Toynbee, *Mankind and Mother Earth* and *A Study of History*, (One volume illustrated edition)
Michael Sullivan, *Symbols of Eternity, the Art of Landscape Painting in China*

Penguin Books
Anthony Stevens, *On Jung*
Steven Pinker, *The Language Instinct*

Phaidon Press
E H Gombrich, *Symbolic Images, Studies in the Art of the Renaissance* and *The Sense of Order*

Praeger Publishers (An imprint of Greenwood Publishing Group Inc, Westport CT 1973)
Jack J Spector, *Freud's Aesthetics*

Prentice Hall
D E Berlyne, *Aesthetics and Psychobiology*

Psychiatric Quarterly
Vol 27 (1953), Contribution by E L Margetts, "Concept of the Unconscious in the History of Medical Psychology"

Rockefeller University Press
Donald R Griffin, *The Question of Animal Awareness*

Routledge
Susan Isaacs, *The Social Development of Young Children*

Sage Publications
Arthur Asa Berger, *Media Analysis Techniques*

Scientific American
October 1992, Contribution by Robert J Blumenschine and John A Cavallo, "Scavenging and Human Evolution"

Sheil Land Associates
Hugh Brody, *Living Arctic, Hunters of the Canadian North*

Sheldon Press
Anton Ehrenzweig, *The Psychoanalysis of Artistic Vision and Hearing*

Simon and Schuster
William F Allman, *The Stone Age Present*, 1994 p 51

The State University of New York Press
Balaji Mundkur, *The Cult of the Serpent*

Thames and Hudson
John Summerson, *The Classical Language of Architecture*
Michael Sullivan, *The Three Perfections, Chinese Painting, Poetry and Calligraphy*
Steven Mithen, *The Prehistory of the Mind*

Twins
July/August 1984, Contribution by Nancy S Segal, "The Nature vs Nurture Laboratory"

University of California Press
Brewster Ghiselin ed *The Creative Process*, Contribution by Christian Zervos, Conversations with Picasso
Rudolf Arnheim, *Towards a Psychology of Art*

The University of Chicago Press
Albert Hofstadter and Richard Kuhns eds, *Philosophies of Art and Beauty*, Contribution by John Dewey, "Art as Experience"

John Wiley and Sons
Jay Appleton, *The Experience of Landscape*

Yale University Press
Theodosius Dobzhansky, *Mankind Evolving*
Roy A Rappaport, *Pigs for the Ancestors, Ritual in the Ecology of a New Guinea People*
John Summerson, *Architecture in Britain 1530 to 1830* (9th edition 1993, first published by Penguin Books 1953)

ACKNOWLEDGEMENTS

ILLUSTRATIONS

1 Eleanor Greeves, Author's collection.
3 The Marylebone Cricket Club.
4, 18, 32, 33, 34, 35, 36, 37, 38, 39, 40, 46, 55, 60 (Chartres Cathedral interior), 74, 77 A F Kersting.
Plate 1, plate 6, 7, 8, 57, 65 Giraudon/Art Resource NY.
Plate 2 Museum Boijmans van Beunigen Rotterdam.
5, plate 8, 8, 25, 58, 61, 100 Alinari/Art Resource NY.
Plate 3, 22 The Oriental Institute of the University of Chicago.
Plate 4 Collection of the National Palace Museum, Taiwan
Plate 5, 57, 99 National Gallery, London.
Plate 7 Oskar Reinhart Collection, "Am Römerholz" Winterthur, Switzerland.
7 Scala/Art Resource NY.
9 Yvonne Vertut.
10 Werner Forman/Art Resource NY.
11, 14 Penguin Books (11 from Stevens, *On Jung*, 14 from Vernon, *The Psychology of Perception*).
12 Succession Picasso DACS/2000.
13 Sinauer Associates Inc (from Futuyma, *Evolutionary Biology*).
15 Century Books (from Pitts and Roberts, *Fairweather Eden*, examples from Olduvai drawn by Michael Pitts after M Leakey, example from Boxgrove by courtesy of the Boxgrove project).
16 DACS/2002/Tate Gallery London/Art Resource NY.
17 Marilu Pease/Monkmeyer.
19, 27, 43, 98 The British Museum.
20 Jennifer Harman after a photograph by Nimatallah/Art Resource NY.
21 Musée du Louvre, Paris.
23, 71 Thames and Hudson (23 from Miller, *the Art of Mesoamerica from Olmec to Aztec*, 71 from Cobban ed. *The Eighteenth Century*).
25, 34 Erich Lessing/Art Resource NY.
26 Griffith Institute, Ashmolean Museum, University of Oxford.
28 Pitt Rivers Museum, University of Oxford.
29, 106 NHM Picture Library.

30, 47, 75 V and A Picture Library .
31, 60, 83 British Architecture Library, RIBA, London (from Banister Fletcher, *A History of Architecture on the Comparative Method*).
42 Foto Marburg/Art Resource NY.
45 The British Library (shelfmark 11102.c.46/28, from Hayakawa, *The Garden Art of Japan*).
48 Akio Kawasumi.
49 Van Gogh Museum, Amsterdam, Vincent van Gogh Foundation.
50, 52 The Royal Geographical Society Picture Library.
51 National Trust Photographic Library.
53 Marsilio Editore
56 Angelo Hornak.
59 NRM/Science and Society Picture Library.
62 Burke Museum of Natural History and Culture, Seattle, Catalog # 1163, Kag-wantan Wolf Clan, collected by George T Emmons, Accession date 1909.
63 Kodansha Ltd (from Yanagi, Takahashi, Tsuji and Magatsuka, *Byzantium*: Cassell, 1978).
64 Trustees of the V and A.
66 RMN Picasso.
67 Oxford University Press (from Toynbee, *A Study of History*, one volume illustrated edition).
69 The British Library (shelfmark 457 a 4(2) 74, from Disel, *Erlustierende Augenweide in Vorstellung hörticher Gärten und Lustgebäude*).
70 Eleanor Greeves, (from Sullivan, *The Arts of China*, Cardinal 1973).
72, 73 Donne Bryant/Art Resource NY.
82 Conway Library, Courtauld Institute, University of London.
84 St Paul's Cathedral Library (photographs, Geremy Butler).
86, 91 (Parthenon analysis), 104 John Wiley and Sons inc (from Ching, *Architecture, Form, Space and Order*). 104 also from DACS, London 2002
87 Tahir Zadeh Bihzad (from Edwards, *The Persian Carpet*).
88 The Parker Gallery.
89 Lund Humphries (from Colvin, *Trees for Town and Country*).
92 The British Library (shelfmark LR 56 c 2, from Creswell, *Early Muslim Architecture*).

93 The British Library (shelfmark L45/341, from Stierlin, *L'Architecture de l'Islam de L'Atlantique au Gange*.
94 The British Library (shelfmark TAB 132 d, from Goury and Jones, *Plans, Elevations, Sections and details of the Alhambra*).
97 The British Library (shelfmark X429/3928 from Stierlin, *Living Architecture Ancient Mexican*).
101 Rijksmuseum Amsterdam.
102, 108, 109, Dover Publications Inc. (from Huntley, *The Divine Proportion*).
103 Parthenon Publishing Group (from Cull, *The Sourcebook of Medical Illustration*, free of copyright).
110, 111, 112 Little Brown (from Stevens, *Patterns in Nature*).
Unnumbered golden ratio diagrams pp226, 227 & 228 Michael Pooley.

COPYRIGHT QUERIES

In the following cases my efforts to trace the holder of the copyright failed to obtain a reply. If any copyright holder who remains unacknowledged would contact me c/o The Skylark Press I should be very happy to arrange for an appropriate acknowledgement to appear in any future edition.

Quotations in the text

Benedikt Taschen Verlag
Andreas Volwahsen, *India*

Harrap
Clark Wissler, *Man and Culture*

Reed Book Services Ltd
S H Skaife, *African Insect Life*

Viking
Laurence van der Post and Jane Taylor, *Testament to the Bushmen*

Illustrations

43, 46, 70, 80, 83, 90, 95, 97, 107

Preface

Who is this fellow Edwards? Is he a psychologist? An aesthetician? And, if not, what right has he to expound upon the psychology of aesthetics?

The answer, judged by these criteria, is that I have no such right; I am neither a psychologist nor an aesthetician. Nor can I – since these subjects come into the story – claim any authority in the fields of semiotics, genetics, anthropology, either social- or paleo-, the evolution of the human mind, or the history of art and architecture outside Europe and the Middle East. I am a retired architect and town planner whose working life was divided between the practice and the teaching of these arts. My special topic was the history of the English suburban housing estate.

As a teacher of town planning, I found myself lecturing to postgraduates on the theory of urban design. It is at best an intangible subject and my lectures weren't, I fear, as good as they should have been. At all events the students, sharp-witted if sometimes a bit philistine, had little difficulty in confounding me in discussion. This experience – together with a chance remark by a friend that aesthetics, traditionally an aspect of philosophy, is properly an aspect of psychology since it deals with the impact of external influences on the mind – led me to conclude that traditional aesthetics got off on the wrong foot. I decided to devote my retirement to an investigation of my friend's remark, limiting myself to the visual arts since they were my field.

The idea wasn't quite as daft as it sounds. In the first place I had borrowing rights from the Cambridge University Library – ten books at a time for two months – so, since I live within reach of Cambridge, I was able to work from home; secondly my father was a collector of middle eastern pictures, carpets and objets d'art and I was brought up in a virtual museum of these artefacts, an experience which provided me with an

awareness of the arts of that region as well as those of western Europe; thirdly I had both practised and taught two of the arts whose aesthetic characteristics would come into my enquiry; and, finally, one of them, town planning, is the most multi-disciplinary of disciplines and I was, as a planner, used to reconnoitring subjects outside my own field and to recognising links between apparently disparate topics.

If, however, I were to reconnoitre such subjects I required expert advice. To this end, I wrote to many eminent people; where they could help they did, where they couldn't they suggested alternatives and I wrote accordingly. Everyone was kind, generous and helpful. I have to apologise not only for bothering them – they must have been surprised to receive an enquiry from someone in a totally different field from their own – but also for what they must surely regard as the superficiality of what now appears. The need to establish links between apparently disparate topics means that I have been unable to study any one of them as fully as a specialist would consider desirable. It is the fate of the synthesiser.

The experts are:

On semiotics: David Cardiff, University of Westminster.

On social anthropology: Professor Robin Fox, Rutger's University, New Jersey.

On psychology: Professor Gustav Jahoda, University of Strathclyde; Dr Anthony Storr, University of Oxford; Dr Anthony Stevens; Professor Thomas Bouchard, University of Minnesota.

On paleoanthropology: Richard Leakey; Professor Ian Hodder, University of Cambridge; Professor Chris Stringer, Natural History Museum, London.

On genetics: Professor Stephen Jones, University of London; Dr Nicholas Mascie-Taylor, University of Cambridge; Dr Alastair Ewing, Open University; Dr G E Shaw, University of the Third Age; Professor Le Roy Hood, University of Washington; Professor Daniel J Kevles, California Institute of Technology.

On human evolution, including the evolution of the human mind: Dr Graham Richards; Professor Robin Dunbar, University of Liverpool; Dr Leslie C Aiello, University of London; Professor Merlin Donald. Queen's University, Kingston, Ontario; Dr Robin McKie.

On the histories of art and architecture: Dr Jean Michel Massing, University of Cambridge; Dr Stephen Hugh-Jones, University of Cambridge; J Wisdom, Librarian St Paul's Cathedral; Dr Julian Raby, University of Oxford; Dr Doron Chen, Belaziel Academy of Art and Design, Israel; Dr Wladimir Zwolf; Dr Giles Tillotson, University of London.

❋ ❋ ❋

If the experts provided me with sources of information for this enquiry I could never have written it without the support of my family and friends; in particular without my three daughters, Jennifer, Alison and Miranda – who kept me at it for almost two decades, without Peter Gray Lucas – whose chance remark about aesthetics as an aspect of psychology launched me into it and who went on to provide me with morsels of information for years afterwards – without James Madge of the University of Westminster – whose advice was most helpful in the early stages – without Michael Sullivan, Fellow Emeritus of Chinese Art at St Catherine's College Oxford – who was always ready to answer questions about the arts of China – without my erstwhile colleague Denis Broodbank and his son Cyprian of the Department of Archaeology at the University of London – both of whom did much to steady me on the way – without Anne King-Hall – who gave most helpful advice about publishing – without Ralph Rookwood and Richard Lipsey – both of whom made invaluable comments on the text – without Graham Howes – who gave me constant encouragement year after year – without Diane Russell who prepared the index, without Jane Tatam who steered me with extraordinary patience through the shoals of publishing, and, above all, without my housekeeper Betty Osborn, whose utter devotion and ineradicable cheerfulness kept me going and who, by so splendidly looking after the domestic chores, left me free to write. She, more than anyone else, made this book possible.

I thank them all. I need hardly add that what follows is my responsibility, not theirs.

Foreword

Most studies in aesthetics regard it as a constituent of philosophy and seek to examine, directly, some aspect of the nature of beauty. My approach is different. I consider that aesthetics, being a matter of the impact of external influences on the mind, is properly a study, not of philosophy but of psychology, and that to investigate beauty directly involves serious problems; chiefly because the word eludes definition. Accordingly I investigate aesthetics as a constituent of psychology and adopt an indirect approach to the investigation of beauty – a strategy which enables me to avoid, so far as possible, the use of the word.

Part One

Communication and the Visual Arts

1 *T A Greeves, no title.*

Part One

Introduction

Here, on the facing page, is a picture; make of it what you will, I shall not refer to it again. Like any work of art, the original was devised in the mind of the artist – my friend, the late Tom Greeves – and has been interpreted in the minds of whoever has looked at it. These include the minds of my children (for whose amusement it was drawn), that of my wife (while she was alive), those of my housekeeper, my guests and myself (it hangs on my staircase) as well as yours (as you refer to it on reading these words). It must evidently constitute a means of communication between Tom's mind and the minds of these others. I consider, as an axiom, that such communication occurs whenever someone responds positively to a work of art.

Part One is an enquiry into how this takes place. Since the study involves communication it must consider the theory of the subject; since it involves the visual arts it must say something about them and since it involves the minds, both of the artists and of the beholders, it must be concerned with psychology. The findings from the psychological part of the enquiry are considered in Parts Two to Four.

Chapter One

The Visual Arts and the Theory of Signs

Some Definitions

I suppose I should begin with a few definitions. Let's start with 'visual arts'.

I include under this heading those arts and crafts which are static and which we experience through our eyes, though awareness of non-visual experiences may also be involved. Thus pictures, though experienced through the eyes, often illustrate stories, myths or events; much painting, all crafts, all architecture, all land- and townscape possess tactile as well as visual characteristics, while architecture and the -scapes involve that potent, but unnamed sense: the experience of space.

The definition therefore includes not only the so-called fine arts of drawing, painting, sculpture and architecture but also still photography; the design of parks, gardens and townscape; crafts such as pottery, cabinet-making, calligraphy, embroidery and the weaving of textiles; smith's work – whether in iron, copper, silver or gold – as well as the many activities that together constitute interior decoration. On the other hand the theatrical and cinematic arts are excluded. Our concern is with static objects and they are mobile.

This definition is, I fear, a little muzzy at the edges. Some works of art, like buildings, sculptures and townscapes, though themselves static, require movement for their experience; some, like gardens, land- and townscapes not only alter with changes in light, weather and the seasons but are also subject to ecological, economic, cultural, technological, social and political

change; while some, like parks, though apparently static, do in fact alter, as the vegetation of which they are composed grows, matures and dies. I hope nevertheless that the reader will consider that this definition describes what most of us think of when someone refers to the visual arts.

I call the communication process which links the mind of the artist and the mind of the recipient 'aesthetic communication', I call the recipient of the communication 'the experiencer' (not the beholder, because, as we have seen, the process may involve non-visual experiences) and, since I try to avoid the use of the word beauty, I call the experiencer's sensation on receiving an aesthetic communication 'aesthetic response'.

Communication: Where our Subject Lies

The *Fontana Dictionary of Modern Thought* has six entries on different aspects of communication[1] together with entries on the related fields of information theory[2], semiology and semiotics[3]; nine in all. Seven of these entries relate to disciplines such as ethnography, literary criticism, geography, sociology, linguistics and control engineering and are not therefore relevant to this study. The other two are semiology and semiotics. The two terms are, according to the dictionary, in part synonymous. The former is described as 'the general, if tentative, science of signs: systems of signification, means by which human beings — individually or in groups — communicate or attempt to communicate by signal: gestures, advertisements, language itself, food, objects, clothes, music, and the many other things that qualify. The subject was proposed by the linguist Ferdinand de Saussure but influentially developed by the French writer Roland Barthes. The latter is described as the 'the study of patterned human behaviour in communication in all its modes. The most important mode is the auditory/vocal, which constitutes the primary subject of linguistics...Semiotics can also mean the study of sign and symbol systems in general for which an alternative term is semiology'.

We seem to be getting somewhere. If semiology is the 'science of signs: systems of signification, means by which human beings communicate', and includes under this heading 'gestures, advertisements, language itself, food, objects, clothes, music, and the many other things that qualify', works of art must, by our axiom, be signs. Furthermore, if semiotics is 'the study

of patterned human behaviour in communication in all its modes', the study of works of art as means by which human beings communicate must also be included within semiotics. Such dictionary definitions are, however, necessarily brief and possibly incomplete. It behoves us therefore to investigate the matter in more detail in order to establish whether our subject lies in both disciplines or in one only, and if one, which?

We should perhaps begin by considering the definitions of the two terms as proposed by their originators. Saussure defined semiology as follows:

> 'La langue est une système de signes exprimant des idées et par là comparable à l'écriture, à l'alphabet des sourds muets, aux rites symboliques, aux formes de politesse, aux signaux militaires, etc. etc. Elle est seulement le plus important de ces systèmes. *On peut donc concevoir une science qui étudie la vie des signes au sein de la vie sociale*; elle formerait une partie de la psychologie sociale, et par consequence de la psychologie générale; nous la nommerons *sémiologie* (du grec *sémeiôn*, 'signe'). Elle nous apprendrait en quoi consistent les signes, qu'elles lois les regissent. Puisqu'elle n'existe pas encore, on ne peut pas dire ce qu'elle sera; mais elle a droit à l'existance, sa place est determinée en avance'.[4]

Semiotics was the brain-child of the American C S Peirce, considered by Sir Karl Popper to be 'one of the greatest philosophers of all time'.[5] He declares: 'I am so far as I know, a pioneer, or rather a backwoodsman, in the work of clearing and opening up what I call *semiotic*, that is the doctrine of the essential nature and fundamental varieties of possible semiosis'.[6] He goes on to define semiosis as follows: 'By semiosis I mean an action, an influence, which is, or involves, a co-operation of *three* subjects such as a sign, its object and its interpretant, this tri-relative influence not being in any way resolvable into action between pairs.'[7] An example may perhaps clarify this somewhat obscure definition. The footprint on the sand discovered by Robinson Crusoe was a sign, the fact that it indicated the presence of someone else on the island was its object, its effect on Crusoe was its interpretant. These three 'subjects' have to be considered together; they cannot be resolved into action between pairs.

To which we may add that Peirce defined a sign as 'something which stands to somebody for something in some respect or capacity'.[8]

We should realise that the two approaches differ in an important respect. According to Saussure's concept the sign is a communication device which takes place between two human beings intentionally seeking to communicate or to express something and using for this purpose artificial, conventional systems such as language, military signals, rules of etiquette or visual alphabets. By contrast Peirce's definition of a sign does not demand that it be intentionally emitted and artificially produced. It can be applied as much to a fossil found by a palaeontologist as to a love-letter or a mayday call.

Peirce's less restrictive definition seems to be more pertinent to our enquiry than Saussure's concept of 'une système de signes exprimant des idées'. I do not mean to suggest that works of art are not artificially produced, they obviously are; or that they do not involve conventions, many of them do and we shall say a little about the nature of these conventions later in this chapter. The conventions of works of art are not, however, of the same order as military signals or rules of etiquette; breaking them may result in shocked incomprehension as happened at the first showing of Picasso's *Les Demoiselles d'Avignon*, but with familiarity such breaches become acceptable.

Accordingly, I consider that of the various activities which are known as communication – together with its related fields – our subject lies most happily within semiotics.

Peirce's Theory of Signs

According to Peirce, 'a sign is either an *icon* an *index* or a *symbol*.[9] He proceeds to explain what he means by these words in fifteen pages of abstruse prose; I can see no reason to inflict them upon the reader. He does, however, include within them a few helpful sentences, thus:

Of icons:

'A great distinguishing property of the icon is that by direct observation of it other truths concerning its object can be discovered than those which suffice to determine its construction'.[10]

One of the commonest of such truths, and one that is particularly relevant to our enquiry, is that of likeness between an iconic sign and its object. Peirce writes as follows:

> 'An example of the use of a likeness is the design an artist draws of a statue, pictorial composition, architectural elevation or piece of decoration, by the means of which he can ascertain whether what he proposes will be beautiful and satisfactory. The question asked is thus answered almost with certainty because it relates to how the artist will himself be affected. The reasoning of mathematicians will be found to turn chiefly upon the use of likenesses which are the very hinges of the gates of their science. The utility of likenesses to mathematicians consists in their suggesting in a very precise way, new aspects of the states of things'.[11]

So an iconic sign resembles its object, developing some aspect of the resemblance rather than being a direct representation of its prototype.

Of indexes:

> 'An index is a sign, or representation, which refers to its object not so much because of any similarity or analogy with it, nor because it is associated with general characters which that object happens to possess, as because it is in dynamical (including spatial) connection both with the individual object, on the one hand, and with the senses or memory of the person for whom it serves as a sign on the other hand'.[12]

and later:

> 'Indexes may be distinguished from other signs, or representations, by three characteristic marks: first, that they have no significant resemblance to their objects; second, that they refer to individuals, single units, single collections of units, or single con-

tinua; third that they direct attention to their objects by blind compulsion'.

Pierce cites several examples:

'I see a man with a rolling gait. This is a probable indication that he is a sailor…Anything which startles us is an index, in so far as it marks the junction between two portions of experience. Thus a tremendous thunderbolt indicates that *something* considerable happened, though we may not know precisely what the event was. But it may be expected to connect itself with some other experience'.[13]

So an index, though directly related to its object, does not resemble it.

Of symbols:

'A *symbol* is a sign which would lose the character which renders it a sign if there were no interpretant. Such is any utterance of speech which signifies what it does only by virtue of its being understood to have that signification'.[14]

To which he adds:

[A symbol is] 'a conventional sign, or one depending upon habit (acquired or inborn)…A standard or ensign is a "symbol", a watchword is a "symbol"…any ordinary word, as "give," "bird", "marriage" is an example of a symbol. It is *applicable to whatever may be found to realize the idea connected with the word*; it does not, in itself, identify those things. It does not show us a bird, nor enact before our eyes a giving or a marriage, but supposes that we are able to imagine these things, and have associated the word with them.'[15]

So Peirce's symbols appear to be synonymous with Saussure's sémiologie: 'une système de signes exprimant des idées'.

A tool

A later authority, Arthur Asa Berger, expressed Peirce's analytical concept by means of the following matrix: [16]

	ICON	INDEX	SYMBOL
signify by	resemblance	causal connection	convention
examples	pictures, statues	smoke/fire symptom/disease	words, flags numbers
process	can see	can figure out	must learn

This could well be a tool which we might use for the analysis of a work of art, but before studying it in detail we must first test it upon a couple of simple examples.

TWO EXAMPLES

(i) Here is a sign.

2 *A crescent.*

Like any other sign, it, in Peirce's words, 'stands to somebody, for something, in some respect or capacity'. To one person, seeing it in respect of the night sky, it could stand for a crescent moon; to another, seeing it in

respect of astronomy, it could stand for the way in which part of the moon's globe is lit by the sun at certain times each month; to a third, seeing it in respect of religion, it could stand for Islam. In the first case the sign is an *icon* – it is, in terms of Berger's matrix, signified by resemblance, something which the recipient of the sign 'can see'; in the second it is an *index* – there is, in terms of the matrix, a causal connection between its shape and the part of the moon's globe which is lit by the sun, a connection which is not immediately evident and which the sign's recipient has to figure out if he is to make sense of it; in the third it is a *symbol* – a convention, something which the recipient, if he is to understand it, 'must learn'.

(ii) Here is a picture of a piece of craft-work. Cricket enthusiasts will recognise it as the weathervane at Lords.

As an icon, it shows an elderly gentleman with a scythe over his shoulder doing something with the bails on a wicket. As an index, it is a means by which somebody who has familiarity with weathervanes can figure out the direction of the wind. As a symbol, it is Father Time lifting the bails from the wicket at the end of an innings, and thus, by analogy, a metaphor for death.

3 *The weathervane at Lord's cricket ground.*

The separation of icons, indexes and symbols in Berger's matrix suggests that a sign cannot be at once an icon, an index, and a symbol. The test shows that this is a misinterpretation. The two examples described above are, as we have seen, simultaneously icons, indexes and symbols. There are many other such cases. A map is an icon, but it involves the symbolic convention of scale, something which in Berger's terms one 'must learn'; a pointing finger, though an icon, involves a symbol; we need to have learnt what it symbolises if we are to find the object indicated.

We may conclude that Berger's matrix is a suitable tool for the analysis of works of art as signs so long as we appreciate that a single sign can appear in more than one of its three categories. We have, however, a problem: according to the matrix, symbols are signified 'by convention', a phrase that may cause confusion when used in the context of a work of art. In these circumstances we should perhaps fulfil our promise of a few pages back and say something about conventions before proceeding further.

Conventions

Convention is defined in the *Oxford English Dictionary* as 'a rule or practice based upon general consent, or accepted and upheld by society at large; an arbitrary rule or practice recognised as valid in any particular art or study'. It is surely evident that such conventions appear throughout the visual arts; we need only think of the un-lion-like lions of medieval heraldry, of the changelessness of Egyptian painting and sculpture over more than two millennia or of the way in which Capability Brown, Humphry Repton and their followers created English landscaped parks in the manner of italianate paintings by Claude Lorrain. We should note, however, that conventions occur not only in the general form of such works but also in the way in which their details are handled, details which are often no less conventional than the works themselves. We could cite many examples of such variety of detail within a convention, fashion provides one field of study, the design of Persian carpets another[17] but surely the most subtle is provided by the classical orders of architecture, a complex grammar of design which, if it is to be used successfully, must first be thoroughly understood and must then be adjusted to meet the needs of each individual case. Sir John Summerson provides two telling quotations from Lutyens on this subject:

> 'You cannot play originality with the Orders. They have to be so well digested that there is nothing but essence left',

and

> 'That time-worn Doric order – a lovely thing – I have had the cheek to adapt. You can't copy it. To be right you have to take it

and design it...You alter one feature (which you have to, always), then every other feature has to sympathise and undergo some care and invention. Therefore it is no mean game, nor is it a game you can play light-heartedly'.[18]

We may conclude that though a work of architecture may be devised in accordance with a convention it *must* vary in detail from the ready worked-out solution which the convention offers. Without such change, it would be little more than a characterless reproduction of its prototype.

St Pancras Church provides an instructive example of the use and misuse of architectural conventions. The architect was H W Inwood, the date was 1818. The external form of the church follows that established, after Wren, by James Gibbs at St Martin-in-the-Fields. The convention involved a columned portico on the west front to signify the importance of the building and the position of the entrance, with a steeple above to show that it was a church; but while Gibbs' details follow Italian renaissance

4 *H W Inwood: St Pancras Church, London.*

prototypes Inwood's derived from Athens. Athenian buildings did not possess steeples so Inwood made one up out of elements borrowed from the Tower of the Winds and the Choragic Monument of Lysicrates. To provide two large vestries he modified the St Martin-in-the-Fields' plan by placing, towards the east end, a pair of caryatid porches which derived from, but did not copy, that at the Erechtheion. In the interior he employed details from the Erechtheion and other famous Athenian buildings but, as Summerson points out, 'these do not give the recepe for everything and where they do not (as the vestry ceilings and the pulpit) Inwood showed himself singularly resourceful in the adaptation of more recondite archaeological material'.[19] All this was fine – Summerson declares that the 'fancy dress fits like a glove' – but when he came to the entrance portico Inwood's resourcefulness dried up. He did not realise, as did Lutyens, that if you 'alter one feature (which you have to, always) then every other feature has to sympathise and undergo some care and invention'. He adopted the Greek ionic convention to the full, copying the Erechtheion's order precisely. This despite the fact that he was building in Portland stone instead of Pentelic marble, and in cloudy, grimy, nineteenth-century London instead of clear, sunny Athens. The result, to me at least, is a sadly dull façade.[20]

Conventions of a critical, though of a different kind, appear occasionally in painting. An artist who flouts them – whether deliberately or by thoughtless accident – may well find himself in trouble. We have already seen how this happened to Picasso, it may be worthwhile to offer another example: Manet's *Olympia* (plate 1). The time was the reign of Napoleon III, a period during which, according to Clive Bell, the upper classes practised a hypocrisy 'blacker even than that of mid-Victorian England'.[21] The conventional nudes of the period were painted from professional models. The artists concerned are described by Kenneth Clark as having 'one characteristic in common; they glossed over the facts. They employed the same convention of smoothed out form and waxen surface; and they represented the body as existing solely in twilit groves or marble swimming baths'.[22] But Manet's girl wasn't painted from a professional model, she wasn't a nymph by a woodland spring. She was a real person, a recognisable Parisian harlot whose 'interesting but sharply characteristic body is placed exactly where one would expect to find it'.[23] That was shocking enough but Manet went further: he introduced a black serving maid delivering a

bouquet, obviously from an admirer, he set the girl's left hand, hiding her pudenda, in the centre and focus of the picture and he called it *Olympia*, the home of the Gods. You didn't need to be a Freud to see the implication. There was a storm, and no wonder.

It's difficult to see how conventions such as that misused by Inwood or broken by Manet relate to the symbol column of Berger's matrix. Perhaps we should return to Peirce.

Symbols

IN PAINTING AND SCULPTURE

We have seen that according to him, 'any ordinary word, as "give", "bird", "marriage" is a "symbol" [such a word] does not, in itself, identify those things. It does not show us a bird, nor enact before our eyes a giving or a marriage, but supposes that we are able to imagine these things, and have associated the word with them.' Furthermore that according to Berger a symbol signifies 'by convention' and its process is 'must learn'.

Peirce's definition appears, at first sight, to create difficulties for anyone who seeks to apply his principles to the visual arts. If a symbol 'does not show us a bird or enact before our eyes a giving or a marriage' can a picture such as Hieronymus Bosch's *The Marriage at Cana* (plate 2) be a symbol? On the face of it, the answer must be no but this is surely a misconception. We have seen that a work of art may be simultaneously, an icon, an index and a symbol. As an icon the picture is, quite simply, a lunch party. But it isn't just any lunch party, it is a *particular* lunch party, indeed a marriage party at which certain events are said to have taken place. To someone who had not learnt about that event the picture would be no more than an icon, but to someone who knows the story, is able to imagine it and is therefore able to associate the picture with it, Bosch's painting is both an icon and a symbol. As a picture of a lunch party, it is an icon, as an illustration of the (known) story it is a symbol.

Representational art abounds in such illustrations; whether of myths, as Botticelli's *Birth of Venus*; of scenes from daily life, as Utamaro's woodcuts of prostitutes in the brothels of Edo; of historical events, as the Bayeux tapestry; of philosophical concepts, as the gardens in certain Japanese

Plate 1 Manet: *Olympia*.

Plate 2 Hieronymus Bosch: *The marriage at Cana*.

Plate 3 A vintage scene: Egyptian, fifteenth century BC.

Plate 4 Fan K'uan: (c 950-1030) *Travelling amid Mountains and Gorges.*

Plate 5 Constable: *The Cornfield*.

Plate 6 Grünewald: *The Crucifixion from the Isenheim Altarpiece*, detail.

Plate 7 Renoir: *Sleeping Woman.*

Plate 8 Goya: *Charles IV of Spain and his Family*, detail.

monasteries; of poetry, as the sixteenth-century Persian manuscript, *The Poems of Niẓami*, and above all of religious themes. If we are to make the most of such works, we need to know what they illustrate. In order to comprehend fully Donatello's *David* – a boy with a severed head beneath his feet, a stone in one hand and a sword in the other – we need to know the story of how he defeated Goliath. And that is something that we can only learn.

We may conclude that an illustration is indeed 'a sign which would lose the character which renders it a sign if there were no interpretant'. On this basis we may properly add 'or illustration' to 'convention' in the symbol column of Berger's matrix.

IN ARCHITECTURE AND THE CRAFTS

A Sung dish is a work of art and, as such, it constitutes, by our axiom, a means of communication between the mind of the artist and the mind of the experiencer. It should therefore be capable of semiotic analysis. It is, however, a piece of craftwork and examples of architecture and the crafts are not, at least at first sight, icons like pictures and sculpture, signifying by resemblance; nor do they appear to involve, like fire and smoke, the causal connection of an index. Are they perhaps symbols like words and flags, signifying by illustration or convention?

In the great majority of cases, the answer is surely yes. Think of a teacup, typically a small round bowl with a question-mark handle on one side; of a Greek temple, typically a large marble box with a gabled roof at a very low pitch and a columned portico at each end; of the pair of inter-war semis-, typically symmetrical with a hipped roof, arched front doors and bay windows capped with mock-tudor gables. The form of each one is conventional so they are evidently symbols.

This, however, is not all.

Such objects – we may call them collectively artefacts – have two functions quite apart from any artistic quality that they may possess. One is practical, the other is informative. Thus, a Wedgwood teacup isn't simply a teacup, it is a special kind of teacup, one that offers a message about the wealth and taste of its owner; the Parthenon wasn't just a temple, it was a piece of propaganda about the greatness of Athens; the pair of inter-war semis- isn't just two twin dwellings, it is a device that tells the world that its

5 *Donatello:* David.

occupants are middle-class people, owners of their homes; not working-class renters of council houses. Each one provides, in its form and decoration, information about the lifestyles, social positions and philosophical beliefs of those who use or built it.

There is clearly a causal connection between the object concerned and the information that it offers. Furthermore, such objects provide the material for the figuring out activities of archaeologists, anthropologists and social scientists. Circumstances which suggest that artefacts are, in semiotic terms, indexes as well as being, as we have seen symbols.

Icons

As we pointed out earlier, an iconic sign resembles its object, developing some aspect of the resemblance rather than being a direct representation of its prototype. In the case of a 1/2,500 Ordnance Survey map, this is done by selecting one of the sign's characteristics, that of length, and relating it mathematically to the features on the ground that the map represents; in the case of a mathematical model it is done by selecting certain of the sign's aspects and translating them into numerical or algebraic symbols so that they can be manipulated without reference to the remainder; in the case of Egyptian art it is done by showing the body and eyes in full face and the limbs and head in profile, a convention that enabled the artists to represent 'all they knew rather than all they saw'[24] (plate 3). Ernst Gombrich's admirable study, *Art and Illusion*, is largely devoted to this topic as it applies to the visual arts. His subject is not, however ours. We are not concerned with iconic signs *per se* but rather with the suitability of Peirce's theory – particularly in its interpretation by Berger – as an analytical device.

Indexes

Symbols and icons are, of necessity, manmade; think of Berger's words, flags, numbers, pictures and statues. Conventions and illustrations are the same; we cannot conceive of a natural convention or an illustration without a theme. Furthermore, a conventional index is a contradiction in terms; 'a rule or practice based upon general consent, or accepted and upheld by society at large' cannot possibly require to be figured out, it just needs to be learnt for its significance to be understood. So while all symbols and the

great majority of icons involve conventions, indexes do not. Do indexes appear in the visual arts? And if so, how and where? We should perhaps begin the enquiry by discussing the place of familiarity in the interpretation of indexical signs, and go on to analyse a few examples in an effort to discover whether the aesthetic communications embodied in the works concerned signify only by resemblance, convention or illustration, or whether they include causal connection as part of their signification process.

FAMILIARITY

Although Berger does not say so, we all know that in order to figure out the presence of a fire from a plume of smoke or a disease from its symptoms one must be familiar with these phenomena. The same is true of any indexical sign. We can figure out the direction of the wind by reference to the Father Time weathervane because we possess familiarity with weathervanes, not because of any necessary relationship between Father Time and the points of the compass. Similar familiarity is required in regard to Peirce's thunderbolt and man with a rolling gait and to my own crescent moon as interpreted by an astronomer. The crucial differences in the processes of understanding required for symbols on the one hand, and icons and indexes on the other, is not Berger's 'must learn'; that is a characteristic of all three. In the case of symbols, we have to learn exactly what a particular sign represents before we can understand it. In the case of icons we need to recognise how the sign resembles its object before we can interpret it; in the case of indexes we require Peirce's 'senses or memory' of the set in which a particular sign lies if we are to figure it out. All three demand awareness and hence learning or instinct, though icons and indexes do not always require the exact knowledge necessitated by symbols. Thus Sherlock Holmes, the supreme figurer-out of indexes, possessed by his own account a mind 'like a crowded box-room with packets of all sorts stowed away therein – so many that I may well have but a vague perception of what was there'. [25]

Familiarity, then, is an essential to the figuring-out process. It is also by common experience essential to the full enjoyment of a work of art; a point which was recognised by the philosopher David Hume in the mid-eighteenth century when he declared that, '...though there be naturally a wide difference in point of delicacy between one person and another, nothing

tends further to increase and improve this talent than *practice* in a particular art, and the frequent survey or contemplation of a particular species of beauty.'[26] The subject has been studied in our own time by the French sociologist of culture Pierre Bourdieu. He writes as follows:

> 'Scientific observation shows that all cultural practices (museum visits, concert going, reading etc.) and preferences in literature, painting or music are closely linked to educational level (measured by qualifications or length of schooling) and secondarily to social origin. The relative weight of home background and of formal education...varies according to the extent to which the different cultural practices are recognized and taught by the educational system, and the influence of social origin is strongest...in "extra curricular" and avant-garde culture.' [27]

and,

> 'Like the so-called naive painter who, operating outside the field and its specific traditions, remains external to the history of the art, the "naive" spectator cannot attain a specific grasp of works of art which only have meaning – or value – in relation to the specific history of an artistic tradition. The aesthetic disposition demanded by products of a highly autonomous field of production is inseparable from a specific cultural competence...This mastery is for the most part acquired simply by contact with works of art.'[28]

All of which is a long-winded way of saying that the full enjoyment of a work of art is, like whisky, an acquired taste, one which demands familiarity with other works of a similar kind – familiarity which results from the individual's upbringing, education and experience, in particular with experience of works of art.

Two landscapes: *Travelling amid Mountains and Gorges* by the Sung Dynasty artist, Fan K'uan, and *The Cornfield* by John Constable(*plates 4 & 5*).

TRAVELLING AMID MOUNTAINS AND GORGES

Michael Sullivan, our leading authority on Chinese painting, declares that, '...to a Chinese the theme of a painting is inseparable from its form, and

both are the expression of an all-embracing philosophical attitude toward the visible world'.[29] He goes on, 'The mountains and rocks, trees and water *mean* something. But to discover what they mean, we should ideally have seen a great many Chinese paintings, steeped ourselves in the *Classics* and *Histories*, studied Buddhist, Taoist, and Neo-Confucian philosophy, and committed to memory a vast amount of poetry; for that is the kind of equipment which the Chinese amateur would bring to his appreciation of landscape painting.'[30] We can interpret this, in terms of the matrix, by saying that in painting *Travelling amid Mountains and Gorges* Fan K'uan employed conventions which caused the picture to be a symbol expressive of an all-embracing philosophical attitude toward the visible world; a symbol moreover whose understanding would not only require a helluvalot of 'must learn' even for an educated Chinese but which would also be quite meaningless to someone who had not experienced something of that discipline. *Travelling amid Mountains and Gorges* is also assuredly an icon; anyone who has visited the valley of the River Li in Central China would recognise the scene as characteristic of the gorges above Guilin. Others who do not know the area can see features in the picture which resemble pine trees, rocks, a waterfall and a bridge as well as a mountain of some kind, though a westerner might well consider that Chinese artists of the Sung dynasty employed somewhat bizarre conventions to portray mountains. There can be no doubt that *Travelling amid Mountains and Gorges* signifies by resemblance.

It seems then that this picture is both a symbol and an icon. Is it also an index? Does it signify something by means of a causal connection, a connection whose nature can only be figured out? The answer seems to be yes. Sullivan assures us that though we shall never get very far if we stop at the merely visual pleasure which a Chinese landscape painting gives us we can nevertheless enjoy such a picture as 'a pure aesthetic experience much as we enjoy music'.[31] There is obviously a causal connection between such enjoyment and Fan K'uan's picture. It is certainly an index.

(For those who find Sullivan's account of Chinese symbolism in landscape difficult to accept I offer a western example, Rembrandt's etching of *The Three Trees*; a picture which has a passing storm for its motive but which is also, surely, a symbol of the crucifixion.)

6 Rembrandt: *The Three Trees*.

THE CORNFIELD

As a contrast to *Travelling amid Mountains and Gorges*, I offer *The Cornfield*. One is Chinese, the other English, one is gloomy, the other bright, one is rendered in ink on an orange-brown background, the other is an oil painting; one offers us a powerfully symbolic but, to a westerner, lightly iconic image of a mountain, while the other possesses no symbolic significance – none at least that I have been able to recognise – but whose evocation of a summer day with a tree-lined lane, a sheep dog and its flock, a field of ripe corn and a boy lapping water from a stream makes it a most compelling icon. Both pictures do, however, have one thing in common: they are both indexes. As in *Travelling amid Mountains and Gorges*, there is a causal connection between *The Cornfield* and the 'pure aesthetic experience' available to whoever may encounter it.

Two Figure Paintings: *The Crucifixion from the Isenheim Altarpiece* by Matthias Grünewald and *Sleeping Woman* by Paul Renoir (*plates 6 & 7*).

THE CRUCIFIXION FROM THE ISENHEIM ALTARPIECE

If the iconic content of *The Cornfield* is elysian, that of the *Isenheim Crucifixion* is both horrific and bizarre. Horrific because it depicts a man in the last throes of being tortured to death, bizarre partly because he is surrounded by four figures in highly melodramatic poses, and partly because the figures include a lamb carrying a small cross on its shoulder as if it were a rifle – a lamb, moreover, which seems to behave as if nothing untoward had happened despite the fact that it has just had its throat cut. In semiotic terms the picture is clearly a symbol, illustrative of a story. But what story? Someone without knowledge of the gospels could hardly be blamed for being puzzled. To one who does know about it and can make sense of Grünewald's highly complex iconography it is surely one of the most profound and moving images of the scene that has ever been painted.

7 Grünewald: *The Crucifixion from the Isenheim Altarpiece*
(see plate 6 for detail).

SLEEPING WOMAN

As an icon the Renoir is delightful; it would be ridiculous to deny its erotic content and fallacious to suggest that such content is irrelevant to its artistic quality – we have already pointed out that iconic signs are usually employed as a means of developing some aspect of the resemblance rather than as a direct representation of their prototypes[32] – but if the iconic content of Renoir's aesthetic communication is magical its symbolic content is slight. Its title, *Sleeping Woman*, tells us that it should be regarded as a scene of everyday life rather than as a formal nude-in-the-studio, but that seems to be all.

Both pictures are masterpieces. They conform to Kenneth Clark's definition: 'the work of great artists in moments of particular enlightenment'.[33] One is a wondrous icon, the other a prodigious symbol but in addition they both offer us the same kind of 'pure aesthetic experience' that we obtain from *Travelling amid Mountains and Gorges* or *The Cornfield*, an indication that they are also indexes, a view which is confirmed by relating them to Peirce's definition of an index, a definition which may be worth repeating since it is the key to our argument:

> 'An index is a sign, or representation, which refers to its object [in each of these cases the 'pure aesthetic experience' which the picture offers] not so much because of any similarity or analogy with it, nor because it is associated with general characters which that object happens to possess, as because it is in dynamical (including spatial) connection both with the individual object, on the one hand, and with the senses or memory of the person for whom it serves as a sign on the other hand.'

and

> 'Indexes may be distinguished from other signs, or representations, by three characteristic marks: first, that they have no significant resemblance to their objects; second, that they refer to individuals, single units, single collections of units, or single continua; third that they direct attention to their objects by blind compulsion.'

'Blind compulsion'. I can think of no better phrase to describe the impact of a masterpiece upon the mind.

Any other work of art could be analysed as a set of signs as we have analysed these four pictures. Examples of architecture and the crafts are, as we have seen, both symbols and indexes though occasionally they are icons as well, think of the Father Time weathervane. Pictures are typically icons and indexes though they are often – like *The Isenheim Crucifixion* or *Travelling amid Mountains and Gorges* – symbols also; while the works of the abstractionists, being without either iconic or symbolic content, are no more than indexical. It seems clear, however, that the aesthetic communication embodied in any work of art is centred within the realm of the index and that from there it extends into the realms of the icon and the symbol, though the richness of the communication, how deeply it lies in the index and how far it extends into the other realms, are matters which depend upon the nature and quality of the work concerned. Kitsch is art which is minimally indexical but which extends widely into the realms of the icon and the symbol.

A Name

If this conclusion is correct, there is no further need for us to investigate the iconic or symbolic aspects of aesthetic communication: icons can be recognised, symbols can be learnt. Indexes, on the other hand require to be figured out. The rest of this study will be concerned with such figuring but before we start there is one thing to be done; we must give the subject a name. We can't call it 'the indexical aspect of aesthetic communication'; that is far too long-winded; we could boil the phrase down to 'indaspaesthecom' but that sounds like some prehistoric monster; Clive Bell's 'significant form' is neat but it has its own meaning so we can hardly borrow it and anyway it doesn't include the idea of communication; 'indexical aesthetic communication' gets us over that problem but is still a dreadful mouthful; I wish I could think of something else but I'm afraid that we're stuck with the abbreviation IAC. Suggestions would be welcome.

(1) *The Fontana Dictionary of Modern Thought*, 1989, p 147.
(2) *ibid*, p 424.
(3) *ibid*, p 769.
(4) Ferdinand de Saussure, *Cours de Linguistique Général*, Payot, 1916, pp33-34.
(5) Karl R Popper, *Objective Knowledge*, Oxford University Press, 1979, p 212.
(6) C S Peirce, *Peirce. Collected Papers 1931-58*, Harvard University Press, 5.488.
(7) *ibid*, 5.484. Interpretant is defined in the *New Shorter Oxford Dictionary* as 'the effect of a proposition or sign-series on the person who interprets it'.
(8) C S Peirce, *Logic as Semiotic: the Theory of Signs*, in *The Philosophy of Peirce, Selected Writings*, Justus Buckler, editor, Kegan Paul, Trench Trubner and Co, 1940, p 99.
(9) *ibid*, p 104.
(10) *ibid*, pp 105-106.
(11) *ibid*, pp 106-7.
(12) *ibid*, p 107.
(13) *ibid*, pp 108-109.
(14) *ibid*, p 104.
(15) *ibid*, pp 113-114.
(16) Arthur Asa Berger, *Media Analysis Techniques*, Sage Publications, 1982, p 15.
(17) See A Cecil Edwards, *The Persian Carpet*, Duckworth, 1953, pp 36-51. (Cecil Edwards was my father. I have, in writing this book followed his example and used the word 'Persian' in preference to 'Iranian', the more recent usage. Like him I consider that 'the word "Iranian" – particularly when applied to the products of the weaver's art – does not suggest the antiquity, the elegance or renown which the word "Persian" awakens in my mind'. *ibid*, p v.)
(18) John Summerson, *The Classical Language of Architecture*, Thames and Hudson, 1980, p 27. I have had the cheek to emend. Summerson's word is adopt. I feel sure that this was a misreading; adapt makes much more sense in the context.
(19) John Summerson, *Architecture in Britain, 1530 to 1830*, Penguin 1953, p 317.
(20) See Summerson, *ibid*, and p 252. I have to confess that the phrase 'copying the Erechtheion's order precisely' is based, not on documentary evidence – Inwood's details for the church seem to have been lost and the RIBA drawings' collection does not possess a measured drawing of the portico – but on a visual comparison of the building with an engraving of the Erechtheion order. The engraving, which appears as plate VI in Chambers' *Civil Architecture*, fourth edition 1826, is stated to be 'from Stuart'. This is presumably James Stuart, whose engravings, together with those of Leroy and the Erechtheion fragments brought back by Lord Elgin provided, according to Summerson, the inspiration for Inwood's design.
(21) Clive Bell, *Landmarks in Nineteenth Century Painting*, Chatto and Windus, 1927, p 172.
(22) Kenneth Clark, *The Nude*, Penguin, 1956, p 152.
(23) *ibid*, p 153.

(24) E H Gombrich, *Art and Illusion*, Phaidon, 1960, p 330.

(25) A Conan Doyle, The Adventure of the Lion's Mane, in *The Case Book of Sherlock Holmes*, Penguin 1931, p 198.

(26) David Hume, *Four Dissertations* 1757, in *Aesthetics*, ed Jerome Stollnitz, Macmillan, 1965 p 91.

(27) Pierre Bourdieu, *Distinction, a Social Critique of the Judgement of Taste*, trans Richard Nice, Routledge and Kegan Paul, 1984, p 1.

(28) *ibid*, p 4

(29) Michael Sullivan, *Symbols of Eternity, the Art of Landscape Painting in China*, Clarendon Press, 1979, pp 1-2.

(30) *ibid*, p 7.

(31) *ibid*, p 2.

(32) For a useful, if somewhat prim, discussion of the erotic aspects of the nude in painting and sculpture see Clark, *op cit*, p 6.

(33) Kenneth Clark, *What is a Masterpiece?*, Thames and Hudson, 1989, p 9.

Chapter Two

Some Problems of Indexical Aesthetic Communication

We have concluded that we do not need to investigate the iconic, artefactual or symbolic aspects of aesthetic communication, only its indexical aspects need to be studied. We have also established, in our initial axiom, that our enquiry must be a study of some aspect of psychology. Together these pieces of evidence suggest that we should now enter the jungle of psychology in an effort to locate, within it, the process of IAC.

Nevertheless, it seems wise, before entering that jungle, to consider three issues: the relevance of iconography and iconology to our enquiry, where, within the minds of the artist and the experiencer, the communication system lies and why we are able, granted sufficient familiarity with similar works of art, to respond to works produced by artists from exotic cultures. Without such preliminary studies, we could waste much time in irrelevant exploration.

Iconography and iconology

You may well have thought, particularly if you are an art historian, that my comment on the Isenheim crucifixion was inadequate: 'to one who does know the story and can make sense of Grünewald's highly complex symbolism it is surely one of the most moving images of the scene that has ever been painted'. I might have been expected to go into it in more detail; our subject is, after all, communication in the visual arts and Grünewald's symbols are part of what he sought to communicate. The meanings attached

to many of them are obscure and their investigation is an indexical activity. Why didn't I attempt it? This question can only be answered as part of a more general problem; how far are iconography and iconology, the twin topics whose concern is the interpretation of symbols in the visual arts, germane to our enquiry?

We must begin with definitions. For this we cannot do better than refer to Gombrich's immensely erudite volume *Symbolic Images, Studies in the Art of the Renaissance*. This is a collection of essays on the iconology of renaissance art; particularly, but not exclusively, that of Italy. Gombrich defines iconography as 'the identification of texts illustrated in a given religious or secular picture' and iconology as 'the reconstruction of a programme rather than the identification of a particular text'[1]. Thus the identification of the four figures in the Isenheim *Crucifixion* is an activity of iconography while the detective work required to reconstruct the programme to which Grünewald must have worked is an activity of iconology.

The two topics are closely related. The iconologist can make blunders in interpretation for lack of iconographic awareness and the iconographer can obtain information about the significance of a picture's subject matter from the iconologist's researches. Gombrich offers examples of both:

He writes of 'a gifted student whose enthusiasm for iconology so carried him away that he interpreted St Catherine with her wheel as an image of Fortuna. Since the saint had appeared on the wing of an altar representing the Epiphany, he was led from there to a speculation of the role of fate in the story of salvation – a train of thought that could easily have led to a postulation of a heterodox sect if his initial mistake had not been pointed out to him'[2].

And elsewhere he provides an account of Rubens' own description (from memory) of the content of a picture, *The Horrors of War*, painted in 1637 or 8 for the Grand Duke of Tuscany.

> 'The principal figure is Mars who, leaving open the temple of Janus (which it was a Roman custom to keep closed in time of peace), advances with his shield and his bloodstained sword, threatening the nations with great devastation and paying little heed to Venus, his lady, who strives with caresses and embraces

8 Rubens: *The Horrors of War.*

to restrain him, she being accompanied by her cupids and lovegods. On the other side Mars is drawn on by the fury, Alecto, holding a torch in her hand. Nearby are monsters, representing Pestilence and Famine, the inseparable companions of war; on the ground lies a woman with a broken lute, signifying harmony, which is incompatible with the discord of war; there is also a mother with her babe in her arms, denoting that fecundity, generation and charity are trampled underfoot by war, which corrupts and destroys all things. In addition there is an architect, lying with his instruments in his hand, to show that what is built for the commodity and ornament of a city is laid in ruins and overthrown by the violence of arms. I believe, if I remember aright that you will also find on the ground some drawings on paper to show that he tramples on literature and the other arts. There is also, I believe, a bundle of arrows with the cord which bound them together lying undone, they when bound together being the emblem of concord, and also painted, lying beside them, the caduceus and the olive, the symbol of peace. That lugubrious Matron clad in black and with her veil torn, despoiled of her jewels and every other ornament is unhappy Europe, afflicted for so many years by rapine, outrage and misery, which, as they are so harmful to all, need not be specified. Her attribute is that globe held by a putto or genius and surmounted by a crest which denotes the Christian orb. This is all I can tell you'.[3]

We can hardly imagine, at least in Western art, a more comprehensive example of iconographic information.

I can see no need for us to follow Gombrich in his exploration of this byway of art history. We are not concerned with *why* Grünewald showed Jesus in such appalling agony, or why he included the four gesticulating figures and that extraordinary lamb in his version of the crucifixion. For us it is enough that he did, that we can recognise them iconically, that – perhaps with the help of an iconographer – we can identify them as Mary, the mother of Jesus, Mary Magdalene, John the Baptist, John the Evangelist and 'the Lamb of God that was slain' and that with this information, together with what we know of the New Testament, we can respond to the aesthetic

symbolic communication embodied in the picture.[4] Later in the essay Gombrich makes this very point: 'to a modern critic the problem of…symbolism in art is an aesthetic rather than an ontological problem. What interests him is what a symbol expresses rather than what it signifies. He may dismiss Bartholdi's *Statue of Liberty* as a "pale abstraction" but find in Delacroix's *Liberty Leading the People* a perfect expression of the struggle for freedom'. To which he adds that 'in contrast to the aesthetician the student of subject matter is interested in naming an individual personification'.[5]

Gombrich's definitions and examples answer our problem. They show that both iconography and iconology are germane to the *subject* of this part of our study – communication in the visual arts – but that only iconography is germane to our *enquiry* – the problem of how the communication between the mind of the artist and the mind of the experiencer takes place – and that to no more than a limited extent. We suggested, at the end of Chapter One, that the aesthetic communication embodied in any work of art is centred within the realm of the index and that from there it extends into the realms of the icon and the symbol. About this iconology has nothing to offer, it is a matter for the art historian. Iconography is concerned with it but not at the centre; by helping the experiencer to learn the meaning of whatever symbols may be illustrated in a work of art it may enable him to respond to the work's symbolic, aesthetic communication. That, however, is all.

Neither topic is relevant to IAC. For that, we must look elsewhere.

Indexical Aesthetic Communication and the Unconscious Mind

THE EXPERIENCER'S RESPONSE

The examples of indexes offered by Peirce, Berger and myself in Chapter One – the sailor related to the man with a rolling gait as the sign; the 'something considerable' related to a thunderbolt as the sign; the fire related to smoke as the sign; the symptom related to disease as the sign; the illumination of the moon's globe by the sun related to the crescent as the sign; the direction of the wind related to the Father Time weathervane as the sign – are not only all indexes, they are all potentially tangible and each one, apart from the 'something considerable' is consciously recollected in

the 'senses or memory of the person to whom it serves as a sign'. On the other hand, the 'pure aesthetic experiences' to which Sullivan refers in connection with Chinese landscapes, and which we found in the four pictures that we analysed in the section on indexes, though certainly indexical objects, are neither tangible nor are they consciously recollected in the senses or memory of the experiencer.

Intangible experiences which elude conscious recollection are, of course, the stock-in-trade of the psychiatrist He seeks to explain them by exploration of the patient's unconscious mind. It is surely reasonable to suggest that Sullivan's pure aesthetic experience may be similarly explained and that it is in the experiencer's unconscious mind that we should seek the causal connection between the sign, the work of art, and its object, the experiencer's aesthetic response. Indeed the connection can only lie there, if it lay in the conscious mind we should know all about it and aesthetics would not be a problem.

To my knowledge, the idea that the experiencer's aesthetic response is, at least partly, rooted in his unconscious mind is the almost universal opinion of those who have written on the relationship between psychology and the visual arts. (I say almost because I have found one exception, Freud, believe it or not, whose ideas on the subject we shall discuss later.) Thus Anton Ehrenzweig *(The Psychoanalysis of Artistic Vision and Hearing* and *The Hidden Order of Art)* and Ernst Kris *(Psychoanalytic Explorations in Art)* both sought to explain what I have called IAC by means of Freudian psychological theory. In the first of these studies Ehrenzweig defined his subject as follows: 'The book deals with the inarticulate form elements hidden in a work of art or – what comes to the same thing – with the unconscious structure of the perception process by which we actively create or passively enjoy these unconscious form elements'.[6]

There is no need, at this stage of our enquiry, to consider the psychological aspects of this conclusion, we shall enter the jungle of psychology in Chapter Three. We may, however, suggest – since by our axiom a work of art constitutes a means of communication between the mind of the artist and that of the experiencer – that Sullivan's 'pure aesthetic experience' appears to be the third stage of a communication process that originates in the unconscious mind of the artist and is transmitted, via the work of art, to the unconscious mind of the experiencer.

Here, however, we encounter a difficulty. Peirce's definition of a sign 'something which stands to somebody for something in some respect or capacity' is concerned only with the third stage in our communication process; it says nothing about the first stage, how a sign may originate. Symbolic or iconic signs must by their nature be deliberate. So are some, but by no means all, indexical signs. Thus Peirce's thunderbolt was an accident of nature, Man Friday's footprint in the sand was man-made but was not deliberate while the Father Time weathervane was both man-made and deliberate. How do these distinctions relate to the IAC embodied in a work of art? Is it a hoped-for by-product of what the artist seeks to communicate iconically, symbolically, or perhaps technically? or is it wholly or partially deliberate? and, if it is wholly or partly deliberate, can it possibly derive from the artist's unconscious mind?

What, in brief, does the artist intend to communicate? And how does this intention relate to the IAC of his work?

THE ARTIST'S INTENTION

Any consideration of what the artist intends to communicate must, for the scarcity of written records, be highly speculative. With rare exceptions, Leonardo is the most obvious, artists express themselves by means of their art rather than in words. If they didn't they would be writers rather than artists. Nevertheless we may be able to discuss a few points which, if they do not answer our questions, may lead us towards some possible answers.

The most fundamental of the artist's intentions must surely be to communicate in such a way as to enable him to pay the bills. This has always meant following his patron's instructions if the work concerned is a commission, or meeting the demands of the market should it be produced for sale. In addition there have been a few whose work has not been so constrained: remittance men like van Gogh, scholars and amateurs like members of the so-called 'southern school' of Chinese landscape or today's artists who teach for a living and paint in their leisure moments. Such people can do as they like.[7]

The demands of the market vary so much from time to time and from place to place, and the artist's response to them depends so much on his own financial circumstances that no general statement is possible. We may note, however, that craftwork has long been produced for sale – Greek

pottery, for example, was a mass production industry – that the freelance painter, draughtsman or sculptor selling his work in the market hardly appeared in the west until the renaissance (was there an earlier example than Mantegna in his role as an engraver?) and that before then, and to my knowledge everywhere else, he worked to instructions, receiving them from the court, from some wealthy individual or from the local religious body (within Christendom, the church). Apart from portraiture that was necessarily iconic, the patron required a symbol so the artist had to express what his patron wished the work to symbolise.

This is exemplified by Henry Moore's *Madonna and Child* for St Matthew's Church, Northampton. Moore described his approach to the project in the following words: 'I began thinking of the *Madonna and Child*...by considering in what ways a *Madonna and Child* differs from a carving of just a Mother and Child – that is, by considering how, in my opinion, religious art differs from secular art. It's not easy to describe in words what this difference is except by saying in general terms that the *Madonna and Child* should have an austerity and nobility, and some sense of grandeur (even hieratic aloofness) which is missing in the everyday *Mother and Child* idea'.[8] Moore's phrase 'I began thinking... etc.' makes it very clear that his initial concern was how he should symbolise the Madonna and Child idea in his project and that at this stage he was not concerned with the project's aesthetic aspect.

Religious art is necessarily symbolic but Moore was not normally a religious artist. Apart from this example virtually all his work was secular and was, however apparently abstract, at bottom iconic. In this it resembles the work of Picasso who is recorded as declaring roundly 'There is no abstract art. One always has to begin with something. One can then remove all traces of reality. One runs no risk for the idea of the object has left an ineffaceable imprint. It is the thing that aroused the artist, stimulated his ideas, stirred his emotions'. Picasso went on as follows: 'Do you think it interests me that this picture represents two people? These two people once existed but they exist no longer. The vision of them gave me an initial emotion, little by little their presence became obscured; they became for me a fiction, and then they disappeared, or rather were transformed into problems of all sorts. For me they aren't two people any more, but forms and colors, understand, forms and colors which sum up, however, the idea

of two people and conserve the vibration of their life'.[9] From this, it seems that the potentially iconic aspect of a picture was the challenge which aroused Picasso, stimulated his ideas and stirred his emotions and that as the picture developed, he became less and less concerned with it as an icon and more and more as a set of problems.

Picasso must surely have been the most experimental artist in history, he was certainly the culmination of a century of experiment in the visual arts. Some of these experiments were iconic, as in Monet's series paintings in which he painted the same scene in different conditions of light, some symbolic – as in the paintings of Gustav Klimt and some indexical – as in the work of surrealists such as René Magritte. It is surely reasonable to suggest that, like Picasso, the artists who carried out such experiments were initially interested in the experiments themselves and that any IACs followed thereafter.

We must remember, however that such experiment, the result partly of the romantic movement and partly of the technological and scientific *zeitgeist* of the period, is exceptional in the history of art. China, for all the political turmoil of its many dynasties, was artistically far more stable than nineteenth and twentieth century Europe. Furthermore, Chinese paintings are almost always embellished with calligraphic inscriptions and it seems possible that these inscriptions might tell us something of the artist's intentions in regard to the picture concerned and hence of the relationship between its iconic, symbolic and indexical characteristics. Sadly, however, they don't. Sullivan describes the matter as follows:

> 'The simplest inscription consists of the artist's name, followed by his personal seal or seals. To this he may add the date, perhaps the name of the man for whom he painted the picture, a note on the occasion and the style he chose. Beyond this the inscription may carry us deep into the realms of philosophy and metaphysics, art history and art criticism, and may well tell us more about the private life of the painter and his relationship with his friends and patrons than can be derived from any other source. An inscription of this kind may turn an otherwise conventional painting into a very human document'.[10]

From this we may infer that the artist's intention was to produce a picture and inscription that together constituted an integrated artistic, social and philosophical whole and as a corollary that the picture's IAC was on a par with, perhaps sometimes subsidiary to, the symbolic attributes embodied in the picture and its inscription.

Sullivan's account of the integrated artistic, social and philosophical whole embodied in Chinese painting is first cousin to Sir Henry Wotton's maxim about architecture: 'Well building hath three conditions; Commoditie Firmeness and Delight.'[11] Unlike Picasso, Wotton did not consider what started the architect off, excited his ideas and stirred up his emotions but we may fairly point out that no architect can begin work without a brief and that any brief must include some account, however vague, of the proposed building's functional requirements. Delight is of course one of the architect's objectives – we have seen how Lutyens modified the details of the Doric order in terms of his own aesthetic tastes – but, at least in my own experience, commoditie is what gets him going.

Wotton's three conditions may, with appropriate allowances for the differences involved, be applied to the crafts. Thus firmness is not a quality which we would regard as suitable to textiles, but if we interpret the word to mean durability we can fairly apply his maxim to well weaving, well embroidering, well smithing, well carving, well cabinet-making and, using the word in its calligraphic not in its literary sense, well writing as well as to Wotton's own well building. There is, however, a profound difference between the activities of the architect and those of the craftsman. The architect operates indirectly; he produces a set of drawings and a specification that he uses to explain his ideas to the client and to instruct the builder. The craftsman, on the other hand, operates directly; he produces the work himself. As a result the architect is not specially interested in the drawings and specification for their own sakes – they are no more than means of communication – but the craftsman is profoundly concerned with the practice of his craft. Gombrich describes this attitude as the 'desire to press against the limitations of the material as far as is humanly possible and to put the victory of mind over matter to the test'.[12] This is the challenge that, I suggest, provides the craftsman with an initial impetus similar to that offered to the architect by commoditie, to the Chinese artist by the need to create an integrated social artistic and philosophical whole, to Picasso

by his two people and to Moore by the symbolic requirements of a Madonna and Child.

To the landscape architect, the challenge is also technical but technical in a different way. He is concerned not with the limitations of his material but with how to turn to his advantage the physical and ecological characteristics of his site. Thus it was that both the Japanese landscape architects from the fourteenth century onwards and their English counterparts of the eighteenth and nineteenth centuries sought to incorporate, within the garden scene, fields, hills, mountains and woods that lay beyond its boundary,[13] that Lancelot Brown was given the nickname of Capability for his habit of announcing that a prospective client's grounds had 'great capability' of improvement and that Alexander Pope urged the creator of a landscaped park to 'consult the genius of the place in all'.[14] Humphry Repton describes this approach to landscape design in the following account of how he set about laying out a park on the site of a fort just outside Bristol:

> 'When I first visited the FORT I found it surrounded by vast chasms in the ground and immense heaps of earth and broken rock; these had been made to form the cellars and foundations to certain additions to the city of Bristol, which were afterwards relinquished. The first idea that presented itself was to restore the ground to its original shape; but a little reflection on the character and situation of the place, naturally led me to enquire whether *some* considerable advantage might not be derived from the mischief which had thus been already done';[15]

and he goes on to describe the scene and how he chose to modify it.

These scraps of evidence suggest that the artist's intention is a two-stage process, though the stages may well overlap. In the first stage the iconic, symbolic, indexical or technical aspect of the artist's work acts as a catalyst which enables him to get started, The second stage introduces the IAC. The second stage is hardly mentioned by the authorities whom we have discussed. Moore said nothing about it at all; Picasso spoke vaguely of a set of problems; the Chinese artist described by Sullivan seemed to be concerned only with the circumstances under which the picture was painted,

including his own stylistic preferences, his relationship with his friends and patron and his philosophical, historical and critical assumptions; Wotton included delight among his three conditions but did not say what this implied; the craftsman's interest, according to Gombrich, was the technique of his craft; Repton's was how to turn the problems of his site to the best advantage and Lutyens, in the letter to Herbert Baker to which we referred in Chapter One, did not go into detail about his modifications to the Doric order, remarking only that 'to be right…you alter one feature (which you have to always) then every other feature has to sympathise and undergo some care and invention'. What did he mean by 'right'? He did not say; perhaps because he did not know, possibly because he took the subject for granted. The similar silence on the part of the others whom we have discussed suggests that they shared Lutyens' apparent ignorance and perhaps his unspoken assumptions, though they must have had reasons for their indexical aesthetic decisions. It is a safe guess that some of the ideas behind these decisions were based upon general principles that the artist learnt in his apprenticeship – for the artist the human body, for the architect form and structure, for the landscape-designer the interaction of space and time – and that the other ideas, those which gave the work its quality, originated in his unconscious mind.

This seems to be the consensus opinion of those who have written on the relationship between art and psychology. Here are a couple of examples out of many, both by Americans: Rudolf Arnheim held, in an essay, *On Inspiration*, that 'man's creative accomplishments must be attributed to causes inherent in man himself', adding that 'nowhere are the contributions of the subterranean forces acknowledged more proudly than in the arts, and psychologists agree that probably no work of art that deserves the name has ever been produced, or can ever be produced, entirely at the level of consciousness'.[16] While Brewster Ghiselin, in his introduction to *The Creative Process*, an anthology of texts on the subject, declared that 'the artist must labour to the limit of human development and then take a step beyond…That step beyond is stimulated by labour upon the limits of attainment. The secret developments that we call unconscious because they complete themselves without our knowledge and the other spontaneous activities that go forward without foresight yet in full consciousness are induced and focused by intense conscious effort spent upon the material to

be developed or in the area to be illuminated'.[17] A view which answers the question posed above: 'if it (the artist's IAC) is wholly or partly contrived, can it possibly derive from the artist's unconscious mind?'

The relationship between the artist's intention, his unconscious mind and what appears on the canvas is perhaps most evident in the case of portraiture. At least since Holbein, the above-average artist has provided in his picture an image of the sitter's personality. Sometimes this is deliberate, generals are made to look brave, philosophers wise, film stars glamorous, but the great portrait offers us a profound analysis of character. Is this a conscious activity on the artist's part? Does he, in applying a tiny dab of paint to the lips or around the eyes, say to himself, 'This man is a libertine, I'll make him look like one?' or does he just get on with the job, finding when it is all over that he has made the sitter an evident libertine? Common-sense suggests the latter. Take Goya's portrait of Charles IV of Spain and his family*(see plate 8)*. Did he really intend that the king should appear such a pompous fool or the queen such an evil harridan? No. People don't do that kind of thing, least of all to someone on whose patronage they depend to pay the bills. I think it far more likely that Goya intended to produce no more than a likeness and that the mysterious chemistry which controlled the muscles of his fingers as he painted the two majas did the same when he painted that extraordinary family portrait; a chemistry which, on the evidence adduced, derived from his unconscious mind.

We may summarise this brief enquiry by declaring that initially the artist seeks to communicate in iconic, symbolic or more rarely indexical terms, that this intention acts as a catalyst for the IAC which he incorporates in his work, that this incorporation consists partly of the conscious application of long-held traditional concepts and partly of decisions of whose impetus he is unaware because they derive from his unconscious mind and that the quality of the work is primarily the result of these decisions. To this we may add that this conclusion parallels our earlier finding that the causal connection between the sign, the work of art, and its object, the experiencer's aesthetic response, lies in his unconscious mind.

We seem to have confirmed our idea, expressed earlier in this chapter, that IAC is a three-stage process which originates in the unconscious mind of the artist and which is transmitted, via the work of art, to the unconscious mind of the experiencer.

A Universal System?

It is perhaps natural that we should be able to receive aesthetic communications from *Charles IV and his Family*, the Isenheim *Crucifixion*, the *Sleeping Woman* or the *Cornfield*. The works of painters such as Goya, Grünewald, Renoir or Constable partake of our own western European, Judaeo-Christian tradition. But what of *Travelling amid Mountains and Gorges*? Of the Lascaux stag? Of the Queen Mother head from Benin? These works must, by the findings of the last section, constitute means of communication between the unconscious minds of their creators and those of ourselves, but a means of communication requires a medium for its transmission. What medium can there be which is common, not only to our own unconscious minds and to those of Goya, Grünewald, Renoir or Constable but also to those of Fan K'uan, the cave painter of Lascaux, the anonymous sculptor of the Queen Mother head and indeed of every artist everywhere? We seem to have encountered a multi-cultural medium of communication which, given a degree of familiarity by the experiencer, is universally comprehensible.

AN IMPLIED ASSUMPTION

This concept does however include an implied assumption: that all mankind is able to achieve the necessary familiarity. So far as the adult, middle-class, élite, twenty-first century westerner is concerned, this appears to be an empirical fact. Such a person may well have received an upbringing and education which, together with reading, travel, watching television, meeting friends and visiting museums and historic monuments, has provided him with the acquired taste described by David Hume and Pierre Bourdieu. Middle class élite westerners are, however, a tiny proportion of mankind. For the rest of humanity the concept, *that the indexical, aesthetic communication embodied in a work of art forms part of a multi-cultural medium of communication which, given a degree of familiarity by the experiencer, is universally comprehensible*, is no more than an untested hypothesis. Can it be validated?

Obviously not. It is axiomatic that we cannot *know* how the Kalahari bushman, the Amazonian Indian or the Melanesian fisherman responds to the products of his own culture, much less to the products of cultures which

9 Above: A stag: from Lascaux, between 17,000 and 19,000 years ago.

10 Right: A bronze head of a queen mother: Benin, probably sixteenth century.

are to him exotic. We can however consider whether there is sufficient circumstantial evidence to convince us that the hypothesis, if not formally valid, is at least probable. For this purpose, we may begin by pointing out that our presumed system of IAC must be at once universal, since if it exists anyone should have the potential to respond to any work of art, and specific, since in practice response is limited to those who are familiar with works of a similar kind; familiarity that results from the individual's upbringing, education and experience. We may then proceed to seek a range of cultural activities which, according to accepted anthropological theory, all mankind has in common. Then – if we find such a range of activities – we can go on to consider whether they vary specifically with different cultures as well as being generically consistent across mankind. Then – if we find that they do vary specifically – we can try to establish whether such variations are the result of learning and experience within the culture concerned.

Positive results from such an enquiry would show that there are multicultural activities with characteristics similar to those of our presumed medium of communication, a finding which would give support to the hypothesis; and the more of such activities there are the more probable would it appear.

On this basis, we should be able to decide whether there is sufficient evidence in support of our implied assumption to enable us to proceed.

UNIVERSALITIES IN CULTURE

I can see little need to take up several pages of print with an account of the changing fashions in anthropological and ethnographic theory which followed each other from the mid-eighteenth century onwards. It is enough to mention that, as early as 1776, the French scholar, J N Demeunier, published a book: *L'Esprit des Usages et des Coutumes des Peuples Différents*, in which he mentioned twenty-nine *usages et coutumes* including such varied items as food and cookery, penal codes and distinctions of rank, as well as dozens of non-European *peuples différents* among them the Auracanians, the Ambrym Islanders and the Surinam Bush Negros; that the nineteenth-century anthropologists, Lewis Henry Morgan, Edward Tylor and Herbert Spencer applied the comparative method to the study of cultures and by so doing provided the basis for later studies in the field, that in 1923 the

American Clark Wissler considered that the characteristics of all cultures could be categorised in accordance with what he called the 'universal pattern' of culture (you will find the list in Appendix One), that in 1945 George Peter Murdock, Professor of Anthropology at Yale, declared that 'even today it is not generally recognised how numerous and diverse are the elements common to all known cultures' [18] and went on to offer 'a partial list of items' – there were seventy-four of them including a few agreeably improbable topics like eschatology, ethnobotany and population policy – 'which occur, so far as the author's knowledge goes, in every culture known to history or ethnography',[19] that in 1971 two anthropologists, Lionel Tiger and Robin Fox, discussed the subject and included, inevitably, juvenile delinquency and its corollary; traditional restraints on the rebelliousness of young men, that two years later a linguist, C F Hockett, not only provided a more detailed list which included, in regard to each example, a note indicating whether it is shared with non-human species and whether it is part of the 'human historical baseline' but also mentioned a number of 'widespread' or 'almost universal' traits[20] and, yes, I'm coming to the end, that Donald E Brown of the Department of Anthropology at the University of California published, in 1991, a book, *Human Universals*, which was entirely devoted to an investigation of the subject.

Brown tells us that in making up his list he drew heavily on Murdock, Tiger and Fox, and Hockett as well as obtaining material from other sources while at the same time omitting certain items for which he was insufficiently convinced by the references. He takes care to emphasise the tentative nature of his list 'as surely as it leaves out some universals it includes some that will prove in the long run not to be universal and even more surely it divides up traits and complexes in ways that will in time give way to more accurate or meaningful divisions'.[21] Unfortunately his account is somewhat wordy: thus the seventy-four 'elements' in Murdock's universal culture pattern (he borrowed the phrase from Wissler) occupy a single paragraph while the 140 activities of what Brown calls the 'universal people' take up eight and a half pages. To make it easier I have prepared a summary which appears in Appendix Three. You will see that the activities in the list are arranged in groups, the groups relate to Brown's paragraphs, the headings are mine.

Brown points out that universals can be divided into 'universals of classification' such as language – all cultures have a language but all

languages are different – and 'universals of content' such as coy flirtation with the eyes – in which the phenomenon is itself universal. To which he adds that many universals lie somewhere between the two, a circumstance which is due to the research activities of anthropologists anxious to fill in the details of what appear, at first sight, to be universals of classification. (As an example he mentions gender studies which, though they rest on a universal of classification – the division of labour by sex – have shown that there is within it 'at least a slender content to the universal'.)[22] In these circumstances it is a little difficult to categorise a particular item as an example of one type or the other but I reckon that of Brown's 140 activities about two-thirds, say ninety-five, lie towards universals of classification and about forty-five towards those of content.

Murdock, who seems to have been unaware of universals of content, gave a very clear description of the characteristics of universals of classification. He declared that cross-cultural similarities appear even more far-reaching when individual items in such a list are subjected to further analysis and went on to offer some examples.

> 'Not only does every culture have a language, but all languages are resolvable into identical kinds of components, such as phonemes or conventional sound units, words or meaningful combinations of phonemes, grammar or standard rules for combining words into sentences. Similarly funeral rites always include expressions of grief, a means of disposing of the corpse, rituals designed to protect the participants from supernatural harm and the like. When thus analysed in detail the resemblances between all cultures are found to be exceedingly numerous.

> 'Rarely…however, do these similarities represent identities in specific cultural content. The actual components of any culture are elements of behavior – motor, verbal, or implicit – which are habitual, in the appropriate context, either to all the members of a social group or to those who occupy particular statuses within it. Each such component, whether called a folkway or a cultural trait or item, can be described with precision in terms of the responses of the behaving individuals and of the situations in

which the responses are evoked. Eating rice with chopsticks, tipping a hat to a woman, scalping a slain enemy and attributing colic to the evil eye are random examples. Any such specifically defined unit of customary behaviour may be found in a particular society or in a number of societies which have had sufficient contact to permit accumulative modifications in behavior'.[23]

The universals of classification, as they are described by Murdock, correspond closely with our presumed system of IAC. Like it, they are not only generically universal but they also vary specifically from culture to culture. Furthermore Murdock's comment that 'cross-cultural similarities appear even more far-reaching when individual items in such a list are subjected to further analysis' matches the fact that design components such as symmetry and unity in diversity appear, so far as I am aware, in works from all cultures. Finally Murdock's statement that 'any such specifically defined unit of customary behaviour may be found in a particular society or in a number of societies which have had sufficient contact to permit accumulative modifications in behavior' accords with two facts: that virtually all the original inhabitants of the Middle and Far East, Africa, the Americas, Oceania and Australia have come to accept the arts of the West; and that the upbringing, education and experience of the adult, middle-class, élite, twentieth century westerner has enabled him to respond to works produced by cultures other than his own. The hypothesis is not proved, it can't be, but on this evidence we can surely proceed with our enquiry.

Murdock was very positive about the basis of his universal culture pattern. 'The essential unanimity with which the universal culture pattern is accepted by competent authorities, irrespective of theoretical divergences on other issues, suggests that it is not a mere artefact of classification but rests upon some more substantial foundation. This basis cannot be sought in history, or geography, or race, or any other factor limited in time or space, since the universal pattern links all known cultures, simple and complex, ancient and modern. It can only be sought, therefore, in the fundamental biological and psychological nature of man and in the universal conditions of human existence';[24] a remark which suggests that if we are to proceed further we must enter the jungle of psychology.

We shall do this in the next chapter, but first we must tie up the threads of this one.

A Conclusion

To summarise the argument so far:

(i) There are, according to D E Brown, 140 'universals' common to all known cultures. About two thirds of them, the 'universals of classification' vary specifically from culture to culture as well as being generically common to all mankind. Furthermore, members of one culture may, by contact with another, come to modify their own specific behaviour in respect of one or more of these universals of classification. This matches our presumed system of IAC; not only is the system, like Brown's universals of classification, both generically common to all mankind and specifically varied from culture to culture, the matching also offers an explanation for the fact that we are able, granted sufficient familiarity with works of a similar kind, to respond to works produced by cultures other than our own. We may therefore reasonably confirm, if not formally validate, the system's existence.

(ii) The IAC between the artist and the experiencer is a three-stage process in which the first stage lies in the unconscious mind of the artist, the second is the work itself, the third occurs in the unconscious mind of the experiencer.

From this it follows, since we are able to respond to works produced by artists from any culture, that this three-stage process must include the unconscious minds not only of Goya, Grünewald, Renoir, and Constable but also but those of Fan K'uan, the cave painter of Lascaux, the anonymous sculptor of the Queen Mother head and, indeed, of every artist everywhere.

We may conclude, putting these findings together, that there lies in the unconscious minds of all mankind, from late Palaeolithic times onwards, a system of IAC which is generically universal, is specifically peculiar culture by culture and whose presence enables anyone who achieves the necessary familiarity to respond to works produced by artists from cultures other than his own.

1 E H Gombrich, *Symbolic Images, Studies in the Art of the Renaissance*, Phaidon, 1972, p 6.
2 *ibid*, pp 5-6.
3 *ibid*, p 126-7.
4 For a full account of the Isenheim Crucifixion see Georg Scheja, *The Isenheim Altarpiece* (English translation by Robert Erich Wolf), Harry N Abrams, New York, 1969.
5 Gombrich, *Symbolic Images*, p 126.
6 Anton Ehrenzweig, *The Psychoanalysis of Artistic Vision and Hearing*, Sheldon Press, 1975, p vii.
7 For an account of the Southern School see Sullivan, *Symbols of Eternity*, pp 77-84.
8. Philip James, *Henry Moore on Sculpture*, Macdonald 1966, p 220.
9. Christian Zervos, Conversations with Picasso, in Brewster Ghiselin, *The Creative Process*, University of California Press, 1952, pp 50-51.
10. Michael Sullivan, *The Three Perfections, Chinese Painting, Poetry and Calligraphy*, Thames and Hudson, 1974 p 11.
11 Henry Wotton, *The Elements of Architecture*, John Bill 1624, p 1.
12 E H Gombrich, *The Sense of Order*, Second edition, Phaidon 1984, p 65.
13 For an account of these techniques see Teiji Itoh, *Space and Illusion in the Japanese Garden*, translated and adapted by Ralph Friederich and Masajiro Shimamura, Weatherhill/Tankosha, 1973, pp 15-17.
14 'Consult the genius of the place in all
 That tells the waters or to rise or fall
 Or helps th'ambitious hill the heavens to scale
 Or scoops in circling theatres the vale
 Calls in the country, catches opening glades,
 Joins willing woods and varies shaddes from shades.'

From Alexander Pope, Epistle IV to Richard Boyle, Earl of Burlington, On The Uses of Riches. Quoted by Nikolaus Pevsner, *The Englishness of English Art*, Architectural Press, 1956, p 167.
15 Humphry Repton, *Observations on the Theory and Practice of Landscape Gardening*, London 1805, p 7.
16 Rudolf Arnheim, *Towards a Psychology of Art*, Faber and Faber, 1967, p 286.
17. Brewster Ghiselin, *The Creative Process*, University of California Press, 1952, pp 18-19.
18 George Peter Murdock, The Common Denominator of Cultures in *The Science of Man in the World Crisis*: Ralph Linton ed, Columbia University Press: 1945: p 124. The list appears in Appendix Two.
19 *ibid*, pp 124-125.
20 C F Hockett, *Man's Place in Nature*, McGraw Hill, 1973, pp 275-279.
21 Donald E Brown, *Human Universals*, McGraw Hill, 1993, p 130.
22 *ibid*, p 48.
23. Murdock, *op cit*, pp 124-125.
24 *ibid*, p 125.

Chapter Three

Some Models of the Mind: Their Relevance to Indexical Aesthetic Communication

Once we'd got iconography and iconology out of the way the last chapter had two aspects; one, deriving from anthropology, was concerned with the similarity between IAC and Brown's universals of classification, the other, deriving from psychology, was concerned with it as part of the unconscious mind. This chapter seeks to investigate three models of the mind in the hope that one of them will not only provide an explanation for the existence of Brown's universals but will also offer a concept of the unconscious mind which fits our findings about its relationship to the creativity of the artist and the response of the experiencer.

The Standard Social Science Model

Murdock, after declaring that the universal culture pattern 'can only be sought in the fundamental biological and psychological nature of man and in the universal conditions of human existence', went on to propound the doctrine, common to anthropologists, of 'the psychic unity of mankind'. He describes it as 'the assumption, now firmly grounded in social science, that all peoples now living or of whom we possess substantial historical records, irrespective of differences in geography or physique, are essentially alike in their basic psychological equipment and mechanism, and that the cultural differences between them reflect only the differential responses of essentially similar organisms to unlike stimuli or conditions'.[1] Murdock's paper was published in 1945 and, as he explains in a footnote, was written

from a post in the naval service. In consequence he was unable to provide evidence or even cite bibliographical references in support of his statement that the assumption is 'firmly grounded in social science'. It is, nevertheless, a statement which we may properly accept.

In the first place he was Professor of Anthropology at Yale and such a person does not normally make a reckless assertion on a matter of fact which lies within his own bailiwick.

Furthermore the idea was not new. There is no need for us to delve into the complex history of anthropological theory but we may note first that the concept that all mankind possesses similar intellectual potential was implicit in the ideas of the seventeenth-century philosopher John Locke who sought to prove – in his *Essay Concerning Human Understanding* published in 1690 – that at birth the human mind is an 'empty cabinet' and that the knowledge and ideas with which it later comes to be filled are the result of experience,[2] secondly that the concept was one of the underlying beliefs of the Enlightenment – one need only remember Thomas Jefferson's ringing preamble to the Declaration of Independence: 'We hold these truths to be self-evident, that all men are created equal', thirdly that during the nineteenth century the concept was gradually smothered by a conviction about the superiority of the white races, a belief which seemed at the time to be obvious – after all the previous three centuries had been the era of European expansion, something which the indigenous peoples of Africa, America, Asia and the Pacific Islands had been unable to resist, and finally that in 1911 the German-turned-American, physicist-turned-anthropologist Franz Boas published a seminal book, *The Mind of Primitive Man*, in which he showed that 'there is no fundamental difference in the ways of thinking of primitive and civilized man',[3] a view which has been confirmed by subsequent research; thus in 1991 the geneticist Steve Jones gave a BBC Reith lecture in which he declared that 'the ancient and disreputable claim that there are inborn differences in ability between human races…has been comprehensively sunk by modern genetics'.[4]

Boas' ideas, developed by other social anthropologists during the first three-quarters of the twentieth century, spawned what the evolutionary psychologists, Jerome Barkow, Lena Cosmides and John Tooby called the 'Standard Social Science Model'.[5] This was the theory that, instincts apart, social influences alone determine human behaviour, a view which was pre-

figured by Murdock in another part of the paper to which we have already referred. He declared that 'culture is in no respect instinctive, it is exclusively learned'[6], and added that while the food quest can be attributed to the hunger drive, shelter to heat and cold avoidance, war to aggression and marriage to the sex impulse, 'such equally universal cultural phenomena as the arts and crafts, family organization and religion' cannot be explained in the same way. Instead he considered that a 'fully satisfactory...explanation of the underlying motivations is available in the psychological theory of acquired or derived drives'.[7] In support of this opinion he declared, on a later page, that 'in the case of those elements of the universal culture pattern which cannot readily be attributed, at least in part, to some recognized basic drive it seems more scientific to ascribe them to derived or acquired drives which naturally vary from society to society than to invent hypothetical new drives for which no factual evidence can be advanced'.[8] A remark that leaves me wondering whence the drives which inspired such men as Jesus, the Buddha, Mozart, Shakespeare, Fan K'uan, or Newton, were acquired or derived.

This glib ignoring of creative genius wasn't however the only, or indeed the principal, weakness in Murdock's argument; it was, quite simply, self-contradictory. His implied assertion that learning alone accounts for the presence of all his seventy-four cultural elements – so far as his knowledge went – in every culture known to history or ethnography (God knows how many that would be.) is statistically so improbable that we may safely discount it, while if we allow for the 140 activities of Brown's universal people the idea becomes even more unlikely. The conclusion is inescapable; if universals are not the result of learning alone they must be, at least in part, innate.

To which I must add that, years later, Murdock recanted his earlier views. In a paper, 'Anthropology's Mythology', presented at a meeting of the Royal Anthropological Institute of Great Britain and Ireland, he rejected the idea that anthropology is the study either of culture or of social relationships, spoke appreciatively of the conclusions of his psychologist colleagues at Yale who considered that 'all human behaviour which is not biologically determined in the narrowest sense depends upon the interaction of two sets of factors. The first is a set of basically innate mechanisms, such as those of perception, cognition and learning through which all

behaviour is mediated, the second consists of the specific conditions under which any behaviour occurs. The mechanisms, being fixed by heredity, are fundamentally identical for all mankind and even to a remarkable extent throughout the mammalian order. The conditions, on the other hand, are almost infinitely variable over time and space. It is through the complex interaction of the constant mechanisms with the varying conditions that man's behaviour becomes adapted to his environmental circumstances' and argued for a new relationship between psychology and anthropology: 'Only if the two disciplines collaborate to the full, with anthropology trusting psychology to reveal the basic mechanism of behaviour and with psychology trusting anthropology to ascertain the relevant configurations of conditions, will a genuine and full-fledged science of man emerge'.[9]

We must surely conclude that the standard social science model does not offer an answer to our problem. The psychic unity doctrine certainly provides a comprehensive 'basic psychological equipment and mechanism' but the model has nothing to say about genius, while the idea that learning alone accounts for the 140 activities of Brown's 'universal people' – not to mention IAC – is self-contradictory. And, most significantly, Murdock himself came to reject it.

Furthermore, it ignores the unconscious mind.

We shall have to look elsewhere.

Interlude: the Question of Innateness

Murdock's recantation was an early manifestation of a swing in the anthropological pendulum that developed during the 'eighties and 'nineties, a swing from the behaviourism of the standard social science model to what Brown calls interactionism; the idea that human behaviour is the product both of human biology and of human culture. Brown's book, itself part of this movement, catalogues the trend as it refers to universals. There is no need for us to follow him in a discussion of the trend's history but we should realise that an innate capacity must be genetic; it wouldn't be innate if it wasn't. It follows that universals of classification involve a combination of genetic and environmental influences. Thus the capacity to speak language, including its components of phonemes, words, grammar and syntax must be genetic while the fact that different cultures have different

languages can only be the result of environmental influences in the culture concerned.

The relationship between these two influences is discussed by a geneticist, Walter Bodmer and a scientific journalist, Robin McKie in their joint study, *The Book of Man*. According to them, 'we inherit 50,000 to 100,000 genes from our mothers and fathers and about half of these are thought to be responsible for brain development – which indicates that our capacity to deduce, make rational decisions, memorise crucial lessons and take control of our immediate surroundings probably has a huge genetic component'.[10]

It isn't easy to study the genetics of such latent attributes; you can't readily distinguish the (possible) effects of genetic inheritance from the (possible) effects of environmental circumstances. Bodmer and McKie put the problem very clearly: 'How can we really tell if we get our temperaments from our parents' genes or if we derive them from aping their behaviours from birth until these actions become so fixed in our psyches that they appear as fundamental to our natures as the colours of our hair and eyes?'.[11]

The problem isn't, however, insoluble. Identical twins possess similar visible attributes and should, hypothetically, possess similar latent attributes. They are, of course normally brought up together and in these circumstances there is no way of distinguishing the effects of genetic inheritance from those of environmental circumstances. Very occasionally, however, identical twins are separated at birth and brought up apart. Comparison of such twins should show whether they show temperamental, and hence genetic, similarities.

Such studies have been carried out at 'The Centre for Twin and Adoption Research' in the Department of Psychology at the University of Minnesota. Their procedure is as follows:

Once a pair of twins have been tracked down and have promised to co-operate they are flown, expenses paid, to Minnesota and subjected to a week-long investigation consisting of a very extensive series of medical and psychological tests. According to Dr Nancy S Segal, a member of the centre, 'the medical evaluation includes a complete medical history, general physical examination, cardiology testing (ECG, chest X-ray, stress test and electrocardiogram), monitoring of blood pressure, body temperature and activity, blood testing, allergy testing, eye examination, and dental examination. The psychological assessment includes a psycho-physiological

test battery (brain waves, speed of reaction measures), individual ability testing, measurement of special mental abilities (spatial skills, verbal fluency), and personality (major personality inventories), psychomotor assessment (hand steadiness, eye-hand co-ordination), life stress interview, life history interview, twin relationship survey, test of emotional responsiveness and measurements of interests, values and expressive style. It is estimated that by the end of the week participants have answered over 15,000 questions'.[12]

Comparison of the results shows that the twins exhibit not only an overwhelming similarity in physical features but remarkable personal similarities, similarities that can only be due to genetic influences. According to Professor Thomas J Bouchard, the leader of the centre 'about two thirds of the reliable variance in measured personality traits is due to genetic influence'.[13] While Bodmer and McKie quote, 'as a good anecdotal example' the case of the two Jims, Jim Lewis and Jim Springer, a pair of identical twins who were investigated at the Centre. 'When brought together after thirty-nine years of leading utterly separate lives, they looked superficially dissimilar, sporting different hairstyles and clothes. But after their first few hours together, their reminiscences began to peel back layers of lives that contained some astonishing parallels. For a start they both drove Chevrolets, chain smoked, gnawed their fingernails and enjoyed stock-car racing. Each had built a workshop for himself in the basement of his house. In his, Jim Lewis built miniature picnic tables, and in his, Jim Springer constructed miniature rocking chairs. Furthermore each had married twice and both of their first wives were named Linda, while both of their second wives were called Betty'.[14]

Bodmer and McKie emphasise that some features shared by the two Jims could only be coincidental. 'It is inconceivable that anyone could be genetically programmed to fall in love with persons of a certain name (no matter what Oscar Wilde argued). Similarly there is no way they could have been biologically "hard-wired" from birth to end up making workshops so that they could manufacture wooden furniture. Nevertheless it is also obvious that although the men had spent all their lives apart they acted in many ways like mirror images of each other, an observation supported by personality analysis. When the two Jims were given tests that measured tolerance, conformity, flexibility, self-control and sociability, their

results were so close that they could have come from the same person. Yet, of course, both men had led utterly different lives.'[15]

And, according to another twin researcher, Richard Rose of Indiana University: 'No dimension of behaviour seems to be immune from the effects of genetic expression.'[16]

This sees positive enough, but Bouchard emphasises that his evidence does not imply biological determinism – the doctrine that we are helpless prisoners of our genes and that we lack the free will to change and improve ourselves.

> 'Current thinking holds that each individual picks and chooses from a range of stimuli and events largely on the basis of his or her genotype and creates a unique set of experiences – that is people help to create their own environments. This view of human development does not deny the existence of inadequate and debilitating environments nor does it minimize the role of learning. Rather it views humans as dynamic creative organisms for whom the opportunity to learn and to experience new environments amplifies the effects of the genotype on the phenotype'.[17]

and

> 'The proximal cause of most psychological variance probably involves learning through experience just as radical environmentalists have always believed. The effective experiences, however, to an important extent are self-selected and that selection is guided by the steady pressure of the genome (a more distant cause). We agree with Martin *et al.* who see "humans as exploring organisms whose innate abilities and predispositions help them select what is relevant and adaptive from the range of opportunities and stimuli present in the environment. The effects of mobility and learning therefore augment rather than eradicate the effects of the genotype on behaviour"'.[18]

Bodmer and McKie summarise the argument as follows: 'What is quite clear from the work of Thomas Bouchard, Richard Rose and others is that

the idea that a few genes stamp the human character is an incorrect one. There must be a minimum of at least a hundred, perhaps several hundred genes, of as yet unguessable function, which cumulatively shape personality – in conjunction with environmental influences. Individually none of these genes plays an overwhelming role within the mind. Instead each contributes a small amount to the mental mosaic of personality'.[19]

This seems pretty conclusive, but what about universality? Bouchard and Rose's respondents were Americans, mostly we may presume, white. Do their findings apply also to other nations and races? We shall discuss this question more fully in Part Two but in the meantime we may remember Murdock's statement that 'all peoples now living or of whom we possess substantial historical records, irrespective of differences in geography or physique, are essentially alike in their basic psychological equipment and mechanism, and that the cultural differences between them reflect only the differential responses of essentially similar organisms to unlike stimuli or conditions', and Jones' assertion that 'the ancient and disreputable claim that there are inborn differences in ability between human races...has been comprehensively sunk by modern genetics'. We may conclude that Rose's assertion that 'no dimension of behaviour seems to be immune from the effects of genetic expression' applies not only to Americans but to everyone else as well.

On this basis we can proceed to the next stage of our enquiry; a consideration of whether Freud's model of the mind is any more helpful to us than is the standard social science model in its interpretation by Murdock.

Freud

For this we needn't, praise God, consider more than a tiny part of the twenty-four volumes of his contributions to psychoanalysis. His clinical activities do not concern us, nor do his studies of dreams and errors. Our interest is limited to two questions; one is general: how far does his theory of the mind provide an explanation for Brown's universals together with the findings of Bouchard and Rose and, as a corollary, the universality of IAC? The other is specific: how does his attitude to art relate to our own conclusions about the experiencer's response, the artist's intention and the unconscious minds of both?

But first we must try, briefly, to place his work in a historical context.

HISTORICAL ANTECEDENTS

Freud can hardly be accused, like those who accepted the standard social science model, of ignoring the unconscious mind but he did not, as is sometimes thought, discover it. He was the first to attempt its scientific study but its existence had been recognised many centuries before he was born. Lancelot Law Whyte opens the fifth chapter of his book, *The Unconscious Before Freud*, with the following quotation: '"Almost since the dawn of civilization man has had an inkling of understanding that mind activity outside of our waking consciousness does exist."'[20] Elsewhere he declares that 'in ancient Greece, in Rome and through the centuries of the Middle Ages many thinkers, some of them of great influence, avoided the self-centred mistake of treating the awareness of the individual as primary in the realm either of value or of philosophical thought. For them the direct experiences of the person were subordinate to other principles, divine or material, that in some degree controlled the fate of the individual. This was indeed the almost universal assumption, explicit or concealed, until self-conscious Europeans began to treat mind as an autonomous realm of being, a thing following its own laws'.[21]

The most influential of these self-conscious Europeans was Descartes. His ideas were not new. The concept that mind and body are separate and distinct had long been part of human thinking; 'many religious and early philosophers, Plato for example, assumed a…separation of soul and mind from the material universe'.[22] But just as Freud was the first to attempt a scientific study of the unconscious so Descartes was the first thinker to 'assert a sharp division of mind from matter as the basis of a systematic philosophy claiming scientific clarity and certainty'.[23]

Whyte's book is, essentially, an account of the reaction to this dualism. He declares that 'the general conception of unconscious mental processes was *conceivable* [in post-Cartesian Europe] around 1700, *topical* around 1800, and *fashionable* around 1870-1880'[24], stating earlier that these changes were due 'to the imaginative efforts of a large number of individuals of varied interests in many lands'.[25] He offers many quotations to support his case. There is no need to reproduce them here but we may record that they include excerpts from texts by (among pre-Cartesian sages) Plotinus, St Augustine, Dante, Paracelsus, St John of the Cross, Montaigne and Shakespeare, and

(after Descartes) Pascal, Spinoza, Milton, Newton, Ralph Cudworth, Lord Shaftesbury, Leibniz, Vico, Rousseau, Hume, Kant, von Herder, Fichte, Goethe, Schiller, Wordsworth, Coleridge, Hegel, Schopenhauer, de Quincey, Herbart, Sir William Hamilton, W B Carpenter...the list goes on. Whyte concludes that 'by 1870-1880 the general conception of the unconscious mind was a European commonplace, and that many applications of this general idea had been vigorously discussed for several decades.'[26]

Freud seems to have been ignorant of this climate of theory. Whyte provides two references on this subject. One is a letter, written to his friend, Wilhelm Fliess, when Freud was forty-two. In it he declares: 'I found my insights stated quite clearly in Lipps, perhaps rather more so than I would like,' to which he adds 'The representation of our ideas is close in details as well.'[27] The other is a note written at the age of sixty-nine. '"The overwhelming majority of philosophers regard as mental only the phenomena of consciousness. For them the world of consciousness coincides with the sphere of what is mental."'[28] Whyte comments as follows: 'This curious mistake shows how narrow his reading had been and how wrong a conception he must have had of his own originality'.[29] This ignorance is the more surprising when one sets it in the context of the intellectual milieu in which Freud grew up. Freud's parents were middle-class Viennese Jews possessed of a culture that, according to the American, Jack J Spector, involved 'the rule of mind over body, Voltairian scepticism and the Enlightenment ideal of social progress through science, education and hard work'.[30] He attended the Viennese *Gymnasium* where he received a classical education which included readings of Goethe and Shakespeare and where he obtained the *Matura*, a degree similar to a BA, at seventeen, a year earlier than usual. It seems hardly credible that a man with his brilliant mind, liberal upbringing, and generous education should have been unaware of the historical background of his own subject.

FREUD'S ATTITUDE TO ART

Gombrich, also by origin a Viennese, has discussed Freud's attitude to art, declaring it to have been typical of his age and class. 'Those of us who were still in contact with his [Freud's] generation of highly educated doctors and lawyers will recognise in his letters the approach to art that characterised

the most cultivated "Victorians" of Central Europe.'[31] To which he adds: 'We must not forget that in the tradition of the nineteenth century what was called the "spiritual content" of a painting came first. The way the artist visualised the sacred personages and the events in which they were involved was always considered the true test of greatness. It was the critic's task to elucidate these subtleties rather than to enlarge on the balance of the composition or the characteristics of the brushwork.'[32] This was certainly Freud's opinion. Gombrich quotes a letter written by Freud to his fiancée in 1883 after a visit to the great Dresden galleries. It is too long to quote in full but we may mention his response to Titian's *Tribute Money*. '"The only painting that really enthralled me was Titian's *Tribute Money*...This head of Christ, my darling, is the only plausible one that allows us to imagine such a person. Indeed I had the feeling that I now *had* to believe that that person was really so important because its representation is so successful. Yet there is nothing divine in it. A noble human face far removed from beauty but full of seriousness, sincerity, profundity, a mellow aloofness and yet a deep seated passion – if all this does not lie in this picture physiognomics does not exist...So I left with an exalted heart."'[33]

Such enthusiasm was typical of the man. According to Spector, whose book, *The Aesthetics of Freud, A Study in Psychoanalysis and Art*, is a very comprehensive study of the subject, Freud wrote about art 'with an intimacy that suggests that it meant something more to him than a scientific problem'.[34] Researching the book cannot have been easy. Apart from two extended essays – *The Moses of Michelangelo* and *Leonardo da Vinci and a Memory of his Childhood* – Freud never wrote systematically about art and his ideas on its psychology are strewn across his writings. Furthermore he was not only vague in his statements 'just when one wishes for clarification, Freud remains silent or unclear, or speaks contradictorily',[35] he also 'carefully avoided claims to a comprehensive theory of aesthetics' and adopted a 'position of coy retreat before the artist's secret of achievement'[36] leaving 'the subject of genius or technique to aestheticians and to the artists themselves'.[37]

This confusion may perhaps be understood if one realises that Freud's interest in works of art was – as shown by the account of *The Tribute Money* – concerned with their associations and that, according to Spector, he 'approached aesthetic questions mainly for their bearing on his

psychoanalytic work'.[38] The first point is exemplified by photographs of his apartment in Vienna and its reconstruction in the Freud Museum at 20 Maresfield Gardens, Hampstead. These show him to have been an obsessional collector of antique statuettes; they are not, however, arranged in such a way as to show them to the best advantage. They crowd the horizontal spaces so closely that not one can be appreciated as an aesthetic object in its own right. It is the collection of someone whose interest in the arts is associative rather than aesthetic. Freud admits as much in the opening paragraph of his essay *The Moses of Michelangelo:*

> 'I may say at once that I am no connoisseur of art, but simply a layman. I have often observed that the subject matter of works of art has a stronger attraction for me than their formal and technical qualities though to the artist their value lies first and foremost in these latter. I am unable rightly to appreciate many of the methods used and the effects obtained in art…Nevertheless, works of art do exercise a powerful effect on me, especially those of literature and sculpture, less often of painting. This has occasioned me, when I have been contemplating such things, to spend a long time before them trying to apprehend them in my own way, i.e. to explain to myself what their effect is due to. Wherever I cannot do this, as for instance with music, I am almost incapable of obtaining any pleasure. Some rationalistic, or perhaps analytic, turn of mind rebels against being moved by a thing without knowing why I am thus affected and what it is that affects me.
>
> 'This has brought me to recognize the apparently paradoxical fact that precisely some of the grandest and most overwhelming creations of art are still unsolved riddles to our understanding'.[39]

We might have expected that Freud of all people would have investigated these riddles as an aspect of psychology – they are after all concerned with the impact of external influences on the mind – but he didn't. Instead he discussed the artist's intention: 'In my opinion what grips us so powerfully can only be the artist's *intention,* in so far as he has succeeded in expressing

it in his work and in getting us to understand it. I realize that this cannot be merely a matter of *intellectual* comprehension; what he aims at is to awaken in us the same emotional attitude, the same mental constellation as that which in him produced the impetus to create'.[40] And he proceeds to devote twenty pages to an elaborate analysis of the illustrative characteristics of the work and of the comments of previous historians and critics upon it. All this in an effort to establish Michelangelo's *intended* meaning; a matter which, as we have shown, is irrelevant to IAC and which Gombrich considered, in another context, to be 'not a psychological category at all'.[41]

Rather than attempt to answer these unsolved riddles Freud approached the psychology of art much as he approached the psychology of his patients. Spector tells us[42] that his primary interest in art, apart from his collecting, was for its themes related to the dream, the unconscious, sex and neurosis. This is exemplified by the essay, *Leonardo da Vinci and a Memory of his Childhood*, a study which does not pretend to be a critique of the artist's work but is rather a psychoanalytic biography using as evidence what little is known of Leonardo's childhood together with an application of Freud's theories to certain of his pictures.

It was a limited attitude. I cannot avoid reservations about the opinions of a scientist who is unaware of the history of his own subject, an approach to the psychology of art which carefully avoids any discussion of creativity, a study of a masterpiece which does no more than consider the artist's intention, an obsession with collecting which makes no attempt to display the objects collected to their best advantage, or an interest in art which is concerned with themes related to the dream, the unconscious, sex and neurosis – but which ignores architecture, the crafts, townscape or the design of gardens.

What about IAC? Here I can do no better than quote Spector, the italics are mine: 'Freud's "aesthetics," *failing to work out the connections among artist, spectator and work of art*, has little to say about the key areas of perception and emotion in art.'[43]

Freud's approach to art seems to have little to offer us in our enquiry. Can we do any better with his model of the mind and in particular its relationships to the findings of Bouchard and Rose, to Brown's universals and hence to IAC?

FREUD'S MODEL OF THE MIND

Initially Freud offered a simple division of the mind into two parts, conscious and unconscious. For this, he assumed that the unconscious consisted of impulses, thoughts and feelings which were unacceptable to the conscious part (which he called the 'ego') and which were therefore repressed. In time, however he found that this concept was inadequate to explain certain events that occurred to patients whom he analysed. In particular he concluded that repression could occur without conscious knowledge or intention and that the term 'unconscious' was better used as a descriptive adjective than as a topographical noun. Furthermore, it was evident that there is a distinction among unconscious ideas. Some are *capable* of becoming conscious while others are *denied access* to consciousness. Freud called the former 'preconscious' the latter 'unconscious' insisting that 'the frontier between them…is sharp, and the difference not one that can be expressed in terms of gradations of awareness or degrees of psychic clarity'.[44]

The psychologist Anthony Storr has summarised Freud's conclusions as follows: 'Although everything which was repressed was unconscious, not everything which was unconscious was repressed.'[45] This finding led him to propose a tripartite model consisting of the 'ego', the 'id' and the 'super-ego'.

Freud saw the id as primitive – the oldest part of the mind – unorganised – operating without regard to the dictates of logic or external reality (Storr declares that it 'ignores the categories of time and space and treats contraries like dark/light or high/deep as if they were identical')[46] – and emotional – embodying the instincts related to psycho-sexual gratification (*libido*). In addition he considered it to be wholly unconscious, to be the part from which the other structures are derived, and to contain, in his own words,

> 'everything that is inherited, that is present at birth, that is laid down in the constitution – above all therefore, the instincts which originate from the somatic organisation and which find a first psychical expression here in forms unknown to us…'[47]

> 'It is the dark, inaccessible part of our personality, what little we know of it we have learnt from our study of the dream-work and the construction of neurotic symptoms, and most of that is

of a negative character and can be described only as a contrast to the ego. We approach the id with analogies; we call it a chaos, a cauldron full of seething excitations...It is filled with energy reaching it from the instincts, but it has no organization, produces no collective will, but only a striving to bring about the satisfaction of instinctive needs subject to the observance of the pleasure principle'.[48]

The ego is, by contrast, wholly conscious. O L Zangwill describes it, in the *Oxford Companion to the Mind*, as 'essentially the mind as ordinarily conceived. It is the instrument of learning and of adaptive relationship to the environment...concerned essentially with perception, memory and the control of speech and volitional activity'.[49] Its prime function is self-preservation.

Freud wrote as follows: 'As regards *external* events it performs that task by becoming aware of stimuli, by storing up experiences about them (in the memory), by avoiding excessively strong stimuli (through flight), by dealing with moderate stimuli (through adaption) and finally by bringing about expedient changes in the external world (through activity). As regards *internal* events, in relation to the id, it performs that task by gaining control over the demands of the instincts, by deciding whether they are to be allowed satisfaction, by postponing that satisfaction to times and circumstances favourable to the external world or by suppressing their excitations entirely.'[50]

According to Zangwill, the super-ego originally derived from parental prohibitions and criticism. 'While closely related to consciousness [it] is in part unconscious and derives its energies vicariously from the id. It operates as a monitor of conduct and a major source of control through repression. The super-ego constitutes the nucleus of conscience and provides the foundations of adult morality'.[51]

In Freud's words: 'The long period of childhood, during which the growing human being lives in dependence on his parents, leaves behind it as a precipitate the formation in his ego of a special agency in which this parental influence is prolonged. It has received the name of *super-ego*. In so far as this super-ego is differentiated from the ego or is opposed to it, it constitutes a third power which the ego must take into account.'[52]

Freud's ideas are fascinating. Sadly, however, his model doesn't match either Brown's conclusions or the findings of Bouchard and Rose. Why?

We concluded, in our assessment of the standard social science model, that universals must be at least in part innate, while in our discussion of Bouchard's twin studies we quoted Rose's finding that 'no dimension of behaviour seems to be immune from genetic expression'. If Freud's model is accepted these conclusions mean that the id must not only contain some if not all of the capacity to practise each of Brown's 140 universals, it must also provide the home for every dimension of behaviour since it contains 'everything that is inherited, that is present at birth, that is laid down in the constitution'. It is, however, 'the dark, inaccessible part of our personality...we call it a chaos, a cauldron full of seething excitations...filled with energy reaching it from the instincts, but it has no organization, produces no collective will, but only a striving to bring about the satisfaction of instinctive needs subject to the observance of the pleasure principle'. I'm sorry but I cannot see how this dark, inaccessible part of our personality, this chaos, this cauldron full of seething excitations lacking either organisation or collective will can accommodate, in Rose's words, 'every dimension of behaviour' including – to mention a few of Brown's universals – such varied activities as taxonomy, divination, fondness for sweet tastes or theories of fortune and misfortune; let alone IAC.

The model is no good to us.

Well, very nearly no good. In its distinction between unconscious and preconscious ideas it provides the framework for what is, in Gombrich's words, 'The most revealing utterance by Freud on his attitude to art'.[53]

The utterance appears in a letter which he wrote at the age of eighty-two to his friend Stefan Zweig on the occasion of a visit by Salvador Dali:

> "'I can really thank you for the introduction which yesterday's visitor brought me. For up to now I was inclined to consider the Surrealists who appear to have chosen me as their patron saint pure lunatics or let us say ninety-five per cent as with "pure" alcohol. The young Spaniard with his patently sincere and fanatic eyes and his undeniable technical mastery has suggested to me a different appreciation. It would indeed be interesting to explore the origins of such a painting analytically. Yet as a critic, one

might still be entitled to say that the concept of art resisted an extension beyond the point where the quantitative proportion between unconscious material and preconscious elaboration is not kept within a certain limit. In any case, however, these are serious psychological problems"'.[54]

Gombrich explains that Freud had discussed the interaction between preconscious material and the unconscious in his book, *The Joke,* in which he declared that the formula for a joke was 'a preconscious idea exposed for a moment to the workings of the unconscious' and that Ernst Kris regarded this as the 'germinal model for any account of artistic creation on Freudian lines'.[55] The reference to Kris is not given but it appears to be from his *Psychoanalytic Explorations in Art*. I can see no need to follow Gombrich in his discussion of this theory except to say that it is, as always with Gombrich, illuminating but that I remain unconvinced. The highly literary form of a joke may perhaps provide a model for the creative activity involved in writing a poem or acting in a play but it seems hardly adequate to explain that involved in devising such works as a cottage garden, a fan vault, a Sung dish or a Persian carpet.

We must surely conclude that apart from that unconvincing sentence in the letter to Stefan Zweig – not a large proportion of the twenty-four volumes of his contributions to psychoanalysis – Freud had nothing to say which would be of value to us in our enquiry. We have already reached this conclusion in regard to his approach to art while the id – according to his own account – cannot possibly accommodate all Rose's dimensions of behaviour or Brown's 140 universals, let alone IAC.

Another blind alley.

Jung

FREUD AND JUNG

The period was 1911-12. Jung had met Freud four years earlier and had become his most trusted colleague, the man who, Freud felt sure, would succeed him as leader of the psychoanalytic movement.

It didn't work out that way.

To understand why this happened we must place the events in context; in particular we must realise first that neither of them were easy people to get on with; Anthony Stevens lists eight of Freud's associates apart from Jung in regard to whom enmity followed friendship, adding that Jung had considerable difficulty in relating to men and had few male friends except a companion from childhood,[56] secondly that at this time the idea of innateness which we discussed earlier had not yet developed; Locke's theory of 'the empty cabinet' remained in principle undisputed though people had begun to recognise that the cabinet wasn't quite empty, in particular that it contained instincts such as hunger, sex and self-preservation, and thirdly that Freud had not yet developed the tripartite theory of the mind which we described in the last section. He still saw the mind as divided into two parts, conscious and unconscious. Furthermore he assumed that the unconscious part consists of memories peculiar to the individual, that these memories when repressed are invariably sexual in nature and that the energy (*libido*) which drives the psychic apparatus is sexual in origin and originates in childhood. Finally, that Freud saw himself as a prophet. Stevens describes Jung's recollection of Freud's attachment to his sexual theory, 'He seemed committed to [it] to an almost fanatical degree…When he spoke of it his tone became urgent…A strange deeply moved expression came over his face…It was as if the subject had assumed a *religious* meaning for Freud, who was an atheist – he had rejected God and put sex in His place…' and '"My dear Jung, promise me never to abandon the sexual theory. That is the most essential thing of all. You see, we must make a dogma of it, an unshakeable bulwark…" In some astonishment Jung asked, "A bulwark – against what?" to which Freud replied, "Against the black tide of mud – of occultism."'[57]

Jung did not make the promise.

From about 1900 onwards he was a physician at the Burghölzli hospital in Zürich where he treated patients suffering from schizophrenia and hallucinations. His experience with these people convinced him that there must exist a universal foundation to the human psyche. Stevens writes as follows: 'Not only did the strange ideas, hallucinations and visual images reported by individual schizophrenics resemble those reported by others, but they also bore a startling similarity to the mythologems and religious images which had been widely reported by students of cultural history

from all over the world. Jung gathered a wealth of evidence which persuaded him that this universal symbolism was due less to individual experience or cultural dissemination than to the structure of the human brain and to a fundamental component of the unconscious psyche which was shared by all mankind.'[58]

These findings led Jung to spend most of 1910 collecting information on archaeology, mythology and comparative religion, material which he incorporated in a book which appeared in two parts in 1911 and 1912. In it he made three declarations: first, using as evidence parallels between an account of the fantasies described by one of his patients and the results of his archaeological, mythological and religious researches, he propounded the hypothesis that the unconscious is collective to all mankind rather than specific to each individual – a view which ran contrary not only to Freud's opinions but also to the then undisputed principle of Locke's empty cabinet; secondly he dismissed Freud's concept of the *libido* as exclusively sexual – offering instead the hypothesis that it is non-specific psychic energy and arguing that sexuality is but one form in which such energy can be channelled; and thirdly he rejected one of Freud's cardinal doctrines, that the Oedipus or Electra complex was a developmental stage through which every boy and girl must pass.

To one who sees himself as a prophet, such views were heresy. It is hardly surprising that their friendship turned to enmity and recrimination.

TWO PROBLEMS

Whatever one may think about Freud's preoccupation with sex, his warning to Jung about 'the black tide of mud – of occultism' was amply justified. Jung was, in my judgement, an odd fish. He was sensitive to the point of clairvoyance but some of his ideas, e.g. his interest in alchemy – a subject to which he devoted ten years of his life – were pretty bizarre.[59] These circumstances have caused many people, Gombrich one of them, to find difficulty with his 'mixture of mystical and scientific pretensions'.[60] It is a fair description but I don't think we need worry so long as we take care to limit ourselves to an investigation of his scientific pretensions and seek, wherever possible, to confirm them by common-sense or independent evidence.

Jung's mysticism is not, however, the only aspect of his writings to have caused difficulty; unlike Freud who possessed an excellent literary style,

Jung's language is at best turgid and at worst barely comprehensible. In these circumstances I have chosen, rather than quote him, to adduce as evidence Stevens' admirably clear interpretation of his theories. With this caveat we may proceed.

JUNG'S MODEL OF THE MIND

Stevens illustrates Jung's model of the psyche by means of the accompanying diagram. We may summarise his description as follows:

11 Anthony Stevens: Diagram of Jung's model of the mind.

The mind may be represented by a set of concentric spheres of which the first is 'consciousness', the second the 'personal unconscious' the third the 'collective unconscious' and the fourth – at the centre of the assembly – the 'self'. The 'ego' skims around the consciousness sphere and is linked to the self by the 'ego-self' axis. The constituents of the personal unconscious are 'complexes', those of the collective unconscious are 'archetypes'. They are linked together.

Stevens goes on to describe the characteristics of these components. His account is, however, too long to summarise fully. In what follows I have tried to include what are, from our own standpoint, the most important aspects of each component. For this reason, I don't mention four matters which, because they are of special concern to analysts, are among the best-known aspects of Jungian theory. These are the persona, the image which we present to society; the shadow, the assembly of ideas which we repress because we regard them as undesirable; and the anima and animus, the psychological characteristics of the opposite sex which we carry in our minds and which help to establish and maintain the heterosexual bond.[61]

CONSCIOUSNESS AND THE EGO

'The Ego,' Stevens says, 'is the focal point of consciousness. It is what we refer to when we use the words "I" or "me". The ego carries our conscious identity. It is the conscious organiser of our thoughts and intuitions, our feelings and sensations, and it has access to those memories that are unrepressed and readily available.

'The ego is the bearer of personality. Placed as it is on the outer layer of the psyche the ego mediates between subjective and objective realms of experience. It stands at the junction between inner and outer worlds…it is the mediator of the self to the world and of the world to the self. [In addition] it is the perceiver of meaning and an assessor of value, activities which not only promote survival but also make life worth living'.[62]

COMPLEXES AND ARCHETYPES

According to Stevens 'a complex is a group of associated ideas bound together by a shared emotional charge: it exerts a dynamic effect on conscious experience and on behaviour. An archetype, on the other hand is an innate "centre" or "dominant" common to both the brain and the psyche, which has the capacity to initiate, influence and mediate the behavioural characteristics and typical experience of all human beings, irrespective of race, culture, historical epoch or geographical location'.[63] Both should be conceived not as fixed or static but as dynamic 'systems' in a constant process of interaction and change. All are under the co-ordinating influence of the Self.[84]

Unlike Freud who conceived of complexes as involved solely in illness Jung saw them as essential parts of a healthy mind. Furthermore, they seem to be autonomous, behaving like independent beings and possessing 'a will, a life and a personality of their own'.[65]

Stevens goes on: 'At the heart of every complex there is a "nuclear element" which functions beyond the reach of the conscious will. It is around this that the emotionally charged associated ideas cluster. What provides the nucleus? in the case of the major complexes – for example, the mother and father complexes…[Jung] came to the conclusion that the nuclear element was a component of the collective unconscious…He called them [after 1919] "archetypes"'. Before that it was 'primordial images'.[66]

THE PERSONAL UNCONSCIOUS

Elsewhere Stevens declares that a 'close functional relationship exists between complexes and archetypes, in that complexes are "personifications" of archetypes: complexes are the means by which archetypes manifest themselves in the personal psyche'.[67] As a result the personal unconscious is the product of interaction between the collective unconscious and the environment in which the individual grows up.

There is, however more to it than that.

According to Jung, "Everything of which I know, but of which I am not at the moment thinking; everything of which I was once conscious but have now forgotten; everything perceived by my senses but not noted in my conscious mind; everything which, voluntarily and without paying attention to it, I feel, think, remember, want, and do; all the future things which are taking shape in me and will sometime come to consciousness; all this is the content of the unconscious'.[68] 'Besides these, we must include all more or less intentional repressions of painful thoughts and feelings. I call the sum of these contents the 'personal unconscious'.[69]

ARCHETYPES AND THE COLLECTIVE UNCONSCIOUS

The collective unconscious, and with it the archetypes of which it is composed are, by Jung's theory, inherited. Furthermore, according to Jung, 'there are as many archetypes as there are typical situations in life',[70] to which Stevens added 'the human infant…is a highly complex creature

endowed with a huge repertoire of built-in expectations, demands and patterns of response, whose fulfilment and expression depend on the presence of appropriate stimuli arising in the environment. As a result, the archetypal endowment with which each new-born infant is equipped enables it to adapt to reality in a manner indistinguishable from those of our remote ancestors'.[71] Stevens describes how this adaptation occurs – how an archetype of the collective unconscious becomes a complex in the personal psyche – 'an archetype becomes active in the psyche when an individual comes into proximity…with a situation or person whose characteristics possess *similarity* to the archetype in question. When an archetype is successfully activated it accrues to itself ideas, percepts and emotional experiences associated with the situation or person responsible for its activation, and these are built into a complex which then becomes functional in the personal unconscious.'[72]

THE SELF

The instrument of such adaptation is the Self, the sum total of the new-born infant's archetypal endowment, in Jung's phrase 'the archetype of archetypes'.[73] The Self is, according to Stevens, the psychic organ of adaptation *par excellence*. It is 'the organizing genius behind the total personality…It gives us intimations of ultimate matters of which the ego remains ignorant. The ego is privy purely to our conscious preoccupations, but the Self has access to an infinitely wider realm of experience'.[74]

JUNG'S MODEL, THE PSYCHIC UNITY OF MANKIND, THE UNIVERSALS OF CLASSIFICATION, AND INNATENESS

There are remarkable similarities between, on the one hand, different aspects of Jung's model of the psyche and, on the other hand, Murdock's findings about the psychic unity of mankind and the findings of Rose, Bouchard and others about the innateness and characteristics of human personality and the extent of its genetic expression. Let us take them in turn.

(i) Perhaps the most striking, certainly the most obvious, example of such similarity is that between the collective unconscious with its archetypes

and the psychic unity of mankind; a similarity which is forcibly illustrated by Stevens' statement that the archetype possesses the 'capacity to initiate, influence and mediate the behavioural characteristics and typical experience of *all human beings, irrespective of race, culture, historical epoch or geographical location*' together with Murdock's account of the psychic unity of mankind as 'the assumption, now firmly grounded in social science, that *all peoples now living or of whom we possess substantial historical records, irrespective of differences in geography or physique, are essentially alike in their basic psychological equipment and mechanism*'. (My italics)

(ii) Furthermore Jung's assertion that archetypes are inherited and that there are as many of them as there are typical situations in life matches Rose's conclusion that 'no dimension of behaviour seems to be immune from the effects of genetic expression'.

(iii) Stevens' account of how an archetype of the collective unconscious becomes a complex in the personal psyche – 'an archetype becomes active in the psyche when an individual comes into proximity…with a situation or person whose characteristics possess *similarity* to the archetype in question. When an archetype is successfully activated it accrues to itself ideas, percepts and emotional experiences associated with the situation or person responsible for its activation, and these are built into a complex which then becomes functional in the personal unconscious' – corresponds, not only with Bouchard's statement (quoting Martin et al) that humans are 'exploring organisms whose innate abilities and predispositions help them select what is relevant and adaptive from the range of opportunities and stimuli present in the environment' but also with Brown's universals of classification in that they are generically consistent throughout mankind while being specifically peculiar to the culture concerned. (As an example: according to Jung's theory the language-capacity archetype of an infant brought up in an Urdu-speaking household will be activated by his upbringing to become a speaking-Urdu complex in his personal unconscious, according to Bouchard the infant's innate ability and predisposition to speak a language help it to select Urdu from the range of opportunities and stimuli present in its environment, while, according to Brown, language, a universal of classification, generically consistent

throughout mankind, is developed specifically as Urdu in the infant's Urdu-speaking household.) We may conclude that Jung's 'archetypes', Brown's 'universals of classification', Rose's 'dimensions of behaviour' and Bouchard's 'innate abilities and predispositions' are synonymous, different ways of describing the same phenomenon.

Furthermore if, as we have argued, IAC is a universal of classification in addition to those in Brown's list, it must also be among Rose's dimensions of behaviour, Bouchard's innate abilities and predispositions, and Jung's archetypes.

Jung's archetypes?

We seem to have found what we seek; a psychological theory whose concept of the unconscious mind accommodates the psychological aspect of IAC. How, in terms of the theory, does the process of IAC occur?

IAC AND CREATIVITY

First, IAC must include many archetypes. We cannot imagine how a single archetype could constitute the communication processes involved in the creation and enjoyment of, to repeat ourselves, a cottage garden, a fan vault, a Sung dish or a Persian carpet.

Secondly, a single work can, indeed probably does, involve more than one archetype. One might be religious – Brown's religious or supernatural beliefs – one concerned with the mathematics of proportion and one with the human figure. Think of the Parthenon.

Thirdly, you will remember that we described IAC as 'a three stage process which originates in the unconscious mind of the artist and is transmitted, via the work of art, to the unconscious mind of the experiencer'. Jung's model enables us to develop this idea. Let us take as an example Picasso's picture, *Les Demoiselles d'Avignon*. According to John Richardson, *The Life of Picasso, volume two, 1907–1917: The Painter of Modern Life*, he intended the picture to depict an assembly of prostitutes in a brothel, perhaps in accordance with an essay by Baudelaire, *Le Peintre de la Vie Moderne*, which suggested whoredom as the ideal subject for a sculptor. (Picasso's own title, *Le Bordel d'Avignon* was modified by his friend André Salmon in an effort to assuage public prudishness when he put the picture on exhibition.) We may assume that the collective unconscious

12 Picasso: *Les Demoiselles d'Avignon*.

includes as an archetype – a typical situation in life – the image of a naked woman and that this archetype lay in the unconscious minds both of Picasso and of whoever might experience the picture. According to the theory, the archetype in Picasso's mind became activated to become a complex in his personal unconscious and in the process of being activated it accrued to itself 'ideas, percepts and emotional experiences' associated with the people and works with which Picasso had been in contact. We do not know what these were but we may reasonably assume that they included his upbringing, his habit of frequenting brothels, his experiences both as a student and as an artist, his contact with other artists and critics, and his awareness of

other works of art including Iberian sculpture and African Negro carving. This adaptation must, by the theory, have occurred under the controlling influence of the Self 'the psychic organ of adaptation *par excellence*'.

Some external event, such as a reading of Baudelaire's essay, led him to conceive the picture, consciously, in his ego. This concept passed, via the ego-self axis, first to the self and then to the complex in the personal unconscious where it obtained access to the 'ideas, percepts and emotional experiences' which were already there. All these factors were then built into the complex.

Furthermore, by the theory this complex would, like other complexes be autonomous, possessing 'a will, a life and a personality of its own'. This autonomy provides an explanation for the phenomenon that we noted earlier; the artist's strange inability to offer more than the most general explanation of why – apart from an account of his approach to the iconic or symbolic aspects of his work – he acts as he does. The complex, being autonomous, acts independently of the artist's intention causing the picture to be the result of two activities; the conscious operation of Picasso's ego and the unconscious, autonomous, operation of his complex. And it is the complex that supplies IAC.

The naked woman archetype lies in the experiencer's share of the collective unconscious just as it lay in Picasso's. The experiencer, on encountering *Les Demoiselles d'Avignon*, responds to it consciously via his ego while at the same time his experience of the picture is transmitted unconsciously – via the ego-self axis – to the self whence it is passed to one of his complexes. This was, of course, originally an archetype which had been activated to become a complex in his personal unconscious and which had, in the process, accrued to itself 'ideas, percepts and emotional experiences' associated with the people and works with which he had been in contact. We can have no idea what these were but we may be sure that if he were to receive the IAC which Picasso offered they must have been such as to provide him with experience of works of art generally and with examples similar to *Les Demoiselles d'Avignon* in particular. With such familiarity he can respond unconsciously to the IAC incorporated in the picture as well as consciously to its symbolic and iconic attributes; without it his complex would not have been appropriately activated and he would be unable to respond, except perhaps in disgust, to the picture. (You will

remember that we referred earlier to the shocked incomprehension that greeted it on its first showing, adding that with familiarity such breaches of convention become acceptable.) Familiarity? This too we have encountered before, in the writings of David Hume and Pierre Bourdieu, writings which we summarised by declaring 'that the full enjoyment of a work of art is, like whiskey, an acquired taste, one that demands familiarity with other works of a similar kind – familiarity that results from the individual's upbringing, education and experience, in particular with experience of works of art'.

IAC is like radio. The collective unconscious is the ether; the message is broadcast, via the work of art, by the artist's complex. For it to be received the experiencer's complex must be tuned in, by familiarity with similar works, to the same wavelength. Both complexes derive from one or more archetypes which, being common to all mankind, are shared by them both but which are activated differently by their different experiences.

Jung's model of the psyche seems to give us what we seek: it explains our ability to respond to works which originated in cultures other than our own, it fits Brown's universals of classification, it provides for the psychological aspect of IAC, it accounts for the need for familiarity in artistic appreciation, it gives a reason for the artist's inability to offer more than the most general explanation of why he acts as he does and it has a structure within which we can devise a theory of creativity.

We seem to be home.

1 Murdock, *op cit*, p 126.
2 See Marvin Harris, *The Rise of Anthropological Theory*, Routledge and Kegan Paul, 1968, p 11.
3 Franz Boas, *The Mind of Primitive Man*, Revised Edition, The Free Press, 1968, p 5.
4 Steve Jones, 'We are all Cousins under the Skin', *The Independent*, December 12th, 1991.
5 See in this connection the introductory essay by Leda Cosmides and John Tooby to *The Adapted Mind*, Jerome H Barkow, Leda Cosmides and John Tooby eds, Oxford University Press, 1992.
6 Murdock, *op cit*, p 126.
7 *ibid*, p 128.
8 *ibid*, p 129.
9 Proceedings of The Royal Anthropological Institute of Great Britain and Ireland, 1971, p 21 and p. 22.

10 Bodmer, Walter and McKie, Robin, *The Book of Man*, Little, Brown and Company, 1994, p 131.
11 *ibid*, p 132.
12 Segal, Nancy S, *The Nature vs Nurture Laboratory*, Twins, University of Minnesota, July/August 1984.
13 Bouchard, Thomas J Jnr, 'Genes Environment and Personality', *Science*, Vol 264, 17th June 1994, p 1700.
14 Bodmer and McKie, *op cit*, pp 133 and 134. See also Alice Volmar, 'Together Again', *Friendly Exchange*, Department of Psychology, University of Minnesota, Winter 1984, p. 28.
15 *ibid*,
16 *ibid*, p 135.
17 Bouchard, *op cit*, p 1701.
18 Bouchard, Thomas J Jnr, *et al*, 'Sources of Human Psychological Differences: The Minnesota Study of Twins Reared Apart', *Science*, Vol. 250, 12 October 1990, p 227.
19 Bodmer and McKie, *op cit*, p 136.
20 E L Margetts, 'Concept of the Unconscious in the History of Medical Psychology', *Psychiatric Quarterly*, 27 (1953), p 1.
21 Lancelot Law Whyte, *The Unconscious Before Freud*, Tavistock Publications, 1962, p 60.
22 *ibid*, p 26.
23 *ibid*.
24 *ibid*, pp 168-169.
25 *ibid*, p 63.
26 *ibid*, pp 169-170.
27 *The Complete Letters of Sigmund Freud to Wilhelm Fliess, 1887-1904*, Belknap Press of The Harvard University Press, 1985 p 324. Lipps was a philosopher, Theodor Lipps, whose book, *Grundtatsachen des Seelenliebes*, Freud was reading at the time.
28 Whyte, *op cit*, p 170.
29 *ibid*.
30 Spector, Jack J, *The Aesthetics of Freud, A Study in Psychoanalysis and Art*, Allen Lane, The Penguin Press 1972, p 20.
31 E H Gombrich, 'Freud's Aesthetics', *Encounter*, January 1966, p 30.
32 *ibid*, p 31.
33 *ibid*. The translation from Freud is Gombrich's own.
34 Spector, *op cit*, p viii.
35 *ibid*.
36 *ibid*, pp 79-80.
37 *ibid*, p viii.
38 *ibid*.
39 Sigmund Freud, *Complete Psychological Works*, Standard Edition, Vol 13, Hogarth Press, 1955, p 211-212.

40 *ibid*, p 212
41 Gombrich, *Symbolic Images, Studies in the Art of the Renaissance*, p 17.
42 Spector, *op cit*, p 26.
43 *ibid*, p 123.
44 Richard Wollheim, *Freud*, Fontana/Collins, 1971, p 161.
45 Anthony Storr, *Freud*, Oxford University Press, 1989, p 46.
46 *ibid*, p 47.
47 Freud, *op cit*, Vol 23, p 145.
48 *ibid*, p 73.
49 O L Zangwill, 'Freud on Mental Structure', *The Oxford Companion to the Mind*, Oxford University Press, 1987, p 278.
50 Freud, *op cit*, Vol 23, pp 145-146.
51 Zangwill, *op cit*, p 278.
52 Freud, *op cit*, Vol 23, p 146.
53 Gombrich, *Freud's Aesthetics*, p 34.
54 *ibid*, pp 34-5. The translation from Freud is Gombrich's own.
55 *ibid*.
56 See Anthony Stevens, *On Jung*, Penguin, 1990, p 23.
57 *ibid*, p 24
58 *ibid*, pp 20-21.
59 For an account of his interest in alchemy see *ibid*, pp 229-246.
60 Gombrich, *the Sense of Order*, p 263.
61 For an account of these matters see Stevens, *op cit*, pp 42-47.
62 *ibid*, p 30.
63 *ibid*, p 28.
64 *ibid*.
65 *ibid*, p 31.
66 *ibid*, pp 31-32.
67 *ibid*, p 28.
68 C G Jung, *The Collected Works of C G Jung*, H Read, M Fordham and G Adler eds, Routledge, 1953-78, Vol 8, para 382.
69 *ibid*, para 270.
70 *ibid*, Vol 9, part 1, para 99.
71 Stevens, *op cit*, pp 40-41.
72 *ibid*, p 32.
73 *ibid*, p 41.
74 *ibid*.

Part Two

Plugging the Holes in Jung's Argument

Part Two

Introduction

Home? No, I'm afraid not, our enquiry is still incomplete. We can explain our response to the Lascaux Stag by reference to the collective unconscious but we haven't considered how it became collective; we can say that both we and Picasso have in our minds an archetype of a naked woman but we haven't considered the origins of such archetypes; we haven't, apart from the very obvious case of *Les Demoiselles d'Avignon*, attempted to find an archetype which underlies the IAC of a particular work of art and we have done nothing to explain man's enjoyment of nature. To complete our study we must provide answers to such questions and Jung's writings are the obvious place to look for them. Sadly, however, his ideas about the origins of archetypes and of the collective unconscious are no more seaworthy than was the *Titanic*. Perhaps I should explain why.

Jung, writing in the earlier part of the twentieth century, accepted the then current theory – known as Lamarckism after the Chevalier de Lamarck, an eminent naturalist of the late eighteenth-early nineteenth centuries who is often thought, erroneously, to have been its originator[1] – that characteristics acquired by individual experience could be passed on to subsequent generations. He declared that 'the collective unconscious is an image of the world that has taken aeons to form. In this image certain features, the archetypes or dominants, have crystallized out in the course of time',[2] and, after stating that 'there are as many archetypes as there are typical situations in life', he added that 'endless repetition has engraved these experiences into our psychic constitution'.[3] Today the application of genetics to Darwinian evolution has caused Lamarckism to be a biological

heresy and though Jung did, towards the end of his life, do something to correct this mistake — he made a clear distinction between the unconscious 'archetype-as-such', which is inherited, and the archetypal images which it gives rise to, which are the result of experience — neither he nor his disciples have attempted to match the theory of archetypes with accepted concepts of human evolution.

As for the collective unconscious, Jung asserted that it is 'the mighty deposit of ancestral experience accumulated over millions of years, the echo of prehistoric happenings to which each century adds an infinitesimally small amount of variation and differentiation'.[4] An unconvincing remark. I just don't see how everybody, a Congolese pygmy, a Saharan Arab, a Mongolian horseman, a Patagonian Indian as well as you and me, could be the recipient, century by century, of this infinitesimally small amount of variation and differentiation. There must be some other explanation.

Part Two is an attempt to answer these questions.

1 See in this connection Erasmus Darwin: *Zoonomia*, section 39, part 4, item 8.
2 Jung, *op cit*, Vol 7, para 151.
3 *ibid*, Vol 9, Part I, para 99.
4 *ibid*, Vol 8, p 376, para 729.

Chapter Four

A Definition and a Context

The Archetype, Some Definitions

We have noted Stevens' statement that 'an archetype…is an innate "centre" or "dominant" common to both the brain and the psyche, which has the capacity to initiate, influence and mediate the behavioural characteristics and typical experience of all human beings'. This, however is only one of several definitions which Jung and Stevens offer between them. In these circumstances, the student can do little more than record what the gurus have to say and, having done so, make up his own mind. With this warning let us begin with Jung himself.

JUNG'S CONCEPT

Jung makes it clear that the concept of the archetype is not new. Stevens quotes him as describing archetypes as 'active living dispositions, ideas in the Platonic sense'[1] adding that 'for Plato, "ideas" were mental forms which were superordinate to the objective world of phenomena. They were *collective* in the sense that they embody the *general* characteristics of groups of individuals rather than the specific characteristics of one. Thus a particular dog has qualities in common with all dogs (which enable us to classify him as a dog) as well as peculiarities of his own (which would enable his master to pick him out at a dog show)'.

Elsewhere Jung elaborated on this account declaring that

'archetypes are not determined as regards their content, but only as regards their form and then only to a very limited degree. A primordial image [i.e. an archetype] is determined as to its content only when it has become conscious and is therefore filled out with the material of conscious experience. Its form...might perhaps be compared to the axial system of a crystal, which, as it were, preforms the crystalline structure in the mother liquid, although it has no material existence of its own. This first appears according to the specific way in which the ions and molecules aggregate. The archetype in itself is empty and purely formal, nothing but a *facultas praeformandi*, a possibility of representation which is given *a priori*. The representations themselves are not inherited, only the forms, and in that respect they correspond in every way to the instincts, which are also determined in form only. The existence of the instincts can no more be proved than the existence of the archetypes, so long as they do not manifest themselves concretely. With regard to the definiteness of the form, our comparison with the crystal is illuminating inasmuch as the axial system determines only the stereometric structure but not the concrete form of the individual crystals. The only thing that remains constant is the axial system, or rather, the invariable geometric proportions underlying it. The same is true of the archetype. In principle, it can be named and has an invariable nucleus of meaning – but always in principle, never as regards concrete manifestation.'[2]

Elsewhere Jung summarises his argument in one sentence and an accompanying footnote:

The sentence: 'The archetype is essentially an unconscious content that is altered by becoming conscious and by being perceived, and it takes its colour from the individual consciousness in which it happens to appear.' And the footnote: 'One must, for the sake of accuracy, distinguish between "archetype" and "archetypal ideas". The archetype as such is a hypothetical and irrepresentable model, something like the "pattern of behaviour" in biology.'[3]

STEVENS' INTERPRETATIONS

In his discussion of Jung's Lamarckist tendencies, Stevens declares that 'the archetype-as-such (the *predisposition* to have a certain experience) which is inherited, not the experience itself',[4] elsewhere, in tracing a similarity between Jungian and ethological theory he tells us that it is 'the inherent neuropsychic system – the innate releasing mechanism – which is responsible for patterns of behaviour like the zigzag dance [of the male stickleback when he encounters a gravid female] or patterns of experience like falling in love' and in the following paragraph he quotes Jung as asserting that 'the archetype does not "denote an inherited idea, but rather an inherited mode of functioning"'.[5]

This is confusing; the archetype can hardly be at once an innate centre, a predisposition, a neuropsychic mechanism, a mode of functioning, an unconscious content and a hypothetical and irrepresentable model. How can we resolve these multiple definitions?

Only, I think, by suggesting that the archetype resembles religion, in that it is a profound concept whose interpretation varies according to the direction from which it is approached. If this is so we may, at the risk of behaving like Lewis Carroll's Humpty Dumpty, use whatever definition seems appropriate in a particular context. We, after all, approach it from the direction of aesthetics, Jung and Stevens approached it from the direction of psychotherapy.

Nevertheless it might help if we were to consider first whether there is any difference between Jung's 'unconscious content that is altered by becoming conscious and by being perceived' and his 'hypothetical and irrepresentable model' – I don't see any substantial difference between them so let's stick to the unconscious content – and secondly how Stevens' 'predisposition to have a certain experience' compares with Jung's concept.

Instincts apart I don't see how anybody can be predisposed to do something about which he is ignorant. If I am right – and I regard this statement as axiomatic – any predisposition must relate to an activity whose recollection lies in the individual's ego, in his personal unconscious or in his part of the collective unconscious. Thus my own predisposition to avoid stinging-nettles relates to the recollection in my ego of running into a nettlebed in my childhood, the housewife's predisposition to select Heinz'

baked beans rather than some other variety relates to the recollection, in her personal unconscious, of thousands of advertisements assuring her that Heinz' baked beans are better than any others, and the 'innate abilities and predispositions' to which Bouchard referred must relate to recollections which lie in the individual's part of the collective unconscious. Furthermore there is evidently a close correspondence between one of Bouchard's 'innate abilities and predispositions' and Stevens' inherited 'predisposition to have a certain experience'. And if, as we have seen, Bouchard's innate abilities and predispositions appear to be synonymous with Jung's archetypes the same must apply to Stevens' inherited predispositions. His definition is closer to Jung's than appears at first sight.

This being so we may choose, amongst those on offer, the Master's definition:

> 'The archetype is an unconscious content that is altered by becoming conscious and by being perceived, and it takes its colour from the individual consciousness in which it happens to appear'.

With this in our quiver we can go on to the next stage, a summary of current evolutionary theory.

Some Aspects of Evolution

We have all heard of natural selection, the survival of the fittest, but how does it work? We can't possibly answer this question in one section of a brief chapter but we may be able to mention some of the more important aspects of the subject, paying particular attention to those which seem to be germane to our enquiry. Perhaps we should start with the Book of Genesis.

CREATIONISM

It all began at 9.00 a.m. on 23rd October, 4004 BC. That was the conclusion of James Ussher, Archbishop of Armagh and James Lightfoot, the most learned Hebraist of his day who, between them, had set about calculating the date of the creation. They published their findings towards the end of the seventeenth century and it became the accepted doctrine for over a hundred and fifty years. Some people disagreed – thus the English geologist

Charles Lyell showed, by study of volcanic rocks and geological strata, that the earth had started well before the fifth millennium BC while the French naturalist, Buffon, Darwin's grandfather Erasmus and, most notably, another French naturalist Lamarck – whom we mentioned in the introduction – propounded evolutionary rather than creationist concepts. Creationism was, however, the accepted theory and Ussher's date was printed in the Authorised Version of the Bible until well into the nineteenth century.

THEORIES OF EVOLUTION: LAMARCK AND DARWIN

Lamarck, and, before him, Erasmus Darwin, held that these gradual evolutionary developments occurred as the result of the inheritance of acquired characteristics; that, as an example, the ancestors of today's giraffes stretched their necks out to nibble twigs from the tops of trees, that this caused their necks to lengthen and that this lengthening was passed on to their offspring generation by generation so that, after many generations, today's giraffes have long necks.

Darwin had a different, but related, idea. He noted that organisms sometimes vary, albeit by small amounts, from one generation to the next and that man exploits such variation to breed domestic animals that possess certain characteristics. Thus the tail of the fantail pigeon is the result of interference by fanciers who would mate a pair of pigeons with spreading tails, select from the fledglings the one with the most spreading tail, use it to breed the next generation and cull the rest. Darwin suggested that the same thing happened in nature. Malthus had shown that in each generation far more offspring are born than there is food and other resources to support them and that as a result only a small proportion of any generation lives long enough to procreate the next one. Darwin argued that the corollary to Malthus' discovery is that life is a struggle for survival and that organisms which survive the struggle are those which are genetically best able to adapt to the environment in which they live. Thus the proto-giraffes which survived long enough to procreate the next generation were those who, born with longer necks than their fellows, were able to eat leaves which were out of reach of the others. This happened, generation after generation until the proto-giraffes became the creatures whom we see today; able to browse off the tops of the stumpy, mushroom-shaped thorn trees which

are a typical feature of the East-African savannah. ('Environment' must here be understood to comprise not only physical environment – things like temperature, climate and soil, but also biological environment – associated organisms which serve as food, parasites or competitors – as well as social or cultural environment, most important in human welfare.)

He who can adapt may survive, he who can't won't.

HEREDITY: MENDEL

There was, however, a hole in Darwin's theory – a hole of which he was fully aware. The theory was based on the existence of genetic variation, but it did not include any account of how genetic variation came to pass. Nevertheless, independently and without Darwin's knowledge, the subject was beginning to be investigated.

The *Origin of Species* was published in 1859. Two years earlier the Austrian monk Gregor Mendel began crossing peas in the garden of his monastery at Brünn in what is now the Czech Republic. He chose peas for his experiments because they had clearly marked characteristics; some were tall, over six feet high, others dwarf, only about eighteen inches; in some the ripe seed is yellow, in others it is green; in some the seed is wrinkled, in others it is smooth. He tried to see what happened when strains were bred pure and when they were crossed.

He found that, when tall plants were crossed with tall plants, the offspring were tall and when dwarf plants were crossed with dwarfs the offspring were dwarf. He then crossed tall plants with dwarfs and found that tall ones were produced, but when he crossed these hybrids he found, astonishingly, that tall plants and dwarfs were produced in the ratio of three to one. He crossed the dwarfs with dwarfs and found that they bred pure over many generations, but when he did the same with the tall plants he found that one third of them bred pure while the other two thirds turned out to be like their hybrid parents giving three talls to one dwarf among their offspring.

The following diagram may make this clear; T stands for tall, D for dwarf:

```
Pure bred                    Pure bred
tall parents   T x D   dwarf parents
                 |
Hybrid       T  x  T       Hybrid
             |     |
      T      T     T       D
     Pure  Hybrid Hybrid  Pure
```

When he experimented with plants that had yellow and green seed and with those whose seed was smooth or wrinkled he found that the same occurred.

Mendel suggested that the pollen and the ovule each contained a particle, we now call such particles genes, which contained a code for the characteristics – height of plant, colour or smoothness of seed – of their offspring; that when the pollen fertilised the ovule the resulting seed had two such genes and that sometimes one of them masked the effect of the other. He called the masking gene 'dominant' and the masked gene 'recessive'.

His paper was published in an obscure journal, *The Transactions of the Brünn Natural History Society*, and though he sent it to the most eminent biologists of his day it was ignored. His findings were forgotten for thirty years, a period during which the problem of genetic variation remained in limbo.

THE FRUIT FLY

And then, in 1900, his work was rediscovered. In the following year a Dutch biologist, de Vries, tested Mendel's conclusions by applying them to evening primroses. He found, to his surprise, that now and then a new flower colour turned up within a pure line and that this colour was inherited. He called these random changes 'mutations'.

The study of mutations did, however, present difficulties; any such enquiry had to take place over many generations and this took time. Plants weren't much good for the purpose, most of them take a year from one sowing to the next, and mammals, even prolific ones like mice and rabbits, aren't that much better, man was the worst of the lot. What about insects? Here, an American, Thomas Hunt Morgan, had a stroke of luck; he tried

working with the fruit fly, *drosophila melanogaster*. It was easy to find, it could be bred by the thousand in milk bottles, it needed little space, it lived on simple foods, it had only four chromosomes – the sections of DNA on which genes are located – and, best of all, it was astonishingly prolific; a drosophila egg hatched, turned into an adult, mated and was itself producing eggs within ten days.

Drosophila provided the means by which Darwin's theory could be validated.

MUTATIONS

Morgan and his associates found that mutations vary greatly in their effects; many were detrimental, others were neutral, or almost neutral in their consequences, a few were beneficial, and some were useful in certain environments and harmful in others. Thus a mutation for a hooked nose might be beneficial in Israel, neutral in Britain and fatal in Hitler's Germany. In every case, however, any assessment of the usefulness or harmfulness of a genetic variation, i.e. on the probability of its effect on an organism's survival or the nature of its progeny, could only be made in the context of the organism's environment – a concept which involved not only the physical, social and biological aspects to which we have already referred but genetic ones also; a mutated gene may be useful when associated with some genes but harmful when associated with others.

The American geneticist, Theodosius Dobzhansky, summarised the relationship between mutation and natural selection in one sentence: 'The process of mutation supplies the genetic raw materials with which natural selection can operate',[6] to which he added: 'Selection fails to perpetuate the harmful mutants even though they are many; it perpetuates the neutral ones in proportion to their frequency and it multiplies the useful ones even though these are few.'[7]

Dobzhansky's book appeared in 1963. The next thirty years were a period of rapid development in genetics following upon Watson and Crick's discovery of DNA, the double helix, in 1953. The findings of these researches are complex and most of them hardly relate to our study. We should, however mention, very briefly, a few of them.

THE CONTINUITY OF GENES

A gene dies with the organism of which it formed a part. If, however, the organism has produced offspring the gene will have ensured its own continuity by providing, in this offspring, a replica of itself. This doesn't just happen once, genes go on from generation to generation forming such replicas at each stage. According to the English zoologist Richard Dawkins, 'They [the genes] are the replicators and we are their survival machines. When we have served our purpose we are cast aside. But genes are denizens of geological time: genes are forever.'[8]

GENE CO-OPERATION

Dawkins emphasises that genes do not operate on their own. 'However independent and free genes may be in their journey through the generations they are very much *not* free and independent agents in their control of embryonic development. They collaborate and interact in inextricably complex ways, both with each other and with their external environment. Expressions like "a gene for long legs" or "a gene for altruistic behaviour" are convenient figures of speech, but it is important to understand what they mean. There is no gene which single-handedly builds a leg, long or short,' to which he adds: 'Embryonic development is controlled by an interlocking web of relationships so complex that we had best not contemplate it. No one factor, genetic or environmental, can be considered as the single "cause" of any part of a baby. All parts of a baby have a near infinite number of antecedent causes, but a *difference* between one baby and another, for example a difference in length of leg, might easily be traced to one or a few simple antecedent differences, either in environment or in genes'.[9] But if no one factor, genetic or environmental, can be considered as the single 'cause' of any part of a baby individual genes do have specific effects; particular genes have been shown to be the cause of genetic diseases such as cystic fibrosis. Moreover, a single gene can appear in more than one form. Thus we all have a gene for eye colour but some of us have blue eyes, some brown, some hazel; these variations, known as alleles, are among the most important ingredients of Mendelian inheritance. There may be many alleles in a population – mankind has several different kinds of eye colour – but in any pairing there can only be two, one from the male and one from the female.

UNEXPECTED VARIATIONS

During the late 'sixties and early 'seventies new scientific techniques led to the discovery of huge and unexpected amounts of genetic variation, variation which could not be observed from visual observation of the drosophila flies which provided the material for study. There was so much of it that many geneticists, in particular the Japanese, Motoo Kimura, came to doubt whether natural selection could be involved in maintaining all the variation in the population. This led to the idea that most variations are the consequence of neutral mutations that are neither beneficial nor deleterious to the organism concerned and that due to chance their frequency may decrease until they are eliminated or fixed within the population. This, however, was only the tip of the iceberg; later studies revealed yet larger amounts of variation, both in the parts of the DNA double helix which carry genes and in those parts (so called junk DNA) which, apparently, do not.

GENETIC DRIFT

The chance element in Kimura's concept can be explained by the theory of 'genetic drift' (see diagram opposite). This is the idea that over several generations individuals who inherited a particular characteristic might happen, by accident, to survive while their siblings died young. Such chance fluctuations are particularly likely in small populations and, as we shall see, our ancestors were rare creatures living in small groups.[10]

These findings led to the establishment of two schools of geneticists, one, the 'neutralists', argued for considerable variation but caused by chance events rather than selection while the other, the 'selectionists', adhered to the original orthodoxy. As an ignoramus in genetics, I am happy to leave this debate to those concerned.

THE 'PURITY' OF HUMAN GENETICS

Genes are inconceivably small; according to the geneticist Steve Jones 'the size of a single gene in the whole length of DNA is that of an ant compared to Mount Everest and the job of finding it is not much easier'.[11] Nevertheless, difficult though it is, geneticists have found the genes for all the most important single-gene defects in humans. We might have expected

Generation

0
1
2
3
4
5
6
7
8

13 *A diagram showing genetic drift in a small population of birds.*

In every generation, each of the grey and white strains produces two identical offspring; half of them die in infancy and the size of the population remains constant. The deaths are, however, random and do not depend on the strain of the individuals concerned. After several generations, and quite by chance, the greys become extinct, leaving the whites as sole survivors.

that if they could manage that they would also have found the genes responsible for the '[roughly] two thirds of the reliable variance in measured personality traits' which, according to Bouchard, are innate. This, however, has not happened; Jones, writing in the early 'nineties, declared that reputable scientists 'hardly concern themselves' with the understanding of traits such as genius.[12]

The reasons for this non-involvement seem to have been, at least in part, historical. Human genetics originated in the late nineteenth century with the studies of Charles Darwin's cousin Francis Galton – a brilliant scientist in his own right – who proposed the theory of eugenics; the idea that the human race might be improved in the manner of plant and animal breeding. It was known that the hard-working, the intelligent and the prosperous had fewer children than the lazy, the stupid and the poor, a fact which suggested that ability was inborn rather than acquired and that evils such as alcoholism, criminality and poverty – as well as an inadequately defined feeble-mindedness – were the result of genetic inheritance.

The concept seemed reasonable and the idea took hold among intellectuals in Europe and America. Thus Churchill, one of Galton's followers, declared that 'the unnatural and increasingly rapid growth of the feeble-minded and insane classes constitutes a national and race danger that it is impossible to exaggerate. I feel that the source from which the stream of madness is fed should be cut off and sealed off before another year is past'.[13] Tragically, however, Hitler read about it when in prison after the abortive *bierkeller putsch* and it provided him with the rationale for the holocaust. Partly as a result, partly because of the laxity of its research and partly because – quite apart from Hitler – it was ethically dubious, eugenics became a dirty word during the second part of the century and human geneticists insisted, very properly, on the utmost rigour in the pursuit of their studies. It's easier to be rigorous when you study the genetics of a tangible affliction like Huntington's disease than when you study the (possible) genetics of a vague attribute like the use of non-linguistic modes of communication, and human geneticists tended to become, even more than the rest of us, enclosed in their own water-tight compartments.

Furthermore, genetic research is expensive. Finding the gene for cystic fibrosis cost a hundred and fifty million dollars and the human genome project – the map of every gene in the human DNA – was predicted to cost

about as much as a trident submarine. Now that it is complete, the finding of individual genes has become very much cheaper. Governments are, however, properly anxious to ensure that the sums involved in genetic research are devoted to plans which seem likely to offer benefits to human health rather than to imponderables like the inheritance of psychological attributes.

These matters are exemplified by *The Code of Codes*, a valuable American compendium, published in 1992, which considered molecular genetics, the human genome project and the social and ethical issues which they raise. Its contributors discussed the genetics of disease at length but hardly mentioned intelligence, let alone Bouchard's investigations.

GENES FOR INTELLIGENCE

Such self-denial could not last. Within five years of the publication of *The Code of Codes* a team led by the English geneticist, Robert Plomin, began to seek a gene which was related to differences in intelligence. The group knew that though most genes are the same for everyone a small proportion, about five to ten per cent, have alleles which, as with eye colour, cause individual differences. They argued, on the assumption that intelligence is the result of allele variation, that the allele-bearing genes of exceptionally bright people would differ from those of people whose intelligence is no more than average. They had reason to believe that a particular chromosome, known as 'chromosome 6', was a likely candidate for genes important in brain functioning so, to test their theory, they collected DNA samples from children with IQs of over 160 and compared them – as they applied to chromosome 6 – with samples from children with IQs of the average figure of 100.

They found that a particular gene, known as IGF2R, has several alleles one of which was found in thirty-three per cent of the super-bright children but in only seventeen per cent of those with an average IQ.

This was of course only a beginning. Intelligence, like the length of leg, must surely be the result of gene co-operation and it has been suggested that IGF2R's allele probably adds no more than four points to an individual's IQ. We may, however, be sure that more such findings will follow, and that despite Jones' remark it will not be long before reputable scientists begin to concern themselves with the understanding of traits such as genius.[14]

Perhaps some of them will proceed to investigate the genetic implications of Bouchard's discoveries.

※　※　※

This has been, necessarily, a very sketchy reconnaissance. I hope, however, that it will provide an adequate context for the next stage of our quest: an attempt to plug the holes in Jung's argument.

1 Stevens, Anthony, *Archetype, a Natural History of the Self*, Routledge, 1982, p 39, quoting *Jung's Collected Works*, Vol 8, para 154.

2 Jung, C J, *The Archetypes and the Collective Unconscious*, second edition, Routledge 1968, p 79-80.

3 *ibid*, p 5.

4 Anthony Stevens, *On Jung*, p 38. He explains that 'archetype-as-such', a depressing phrase if ever there was one, derives from Kant's *ding-an-sich*.

5 Stevens, *Archetype, a Natural History of the Self*, p 18.

6 Dobzhansky, Theodosius, *Mankind Evolving*, Yale University Press, 1962, pp 139-140

7 *ibid*, p139.

8 Dawkins, Richard. *The Selfish Gene,* Oxford University Press, 1989, p 35

9 *ibid*, p 37.

10 For accounts of genetic drift see Dawkins, *The Blind Watchmaker*, Penguin Books, 1991, pp 271, 303-4 and 312, Steve Jones, *The Language of the Genes*, HarperCollins, 1993, p 103, also Marion Hall and Tim Halliday eds, *Biology: Brain and Behaviour, Book 1, Behaviour and Evolution*, Open University, 1992, pp 85-86.

11 Steve Jones, *Genetics for Beginners*, Icon Books, 1993, p 113.

12 Steve Jones, *The Language of the Genes*, HarperCollins, 1993, p 2.

13 Jones, *Genetics for Beginners*, p 28. No reference is given.

14 For an account, comprehensible to a layman, of Plomin's researches see Geoffrey Miller and Rosalind Arden, *Natural Born Genius? The Search for the Genes of Intelligence*, Equinox, 1997 pp 13-15.

Chapter Five

The Evolution of the Human Mind with Jung's Archetypes and the Collective Unconscious

The Timescale of Human Evolution

It's difficult, unless you happen to be a geologist or an astronomer, to make sense of big numbers. One-hundred, two-hundred, three-hundred, four-hundred mean something to us all; after a hundred-thousand an extra nought at the end of a figure doesn't convey very much. What to most of us do the words 'a million' *signify*?

In my experience it helps to understand the implications of such numbers if we relate them to something which we know about. I remember being told, in a science lesson at school, that if we were to imagine the solar system as a pea – for the sun – and several grains of sand – for the planets – whirling around Piccadilly Circus the nearest star would be in the neighbourhood of Birmingham. I don't know whether the teacher got it right but he did give me a feeling for astronomical distance. Human evolution doesn't involve the kind of numbers that are the daily fare of the astronomers or the geologists but it does involve millions. Perhaps it would help if, following my school teacher, I were to offer a few examples. Here are four:

There are one million millimetres in a kilometre.

There are 2,419,200 – say two and a half million – seconds in four weeks.

There are 525,600 – something over half a million – minutes in a year.

At the millennium there were 730,483 – roughly three quarters of a million – days in the Christian era.

I hope this helps. With it under our belts, we can consider, very briefly,

how man evolved. It may help to relate the following account to the chronology on the facing page though I must emphasis that it is uncertain as well as being simplified: the fossils upon which paleoanthropologists base their conclusions are rare objects and different authorities interpret them differently.[1]. You will note that I have shown the different species in separate boxes. This is for ease of reading, not because there was a time-gap between them. In fact they must have overlapped though probably not by very much. Our ancestors were rare creatures and a genetic mutation would have passed quickly – in geological terms – through the population.

Heaven knows where and when the story started but for our purposes we can begin in equatorial Africa about ten million years ago. At that time, the climate started to dry out, the temperature to fall and the forests to retreat. The apes, less able than the monkeys to cope with this environmental change, succumbed – or most of them did. The survivors included the ancestors of today's gorillas, orang-utans and, most significantly for our story, chimpanzees. Then, about four and a half million years ago, one group – scientists call the creatures *Ardepithecus Ramidus* (ardepithecus, ground ape; ramidus, root) – split off from the chimps and began to walk upright and to exploit the habitat of patchy woods and clearings which bordered the forests. In so doing, they started the line which led, ultimately, to ourselves. They weren't numerous and mortality must have been very high. It was touch and go between extinction and survival.

Ramidus seems to have been around at the time of a momentous change in the geology of East Africa. This was a bout of volcanism and mountain building along the line of the Rift Valley, that extraordinary geographical feature that runs through Ethiopia, Kenya and Tanzania to Mozambique. This change led to alterations in climate and vegetation; to the west the monkey's and chimpanzee's habitat of the rain forests continued, while, to the drier east, the landscape became one of woodlands, forest grasslands and savannah, the kind of thing which ramidus had found at the edge of the jungle. At the same time, the Rift Valley became the site of lakes and great rivers whose shores and sandbars provided the habitat for our next ancestor, *Australopithecus Anamensis*.

The australopithecenes didn't have anything to do with Australia. They were so called – the word means 'southern ape' – because his fossils, those of a later branch of the family, were first found in South Africa. Anamensis

A Simplified Chronology of Hominid Succession

Millions of Years Ago	Hominid Type	Characteristics or Events
		Mountain building adjoining the rift valley.
4.5	Ardepithecus ramidus	The hominid and chimpanzee lines divide. Ramidus emerges from the forest, begins to walk upright and to exploit the habitat on its margins.
4	Australopithecus anamensis	Erect posture, thus freeing arms and hands for manipulative activities.
3.5 – 3	Australopithecus afarensis	Long arms and short legs like an ape's but hipbones more like those of a modern human.
2.5	Australopithecus africanus	Differed from Afarensis in certain details, walked but could not stride or run.
2	Homo habilis	As Africanus but with crude stone-cutting tools, variable but larger brain size. *Robust australopithecines: heavy jawed creatures.*
1.5 – 1	Homo erectus	Larger brain, more elaborate tools, use of fire. Emerges from Africa, going as far as Java, China and later Europe.
0.5 / 0.4 / 0.3 / 0.2 / 0.1 / 0.0	Homo heidelbergensis / Homo sapiens	Much larger brain. *Neanderthalers: Europe and western Asia, stocky, athletic, brain slightly larger than ours.* Emerges from Africa, spreads worldwide, develops creativity.

Boxes which refer to 'dead end' species are shown with a broken line and are named and described in italics outside the box.

was clearly an ape, but he had one very un-apelike characteristic. He walked. And walking – by freeing the upper limbs to become manipulative arms and hands instead of propulsive legs and feet – gave him profound evolutionary potential. The australopithecenes were not like us, their brains were relatively small and they didn't use tools to make tools, but their bipedalism put them firmly on the evolutionary road. Without it, their descendants couldn't have become human.

Anamensis disappears from the record about four million years ago. His successor, and possible descendant, *Australopithecus Afarensis* was in many ways similar to anamensis though he was probably smaller. He lasted until about 2.9 million years ago when he was succeeded by Australopithecus Africanus – the one whose fossil gave the tribe its name.

Africanus' lifestyle was probably analogous to that of today's savannah baboons; living in troops of up to a hundred individuals in a habitat of patchy, open woodland with some high forest, sleeping in trees or on cliff ledges, feeding on grubs, shoots, fruits and bird's eggs with an occasional young monkey or antelope. Like us, he walked but, unlike us, he couldn't cope with long-distance striding or running.

And then, about two and a half million years ago, the lineage divided once more; three kinds of 'robust' australopithecines with thick jaws and big back teeth split off from the trunk of light-limbed 'gracile' hominids which led to ourselves and a new creature, *Homo Habilis* 'handy man', arrived. Habilis had a bigger brain than the australopithecines (it varied between 500 and 800 mls in volume against afarensis' 350-500 mls), he chipped stones to make crude tools and he perfected the australopithecine's walking ability to include running.

By one and three quarter million years ago, several different varieties of hominid seem to have existed simultaneously, each occupying a different ecological niche. There were the robust australopithecines, two kinds of habilines, one small and one large, and, the most advanced of the line, *Homo Erectus*. After a few hundred thousand years, the others had died out, leaving erectus as the only hominid. And erectus certainly makes a convincing human.

His convincingly human characteristics included a larger brain than habilis' (700-800 mls against habilis' 600-800), the ability to make more elaborate stone tools than habilis could achieve, more meat in the diet,

efficient social organisation and an ideal physique for long distance walking, (some hand-axes found in Olduvai in Tanzania were made up of lavas brought from as much as twenty kilometres away). In addition he seems to have harnessed fire (he didn't have to create it, fires occur spontaneously in nature) and he was certainly the first intercontinental traveller in our lineage. He not only spread around Africa but reached Java, Spain and China where he seems to have survived until quarter of a million years ago; long after he was replaced, in Africa and Europe, by the next in the series. This was *Homo Heidelbergensis* who arrived on the scene about 400,000 years ago. Heidelbergensis was the half-way house between erectus and modern *sapiens*, his brain size approached our own (we have an average of about 1300 mls, his was 1100-1400), his braincase was more like ours and he was the ancestor both of ourselves and of the ice age *Neanderthalers*, people whose lineage began to differentiate from heidelbergensis' about 150,000 years ago.

The neanderthalers were heavy-boned, stocky, athletic, beetle-browed people, physically adapted to the cold, with brains slightly larger than our own who lived in Europe and the Near East – their remains have been found as far west as Wales and as far east as Uzbekistan. They had campsites with communal fires where they remained all the year round. They were hunters, but only brought home large pieces of their quarry – when they caught small animals like rabbits or foxes they ate them in the field. They seem to have survived, though latterly only in isolated pockets in western Europe, until about 30,000 years ago. They overlapped with, and were gradually superseded by, the lighter, more mobile, more socially cohesive *Homo Sapiens*; people who had originated in Africa about 130,000 years ago whence they emerged, about 90,000 years ago, to take over the world.

And they were modern humans, the people who achieved, between about 30,000 and about 15,000 years ago, the cave paintings of France and Spain, about 10,000 years ago the neolithic revolution, about 5,000 years ago the first civilisation, the Sumerian, and 50 years ago the atomic bomb.

It is, by any standards, an extraordinary story. Furthermore, it has, to me at least, four particularly remarkable aspects. Let us take them in turn.

The first is the small part played by homo sapiens – 130,000 years out of 4,500,000 – 2.89 per cent; and it is only a little under 5.5 per cent if we start with homo habilis instead of ardepithecus ramidus. Moreover, if we look

at the history of homo sapiens the proportions become even more remarkable. The neolithic revolution took place about 10,000 years ago and the first civilisation, the Sumerian, about 5,000, so 4,490,000 years out of 5,000,000 – 99.78 per cent of human and hominid history – occurred before the neolithic revolution and 99.89 per cent before the beginning of civilisation. (If you jib at starting with ramidus the figures from habilis onwards are 99.6 for the neolithic revolution and 99.8 for the beginning of civilisation.)

The second, hardly less surprising, aspect of the story is the growth of the brain. For two million years it remained small: then in the next two and a half million years – a short period in evolutionary terms, it tripled in size from the australopithecine's volume of about 400 mls to our own of 1300 mls. Furthermore the speed of growth was not even. It remained fairly constant until the appearance of heidelbergensis when it took off, almost doubling its size in half a million years, a change which, according to the psychologist/primatologist/paleoanthropologist Robin Dunbar[2] coincided with an increase in meat eating, an event which was, he suggests, linked to the beginnings of organised hunting. Moreover the growth consisted, not of an increase in the size of the brain as a whole, but of one of its parts, the neocortex, a thin layer of neural tissue, about three millimetres deep, which surrounds the inner mammalian brain and which is the place where conscious thought takes place.[3]

So with heidelbergensis mankind began to think – no doubt seriously, perhaps even humorously.

The third, even more astonishing aspect, is homo sapiens' emergence from Africa. At first scientists thought that the emergence took the form of a slow trickle spread over several hundred, perhaps several thousand, years. This, however, has been shown to be wrong. The paleoanthropologist, Chris Stringer and his colleague, the scientific journalist, Robin McKie describe, in this connection, the findings of Professor Ken Kidd and Sarah Tishkoff of Yale University's Department of Genetics. Kidd and Tishkoff found that the bases – they are known as CTTTT – along a tiny section of the DNA sequence possessed by people living in sub-Saharan Africa vary considerably while the bases along a similar section possessed by everyone else are consistent. 'Africa shows complete variability. The rest of the world does not. And there is only one feasible explanation: that the small wave of

settlers who set off from their African home to conquer the world was made up of a tribe or group of African *Homo sapiens*...[who] carried this combination out to the world 100,000 years ago, and now scientists have picked up its signal like a discarded calling card'.[4] Stringer and McKie go on to quote Professor Kidd:

> 'This says one thing. It says [that] the rest of the world was peopled from one sub-set of Africans...It also says that only one wave of these people was responsible. And thirdly it allows us to put a fairly accurate date on that emigration: around 90,000 years ago.'[5]

Kidd and Tishkoff didn't calculate the probable size of the sub-set of Africans. I have, however, found two pieces of evidence to fill this gap; one is offered by the British geneticists Shahin Rouhani and Steve Jones in a contribution to the *Cambridge Encyclopaedia of Human Evolution*, the other appears in Dunbar's *Grooming, Gossip and the Evolution of Language*. Rouhani and Jones consider that, subject to reasonable assumptions, the first emigrant population may have consisted of 'say six breeding individuals for seventy years (although a less marked bottleneck for a longer period would also produce the same results). Given that only adult humans are reproductively active and some may have had more than one mate at a time this corresponds to an actual population size of about fifty individuals...an astonishingly small number to be the ancestors of all non-African humans'.[6] Dunbar, in another context, gives us a possible figure. He shows[7] that among primates there is a correlation between the size of the animal's neocortex and the size of its social group. Humans are primates and the size of the human neocortex should, in accordance with the correlation, accord with a social group of about 150, a figure that matches the social groups to be found in a wide range of cultures. Dunbar mentions the hunter-gatherer tribes who inhabit the deserts of southern Africa and Australia as well as the forests of South America, the earliest near-eastern farmers, the modern horticulturists of Indonesia and the Philippines, the Hutterites (a fundamentalist Christian sect who live in communes) of Dakota and southern Canada, the Mormons on their trek from Illinois to Utah, business organisations, the 'companies' to be found in many armies, and

the ideal size for a Church of England congregation. Dunbar summarises his findings as follows: 'The figure of 150 seems to represent the maximum number of individuals with whom we can have a genuinely social relationship, the kind of relationship which goes with knowing who they are and how they relate to us'.[8] (For fun, I checked Dunbar's conclusions against my own Christmas-card list. There were about eighty names but when I allowed for couples and children I had, honestly, 149 individuals.)

Kidd's sub-set of Africans from whom the rest of the world was peopled must surely have constituted such a social group. They were hunter-gatherers like the tribesmen of the Kalahari desert or the Amazon jungle, they could hardly have operated effectively with substantially more or less than Dunbar's number of 150 – less would have been inadequate and more would have required a hierarchy of command – and 150 is not impossibly far from Rouhani and Jones' minimum of fifty individuals.

Does all this boggle your mind? It certainly boggles mine.

(To which I should add that some authorities consider that the emergence from Africa didn't happen at all and that modern humans developed independently in different parts of the populated world during the past million years, a scenario which Kidd politely described as posing 'some serious problems'. To which he added: 'If I were being truthfully blunt, however, I would have to say that our work blows the theory right out of the water. It is utterly incompatible with the facts that we have discovered.')[9]

And the fourth, surely the most remarkable aspect of this evolutionary story, was the explosion of creativity, expressed initially in cave painting, then in neolithic agriculture, then in civilisation, and finally in industrial technology. An exponential development whose control constitutes the greatest challenge to human and hominid survival since ramidus emerged from the forests.

This brief summary is based on the accounts of paleoanthropologists. They like hard facts – literally hard, things like fossil skulls or stone tools – and their discoveries have been chiefly concerned with the physical aspects of hominid history. During the last decade some of them, employing the techniques of linguists, geneticists and primatologists, have extended their field of enquiry but for the most part they have paid relatively little attention to the evolution of the human psyche; perhaps they regarded it as too intangible a topic for rigorous investigation. Others were, however, working

in this field. During the 'eighties and 'nineties a group of social scientists, disenchanted with the Lockeian 'empty cabinet', which was the standard model of the human mind among their professional colleagues, began to apply natural selection to the evolution of the human mind as the paleoanthropologists had applied it to the evolution of the human skeleton. It wasn't easy, there weren't any fossil minds to be unearthed, but by 1983 enough had been done for two Harvard sociobiologists Charles J Lumsden and Edward O Wilson to propound a theory of 'gene-culture co-evolution' according to which human evolution was the result of two interacting processes, one biological and the other cultural:– 'Culture is created and shaped by biological processes while the biological processes are simultaneously altered in response to cultural change',[10] for their west coast compatriots Jerome H Barkow, Leda Cosmides and John Tooby to edit, ten years later, *The Adapted Mind*, a book to which we have already referred. This was a compendium of eighteen essays on different aspects of 'the complex, evolved psychological mechanisms that generate human behavior and culture',[11] and for their compatriot, the anthropologist William F Allman, to declare soon afterwards that 'evolution carved the human brain into a collection of specialized mental mechanisms that helped our ancestors meet the challenges of their everyday lives, whether it was finding food, finding shelter or escaping from predators'.[12]

Allman's analysis offers us a possible lead. If we can define these intelligences and show that Brown's universals derived from them, we might be able to relate Jung's ideas about the origins of archetypes to the conclusions of the evolutionary psychologists. We should realise, however, that any discussion of these matters is necessarily speculative and that such speculation, conducted by a layman, is bound to be suspect. This hardly worries me – in my eighties I'm too old to mind such comments – but I thought I should warn you before we proceed.

The Pre-requisites of Hominid Survival

We noted, in the last section, that ramidus' mortality must have been very high. He was surely slower and less agile than the chimps and he was in any case weak and, without either sharp claws or large teeth, defenceless. How did he and his successors manage to avoid predation?

Dunbar declares[13] that they did so by being relatively large and by living in groups. He points out that a predator cannot easily handle a prey animal that is significantly larger than itself and that a group of prey animals is more defensible than a loner; it has more eyes than a loner with which to detect stalking predators, its numbers, running in all directions, create confusion in an attacker and collectively the group may launch a counter-attack. 'Think of it in human terms. Being handbagged by one granny would not put off the average mugger, but even the most determined thug will balk at being handbagged by twenty grannies simultaneously.'

I'm sure he's right but I fancy that there is more to it than that. I suggest, following Darwin, that ramidus and his descendants survived because they possessed one or more innate, and hence genetically derived, capacities that enabled them to adapt to their environment. These capacities must have been psychological – man came to dominate because he was cleverer than other animals, not because he was stronger – and must therefore have originated in cells in the brain. The capacities may be subsumed under the heading of intelligence, a concept that sounds reasonable until, attempting to define it, we enter a maze.

The obvious place to search for a definition is the *Oxford Companion to the Mind*. Following several pages of discussion of the subject, the section on intelligence concludes with a contribution entitled 'The Art of Good Guesswork' by Horace B Barlow. He declares that the nature of intelligence 'can be rather satisfactorily defined simply be stating its goal, namely guessing right'.[14] Initially this appears to lead to a circular argument. The goal, in the context of our enquiry, can only mean 'whatever might enable them to adapt to their environment'. If ramidus and his descendants survived because they had the ability to guess right about whatever might enable them to adapt to their environment we are back to where we started. If, however, we think in more specific terms Barlow's definition begins to make sense; we all know of people who can guess right about some things but are off-beam about others.

What sort of things did our ancestors need to guess right about in order to adapt to their environment and so to survive?

I suggest that, apart from instincts and Dunbar's group-living, their 'survival intelligence' must have included awareness – so that they could

watch for food, water, mates or predators and recognise a secure vantage-point – together with the abilities to use tools and to communicate with their fellows. I call these 'the three capacities'; we may reasonably suggest that they correspond with Allman's specialised mental mechanisms. Let us take them in turn.

AWARENESS

Awareness is almost as elusive a concept as intelligence; as soon as we attempt to discuss it, we find ourselves in a philosophical quagmire, for example:

Me	I know that I'm aware but what about you?
You	Of course I'm aware.
Me	Prove it.
You	I just am, I know I am. You prove that you are.
Me	So, you can't prove it.
You	You can't prove it either.
Both of us together	You're just a bloody solipsist!

We could go on like this for hours but to do so would surely be a waste of time; it seems better to assume that all mankind is aware and seek a specialist's definition of the word. The American ethologist, Donald R Griffin offers the idea that awareness is 'the whole set of interrelated mental images of the flow of events; they may be close at hand in time and space, like a toothache, or enormously remote as in the astronomer's concept of stellar evolution'.[15]

This sounds reasonable but does what he says apply to our hominid ancestors? This seems doubtful; if I can't be sure that you are aware and you can't be sure that I am how can we both be sure that ramidus was? Perhaps we should begin by considering awareness in animals. What about dogs? They seem to be aware.

Millie, my spaniel, is too damned aware. She is aware of her name, of when it is time to get up, time for her breakfast bonio, time for her walk, time for her after lunch tit-bit, time for me to throw a toy for her, time for her supper, time for me to scratch her tummy, time for her goodnight snack. Above all, she is aware of the presence of a cat in the garden. I am in thrall

to Millie's s awareness. You may argue that a dog is exceptional, but other animals display awareness in other ways; a tern, returning from a foraging expedition with food for its chicks must be aware, on a beach crowded with nesting sites, of the position of its own nest; a honey-bee, seeing the waggle-dance of a fellow worker, must be aware of its meaning; that there is food to be found in a certain direction and at a certain distance. A bird, feigning injury to distract a predator from a fledgling, must be aware of the danger to its offspring and of the possible effect of its action. Awareness may vary in kind or degree from one species, genus or phylum to another, but Griffin is surely correct in declaring '…it seems more likely than not that mental experiences, like many other characters, are widespread, at least among multi-cellular animals, but differ greatly in nature and complexity'.[16] And if awareness is 'the whole set of interrelated mental images of the flow of events' this must also be true of awareness.

So we share awareness with animals, and if with animals presumably with ramidus, but is awareness innate? Surely it must be, think of Bouchard's findings; and if so it can only be an evolutionary inheritance. Here Griffin didn't quite commit himself though he was evidently sure that it is – he wrote during the heyday of belief in the standard social science model and his book is essentially a defence of his ideas against the behaviourism of his professional colleagues – he suggests that, 'The better an animal understands its physical, biological and social environment' – we might say the more aware it is – 'the better it can adjust its behavior to accomplish whatever goals may be important in its life, *including those which contribute to its evolutionary fitness.*' (my italics)[17]

And what goals would our ancestors have needed to accomplish in order to achieve evolutionary fitness? We have already specified them: the finding of food, water or mates, together with the recognition of predators and of secure vantage-points. Had ramidus, anamensiss and the rest not achieved them we should not be here.

TOOLS

When, years ago, I first dabbled in paleoanthropology I read a book in which the author suggested that the essential characteristic of man – as against his ape-like ancestors – was his ability to use tools. She would not have said this had she been writing today. We now know that African

vultures use stones to smash ostrich eggs, that Galapagos finches use sticks to probe into bark for insects, that sea otters carry stone anvils upon which they break open shellfish and that chimpanzees not only use tools but even make them. Thus they crack open palm nuts by hammering them with stones on wooden anvils, they use crushed leaves as sponges to mop up water, they use whole leaves as we use toilet paper, to clean themselves and their infants, and they use sticks to fish for termites. This is quite a complex process; a chimp will begin by selecting a suitable stick on the basis of its width, strength and length, he will modify it by stripping its leaves, he will push it into a hole in a termite mound and pull it out again, hopefully covered in termites and he will then put the termite-laden stick between his lips and suck off the insects – ooh, delicious!

Probably ramidus did the same kind of thing, perhaps in greater variety, but there is no direct evidence. Stones which have been used for crushing bones or cracking nuts are indistinguishable from stones which haven't been so used while leaf-sponges and sticks for termite-fishing are certainly artefacts – products of workmanship as against natural objects – but they don't last and we can have no idea what the tools used by the early hominids were like if indeed they existed. It is, nevertheless, fun to speculate. What about this?

The zoologist Colin Tudge suggests[18] that the earliest australopithecines lived a double life, half in trees and half out of them, sleeping, like today's chimps and gorillas, on platforms in the branches, emerging to feed on the ground, dashing across clearings to escape the many dangers, and in pursuit of prey and keeping an eye open for predators. 'Thus we may envisage Lucy [the name given to a three-and-a-quarter-million-year-old fossil skeleton of australopithecus afarenis] and her tribe standing upright in the boughs on the edge of a copse, holding for balance a branch above, in a good, safe, all-seeing position – highly reminiscent of a watchful meerkat.' 'Holding for balance a branch above.' It doesn't seem too fanciful to suggest that a million-and-three-quarter years earlier one of Lucy's amamensis ancestors, emerging from the forest, staggering around on two legs instead of four, used a stick both to help him balance – I've done this, walking among mountains – and occasionally as a club with which to attack small prey or knock fruit from the branch of a tree.

An innate capacity to conceive, devise and use such a tool would have helped him to adapt to his new environment and so to survive.

COMMUNICATION

We all know that animals communicate; birds sing, dogs pee on lamp-posts, bees dance. According to the American linguist Steven Pinker: 'Non-human communication systems are based on one of three designs: a finite repertory of calls, (one for warnings of predators, one for claims to territory, and so on), a continuous analogue signal that registers the magnitude of some state (the livelier the dance of the bee the richer the food source that it is telling its hive-mates about), or a series of random variations on a theme (a birdsong repeated with a new twist each time)'.[19] Dunbar tells us that primates go further: 'Primate communication is much more complicated than anyone had previously imagined. Vervets, for example, clearly distinguish between different types of predators and use different calls to identify them. They distinguish ground predators like leopards from aerial predators like eagles, and both of these from creepy-crawlies like snakes. Each type of predator elicits a different type of call.' He goes on to describe a particular example: 'All the information they needed to identify the type of predator was contained in the sound itself – just as all the information you need to identify a leopard is contained in the sound "leopard", but not in the sounds "watch out" or "help"'.[20] He goes on to describe the reactions of young female gelada baboons to the appearance of a new baby: 'When a female gives birth, the new baby becomes a subject of fascination to the other young females in the group, especially those just past puberty who have not yet given birth themselves. When one of these young females approaches an older sister, or her mother, who has a new baby, the excitement in her voice is palpable. Her contact calls race up and down the vocal scale like an excited child's, the words tumbling over themselves as they pour out in a confused torrent. The emotional overtones are clear...but this is more than simply mindless gibbering: here is real communication of the excitement of the moment.'[21]

Studies of communication among chimpanzees have, by contrast been disappointing. They have typically taken place among captive animals – brought up with infants in human families or trained in the laboratories of psychologists rather than among wild chimps observed in the jungle – and have consisted of attempts to teach them language, initially spoken, later in the form of a code. There is no need to describe the experiments here, the

literature is extensive and Dunbar and Pinker both give accounts of it.[22] We may, however, record Dunbar's conclusion: 'I think it fair to say [that] this research has convincingly demonstrated that chimps understand several important concepts, including numbers, how to add and subtract, the nature of basic relations (such as "is bigger than", "is the same as" and "is on top of"), how to ask for specific objects (mostly foods) or activities (a walk in the woods or a game of chase), and how to carry out complex instructions ("take the can from the fridge and put it in the next room")...However despite all the effort devoted over the past three decades to training apes to use language, none of them has progressed convincingly beyond the simple two and three word sentences typical of two-year old human children...Even in contrast with the fluent witterings of the gelada's contact calling the conversational skills of language-trained apes seem stilted and laboured. Chimps may, at best, have a foot on the language ladder, but it is not all that we might have expected of an ape standing on the very threshold of humanity.'

The researchers were American social scientists and their activities can be seen as aspects of the then fashionable theories of behaviourism and the standard social science model. I, who do not share these ideas, am surprised, not that the conversational skills of language-trained apes seem stilted and laboured, but rather that in the circumstances they had any conversational skills at all. Imagine the effect on a baby chimp of being taken away soon after birth from its mother and its siblings and at being brought up, perhaps alone, by a different animal in an alien environment and at having, under these conditions, to learn an outlandish means of communication.

I hope you agree that we need not share the social scientists' disappointment. We are concerned not with the possible linguistic abilities of chimpanzees but with whether there is sufficient evidence to convince us that the innate communication capacities which ramidus must, as a primate, have possessed were sufficient to have contributed significantly to his survival. To me the answer is 'almost certainly yes'. I cannot see how the calls uttered by vervet monkeys to warn about the presence of different kinds of predator, the excited witterings of young female gelada baboons on encountering a new baby, the positive response of a chimp to a request that he take a can from the fridge and put it in the next room, can be anything but expressions of innate communication capacities possessed by the

creatures concerned. These are capacities, in the case of the vervets to deliver and to receive an important communication, in the case of the baboons to express an emotion and in the case of the chimp, to receive and act upon – though not to deliver – a quite complex instruction even though it was expressed in a medium which was alien to that of his forbears (which doesn't mean that he couldn't have received, acted upon or delivered an even more complex instruction had the medium been that of his normal lifestyle). I can see no reason why ramidus – almost certainly more intelligent than the vervets or the baboons and probably at least on a par with the chimps – should not have had similar capacities. If so these capacities would have helped cement the bonds which held their social groups together, thus contributing to their ability to adapt to the environment of the East African savannah.

COGNITION

I have, for reasons of clarity, considered Dunbar's group-living and my own three capacities separately but they were frequently connected. We have already suggested that communication would have helped to cement the bonds that united ramidus' social groups, while awareness is axiomatically a prerequisite of tool usage – you can't use a tool without being aware of what it's for, of Dunbar's group-living – no creature can live in a group without being aware of its fellow-members, of memory – you can't remember something of which you have never been, consciously or unconsciously, aware and of communication – you can't just communicate, you can only communicate *with* somebody *about* something, the one involves awareness of one's fellows, the other awareness of one's environment.

Intertwined, these factors, together with the instincts, constitute cognition, defined in *The Oxford Companion to the Mind* as 'the use or handling of knowledge'. It is surely self-evident that this is something which the primates, and I'm sure others also, possess. Thus a chimpanzee can't use a stick to fish for termites without using the knowledge that they are good to eat and that they live in mounds – both matters of memory and hence of awareness – and that a stick can be used to extract them – a matter of tool usage. Furthermore, according to the archaeologist Steven Mithen, 'the intensity of social life among chimpanzee groups is...essential for

maintaining the tool use traditions'[23] so social awareness comes in as well. Only language is missing and we have seen that according to Dunbar primate communication is much more complicated than anyone had previously imagined so perhaps communication, though of course not spoken language, is also involved. All distinct but, like the strands of a rope, intertwined.

We may conclude that ramidus' survival was due not only to the three capacities acting independently but also to a cognitive capacity that could, in different ways and under different circumstances, bind them together; and that all were developed from capacities possessed by his primate ancestors. His survival was, as we have seen, a touch and go affair. Without these capacities he would have been extinct after a few generations.[24]

The Three Capacities, Cognition and Genetic Theory together with the Collective Unconscious and its Archetypes

Group-living and the three capacities, complex enough in themselves, became far more complex with the evolution of mankind; groups grew to their maximum size commensurate with effective communication among their members, communication developed into language, tool usage evolved into tool making, awareness proliferated – imagine all the dangers, problems and opportunities of which homo erectus had to be aware in order to be able to walk from Africa to China – while later thought, chiefly language based, provided homo sapiens with a far greater cognitive capacity than that possessed by ramidus – a development which Toynbee, who called it 'the dawn of consciousness in the biosphere', considered to be 'the most momentous event to date in human history'.[25]

These matters, together with belief in the supernatural and their relationship with genetic theory, are what this section is about. Let's start with awareness.

AWARENESS

When we discussed awareness in the last section we quoted Griffin's definition: 'the whole set of interrelated mental images of the flow of events; they may be close at hand in time and space, like a toothache, or enormously remote as in the astronomer's concept of stellar evolution'. Griffin

didn't say so but awareness can't, axiomatically, exist on its own. It requires a subject, an individual or group of individuals who are aware, and an object, some constituent of 'the whole set of interrelated mental images of the flow of events'. Furthermore, this constituent must, on the face of it, take one of three forms: the individual's (let's say the person is male and confine it to him, the grammar gets complicated if we have to worry about gender and bring in the group all the time) awareness of his fellows, of his environment and of himself. We may dub the first 'social-awareness', the second 'environmental-awareness' and the third 'self-awareness'. It is surely axiomatic that social awareness is a pre-condition of group-living – you can't live in a group unless you are aware of your fellow members – that self-awareness involves, among other things, memory – I can remember things which lie in my own mind, I can't remember things which lie in yours – and that environmental awareness is a matter of sensory experience – we *see* the blue of the sky, we *smell* the scent of a rose, we *feel* the warmth of the sun, we *taste* the sweetness of honey, we *hear* the sound of thunder.

I say 'on the face of it' because the three kinds of awareness are not discrete. A man's awareness of his colleagues, of his children, of his beloved, is different in kind from his awareness of trees, of wine, of bird-song, but all six are part of his environment and his social-awareness derives, like his environmental-awareness from his sensory experiences. Moreover neither is a matter of sensory experience alone. Thus seeing, one of the senses, is, by itself, meaningless; no more than the receipt in the brain of a set of images of unrelated shapes and colours. Add memory and the arrangement of shapes and colours begin to make sense – a process that is exemplified by the accompanying diagram.

14 Seeing and perceiving.

Memory enables us to perceive what we see; and memory is, as we have shown, an aspect of self-awareness.[26]

All three kinds of awareness, though different, are linked.

There is another point that should be mentioned in our discussion of awareness:

We noted in the last chapter that according to Dunbar our ancestors survived because they were relatively large and lived in groups. We have, however, shown that group-living is an aspect of social-awareness, that social-awareness is an aspect of what we may call general-awareness and that general-awareness was one of the three capacities which, by our analysis enabled ramidus and his successors to obtain food, find mates and avoid predation. We may conclude that group-living, though certainly critical for man's survival was not at the top of the hierarchy of his 'survival capacities'. In these circumstances, I can see no need to pursue it as an aspect of hominid survival. Nevertheless it was, as we shall see, fundamental to the development of language, the topic of our next sub-section.

LANGUAGE

We concluded earlier that ramidus possessed innate communication capacities that were at least on a par with those of the vervets, the baboons and the chimps. How did this communication capacity develop among ramidus' successors? In particular how did it relate to mankind's faculty of language?

The conventional view about the origin of language is that there was no relationship. Language was thought to have developed late in man's history as a means by which the members of a hunting group were enabled to co-ordinate their activities. Dunbar offers another and to me a more convincing theory; he suggests that language developed much earlier and as a social glue, a means by which the members of a hominid group were held together.

Initially this was provided by the practice of grooming. Dunbar points out that some of the primates spend up to twenty per cent of their time grooming each other, an activity whose purpose is both hygienic and an expression of friendship and loyalty. Thus studies of vervet monkeys in the wild have demonstrated that a 'grooming partner is something special, who should be supported in moments of need, on whose behalf the taking of risks is warranted';[27] while female gelada baboons 'are very selec-

tive about those that they groom and those that they support in altercations…They are clearly well aware of those they owe loyalty to and they don't have to have groomed with them half an hour beforehand to know it.'[28] And, no less significantly, this activity isn't universal among primates: it occurs particularly among species such as macaques, baboons and chimpanzees that live in relatively large groups.

Dunbar goes on to suggest that danger from predators and the need to enlarge foraging areas led ramidus and his successors to form larger groups than those of their primate cousins, groups which were too large to be held together by physical grooming alone, and that what he calls 'vocal grooming' – grooming at a distance that developed from the conventional contact calls that are characteristic of the more advanced monkeys and apes – began to supplement physical grooming as a bonding mechanism, a process that would have begun with the appearance of homo erectus. Eventually the steady increase in group size made physical grooming impractical as a means of group bonding while vocal grooming's flow of vocables, which was all that early erectus could manage, became inadequate to hold groups together. For this purpose the vocables had to acquire meaning. Language had begun but its content was social. It was gossip, not discussion. Furthermore it must have been learnt; the capacity to communicate by language is both innate and universal – we all have it – but the language in which we communicate is learnt; I speak English, not Chinese.

All this must have taken at least a million years. The change from gossip to symbolic language – symbolic in the Peircean sense, signifying by convention – seems to have occurred during, or perhaps just before, the era of homo heidelbergensis. This change not only made discussion possible, it enabled our ancestors to develop the faculty of rational thought. But for that and for the factors that caused it we must consider the last of our three capacities, the use of tools.

TOOLS

We suggested earlier that ramidus may have modified sticks to form tools much as today's chimps strip the leaves off them to form rods for termite fishing but that we have no direct evidence; ramidus's sticks have disappeared. Scraping the leaves off a stick with a broken flint isn't a long

way from pulling them off with one's fingers. Did ramidus, or more probably amamensis, whose erect posture freed his hands for manipulative activities, do something of the kind? We shall never know but the idea seems reasonable. If he did, he used tools to make tools, an event which, carried out in stone, was — even more than the use of fire — the most momentous technological innovation in mankind's history.

It happened over two million years ago during the era of homo habilis. He knocked one cobble against another in such a way as to detach from it a thin sliver of stone, a sliver that, with its sharp edge, could be used as a knife, while the fractured cobble, after several slivers had been detached from it, developed its own sharp edges and could be used a chopper. Armed with these tools — more versatile than cobble hammers and sharper than anything made from wood or bone — he was able to strip the tissue and crush the bones of the occasional antelope or baboon whose remains he found as, scavenging, he wandered the savannah and its riparian woodlands.

Habilis' discovery enabled him to increase the proportion of meat in his diet. This in turn bumped up the amount of energy available to his brain, causing it to grow significantly larger. His brain grew because his digestive system, originally designed to process vegetable matter that was low in nutrition, found itself with a surplus of concentrated and nutritious food, a surplus which was used to feed the brain. Furthermore, those who started to eat meat were those who, with bigger brains than their fellows, were best equipped to gain access to it.

Nevertheless in human, if not in geological terms, the rate of technological change was slow. Roughly a million years passed between habilis' knocking a blade off a cobble and erectus' invention of the hand-axe, a tool — pear shaped, symmetrical on both faces with small chippings around the blade — that could be used to deflesh a carcass as well as to crush its bones. And once this form was mastered it went on being used for over a million years more, a period during which only one new production technique, the so-called Levallois method employed by the neanderthals, was developed. This slowness of change is something of a mystery, perhaps it happened like this because flint-knapping is a technical skill rather than an intellectual activity and did not, in consequence, require an exceptionally large brain.

Right: A hand-axe from Olduvai Gorge, Kenya: 1,700,000-1,200,000 years ago.

Bottom left: Another hand-axe from Olduvai Gorge: 800,000-600,000 years ago.

Bottom right: A hand-axe from Boxgrove, Sussex: 500,000 years ago.

15 The conservatism of hand-axe design.

But if making a hand-axe didn't require an exceptionally large brain, it did require creativity, both in the conception and in the implementation of the project. The task required, like the making of any other artefact, a design – here of course in form of an image in the mind of the knapper – while the design's implementation required that the knapper should relate that image to the shape of the stone from which the tool was to be chipped. The design was masterly, ideal for a scavenger; it was light enough to carry, its symmetry made it easy to wield, while its pear shape offered a good grip as well as providing a point at one end for puncturing, a broad blade at the

other for chopping and a long narrow blade at each side for cutting. As for the implementation, the relationship of the image to the stone wasn't a one-off affair; every blow that the knapper made had to be carefully judged in position, force and direction. The conclusion is inescapable: for all those million or so years some of our homo erectus ancestors – not all would have possessed the necessary ability – must have practised as creative craftsmen.

They would, of course have had to learn the skill from the previous generation, but, just as a child must have an innate capacity for learning a language, they must have had an innate capacity for learning how to knap a hand-axe; had it been otherwise, the skill would surely have been lost after a few generations instead of lasting for over a million years. Moreover, the extreme conservatism of the hand-axe's design suggests that the skill was more innate than learnt, the result of genetic mutations rather than of cultural influences: while the design's remarkably high quality could only have been achieved if these mutations involved creative potential and an awareness, at the very least, of symmetry as well as of the ability to chip flakes from a stone core.

SCAVENGING AND HUNTING

We suggested, a couple of paragraphs back, that the hand-axe was the ideal tool for the scavenger. The implication, that our ancestors were scavengers rather than hunters, seems unworthy; it's nicer to think of them as at one with grand hunters like lions and tigers rather than with mean scavengers like jackals and vultures. Furthermore, Darwin – writing before any hominid fossils earlier than neanderthal had been found – had suggested that hunting was the behavioural characteristic that led to the split between man and ape. As a result the image of 'Man the hunter' became for a hundred years the assumed basis of hominid ecology. Then, during the last two decades, some paleoanthropologists came to realise that this wasn't possible; the male australopithecines, five feet tall, weighing no more than 100 pounds and with no effective weapons could not have caught up with a gazelle or been a match for an elephant. Hunting, except on a limited scale, was beyond them. Habilis wasn't much bigger but surprisingly his choppers and hammerstones have been found in association with fossilised bone fragments of animals like elephants and gazelles. Why?

The only feasible explanation is that these residues were the result of the butchering of scavenged carcasses; in the case of small animals they would have been the result of big-cat kills, while in the case of large animals they would have been the consequence of disease or drowning. The anthropologists Robert J Blumenscheine and John A Cavallo suggest that 'the earliest hominids probably scavenged and took small prey with their hands as chimpanzees and baboons do. Only their next step was unique: they began to use tools to butcher large carcasses that non-human primates cannot exploit.'[29] To which they add[30] that no tools clearly designed as weapons appear either among the 'Oldowan' tool kits of homo habilis or among the 'Acheulean' tool-kits of homo erectus. Hand-axes, however, were there.

Erectus, then, was primarily a scavenger. How did hunting come to pass?

I don't think it can have been a genetic mutation. Chimpanzees hunt in groups, climbing after monkeys in the forest canopy and if mankind's hunting was the result of a late genetic mutation the chimps must have had an early one – an unlikely idea. It seems more probable that our common ancestor was a hunter, that after the split occurred the chimps continued the practice while their less agile cousins gave it up for scavenging, and that the hunting gene remained dormant among the hominids until the era of homo heidelbergensis when the invention of weapons made hunting possible once more. This event caused a positive feedback; hunting provided more meat, eating more meat led to a larger brain, a larger brain led to better weapons, better weapons enabled hunting to be more effective, more effective hunting provided still more meat, eating still more meat led to a still larger brain…etc.

And this second enlargement of the brain provided the foundation for the achievements of homo sapiens including symbolic language, conscious thought, belief in the supernatural, the development of cognition, the emergence from Africa and the explosion of creativity.

LANGUAGE AND THOUGHT

We might imagine that symbolic language provides the basis of conscious thought; it's certainly the medium in which we decide what to have for lunch or fantasize about winning the jackpot in the national lottery. Such verbal thinking has, however, serious limitations; we may employ it in our

day-to-day living but it isn't much use to the composer when he devises his melody, to the mathematician when he conceives his theorem or to the potter when he considers the shape of his vase; and as for writing, every author knows how difficult it is to translate thoughts into words. Furthermore while the *language* in which we communicate is learnt, the *capacity* to communicate, chiefly but not exclusively by language is, as we have seen, unconscious, innate and universal. It seems that we all possess, in our unconscious minds what Pinker describes as 'a silent medium of the brain – a language of thought or "mentalese" [which is] merely clothed in words whenever we need to communicate them to a listener'.[31]

If mentalese is in any sense a language it must have, at the very least, a grammar and a lexicon – or more strictly a thesaurus (lexicons are made up of words while a thesaurus was, in its original Greek, a treasure-house).

Let's start with the grammar.

The existence of a universal grammar was first demonstrated by the American linguist, Noam Chomsky. He pointed out that children are able, without formal instruction, to assemble complex, and to them new, sentence constructions and that they could only do this if they were, in Pinker's words, 'innately equipped with a plan common to the grammars of all languages, a Universal Grammar, that tells them how to distil the syntactic pattern out of the speech of their parents'.[32]

Chomsky, writing before Dunbar, was sceptical about how his universal grammar could have been the result of Darwinian natural selection. I don't think this need worry us; the million or so years during which erectus gossiped would surely have been long enough for a series of small mutations to take place, each one affecting his brain, enriching his gossip, contributing to the enlargement of his social group and so making it easier for him to find a mate, to obtain food and to avoid predation. Finally – with hunting, meat eating and the enlargement of the neo-cortex, the area in which, it will be remembered, thought occurs – there was a spurt. In the era of heidelbergensis erectus' proto-universal grammar dropped the proto- and became the universal grammar of modern humans.

What about the thesaurus?

Pinker points out – with a dozen or so examples ranging from Coleridge in his writing of Kubla Khan to Einstein imagining himself riding a beam

of light and looking back at a clock – that many 'creative people insist that in their most inspired moments they think not in words but in mental images'[33] (a conclusion which fits well with our own findings in Chapter Two) and goes on to offer the following quotation from Einstein on the subject.

> 'The physical entities which seem to serve as elements in thought are certain signs and more or less clear images which can be "voluntarily" reproduced and combined...This combination play seems to be the essential feature in productive thought – before there is any connection with logical construction in words or other kinds of signs which can be communicated to others. The above mentioned elements are, in my case, of visual and some muscular type.'

(Compare our remark about Goya's portrait of Charles IV of Spain and his family: 'The mysterious chemistry which controlled his [Goya's] fingers as he painted the two majas did the same when he painted that extraordinary family portrait; a chemistry which, on the evidence adduced, derived from his unconscious mind.')

> 'Conventional words or other signs have to be sought for laboriously only in a secondary state, when the mentioned associative play is sufficiently established and can be reproduced at will.'

We may conclude from such examples that the thesaurus is an assembly of images of which some can, though often with difficulty, be translated into words while others can only be adequately expressed in a non-verbal medium such as music, mathematics or the visual arts.

Where did these images come from? That's easy. Way back, far earlier than ramidus, our ancestors must have had images in their minds. Remember Griffin's definition of awareness: 'the whole set of interrelated mental images of the flow of events', and his conclusion that: 'the better an animal understands its physical, biological and social environment' – we might say the more aware it is – 'the better it can adjust its behavior to accomplish

whatever goals may be important in its life, including those which contribute to its evolutionary fitness.' It appears that the images which constitute the thesaurus are the result of the accumulation, within the unconscious and over millions of years, of 'awareness-mutations' which, affecting the brain and hence the mind, enabled our ancestors to survive.

This, however, is no more than a hypothesis. Can we support it with independent evidence?

I think so.

If you refer to Appendix Four – the analysis of the activities of Brown's 'Universal People' with the three capacities, certain instincts and belief in the supernatural – you will notice that every single one of his one hundred and forty universals appears under one of the three varieties of awareness; enough surely to support the hypothesis. (Brown's universals are, admittedly activities, not the images which, by our argument, must constitute the thesaurus, but I don't think this need worry us. The existence in Brown's list of activities such as dance, or the use of words for parts of the body, must surely presuppose mental images, present in the thesaurus which relate to these matters.)

Furthermore, all but thirteen of Brown's activities appear either as a single awareness – e.g. the recognition of the family as a group – as two, or sometimes three, kinds of awareness – e.g. sense of self versus other (for two) or decision making (for three) – as an awareness together with one of the other capacities – e.g. the use of a smile as a friendly greeting – or as an awareness together with one or more of the instincts – e.g. powerful sexual jealousy. The odd thirteen, all grouped as religion, myth and magic, appear as an awareness together with belief in the supernatural. The analysis indicates that Brown's universals are not only innate – they wouldn't be universal if they weren't – but that apart from religion, myth and magic they all derive from the three capacities together with the instincts.

RELIGION, MYTH AND MAGIC

It is hardly surprising that religion, myth and magic have different origins from the others. The most dedicated church-, mosque- or temple-goer wouldn't suggest that ramidus or the australopithecines believed in the supernatural. Nevertheless at some stage in their history our ancestors must have begun to believe in such things and the belief must have become fixed

in their brains, and hence their minds, as the result of a set of genetic mutations. If you are a believer, you will surely attribute the most important of them, religious or supernatural belief, to divine intervention. If, on the other hand, you are an infidel like me you will need some other explanation; preferably in accordance with selectionist evolutionary theory. What about this?

The French social anthropologist, Emile Durkheim, considered that individual imagery and group cohesion rather than conceptions and beliefs are the essential elements of religion. He pointed out that to the believer 'the real function of religion is not to make us think, to enrich our knowledge, nor to add to the conceptions which we owe to science…[conceptions] of another origin and another character; but rather to make us act, to aid us to live. The believer who has communicated with his god is not merely the man who sees new truths of which the unbeliever is ignorant; he is a man who is *stronger*.'[34] To which he adds that 'whoever has regularly practised a religion knows very well that it is the cult which gives rise to these impressions of joy, of interior peace, of serenity, of enthusiasm which are, for the believer, an experimental proof of his beliefs. The cult is not simply a matter of signs by which the faith is outwardly translated; it is a collection of means by which this is created and recreated periodically.'[35]

The cult, however, is, in Durkheim's opinion an expression of society. 'This reality [the foundation of religious experience], which mythologies have represented under so many different forms, but which is the universal and objective cause of these sensations…out of which religious experience is made is society…then it is action which dominates the religious life because of the mere fact that it is society which is its source.'[36]

Durkheim's theory explains the effectiveness of religion as a social glue; something which, however dreadful its later consequences – we need only think of the expansion of the caliphate in the seventh century, the thirty years' war a millennium later, or the recent events in the Holy Land – our ancestors would have found invaluable. A clan of heidelbergensis whose members possessed a gene for the frequent practice of religious ritual, and with it a propensity to believe, would have been more cohesive than clans whose members only relied on language to hold them together. This would have helped them to succeed in conflict, no doubt killing the men, raping

the women and enslaving the children. After several thousand years of such activity the gene would have appeared in the form of religious or supernatural beliefs – as one of Brown's universals. Think, as a recent example of the use of such ritual, of the Nüremberg rallies. (It's worth noting in this connection that a group from Bouchard's team at the University of Minnesota found, in an analysis of information obtained from eighty-four pairs of twins who participated in some of their studies of twins reared apart, that individual differences in religious attitudes, interests and values arise from both genetic and environmental influences, and, more specifically, that genetic factors accounted for approximately fifty per cent of the observed variance on their measures.)[37]

Durkheim only discusses religion, what about myth and magic?

The distinction between religion and the others is somewhat blurred; most, perhaps all, religions contain myths, priests have been known to practise magic as part of their rituals while theories of fortune and misfortune have sometimes been tied up with religious beliefs – think of the Book of Job. On the other hand, divination, folklore and attempts at weather control are more typically aspects of myth or magic than of religion. Perhaps, remembering Motoo Kimura's finding that most genetic variations are the result of neutral mutations that are neither beneficial or deleterious to the organism concerned, we can regard belief in myth and magic as the consequences of chance events rather than of natural selection. On this basis the varieties of myth and magic which appear in Brown's list can, like the others on the list be assumed to have contributed to mentalese's thesaurus.

COGNITION

Cognition was, you will remember, defined in the *Oxford Companion to the Mind* as the 'use or handling of knowledge'. Religion, myth and magic are aspects not of knowledge but of faith and should, in terms of the definition, be excluded from any consideration of cognition. Here, however, I am prepared to cheat a little, adding faith to knowledge in the definition. I don't think it matters, to take an obvious example, whether somebody eats a tiny wafer and sips a mouthful of wine because he *knows* that they constitute an aperitif or because he *believes* that they are, spiritually, the body and the blood of Christ. In one case, he is using knowledge, in the other he is using

faith. In the context of cognition what is important is the combination of the physical activity – in this case eating and sipping – and the mental process – in this case knowledge or faith – not which of the two he happens to use on any particular occasion. And anyway such knowledge or faith is an aspect of awareness. This intertwining of awareness, tool usage (where appropriate) memory and thought – chiefly language based – is my interpretation of the *Oxford Companion's* definition.

While cognition existed, as we have seen, in an elementary form long before ramidus – and no doubt developed further during the four million years between his appearance and that of heidelbergensis – its development must have accelerated rapidly with the establishment of symbolic language and symbolic language's concomitant of language-based thought. You can use your knowledge of a particular problem, such as the selection of a secure vantage point from which to watch for predators, much more effectively if you can think about it and discuss it with others than if you can only act, like termite-fishing chimps, on a combination of memory, instincts and the three capacities.

The *Oxford Companion's* account of cognition isn't, however, confined to its definition. According to the author: 'Those who stress the role of cognition in perception underline the importance of knowledge-based processes in making sense of the "neurally coded" signals from the eye and other sensory organs. It seems that man is different from the other animals very largely because of the far greater richness of his cognitive processes. Associated with memory of individual events and sophisticated generalizations they allow subtle analogies and explanations – and ability to draw pictures and speak or write.'[38] We may note that this statement accords with our interpretation of *The Oxford Companion's* definition; that cognition is an intertwining of awareness, tool usage, memory and thought, chiefly language-based. Awareness clearly relates to 'knowledge-based signals from the eye and other sensory organs', memory to 'memory of individual events', while thought, chiefly language-based, must provide the basis of 'sophisticated generalisations...subtle analogies and explanations' as well as of 'the ability to draw pictures [tool-usage] and speak or write'.

Furthermore we should realise what the statement implies: the *practice* of cognition cannot be innate; nobody can use or handle knowledge except

within a culture of whose characteristics he is at least partly aware, and if cognition were culturally determined it couldn't be innate. On the other hand, the *capacity* to do these things – what *The Oxford Companion* calls the cognitive processes, far richer than those of other animals – must be innate. If it weren't we shouldn't be different from them.

No wonder Toynbee considered its dawn in the biosphere to be the most momentous event to date in human history. (You may have noticed that I had the effrontery, on page 117, to translate his use of the word consciousness to mean cognitive capacity. If you want to know why, refer to Appendix Five.)

TO SUMMARISE

By about 100,000 years ago mentalese had become established in the minds of our ancestors as the result of many awareness-mutations which had begun to take place long before ramidus emerged from the forest. Some of our ancestors had, for over a million years practised as creative craftsmen. They all had, for about the same period, developed gossip and had, for some two or three hundred thousand years, spoken in symbolic language. They had, more recently, developed cognition and they believed in at least one god.[139]

They were ready to go.

Then, ten thousand years later, a small number of them, perhaps about 150, crossed into Asia. All but the sub-Saharan Africans are descended from that group.

How does all this relate to the theory of archetypes and the collective unconscious?

I think they match it very well. Think of the tiny group from whom almost all of us are descended; whatever was in their genes must be in ours, unless we happen to be sub-Saharan Africans, a small proportion of the whole. The emergence from Africa provides the explanation for the existence of Brown's universals, including religion, myth and magic, for Rose's conclusion that no dimension of behaviour seems to be immune from genetic expression, for Bouchard's 'innate abilities and predispositions', for the world-wide phenomenon of creativity as well as for Jung's collective unconscious with its archetypes 'as many as there are typical situations in life'. And, if that doesn't convince you, what about mentalese, Pinker's 'silent medium of the brain'? Its thesaurus is surely the

collective unconscious, while the thesaurus' images – of which some can though often with difficulty be translated into words while others can only be expressed in non-verbal media – are evidently archetypes.

We seem to be home, well, almost. To clinch the argument we need some examples; most appropriately in the visual arts since that is our field of enquiry. You will find them in Parts Three and Four.

POSTSCRIPT

You may have wondered why I said nothing in the last section about the explosion of creativity.

The reason is simple. I ignored the explosion because – for all its importance in man's history – it is not germane to our enquiry. We have sought, in Part Two, to validate Jung's theory of the collective unconscious and its constituent archetypes by relating them to evidence from genetics and human evolution – in particular the evolution of the human mind – up to and including the emergence from Africa. The explosion occurred some 50,000 years after the emergence. Need I say more?

1 'The probable inadequacy of the fossil record and its interpretation should...be born in mind whenever a diagram is offered as a hypothesis of "the" hominine phylogeny'. (Roger Lewin, *Principles of Human Evolution, a Core Textbook*, Blackwell Science, fourth edition, 1998, p 297) a study from which I have taken what seems, to my lay intelligence, to be the most convincing dates and the most straightforward sequence. To which I must add that at the time of going to press the oldest fossils were still being studied and their sequence was not determined. See Lewin pp 253-258 and *passim*.
2 Robin Dunbar, *Grooming, Gossip and the Evolution of Language*, Faber and Faber, 1996, p 127.
3 *ibid*, p 62.
4 Chris Stringer and Robin McKie, *African Exodus*, p 129. I should mention that in the interests of brevity I have omitted some of their more arcane genetic evidence.
5 *ibid*, pp 129-130.
6 Shahin Rouhani and Steve Jones, 'Bottlenecks in Human Evolution', *Cambridge Encyclopaedia of Human Evolution*, Cambridge University Press, 1992, p 283.
7 Dunbar, *op cit*, p 62.

8 *ibid*, p 77.
9 Stringer and McKie, *op cit*, p 130. See also *ibid*, pp 46-51 and Colin Tudge, *The Day Before Yesterday, Five Million Years of Human History*, Jonathan Cape, 1995, pp 225-227.
10 Charles J Lumsden and Edward O Wilson, *Promethean Fire*, Harvard University Press, 1984, p 118.
11 Jerome H Barkow, Leda Cosmides and John Tooby eds, *op cit*, 1992, p 3.
12 William F Allman, *The Stone Age Present*, Simon and Schuster, 1994, p 51.
13 Dunbar, *op cit*, pp 16-18.
14 *The Oxford Companion to the Mind*, p 383.
15 Donald R Griffin, *The Question of Animal Awareness*, Rockefeller University Press, 1976, p 5.
16 *ibid*, p 104.
17 *ibid*, p 85.
18 Colin Tudge, *The Day Before Yesterday*, Jonathan Cape, 1995, p 194.
19 Steven Pinker, *The Language Instinct*, Penguin 1994, p 334.
20 Dunbar, op cit, pp 48-49.
21 *ibid*.
22 *ibid*, pp 51-54, also Pinker, *op cit*, pp 335-341, and for a bibliography p 443.
23 Steven Mithen: *The Prehistory of the Mind*, Thames and Hudson, 1996, p 92.
24 For a study which reaches very similar conclusions to these, though by a different route, see *ibid,*, pp 33-72 and passim.
25 Arnold Toynbee, *Mankind and Mother Earth*, Oxford University Press, 1976, p 26.
26 I must emphasise that this is a brief, layman's account of a very complex topic. I have found that M D Vernon's *The Psychology of Perception* provides a helpful, non-technical, outline of the subject.
27 Dunbar, *op cit*, p 22.
28 *ibid*.
29 Robert J Blumenschine and John A Cavallo, *Scavenging and Human Evolution*, Scientific American, October 1992, p 74.
30 *ibid*, p 76.
31 Pinker, *op cit*, p 56.
32 *ibid*, p 22.
33 *ibid*, p 70. Quoting for Einstein, S M Kosslyn, *Ghosts in the Mind's Machine, Creating and Using Images in the Brain*, Norton, New York 1983 (no page reference given)
34 Emile Durkheim, *The Elementary Forms of the Religious Life*, trans Joseph Ward Swain, George Allen and Unwin, second edition, 1976, p 416.
35 *ibid*, p 417.
36 *ibid*, p 418.
37 See the American Psychological Society's journal, *Psychological Science*, Vol 1, no 2, March 1990, pp 138 and 140.
38 *The Oxford Companion to the Mind*, p 149.

39 Orthodox opinion holds that religious belief began later as part of the creative explosion. I disagree. It must have occurred before the emergence from Africa otherwise the group from Bouchard's team would not have found that genetic factors accounted for approximately fifty per cent of their respondents' differences in religious attitudes, interests and values, nor would religion myth and magic have appeared among Brown's universals.

Part Three

Through Nature's Looking-Glass

Part Three

Introduction

We declared, in the introduction to Part Two, that apart from the obvious case of *Les Demoiselles d'Avignon*, we had not attempted to find an archetype that underlay the IAC of a particular work of art. The next two chapters seek to rectify this omission by offering examples in which similar images, deriving from archetypes in the collective unconscious and hence from our ancestors' awarenesses, self-, social- and environmental-, appear in works created by artists from different cultures and different periods of history. In Part Four the same argument seeks to explain our enjoyment of nature's beauties and our abhorrence of her uglies.

To which I must add a request. As you proceed you will find occasional references to 'a gene for' something or other. When you encounter this phrase please remember Dawkins' remark which we quoted on page 95: 'Expressions like "a gene for long legs" or "a gene for altruistic behaviour" are convenient figures of speech. There's no gene that single-handedly builds a leg, long or short'. So, in what follows don't interpret 'A gene for' literally; it is no more than a convenient figure of speech.

Chapter Six

Sundry Archetypal Images

A Few Preliminaries

ARCHETYPE: CONTENT OR IMAGE

Perhaps we should begin our quest for illustrative examples by recalling that we chose Jung's definition of archetype: 'essentially an unconscious content that is altered by becoming conscious and by being perceived, and it takes its colour from the individual consciousness in which it happens to appear' as the most appropriate of those which we considered; it seemed to subsume the others.

I should, however – remembering that Jung's original phrase for archetype was 'primordial image' – like to substitute 'image' for 'content' in the definition. It would thus become 'essentially an unconscious image that is altered by becoming conscious and by being perceived... etc.'. This amendment would not only do much to relate the definition to the visual arts, it would also match Einstein's dictum that 'many creative people insist that in their most inspired moments they think not in words but in mental images'. I hope that any of the Master's disciples who read these words will not be too shocked at the change.

OUR ANCESTORS' ENVIRONMENTAL AWARENESS

I should not be surprised if you found the argument in Chapter Five somewhat unconvincing. It abounds with phrases like 'it is reasonable to suggest that...', 'perhaps it happened like this because...' and 'on this basis

[something or other] may be assumed to have happened...'. Such qualifications can hardly be avoided in a discussion of a topic as intangible as the evolution of the human mind. The following account may help to support these theoretical concepts; it gives first-hand evidence of the awarenesses, social-, self- and environmental-, possessed by the bushmen of the Kalahari, people whose hunter-gathering lifestyle must have been not dissimilar to that of our ancestors ninety-thousand years ago. The author, Laurens van der Post, was brought up among those whom he describes.

> 'Sometimes...they had a mimic war. The pantomime was based on some half-forgotten historical fact, but the only detail that was clear was that the war had started in the old Homeric way; some comely young Bushman archer from one group had ravished the apricot Helen of a middle-aged and prickly Menelaus in another, and enticed her to leave her home and people with him. The result had been a war between the two groups, but a war with a difference. For no sooner was Helen reclaimed and the ravishing Bushman killed, than both sides were filled with fear and revulsion against their deed, as if suddenly among the acacias of their vast Kalahari garden the voice of God Himself had made the leaves tremble as he reprimanded them for their mutual sin. They instantly sat down to talk to one another and resolved that it must never happen again. Accordingly they divided the desert into two zones promising never to cross the demarcation line between them. They...assured me that none of them to this day would go from one zone to another.
>
> '"But how do you know which zone is which?" I asked, thinking of the thousands of square miles of identical sand, dune and bush.
>
> 'They laughed at my innocence..."Did I not know," they declared, "that there was not a tree, expanse of sand or bush that were alike?" They knew the frontier tree by tree and grass by grass.'[1]

We cannot of course assume that our homo sapiens ancestors possessed such profound self-awareness, such admirable social-awareness and such extraordinary environmental-awareness. Apart from anything else the Kalahari bushmen are sub-Saharan Africans, descended, as we have seen, in a different line from the rest of us. Nevertheless, it's a fair bet that even if our own ancestors didn't achieve the awarenesses of van der Post's bushmen they got some way towards it.

We shall, in seeking examples to support our argument, make this assumption.

GENES, ARCHETYPES AND THE COLLECTIVE UNCONSCIOUS

Before, however, we embark upon our quest we have one matter to consider.

We may reasonably argue that the presence, noted by Gombrich, 'of eyes, jaws and claws among the decorative motives of so many traditions'[2] is the result of three 'awareness archetypes' within the collective unconscious – one for eyes, one for jaws and one for claws – that these archetypes are themselves the result of three genes – one for each – and that these genes are the result of mutations which, by enabling our ancestors to watch for predators, helped to ensure their survival. If this seems a bit complicated the following sequence, taking claws alone, may help.

We may reasonably argue (i) that the appearance of claws in the decorative motives of many traditions is the consequence of a 'claws-archetype' in the collective unconscious, (ii) that this is the consequence of a gene for the awareness of claws in the DNAs of the tiny group which emerged from Africa and (iii) that this was, in its turn, the consequence of a mutation for an awareness of claws, a mutation which may well have occurred long before the appearance of ramidus.

This may explain the presence in many traditions of decorative motives which, like eyes, jaws and claws, evidently originate in awarenesses which our ancestors needed in order to survive; I'm afraid, however, that it isn't enough. There are many motives, no less frequent than eyes, jaws and claws, which must, by our argument, derive from archetypes in the collective unconscious but which don't, evidently, originate in the way just described. Spirals are one example, circles another. Our ancestors can hardly have been unaware of them – for circles think of the sun and moon, for spirals think of snail shells and ram's horns – but an awareness of the spiral shapes

of snail shells or the circular shapes of the sun and moon wouldn't, like an awareness of eyes, jaws and claws, have done much for erectus' evolutionary fitness. How can we explain the presence of circle-archetypes or spiral-archetypes in the collective unconscious?

Here we have to be careful. In considering these matters it's easy to slip, unthinkingly, into Lamarckism; to say that our ancestors, seeing the sun rise every morning and the full moon appear once a month, must, after millions of years, have had recollections of these phenomena imprinted innately upon their minds. Fortunately, however, we have two pieces of evidence that enable us to avoid the heresy.

We have mentioned one of them already. In our discussion of myth and magic, we referred to Motoo Kimura's finding that most genetic variations are the result of neutral mutations that are neither beneficial or deleterious to the organism concerned. It doesn't seem too far-fetched to suggest that our ancestors' innate awarenesses were the result in part of Darwinian natural selection – resulting in phenomena like the awareness of eyes, jaws and claws – and in part of Kimuran chance events – resulting in phenomena like the awareness of circles and spirals.

The other piece of evidence lies in Pinker's mentalese. The images in its thesaurus can't all have been the beneficial consequence of natural selection; those which provided the basis of erectus' gossip may perhaps have been of this kind but it stretches commonsense to suggest that the same is true of those which underlie homo sapiens' far more complex symbolic language. On the other hand a group of heidelbergenses who possessed a gene for symbolic language would have had an advantage in the evolutionary stakes over groups which lacked it; so perhaps the mutations – there must have been many of them – which resulted in the gene for symbolic language were beneficial, not neutral.

I am happy to leave such problems to the geneticists. I assume, in the rest of this enquiry, that some of the archetypes in the collective unconscious are evidently the result of natural selection while others are probably the result of chance events. We shall find both varieties among the miscellany of images discussed in the coming pages.

Representational Art

We have pictures all over the place. They hang in our houses, they appear in our newspapers, they occupy the screens of our TV sets, they decorate the hoardings around our building sites, they fill the museums and art galleries which we visit and they all possess some element, however limited, of IAC. It is surely evident that works of representational art are the most frequent, most obvious and most important examples of artefacts whose IAC, derives, if there is anything in our concept, from the collective unconscious and hence from awarenesses possessed by our remote ancestors. Apart from Jewish and certain Muslim, in particular Arab, societies, (where representational art was considered to infringe the prerogative of the Creator) such works appear, so far as I know, in every culture. Their naturalism varies, in pictures, from the descriptive accuracy of the Lascaux stag to the spikey fantasies of Paul Klee and in sculpture, from the stiff

16 Paul Klee: *They're Biting.*

17 Above: An Atlantaean column: *Tula, Mexico.*

18 Right: Egid Qurin Asam: *The Assumption of the Virgin,* Rohr, Bavaria.

formality of Toltec Mexico to the exuberant baroque of eighteenth-century Germany.

Why say more?

No reason that I can think of. Awareness in its varied manifestations must, axiomatically, underlie all representational pictures and sculpture, and some of the illustrations to the first three chapters will serve as examples: awareness of agony in the Grünewald, of turmoil in the Rubens, of social relationships in the Bosch, of individual personality in the Goya and in the Benin queen mother, of hunting in the Lascaux stag, of food gathering in the Egyptian grape harvest, of landscape in the Fan Ku'an, the Constable and the Rembrandt, and of the human figure in the Donatello, the Renoir, the Manet and the Picasso.

These examples, and any more which you care to name, certainly display the artist's awareness of the topic concerned but – though they all relate to what must have been common experiences of our remote ancestors – the evidence which they provide is too limited in its provenance to support our theory. There are, however, certain representational images that, because they appear in many cultures, may help in this respect. One of them relates to profiles. Let us start there.

Profiles

The Lascaux stag is in profile, so are very nearly all the animals depicted in Cro-Magnon cave paintings; the workers in the grape harvest are in profile, so are all the figures in Egyptian wall-paintings and reliefs; the King, the

19: A Royal Lion Hunt: Assyrian, seventh century BC.

20 The bull ritual: Minoan, about 1500 BC – After photograph by Nimatallah,

horses and the lions are in profile, so are all the animals and figures in Assyrian reliefs; the bulls and their athletic girl-toreadors in the wall-paintings of Knossos are in profile, so are all the figures in the Minoan and Mycenaean wall paintings which have survived; Herakles and the Cerberus are in profile, so are all the figures and animals to be seen on Greek vases; the figures in the sacred procession which decorated the approach to the audience hall at Persepolis are in profile, so are its lions, bulls, shepherds, merchants and kings; Tezcatlipoca, the great sky god is in profile, so are almost all the other figures to be seen in the codices and wall paintings of pre-Columbian America; the girl playing the bagpipes to the herd of deer is in profile, so are all (well, almost all) the other figures and animals depicted in Rajput paintings of the seventeenth to nineteenth centuries.

It's quite a catalogue. I'm open to correction but my enquiries suggest that apart from China, Japan, Indonesia, Persia, Mughal and Ajanta India, post-Hellenic Europe, the Australian aborigines and certain north American tribes, the profile has been virtually universal in pictures or reliefs of people or animals. Furthermore, it appears occasionally even where it was not the norm. In Mughal India the profile was often used in portraiture but not elsewhere; it provides the form of all but a few of the figures in the Bayeux tapestry and among the Italian masters Giotto used it frequently. Thus in his *Entry into Jerusalem* from the sequence of wall-paintings in the Scrovegni chapel at Padua: Jesus, the donkey, and the twelve figures in the foreground are all in profile. Moreover the *Entry into Jerusalem* isn't the only one of its

21 Herakles and Cerberus, Greek vase painting, fifth century BC.

22 A sacred procession: Persepolis, Persia, sixth and fifth centuries BC.

23 Texcatlipoca, the Aztec sky god, sixteenth century.

kind, there are forty such pictures on the side walls of the chapel. In total, they include 375 figures of which over half are in profile.

It seems strange that this convention should have dominated representational painting and relief sculpture for so long and across so many cultures; we don't normally see people or animals in this way. People are seen, in the course of social encounters, in full or three-quarter face while animals, as they run away from us, are seen from the rear. Why did these artists not portray people and animals as they normally saw them? Not surely because a profile is easier to draw than a full or three-quarter face; Giotto could draw a three-quarter face when he wanted to – there are over fifty of them in the Scrovegni chapel – there is, in the Metropolitan Museum of Art in New York, a vase painting showing an artist painting a statue of Herakles, the artist is in profile, the statue in three-quarter face; and as for the Cro-Magnon artists there are several cave paintings which, like the skull in Holbein's portrait of the two ambassadors in the National Gallery, appear formless until they are looked at from the side so that they can be seen in acute perspective.[3] If they could manage that, a three-quarter view would

24 A girl playing the bagpipes with a herd of deer, Indian, nineteenth century.

be easy. These artists were men of genius, there must be some other explanation. What about this?

We may reasonably assume that the collective unconscious includes archetypes of a four-footed mammal and of a human face, they are both typical situations in life, secondly that these archetypes, though unconscious, possess shape – they must, the idea of a shapeless archetype of a concrete object like a human face is self-contradictory – and thirdly that to be effective as archetypes their shapes must be manifest, incapable of confusion with any other shape.

And the most manifest shape, whether of a human face or a four-footed mammal, is its profile.

25 Giotto: *The Entry into Jerusalem*, the Scrovegni Chapel, Padua.

The presence of such images in the collective unconscious would explain why the profile appears so frequently and among such varied cultures; but how, in terms of evolutionary theory, did it get there?

That's easy. The ability to recognise such images was a necessary aspect of our ancestors' environmental awareness. Those who did not possess it, unable to distinguish friend from enemy or a harmless animal from a predator, would not have lived long. Thus according to Griffin:[4] 'The possession of mental images could well confer an adaptive advantage on an animal by providing a reference against which stimulus patterns can be compared.' And he goes on to say, '[The] ability to abstract the essential qualities of an object and recognize it, despite various kinds of distortion is obviously adaptive.'

A convincing explanation? I hope so. But what about snakes, or perhaps

more appropriately serpents? They are animals but they have no recognisable profile so they can't be the subject of the same kind of archetype as those of a human face or a four-footed mammal. How did their image become established in the unconscious mind? And how does the artist, faced with an animal without a manifest shape, express its characteristics?

Serpents

In this we are lucky, we have a study, *The Cult of the Serpent, an Interdisciplinary Survey of its Manifestations and Origins*, by Balaji Mundkur – an Indian biologist working in the United States – which provides an encyclopaedic, fully illustrated and admirably lucid investigation of its subject. Mundkur points out that while snake is the native English word and is far more frequently used serpent 'opens up vast metaphorical possibilities' and goes on to quote the lexicographer Fowler's statement that '"we perhaps conceive serpents as terrible and powerful and beautiful things and snakes as insidious and cold and contemptible"'.[5] A few pages later he adds that such attitudes are universal among mankind.

> 'It would be hard to find a society that does not mingle the "insidious and cold and contemptible" ophidian aspects with the "terrible and powerful and beautiful" ones. Together, they have generated an abundance of cosmogenic, fertility, pluvial and mortuary myths. Serpents above all have been made into one of the most important of cult animals…Is there another species that surpasses it in inciting ambivalent feelings of awe and revulsion, veneration and active antagonism? Whence spring these contradictory emotions – emotions that are displayed in the religious and secular beliefs of modern, urban peoples no less amply than in those of the very primitive?'[6]

Mundkur considers that these emotions derive from fear, adding that 'fascination by and awe of, the serpent appears to have been compelled not only by elementary fear of its venom, but also by less palpable, though quite primordial psychological sensibilities rooted in the evolution of the

primates; that unlike almost all other animals serpents, in varying degrees, provoke phobic responses in human and non-human primates alike; ...and the serpent's power to fascinate certain primates is dependant on the reaction of the latter's automatic nervous system to the mere sight of reptilian sinuous movement'.[7]

This answers our problem. We have suggested that well before ramidus our ancestors must have had innate images in their minds, images which, according to our concept, went on to form archetypes in the collective unconscious. Fear of reptilian sinuous movement is evidently an image of this kind, exceptional in that – despite relating to an animal – it has no recognisable profile.

This, however, creates difficulties for the artist; he can't – to revert to our analogy from radio – broadcast on a serpent wavelength if no serpent wavelength exists. Faced with this problem he broadcasts on the wavelengths of geometry: symmetry in the Egyptian cobra deity, a helix in the poisonous

26 An Egyptian cobra deity.

27 A stone rattlesnake: Aztec.

28 A poisonous water snake: Sarawak.

29 A diamond python: English, nineteenth century.

water-snake from Sumatra, spirals in the stone rattlesnake from Aztec Mexico and in the English diamond python, loops in Cerberus's serpents on the Greek vase and – in cultures as varied as those of Ancient Egypt, of China (both Neolithic and of the eleventh and twelfth centuries BC), of the Elamites of Susa, of the Jains of India, of renaissance Italy and of contemporary Benin – a device known as the ouroboros, a serpent biting its own tail.

30 An uroboros: Chinese eleventh or twelfth century BC.

(It may be worth mentioning that the ouroboros was the subject of many kinds of religious and philosophical symbolism among the cultures which employed it and that it was even considered by Jung's Israeli colleague Erich Neumann to symbolise the pre-ego stage of infantile development;[8] a concept which I do not share. To me the explanation is simpler; the serpent, by being given a geometrical shape, usually a circle, and by being shown biting its own tail, was not only given a broadcastable form, it was also rendered innocuous; it can't bite us if it's biting itself.)

A Problem: the Basilical Section

The churches of western Christendom derive, with rare exceptions, from the basilicas of ancient Rome. The basilica, a court-house, took the form of a long columned hall. It had a high central nave lit by clerestory windows, lower side aisles with windows in the walls and a semi-circular apse for the Judge's throne at one, sometimes at both ends.[9] This plan – with an altar instead of the throne, piers instead of columns and arcades instead of colonnades – provided the typical form of a church. It possessed, in Wotton's phrase, *commoditie*. Its spaces were agreeably varied; it was well

31 S Apollinare in Classe, Ravenna: Plan and section showing the interior.

32 San Zeno, Verona.

lit, it included room for religious processions, it was, at least originally, simple to build and it could be adapted to churches of all sizes from a cathedral to that of a small village. It lasted with modifications – vaults, transepts, a chancel, side chapels, one or more towers – for over a thousand years.

It involved, however, a problem; the raised gable above the nave and the lean-to roofs over the aisles resulted in a section and hence a west front which nobody – or almost nobody – seems to have liked. Only in the early Christian and romanesque churches of northern Italy was it left unmasked, Pisa Cathedral is one example, San Zeno Verona another. Everywhere else devices, sometimes of great complexity, were employed to hide this awkward shape. One, employed at Wells and Peterborough Cathedrals, and more elaborately at the Certosa di Pavia was a huge screen covering the whole façade (the towers at Wells were added later). Another, typical of French cathedrals but employed in many other buildings including a number of German baroque churches as well as St Paul's, where it was combined with a screen, was a pair of towers placed so as to hide the ends of the aisles. In England the builders of the smaller gothic churches couldn't afford two towers so they provided one, set at the end of the nave where it hid the gable and dominated the façade (Saint Andrew's in the Lincolnshire village of Heckington is an example), while the architects of the Italian renaissance used varying devices to resolve the problem. Thus Palladio, at San Giorgio Maggiore in the Venetian lagoon, emphasised the end of the nave, and hence the centre of the façade, with a colossal order of engaged columns, (for the layman I should perhaps explain that 'colossal order' is a technical phrase; it means an order which extends to two stories instead of, as is usual, only one) while Alberti, at Santa Maria Novella in Florence, linked the aisles to the centre with huge consoles; an awkward solution which was copied extensively in baroque Rome and Paris.

Why should so many architects, from different countries at different periods of history have gone to such lengths to hide the west fronts of their churches? Why did they not, as they did with the plan, simply follow – with appropriate stylistic modifications according to the period concerned – the straightforward precedents of romanesque Italy? It isn't enough to say that they went to all this trouble because they didn't like the shape of the basilical west front. It's obvious that they didn't like it,

33 Above: Wells Cathedral.

34 Right: Peterborough Cathedral.

35 Below: The Certosa di Pavia.

36 Right: Amiens Cathedral.

37 Below: Johann Michael Fischer: Church, Benedictine Abbey, Ottobeuren, Bavaria.

38 Saint Andrew's,
Heckington,
Lincolnshire.

39 Andrea Palladio:
San Giorgio Maggiore,
Venice

40 Leon Battista Alberti: Santa Maria Novella, Florence.

I don't like it, I haven't met anyone who does like it and I bet you don't like it. Why?

I offer the following explanation:

According to our theory the apparently universal dislike of this shape is due to the presence in the collective unconscious of an archetype which possessed some resemblance to the basilical west front, which related to some disagreeable, perhaps dangerous, aspect of our hominid ancestor's environmental awareness and which was the subject of a genetic mutation – a mutation which became fixed in the genes either through natural selection or by some chance event.

What could this disagreeable, perhaps dangerous, aspect of our hominid ancestor's environmental awareness have been?

The basilical west front is symmetrical, so are almost all animals. It therefore seems reasonable to suggest that this putative aspect of our ancestor's environmental awareness had to do with some disagreeable, perhaps dangerous animal. It could hardly have been a mammal, a bird or a fish; the basilical west front doesn't resemble any of them; what about some insect? This seems possible; the silhouette of the gable above the nave does bear some slight similarity to the shape of an insect's head, while the sloping roofs over the aisles resemble, distantly, its wings, folded when at rest. Furthermore, many insects are disagreeable, sometimes even dangerous. Is there one, common in the east African savannah, which possesses these characteristics?

Yes there is, the flesh fly. It is described by the entomologist, S H Skaife, as follows:

41 The African flesh fly.

'The large grey "flesh fly" with black stripes on its thorax and a checkerboard pattern on its abdomen is common all over Africa. A powerful flier, distinguished by its loud buzz…[it] can be a loathsome and persistent nuisance on country picnics. The females are remarkable in that they give birth to batches of very mobile, active first stage larvae which develop extremely fast. These flies normally breed in excreta, but the females also drop their larvae on decaying foodstuffs or meat'.[10]

We have seen that homo erectus was primarily a scavenger. His diet certainly included raw meat and to him the flesh fly, breeding in excreta,

must have been not just a loathsome and persistent nuisance but dangerous. A 'flesh-fly-awareness' mutation would have led those who had it to avoid contaminated meat and so to be less likely to die of food poisoning than their fellows. After a few thousand years, natural selection would have caused it to become fixed in the genes so that we, inheriting the profile of the flesh-fly as an archetype in the collective unconscious, became predisposed to abhor anything – including the unmasked west front of a basilican church – whose shape resembles that archetype.

Too far-fetched for credibility? Perhaps. But if you reject this explanation please suggest an alternative.

Sex

In Chapter Four I declared – following Stevens' assertion that the archetype is the predisposition to have certain experiences – that, instincts apart, I didn't see how anybody can be predisposed to do something about which he is ignorant; to which I added that to me this was axiomatic. The remark needs a bit of elaboration. Jung considered that the instincts 'form very close analogies to the archetypes, so close in fact that there is good reason for supposing that they are the unconscious images of the instincts themselves. In other words that they are *patterns of instinctual behaviour*'.[11] I confess that to me this seems unlikely. I can't remember how many instincts there are but there are surely fewer of them than there are archetypes – as many as there are typical situations in life – so the archetypes can't all be patterns of instinctual behaviour, while the idea that (*pace* Pinker) language with all its manifestations is an instinct like hunger or aggression doesn't match my own convictions.

On the other hand some archetypes certainly are patterns of instinctual behaviour and must therefore derive from instincts. Mundkur's conclusion that the fascination of serpents is synonymous with a state of fear is an example, so is 'great interest in the topic of sex' something which was included by Brown as one of his human universals.

It is hardly surprising, if great interest in the topic of sex is an archetype, that sexual references appear in the visual arts of many traditions. They may be found not only in such obvious examples as the nudes of Rubens, Boucher and Renoir (is there a more luscious pin-up than Boucher's *Miss*

42 Boucher: *Miss O'Murphy*.

43 Hokusai: *Festive Lovers*.

44 Left: A pottery jug, Chinese. c 2,000 – 1,500 B.C.

45 Below: The temple of Horus, Edfu, Egypt: The entrance.

46 Bottom: 'Islands in the sea', raked gravel in a dry landscape garden, the Abbot's quarters at Daisen-in, Daikoko-ji, Kyoto.

47 Two silver teapots: English, nineteenth century.

O'Murphy?) but also in Hokusai's occasional images of erotic dreams, in the herms – pillars topped by the head of the god Hermes with erect penises on the shaft – which stood in the streets of sixth century Athens, in the phallic shapes of many Egyptian columns, in the bosomy female figures which were a feature of the sculpture, first of Buddhist and later of Hindu India, for some 1,400 years; as well as in many domes, some towers, occasional pots and some clothing. I illustrate a few examples taken at random; three breasts and an erect penis surely underlie the form of the Chinese jug, a vulva that of the small entrance set between massive pylons in the temple of Horus, a pair of breasts that of the mounds in the dry landscape garden at Kyoto, while the two teapots are assuredly male and female. I have no doubt that you can think of others.

Texture

There is surely no need to emphasise that the visual arts involve, either directly or by imagination, the experience of touch. We may not be able to feel the unbroken surface of a Holbein or the coarse impasto of a van Gogh – we'd be in trouble with the gallery authorities if we did – but we can imagine what they would feel like if we did touch them, and we have all encountered the wooliness of carpet, the smoothness of porcelain, the scratchiness of roughcast. Such textural characteristics are significant in painting, important in the crafts, critical in architecture and vital in both town- and landscape. They must, as typical situations in life, be archetypes; and by our theory they should derive from our ancestors' environmental-awareness. How?

Our ancestors could, of course feel things. We do the same, chiefly with our hands, but our hands are less sensitive than the soles of our feet (why else has the bastinado been for long a system of torture in certain middle-eastern countries?) and unlike us the hominids went barefoot. Consider what this implies. Stubbing your toe or having to take a few steps barefoot along a gravel path are pretty uncomfortable; think what it would mean to have one of the most sensitive parts of your anatomy in constant, varying contact with sand, grass. gravel, water, rock, mud, fallen leaves. Living like this you would very soon develop a profound awareness of the materials of floorscape.

And a hominid who lacked a gene for such awareness would be more likely than his fellows to scratch his foot on a thorn and so develop tetanus, or tread on a scorpion and, limping, succumb to a predator. Natural selection ensured that our ancestors' innate environmental-awareness included an important tactile as well as the more obvious visual element.

This concept may perhaps provide an explanation not only for the presence of tactile characteristics in the visual arts generally but also for the fact that surface texture is a more significant aspect of townscape and garden design, particularly at ground level, than it is of the other visual arts. A piece of sculpture may be smooth like the *Venus de Milo* or rough like an Epstein bronze but, apart from the odd Rodin or unfinished Michelangelo, it isn't smooth in one part and rough elsewhere. Buildings are different; not only do they have roofs and windows as well as walls,

many of them have mixed facing materials – thus Wren, in his city churches, used brick for walls in association with Portland stone for door and window architraves and as the material for porticoes or spires. The landscape architect and urban designer go further; in the floorscapes of gardens, roads and squares they provide such things as lawns, rough-grass, kerbs, asphalt, gravel, paving-slabs, brick, stone, cobbles, concrete, water and planting in close proximity. Functional requirements certainly come into it – you can't readily drive a car on a lawn – but perhaps these varied textures are in part the expression of archetypes in our unconscious minds; images of the many surfaces which our remote ancestors encountered in East Africa.

Japanese gardens provide, at least in my experience, the best examples of such varied textures. I show an illustration.

48 Part of the garden: The Imperial Villa, Katsura, Japan.

49 van Gogh: *Willow-wood and shepherd.*

Space

Here is a drawing by van Gogh. Despite its title, it depicts a space, not a pair of objects.

The idea that space is the chief constituent not only of architecture (so far as interiors are concerned) but also of all landscape and urban design is a commonplace among the practitioners of these arts. The layman, however, typically regards it as a residual background to form – whatever may be left over after objects such as pictures, walls, buildings or planting, have been imposed upon it. This may be because we have no word – like seeing, hearing, tasting – to describe the sensations which space engenders. We can use feeling, but if we do, so it is in a psychological sense like feeling angry or aroused or elated, not in a tactile sense like feeling pain. Furthermore, we have hardly any words to describe the nature of such 'feeling'. We can say that a space is agoraphobic or claustrophobic but such words are extreme; they may be applicable to an airfield or a prison-cell but hardly to a shopping street or a suburban back-garden.

Moreover, the character of a space varies with its usage; think how your living room felt when it was empty of furniture, how it feels with the family around the hearth and how it feels at a cocktail party. It varies with light; think of a square in a country town on a sunny day in June, on a cloudy November evening and after dark lit by street lamps. It varies with the seasons; think of an avenue in summer with leaves on the trees and in winter when they are naked. It varies with movement and hence with time; you can experience a picture by looking at it for a few minutes but to experience a space, and still more a sequence of spaces, you have to walk around it and this can't be done quickly. Furthermore the time dimension can't, like breadth depth or height, be illustrated; an author can only write about the experience of moving around a space, provide a plan or an air-photograph together with one or two ground level pictures and leave it to the reader to imagine what it would be like to experience a sequence of changing views as he walks around a lake or goes from an octagonal ante-room into a long hall. And finally these two varieties of experience are different, the IAC involved in outdoor spatial experience is not the same as that involved in the indoor variety; think of wandering through a park and compare it in your mind with a stroll around a cathedral.

It will be convenient, the reason will become apparent as we proceed, to begin by considering the outdoor variety leaving the indoor to Chapter Seven. Furthermore, since we are concerned with space as an aspect of IAC, we may properly ignore natural environments; our enquiry is about things like parks, squares, streets and gardens, not about things like deserts and mountain ranges.

This isn't a textbook on urban design theory and I can see little need to consider such arcane matters as open and closed vistas, centrifugal roundabouts and borrowed landscapes. There is, however, one aspect of the subject that does concern us: the phenomenon of controlled or leaking space, exemplified on the one hand by an Oxbridge quadrangle and on the other by a suburban road. Few people would deny that the environment of the quadrangle is more agreeable than that of the road or that the quadrangle's space is controlled while the road's space leaks out between the semi-detached houses. If our hypothesis is correct we should be able to show that this and related likes and dislikes – the sensations which space engenders – are the result of archetypes derived, as the consequence of genetic inheritance and perhaps natural selection, from some necessary aspect of our ancestors' environmental-awareness. Here again we are fortunate, there is a book, *The Experience of Landscape* by the geographer Jay Appleton which, though it does not discuss the matter directly, does offer some helpful pointers for our enquiry.

Appleton seeks to answer the question, 'What do we like about landscape and why do we like it?'[12] To this end, he, like us, traces mankind's aesthetic response – in this case his feelings about landscape – to an innate environmental awareness inherited from our remote ancestors. He points out that 'it is…not very long since a keen sensitivity to environment was a prerequisite of physical survival. Any creature born without it would be less likely to live long enough to procreate its species and, by the principle of natural selection, such a sensitivity would continue to be a distinctive attribute of surviving members of the species'.[13] He goes on to show that whether as a predator or as a potential victim of predation 'it is in the creature's interest to ensure that he can see his quarry or predator, as the case may be, without being seen',[14] adding, with examples to back up the assertion, that 'among so-called 'primitive' communities whose livelihood depends on hunting, there can be no doubt that a combination of searching

50 A prospect: a loch on the west coast of Scotland.

and hiding, whether these are rational or spontaneous activities, is fundamental to success'.[15] On this basis he offers two theories to explain our feelings about landscape: one, habitat theory, 'postulates that aesthetic pleasure in landscape derives from the observer experiencing an environment favourable to his biological needs', the other, prospect-refuge theory, 'postulates that, because the ability to see without being seen is an intermediate step in the satisfaction of many of those needs, the capacity of an environment to ensure the achievement of *this* becomes a more immediate source of aesthetic satisfaction'.[16] I can see little need to discuss habitat theory, it relates neither to space nor to the artificial environments with which we are concerned. On the other hand prospect-refuge theory is surely germane to space; a prospect must relate to a wide open space, a refuge to a space which is restricted, while a view from cover – wide and restricted at the same time – embraces them both.

Appleton's conclusions were, among other matters, the subject of a doctorate thesis on environmental preference by D M Woodcock, a postgraduate student at the University of Michigan. Woodcock sought to test prospect-refuge theory by showing photographs of prospects and refuges in three different natural environments (savannah, mixed hardwoods

51 A view from cover, the Pantheon, Stourhead, Wiltshire.

and rain forest) to a panel of two hundred judges. The photographs included, as prospects, not only wide views, which he called primary prospects, but also vantage points from which such views could be obtained, called secondary prospects; and, as refuges, not only views from cover where one could see without being seen, which he called primary refuges, but also areas from which one could see without being seen, called secondary refuges. The judges were asked to express their preferences in respect of each scene on a five-point scale.

Woodcock's findings only partly confirmed Appleton's theory. His judges expressed strong preferences for primary prospects and they preferred savannah to the other environments as the context for both secondary prospects and secondary refuges. On the other hand primary refuges — typically illustrated by photographs of views looking outwards from dense, visually impenetrable woods and thickets — were, if anything, disliked.

At first sight, Woodcock's findings suggest that prospect-refuge theory is of little help to us in our enquiry. I don't, however, think that this matters.

His judges liked primary prospects so that's OK, while their preference for savannah as the context for secondary prospects and secondary refuges is logical when we remember that our ancestors were savannah dwellers. As to the judges' dislike of primary refuges, this could well have been due to an error in Appleton's assumptions. He accepted the view, current at the time that he wrote, that our ancestors were hunters. In fact they were, as we have seen, originally scavengers. A dense, visually impenetrable wood or thicket may provide the right environment from which to stalk game but it doesn't sound like the place from which to keep an eye open for the left-overs from a hyena's breakfast or the partly chewed remains of a leopard's kill.

In these circumstances, it seems worthwhile to consider Appleton's refuges in the light of detailed researches into this aspect of homo erectus' lifestyle.

52 A primary refuge: a tropical rain forest, Brunei.

The study was carried out by Robert J Blumenschine and John A Cavallo whose paper, *Scavenging and Human Evolution*, was mentioned in Chapter Five. It begins by referring to an article by an American archaeologist, Glynn Isaacs, *The Food Sharing behaviour of Protohuman Hominids*, which had appeared some fifteen years previously. Isaacs showed that early hominids had home bases, adding that 'males ranged far in search of scavengeable meat or hunted quarry, females gathered fruits and tubers nearer home and families shared the take'.[17] Such a home base would have had to be secure and therefore restricted – it wouldn't be much use if it wasn't – add a view and it becomes one of Appleton's refuges.

Add a view. As part of their research Blumenschine and Cavallo carried out a remarkable piece of fieldwork. Their account is too long to quote in full but I must record some of their discoveries; in particular how they noted the ways by which scavengers found meat and how they learnt to predict the future availability and location of carcasses: 'to locate scavengeable carcasses before others did, we had to learn how to interpret the diverse clues to the presence of a carcass in riparian woodlands. They include the laboured, low-level, early morning, bee-line flight of a single vulture toward a kill; vultures perched in mid-canopy rather than the crown of a tree, where they nest [and] appendages of a concealed leopard or of its kill dangling from a branch...Every day we monitored the movements, hunting and feeding schedules, and belly sizes of predators, as well as the general activity of their prey. Apart from its possible nutritional payoffs, hominids might have used such information routinely to avoid predators'.[18]

It is surely evident that Woodcock's dense, visually impenetrable woods or thickets would have been useless for such activities and that our ancestors required home bases with wide views. We may conclude that his assumptions were faulty, that as a consequence his findings were mistaken and that Appleton's theory is valid so far as primary refuge is concerned.

His book is an important contribution to aesthetic enquiry. He doesn't, admittedly, discuss space but he isn't alone in that. More significantly, if not more seriously, he disregards an issue of great importance which relates directly to his theory. He hardly mentions security as an aspect of refuge, perhaps he took it as read, an insecure refuge is little more than a trap. Nevertheless, he provides one quotation, from Susan Isaacs, a child-psychologist, which is certainly a description of the creation of secure

refuge though he doesn't see it as such; instead he considers it to be an example 'of the emphasis of contraposition, which makes the refuge symbol conspicuous by being different and is a ubiquitous and deep-seated source of pleasure'.[19]

> 'Whenever the younger children in the school had an opportunity they would arrange the chairs and tables so as to make a "cosy place" with a defensive rampart…The defensive element comes out clearly here and there – "so that nobody can look in", "to keep us warm", or "to keep the tigers out", or "to keep the foxes out". Sometimes the children added to the intensity of their feeling of security by asking a grown-up to "be a tiger – and come from a distance, so that we can hear you growling."'[20]

We may perhaps consider that in this case Appleton's 'ubiquitous and deep-seated source of pleasure' is a matter less of contraposition than of spatial security, a characteristic both of the cosy place with a defensive rampart and of the Oxbridge quadrangle (but not, self-evidently, of the suburban road). And, as a supplement to his argument, that this enjoyment originated in our ancestors' need for refuge which not only provided view from cover, but could also be defended against predators. Think of the children's atavistic cry: 'Keep the tigers out.'

I hope you will agree that we have not only adduced sufficient evidence to conclude that there are spatial archetypes among the other typical situations in life which make up the collective unconscious but also that they derive from aspects of our ancestors' environmental awareness. Following Appleton we can divide them into prospect archetypes leading to images of wide views such as that which appears in Rembrandt's *Three Trees*, refuge archetypes leading to images of secure spaces like the ravine in Fan K'uan's *Travelling amid Mountains and Gorges*, view-from-cover archetypes leading to images of secure spaces from which a view can be obtained like the lane in Constable's *The Cornfield* and archetypes of all three leading to the extraordinary range of spatial experiences which enthral the visitor to Venice – the astonishment as he emerges from the city's strait, shadowed alleyways into the bright sunshine and wide enclosure of the Piazza San Marco; the change as he circuits the campanile into the narrower

53 *Above: Venice: The Piazza San Marco and the Piazzetta, air photograph.*

54 *Left: A Venetian alleyway.*

55 *Top right: The Piazza San Marco.*

56 *Bottom right: The Venetian Lagoon from the Piazzetta.*

space of the Piazzetta, open at both ends; the relief as he retreats from the dazzling sunlight to the shady arcade of the Doge's palace and the wonderment as he stands between the columns of St Mark and St Theodore to enjoy the still restricted prospect of the lagoon. In sequence, surely the most splendid cityscape to be found anywhere.

Scale

Scale, like sex, is easier to experience than to describe. It is usually defined – in connection with the visual arts – as the relationship of the parts, whether of a scene, a building or of some other artefact, to each other, to the whole and, in appropriate cases, to the human figure.

Look, for example, at the two pictures on the facing page: Mr and Mrs Andrews, evidently a prosperous farming couple, are shown on their estate. The corn stook in the foreground, the bench upon which she sits, the tree behind her, his dog and gun, the well-tended farm land, her silk dress – evidently put on specially for the occasion – all fit together perfectly. The couple are just as you would expect to see them or, perhaps more accurately, as they would wish you to see them. We can't say that of *The Five Eldest Children of Charles I.* The kids are OK – though the boy looks somewhat self-conscious in his lace collar and satin suit – but the dogs are ridiculous; the mastiff huge by comparison with the children, the spaniel tiny. Gainsborough, painting a picture to demonstrate the social position of his clients, ensured that all the parts of his picture were in scale with each other; van Dyck, painting a picture as a family record (and I'm sure also as a joke), showed the children as they were and their pets wildly out of scale with anything else in the room.

I chose these two examples because I thought that they might help to explain the meaning and implications of this possibly arcane concept but scale is less often a matter of pictorial art than of architecture and, still more frequently, of land- or townscape. The scale of a building may be small – like the façade of the Certosa di Pavia with its multitude of string courses, parapets, cornices and openings or large, like the west front of Peterborough Cathedral with its three towering arches. (Though I have to point out that in Peterborough the scale is inconsistent; that of the arches is overwhelming while that of the rest of the façade – the entrance porch, the

57 Gainsborough: *Mr and Mrs Andrews*.

58 van Dyke: *The Five Eldest Children of Charles I*.

panelling which covers all the forward surfaces, the enclosing towers with their spirelets – is small; you could make a home in that entrance porch. And the small scale of these elements serves, like the spaniel in van Dyke's painting, to make the arches appear even larger than they are.)

Uniformity of scale is tedious over a large area – think of any suburban housing estate. The mind requires contrast; contrast which in newspapers is provided by headlines and pictures – against the uniform scale of the columns of text – in parks by monuments and forest trees – against the uniform scale of turf, drives and undergrowth – in old cities by palaces, towers and religious buildings – against the uniform scale of the houses – and in new ones by skyscrapers – against the uniform scale of people and cars.

Scale isn't however only a matter of form, it is also a matter of space and of function. Think of Heathrow – an enormous flat emptiness with, upon it, an occasional aircraft or fuel tender like a match-box toy on the sitting room carpet – Red Square in Moscow – a vast parade-ground which only comes to life when it is filled with stuttering tanks or marching men – St Pancras Station – a glazed hanger the scale of whose lattice ribs nicely

59 W H Barlow and R M Ordish: St Pancras Station.

matched that of the steam trains for which it was designed – or the interior of Chartres Cathedral with the small scale of its side chapels, sequestered places for individual prayer, the larger scale of its aisles and ambulatory,

60 Chartres Cathedral: Plan & Interior.

corridors through which one may move from one part of the building to another without disturbing the worshippers, the larger scale of the choir, and the still larger scale of its nave, transepts, and crossing, assembly spaces for the congregation; a variety of spatial scale that is complemented by a similar variety in the scale of its details. Compare the small scale of the triforium arches, the larger scale of the clerestory windows and the arcade, and the still larger scale of the soaring vault.

Consistency of scale in the buildings, together with variety in their architectural character and an occasional enlargement of scale to give emphasis at a critical point in the scene is fundamental to the design of many townscapes. Look again at the illustration of the Piazza San Marco. Despite the arches on its façade, the cathedral is astonishingly small in scale for a building of its importance – its parapet is no higher than those of the buildings that surround the piazza – while its mercurial style, with all those domes, arches, mosaics, crockets, finials and bronze horses, could hardly be more different from the classical regularity of the square's other buildings. Add the red brick campanile, larger in scale than anything else in the vicinity, and you get unity – but with a single contrast – of scale

together with variety in the architectural character of the scene's constituents.

And where in nature would our ancestors have found such unity of scale combined with variety in a scene's constituents? Surely, in the storeys of the ecosystems of which they themselves formed a part. At each storey of a stable ecosystem the scale of its principal elements is, within broad limits, consistent. May I, to persuade you of the accuracy of this assertion, suggest that you carry out the following experiment:

Next time you are in a meadow lie down in it, on your side with an ear on the ground. One eye will be at the base of the grass, the other among it; open them both and survey the scene. The grass appears as a dense jungle through which you can only see a few inches, a ladybird with her hard, shiny, metallic wing-cases resembles a scarlet tank and an earwig some kind of prehistoric monster. All are of the same consistent scale except where a plant of cow-parsley towers above you like a tree.

Or if it is winter, and you don't fancy lying down outdoors, watch a wildlife programme on television. If it's about some tropical rain forest it will certainly show pictures of the forest canopy with its leaves, thin twigs, small birds and light agile monkeys, or if it's about a savannah there will be long grass, isolated trees, medium to large mammals, and birds, everything from a quail to a vulture.

Can you believe, in the context of van der Post's bushmen who 'knew the frontier tree by tree and grass by grass', that the tiny group who emerged from Africa ninety thousand years ago were unaware of this aspect of their environment? I can't. Nor can I believe that their ancestors would have survived for millions of years if this awareness had not been the subject of a genetic mutation. Such an awareness, transmitted over the generations to ourselves, would not only explain the ability of Gainsborough to achieve uniformity of scale in *Mr and Mrs Andrews,* of van Dyke to seek inconsistency of scale in *The Five Eldest Children of Charles I,* of that anonymous master to obtain variety of scale in Chartres Cathedral and of several geniuses over several centuries to bring about the combination of consistency and contrast of scale which we experience in the Piazza San Marco.

For scale and space are together the most important constituents of townscape.

Pleasing Decay

I wouldn't go quite so far as the Rev William Gilpin, an eighteenth-century gentleman of ideas and letters, who declared, in one of his *Three Essays on Picturesque Beauty* that 'a piece of Palladian architecture may be elegant in the last degree, but if we introduce it into a picture it immediately becomes a formal object and ceases to please. Should we wish to give it picturesque beauty…we must beat down one half of it, deface the other, and throw the mutilated members round in heaps. In short from a smooth building we must turn it into a rough *ruin*. No painter who had the choice of the two objects would hesitate which to chuse.'[21] You may laugh, but that is exactly what happened to the Parthenon. In 1687 it was half beaten down during a siege – it was used as an ammunition store by the defenders, a well-aimed bomb hit the gunpowder and the ensuing explosion caused the mutilated members to be thrown in heaps around the Acropolis – then, something over a century later, Lord Elgin defaced what was left by removing the sculpture and bringing his loot home to London.

Would you really like to see the Parthenon in its original form, its honey-coloured marble covered with a thin layer of white plaster upon which certain details were picked out in colour? I wouldn't, indeed the idea horrifies me. Why? What causes us to like patina on bronzes, half-demolished abbeys, the armless Venus de Milo?

The cause, whatever else it may be, certainly isn't IAC. The experiencer's enjoyment of such decay can't be the result of an unconscious communication by the artist; the decay happens long after the artist's death. It is sometimes, as in the case of the Parthenon, the consequence of vandalism, more often of things like earthquakes which shatter buildings, accidents which damage sculpture, plants which grow through cracks in masonry, weak acids in rainfall which dissolve limestone and colour bronze. Pleasing decay is the result not of art but of nature, sometimes assisted by man's destructiveness.

This is clear enough but what makes some decay pleasing?

If our theory is correct there should be, within the collective unconscious, an awareness-of-pleasing-decay archetype that leads us to respond to such things as ruins. Have we any evidence for the existence of an archetype of this kind?

Decay is a typical situation in life and our awareness of it should, according to Jungian theory, be an archetype. Furthermore, our environmentally conscious ancestors must surely have been aware not only of decay in general but also of the difference between recently killed, rapidly decaying flesh – stinking, fly-blown and dangerous – and long dead, slowly decaying timber – easily gathered and useful both for constructing shelter and, late in hominid history, for firewood. The one would have been eschewed, the other sought. It seems reasonable to suggest that *pleasing* decay, if it exists as a specific archetype distinct from decay in general, is the result of our ancestors' innate awareness of the potential value of dead timber. This seems possible, though I can see little reason why such awareness should have been innate rather than learnt, it could, surely, have been either. If, however, it were innate, the appropriate archetypal images should have appeared in different forms in many traditions. Have they?

So far as I have been able to discover, they haven't. I've never heard of pleasing decay as part of Judaic or Islamic culture; Hinduism venerates Shiva as the deity devoted to destruction, but to destruction not as something pleasing but as the necessary concomitant of regeneration; the Aztecs had, among their multifarious pantheon, the earth-goddess Tlazolteotl, the Eater of Filth – hardly an agreeable concept; we can't imagine the superlatively cleanly Japanese regarding decay as anything else but nasty; the Chinese enjoyed ancient monuments for their historical associations but were not attracted to ruins *per se*. If a building fell down they restored it but still regarded it as a relic of past times.[22] As to Europe, pleasing decay was never, to my knowledge, an aspect of classical, Byzantine, medieval, renaissance or baroque taste; the earliest reference to it that I have encountered – the phrase 'moss-grown domes with spiry turrets crowned' – appears in a poem that was written by Pope in 1717.[23]

(What, you may ask, of the ruins of ancient Rome? The answer is that they were not considered to be pleasing, as ruins, though they were regarded both as the relics of a golden age and, during the renaissance, as the model to which every architect should aspire.)

On this evidence, I don't see how there can be an awareness-of-pleasing-decay archetype in the collective unconscious. Nevertheless, some kinds of decay are pleasing. Perhaps pleasing decay is the expression of some other, more assuredly innate, aspect of our remote ancestors' environmen-

tal awareness; we shall have to look and see. Meanwhile we may reasonably place the problem that it engenders on the back-burner.

❈ ❈ ❈

I must apologise for this hotchpotch of material. I assembled it like this because I couldn't think of any way in which to categorise it. The next chapter will, I hope, be more ordered.

1 Laurence van der Post, *The Lost World of the Kalahari*, Penguin Books, 1962, p 221.
2 Gombrich, *The Sense of Order*, p xii.
3 See, in this connection, John E Pfeiffer, *The Creative Explosion*, Cornell University Press, 1985, p 142.
4 *op cit*, p 84.
5 Balaji Mundkur, *The Cult of the Serpent, an Interdisciplinary Survey of its Manifestations and Origins*, State University of New York Press, 1983, p 2.
6 *ibid*, p 5.
7 *ibid*, p 6.
8 See Stevens, *On Jung* p 67.
9 This is a brief, superficial, summary of a highly complex development. For a full account of the derivation of the early Christian basilica from those of ancient Rome see Richard Krautheimer, *Early Christian and Byzantine Architecture*, Penguin Books, 2nd ed, 1975 chapters 1-7, *passim*.
10 S H Skaife, *African Insect Life*, Country Life Books, 1979, p 163.
11 C G Jung, *The Archetypes and the Collective Unconscious*, Trans R F C Hull, Routledge, second edition, 1968, pp 44-45.
12 Jay Appleton, *The Experience of Landscape*, John Wiley and Sons, 1975, p vii.
13 *ibid*, p 67.
14 *ibid*, pp 70-71.
15 *ibid*, p 72.
16 *ibid*, p 73.
17 Blumenschine and Cavallo, *op cit*, p 72.
18 *ibid*, p 75.
19 Appleton, *op cit*, p 157.
20 *ibid*, quoting Susan Isaacs, *Social Development of Young Children*, Routledge, 1933, pp 362-363.
21 William Gilpin, *Three Essays on Picturesque Beauty*, 2nd ed, 1794, pp 7 and 8.
22 I have to thank my friend Professor Michael Sullivan for this information.
23 See Kenneth Clark, *The Gothic Revival*, Constable, 1928, p 27.

Chapter Seven

Archetypes and the Mathematics of Form and Space

I offer as a starting point two texts.

The first is from an article by the architectural critic, Christopher Alexander, who, writing in the late 'fifties, declared that 'the use of geometrical or arithmetical systems to provide internal order in buildings was favoured by the Greeks, by the Renaissance Italians and even…by the Gothic masters. The conviction that an order of this kind plays a major part in producing the experience we call beauty is a deep-seated one'.[1]

The second is a remark by the biologist, D'Arcy Wentworth Thompson, who – writing of 'cell and tissue, shell and bone, leaf and flower' – declared that 'their problems of form are in the first instance mathematical problems'.[2]

If, following these two authorities, we can trace relationships between certain aspects of the visual arts and similar aspects of nature's mathematics – aspects of which our ancestors must surely have been aware – we shall have further evidence in support of our theory.

Let us start with symmetry – or rather symmetries because, as we shall show, they come in several varieties.

Symmetries

According to the English crystallographer, J D Bernal, 'the basic concepts of three-dimensional symmetry are those of rotation, such as the symmetry of a flower; of inversion, as in the symmetry of the right hand and the left hand; and the combination of these with each other and with direct

movements in space. This can be done only in a limited number of ways: 230 for three dimensions, seventeen for two'.³ Seventeen of one and two hundred and thirty of the other are too much for us to cope with, we should do better to limit ourselves to the two basic concepts together with that, translation, in which the motive is repeated by a direct movement in space.

Let us take them in turn.

INVERSIONAL, MORE COMMONLY KNOWN AS BILATERAL SYMMETRY

We have already noted the symmetry of the hand-axe (we didn't describe it as bilateral but that was because at the time we hadn't got far enough with our argument) and have suggested that the extreme conservatism of the axe's design implies that the skills involved in making it were the result more of genetic mutations than of cultural influences; while the design's remarkably high quality could only have been achieved if these mutations

61 Leonardo da Vinci: *The proportions of the human figure.*

involved not only creative potential but also an awareness of symmetry together with the ability to chip flakes from a stone core.

If we are right in these conclusions we needn't worry about the provenance of bilateral symmetry in the visual arts. It had been innate in the minds of our ancestors for – give or take a few hundred thousand – one and a half million years before their emergence from Africa. We may, nevertheless, consider a few examples starting with what is surely the most celebrated expression of the mathematics of form in art: Leonardo's drawing of a man in a square and a circle.

Leonardo's drawing is, however, exceptional. This is partly because pictures which express strict bilateral symmetry typically involve the human figure and, unless – as in certain Byzantine mosaics or among a few Amerindian and aboriginal Australian tribes – the artist is working within a highly formal tradition, he seldom had occasion to show a figure, or even an individual, isolated and full-face; partly because such images could not have been used in the many cultures which employed the profile; and partly because artists of certain cultures which did not employ the profile, e.g.

62 *A painted skin tunic: Sitka, Alaska.*

63 *St John Chrysostom: Mosaic in the church of Saint Luke, Mount Athos, Greece.*

64 Dürer: *Adam and Eve*.

65 The 'Venus of Willendorf'.

66 Picasso: *A bull's head.*

67 *The Buddha fasting: Gandhara, borderlands of Afghanistan and Pakistan.*

68 The Chehil Situn Pavilion: Isfahan, Persia.

69 The garden, Marly near Versailles (now destroyed).

70 *The three great halls of the Imperial palace, Peking.*

71 *The Place Royale: Nancy.*

72 The north acropolis: Tikal, Guatemala.

73 Temple 1: Tikal, Guatemala.

74 Gateway, the Varadarajaswamy Temple, Kanchipuram, near Madras.

75 Joseph Paxton: The Crystal Palace.

76 A rug in the medallion and corner design: Persian.

China and Japan, went in for landscape more often than for the figure. As a result, bilateral symmetry as it appears in pictures is commonly confined to the west where it takes the somewhat relaxed form of a central feature flanked by two or more figures. Grünewald's *Crucifixion*, Dürer's engraving of Adam and Eve and Botticelli's *Birth of Venus* are typical examples.

But if strict bilateral symmetry is rare in pictures, it is common in sculpture. We encounter it from the so-called *Venus of Willendorf*, the earliest known carving, which has been dated at 30,000 years ago to Picasso's bull's head constructed from a bicycle saddle and handlebars. We might mention on the way – albeit with minor irregularities like one foot in front of the other – any number of Egyptian pharaohs, those extraordinary heads from Easter Island, the Atlantean columns of Tula, much from Buddhist India and medieval Europe as well as portrait heads like those of the queen mother from Benin, the Egyptian queen Nefertiti and many renaissance examples.

Strict bilateral symmetry is not, however, confined to sculpture. It appears in the lay-out of gardens, like those of the Chehil Situn at Isfahan, and of Marly near Versailles. It appears in townscapes situated as far apart

in space and time as the three great halls of the Imperial Palace in Peking, the Place Royale at Nancy and the north acropolis in the ruined Maya city of Tikal in Guatemala, where the vista goes up the side of a mountain. Until the impact of the picturesque movement in late eighteenth-century Britain, it appeared almost universally in architecture – I show examples from Mayan Guatemala, Hindu India and Victorian England. (I say almost because apart from Japan – where domestic but not religious architecture seems historically to have been asymmetrical – I can think of only one exception: the Erectheion.) It appears in many Persian carpets, notably in those which display the medallion-and-corner design, an arrangement which, by being bilaterally symmetrical in both the long and the short axes, emphasises the centre[4] and it appears – yes honestly – in virtually every piece of three-dimensional craftwork to be found anywhere. And that makes a lot.[5]

ROTATIONAL SYMMETRY

Bernal described rotational symmetry in terms of flowers. I don't think we need consider the geometry of the subject except to mention that the shape of a flower is just one of many kinds of rotation. Thus a circle is a rotation of a point that is rotated at a fixed distance from another point, a hexagon is, if you will forgive the language, the rotation of one side of an equilateral triangle that is rotated around the opposite apex; and they are only two examples – the most obvious ones – of two-dimensional rotational symmetry. Once we get into three dimensions we find the geometers talking about tetrahedrons, isocahedrons and, heaven help us, pentagondodecahedrons. I think we had better leave it to them, mentioning only that any two-dimensional rotation has a centre and that examples of three-dimensional rotational symmetry, though rotational in plan, are typically bilateral both in elevation and in vertical section.

In nature, rotational symmetry appears not only in flowers but in such things as snowflakes, the iris and pupil of the eye, the shape of a bubble, the raindrop ripples in a pond, many fruits – think of grapes, apples, the cross-section of an orange – certain round and starry fishes, craters – whether as part of volcanoes or, on the moon, as the result of bombardment by meteors, the four thousand or so different species of radiolaria micro-organisms described by Wentworth Thompson[6] and,

of course, the sun and the moon. Enough? I'm sure you can think of some more.

I can see little need to provide examples of rotational symmetry in architecture, garden design and the crafts. There are surely enough pyramids, domes, mandalas, steeples, columns, drums, baskets, wheels, coins, rose-windows, polygonal pagodas, circular pools, earthenware amphorae, porcelain vases, round tables, metal bowls, dinner plates, wine glasses, beer-bottles...to convince all but the most dyed-in-the-wool Freudian that there is a rotational symmetry archetype in the collective unconscious.

But there are, in this list, some items which deserve special attention; the domes, baskets, earthenware amphorae, porcelain vases, metal bowls, wine glasses and beer-bottles. They are all shells, and shells, whether of birds' eggs or of gourds, must have been of great importance to our ancestors. We have suggested that they required home bases with wide views for their scavenging activities, and that, while the males went after meat, the females gathered fruit and tubers nearer home. This is fine so far as it goes but it is hardly complete. A wild orange and a few berries may be tasty and they may supply vitamin C but they don't do much to quench the thirst, particularly during the dry season. Our ancestors needed water at the home base and to carry it there they needed shells, probably of gourds rather than birds' eggs; they would have been too small and fragile. Those who weren't aware of the potential of shells as water-carriers would have had to return frequently to the water-hole where they would have been in danger of predators. I think we can reasonably postulate an archetype for awareness of shells – the result of Darwinian selection – as well as one for rotational symmetry – the result of Kimuran genetic drift.

TRANSLATIONAL SYMMETRY

Perhaps we should begin by recalling Bernal's phrase. After describing rotational and inversional symmetry he referred to 'the combination of these with each other and with direct movements in space'. Geometers call this translation. It consists of the repetition of some geometrical figure, some object or, in a design, of some feature or combination of features.

In the visual arts single translations are rare. I'm sure they exist but offhand I can't think of any apart from lost-wax castings which, since the

original is destroyed in the casting process, hardly count. Multiple translations come in two forms: linked repetitions and detached copies of some master. We tend to consider detached copies as individual objects rather than as translations. Thus the stamps that we obtain in a sheet from the post office are all evidently linked repetitions but if we tear out one of them and stick it on an envelope it ceases to be a linked repetition and becomes a detached copy. And as a detached copy we regard it more as an individual object and less as a translation. The same is true of the artificial stone bird-bath in the garden, of van Gogh's sunflowers above the mantelpiece, of the china parrot on the sideboard. They are all translations but we don't think of them like that; to us each one, separated from its fellows, is a thing on its own.

The intrinsic quality of such detached copies, including the products of industrial mass production, is an interesting problem in aesthetics but it is not ours. We are concerned with the visual arts, not with industry; detached copies lie outside our bailiwick and I can see no need to discuss them here. We have enough to do to investigate linked repetitions.

77 King's College Chapel, Cambridge: south side.

I offer, as illustrations, three examples. The first is the chapel of King's College Cambridge, a building that not only consists of a series of clearly defined bilaterally symmetrical units – each one identical with the next in the series – but whose turrets at the four corners are also translationally symmetrical with each other, combining rotational symmetry with, in Bernal's phrase, a direct movement in space. We could hardly find a simpler architectural concept than that of the chapel's south elevation; a side-chapel base, a perpendicular window and a frilly parapet all defined by pinnacled buttresses and repeated a dozen times – they might almost have been prefabricated. Such simplicity in translational symmetry is characteristic of much western architecture, whether in the classical, the Romanesque or the gothic traditions. Think of the Parthenon with its repetitive colonnade, the leaning tower of Pisa with its invariant arcading, the Royal Crescent at Bath with its identical windows, doors and engaged columns.

Arabic culture – with its mathematical bent and its religious objections to the portrayal of the human figure – provided a more suitable milieu than either classical antiquity or western Christendom for the development of geometrical patterns in the two-dimensional arts and crafts. Look, for example, at this tile mosaic from the Alhambra at Granada. It does, I suppose, correspond to one or more of Bernal's seventeen patterns of two-dimensional symmetry but I'd rather not work out which; the analysis of this extraordinary assembly of translational, rotational and bilateral symmetries – all rectilinear and still more elaborate when seen in colour – is too much for my non-mathematical mind.

Not all translational symmetry is concerned with such abstract shapes. Occasionally we find human figures. These may be caryatids like those on the Erectheion and at Tula, reliefs of marching soldiers or chained captives – most common in Egyptian temples or Sassanian palaces – and stone engravings like this rubbing, from Bali, of girls playing in a gamelin band; a picture whose combination of regularity – in the girl's heads, torsos and legs – and variety – in their arms, hands and instruments – shows that translational symmetry can, in appropriate cases, be imprecise.

These few examples illustrate the fact that unlike its bilateral and rotational cousins translational symmetry is, in principle, infinite. There seems to be no reason, apart from cost and the space available, why King's College Chapel was designed with twelve bays, why the Alhambra's tiles

78 Mosaic wall-tiling, the Alhambra. Granada.

79 Girls playing in a gamelin band: stone-rubbing, Indonesian.

stopped where they did or why there are five virtually identical girls in the gamelin band. In each case the translations could, so far as the pattern is concerned, have been repeated indefinitely.

The same is true of nature. I have long suspected that Malthus' parents possessed a female cat and that his theory of population derived from his youthful experience of the creature's fecundity. Certainly Tiddles, our own family pussy, produced three litters of five kittens a year over her lifespan of some fifteen years (I drowned most of them). An economist friend calculated the number of her potential descendants who would, barring accidents, have been born during this period. I can't remember the figure but it went into millions.

Tiddles was a tabby. Her kittens were not, admittedly, all precise translations of their mother – they included blacks, greys, marmalades and tortoiseshells as well as tabbies – but they were recognisably cats, members of a single species. We seem to have, in our minds, a recognising-archetype which enables us to distinguish a cat from some other creature, moreover this mental attribute isn't new in evolutionary history; remember the remark of Griffin's which we quoted at the end of the section on profiles:

> 'The possession of mental images could well confer an adaptive advantage on an animal by providing a reference against which stimulus patterns can be compared, [and the] ability to abstract the essential qualities of an object and recognize it, despite various kinds of distortion is obviously adaptive.'

'The ability to abstract the essential qualities of an object and recognize it'. The presence of such an archetype in the collective unconscious would do much to account for the presence of translational symmetries in the visual arts.

But not only translational symmetries, all symmetries are about similarities; bilateral symmetries are about the similarity of one side of a mirror image to the other and rotational symmetries are about the similarities of sectors of circles and regular polygons to each other. We have suggested that there are both bilateral and rotational symmetry archetypes in the collective unconscious; on second thoughts I doubt if we need to postulate

separate archetypes for each one. A single 'recognizing-of-similarities' archetype is enough.

Rhythm

Well, not quite enough, there remains rhythm. There is no need to emphasise its importance in the arts – it is after all fundamental to music, poetry and dance as well as to much architecture and craftsmanship – but we may point out that it almost always involves two things; similarities and the dimension of time. You may be able to appreciate the rhythm of the windows on the south side of King's College Chapel at a glance but this is exceptional; you can't do the same with the flowing lines, flowers and birds in this border of a Persian embroidery, still less with the beat of a Brandenburg concerto, the pentameters of 'When to the sessions of sweet silent thought' or the swaying of the corps de ballet in a performance of *Les Sylphides*. The same is true of nature's rhythms. Think of breathing, heartbeat, the breaking of waves on the shore, the flight of birds, the running of animals, the thrusting of copulation, diurnal, lunar and seasonal change. They are all repetitions of similar events and they all take time for their experience. In these circumstances we may reasonably postulate a rhythm-archetype to accompany our recognising-of-similarities archetype in the collective unconscious.

Was the establishment of the rhythm archetype the result of natural selection, as the Darwinians contend? Or of chance, as was suggested by Kimura? It would have been nice, if you were a hominid, to be able to recognise rhythm in the gallop of a wildebeest or in the flight of a flamingo

80 Part of the border of a Persian embroidery.

but would the inability to recognise such phenomena have been fatal, over many generations, to the individuals concerned? Perhaps, in terms of natural selection, they would have been regarded as stupid members of their social group, would have found difficulty in obtaining mates, and would have died childless; or perhaps, as the neutralists suggest, a mutation leading to the establishment of the rhythm archetype became fixed within the population as the result of genetic drift. Either way the mutation seems to have happened; it is not for us to determine the process by which it became fixed in the mind; that can be left to the geneticists.

Fitting Together

FORM

All architecture, all joinery and many crafts involve fitting bits together. The bits may be as simple as the bricks in a wall, as complex as the ribs and panels of a gothic vault or as varied as the parts of a dressing-table but if they are to fit they must be mathematically related. Consider, for example, the stalactite dome in the Hall of the Two Sisters in the Alhambra. It not only possesses Wotton's delight, it is a precise assembly of geometrical units. An irregularity in any one of them would have set the whole thing awry. This suggests that we should, in terms of our theory, look for a 'fitting-together' archetype derived from the necessary environmental awareness of our remote ancestors.

The idea seems at best improbable. In the first place fitting together requires accurate measurement and though our ancestors may well have possessed some skill in measurement, accuracy was almost certainly beyond them. (You will see from Appendix Three that Brown's universals include 'the ability to express the measure of things and distances, though not necessarily with uniform units'.) Secondly, the things which we fit together – bricks to make up a building, pieces of hardwood to construct an item of furniture – are most commonly right-angled parallelepipeds (yes, honestly, let's call them RAPs. for short). The dome in the Hall of the Two Sisters, an assembly of three-dimensional octagons on a curved surface – is very exceptional. Nature, however, apart from a few crystals like dolomite, doesn't go in for either parallelepipeds or right angles; she prefers hexagons

81 The Dome in the Hall of the Two Sisters: The Alhambra, Granada.

and 120-degree joints.[7] And if right-angles hardly appear in nature, the idea that we have inherited some kind of fitting-together-with-right-angles archetype that our ancestors developed as a result of their environmental awareness is no more probable than the idea that they could measure accurately.

Nevertheless, both nature and we ourselves fit things together. There must be a link somewhere, perhaps it lies in anatomy, defined in my encyclopaedia as 'the study of the structure of living things'. Such a study

must include an investigation of how the parts of an organism fit together. The idea that our ancestors possessed an awareness of anatomy may seem improbable but there is evidence to support it.

Recent excavations have shown that homo heidelbergensis knew his anatomy. The *Guardian* of 14th September 1995 included an article about an excavation at Boxgrove in West Sussex of a site that had been occupied by these people. According to the author, Tim Radford, 'Boxgrove folk went in for butchery, using the gleaming new hand-axes. In one place a horse had been disassembled, in another two rhinos. Of this the bones are testimony. They have been gnawed by hyenas and other animals, but underneath the gnaw marks are clean efficient cuts from hand axes'. As for anatomy, he quotes a member of the excavating team: 'One of the things they tell us is that these people are extremely anatomically aware. There is no great meat-feast of slashing and cutting. They know exactly what they want to do when they are disarticulating.'

Was this awareness developed by heidelbergensis or did he inherit it from erectus? I think the latter is more likely. It is pretty evident that once erectus had found the remains of a kill he couldn't waste time; he had to butcher it and take it away before he was overwhelmed by crowds of vultures, jackals or hyenas hoping to share the meal. In order to do this with no more tools than a hand-axe he must have known something about anatomy. Those who lacked this knowledge would have lost out in the struggle for existence so that after many generations an awareness of anatomy would have become innate in the minds of the survivors – the ancestors of heidelbergensis and thence of sapiens.

Subsequently sapiens would have acquired a general awareness of fitting together so that we ourselves have inherited this awareness as an archetype.

This seems possible, though I'm sure you can think of a better answer; perhaps copulation. That's a matter of fitting together if anything is and even the behaviourists accepted that sex is innate in our minds.

But what about the right angle?

I don't think we need worry about it. The right angle seems to be the result of man's efforts to achieve quickly, though extravagantly, the kind of fitting together which in nature is the result of economy exercised over geological time. According to Peter S Stevens, nature's productions are 'shoestring operations, encumbered by the constraints of three-dimensional

space, the necessary relations among the sizes of things and an eccentric sense of frugality'.[8] The extravagance of the right-angle is easily demonstrated by comparing the lengths of the sides of a square and of a hexagon of equal areas. (To save you the bother of working it out the ratio is 1:1·108.) Hexagons are, however, awkward things, easy to fit together in regular, two-dimensional mosaics like honeycombs but impossible to join up into three-dimensional assemblies where the sizes of the units vary. Nature got over this problem by honing the different parts over aeons; think of the evolution of the skeleton. Man, having to do the same task in an instant, found that RAPs of all sizes can be fitted together easily. This, surely one of the great discoveries of history, can hardly have been an aspect of the Neolithic revolution. It seems to have been made independently by different cultures as part of the establishment of civilisation. I don't see it as part of the fitting-together archetype.

SPACE

Both nature, in anatomy and sex, and man, in architecture and the crafts, fit things together. But fitting together in architecture isn't only a matter of Wotton's *firmenesse*, of making certain that the cantilevers, rafters, struts and purlins of a hammer-beam roof join precisely or that the masonry of a tall minaret is arranged so that it remains stable in an earthquake; nor yet of delight, like the Alhambra's dome. It is also a matter of *commoditie*, of ensuring that the spaces of which a building is composed – in a house the rooms – are satisfactorily related to each other. And, as with forms, spaces must not only be mathematically related if they are to fit together, they must also be RAPs, or at least rectangular in plan. Consider, for example, the plan of Wren's favourite, but sadly unexecuted, design for St Paul's. All its domes, semi-domes vaults and piers are based on a series of overlapping and concentric squares. It was surely be one of the most elaborate pieces of spatial geometry ever devised. I can't see much need to analyse it; to do so would take up a page or so of text and by looking at the illustration you can do so yourself. One thing, however, is evident; for all the design's complexity its mathematics are as clear as a Euclidean theorem. This is not, perhaps, surprising; Wren was a mathematician and astronomer before he became an architect.

And what of delight in space?

Delight in indoor, as in outdoor space, is a matter of sequential, varied environmental experiences. Imagine what it would have been like to enter St Paul's by way of the huge portico, then to traverse a restricted space – semi-circular at each end – into the domed vestibule, then to go through another restricted space into a domed area flanked with semi-domes, then into the centre with its great inverted bowl above you and then, when you have got over that, to perambulate through the multiplicity of domes and semi-domes which surround it. Crikey!

(This can be done – but no longer, alas, by the general public. The 'great model' of Wren's design is preserved in the trophy-room of St Paul's and is arranged so that it is possible to look inside and see what the interior would have been like.)

The delight engendered by such sequential experiences must be, at least in part, a matter of fitting-together – a spatial equivalent of that engendered by the dome in the Hall of the Two Sisters. I'm sure, however, that there is more to it than that; a fitting-together archetype may well contribute to our response to some indoor space but it does not include variety, the dimension of time or the unnamed psychological feelings about space which we discussed in the last chapter and to which we have just referred – albeit by implication – in our account of an imaginary stroll around Wren's favourite design for St Paul's. If we are to offer an adequate explanation of indoor spatial delight we must seek an aspect of our forebears' lifestyle which related to spatial variety. What can this be?

It can't, like the archetypes which relate to outdoor spatial experience, derive from our ancestors' need for secure environments; indoor spaces are secure anyway. What kinds of space are there of which our ancestors may reasonably be assumed to have had frequent experiences and which relate to our own varied indoor environments? The most obvious is caves, within and without, but I can think of several others: narrow paths through thickety undergrowth, clearings in woodland, open jungle with tall trees and a high canopy, the forest edge where the scene changes to savannah, the savannah itself, ravines, the feet of cliffs, and above all the dome of the night sky. It is surely inconceivable that our environmentally conscious ancestors did not possess a gene that enabled them to be aware of such varied spaces, particularly when we remember that each one would have had different fauna and flora; important not only in regard to food and

82 Wren's favourite design for St Paul's, the 'Great Model': the portico.

83 Wren's favourite design for St Paul's, the 'Great Model': plan.

84 Three views of the interior.

The vestibule

The dome

The ambulatory

predators but also as the homes of different varieties of biting insects, thorn-bushes and stinging plants. Those who lacked such a gene would not have lasted long; imagine the effect on avoiding predators of blundering into a thicket of the giant stinging-nettles which exist – and we may presume existed – in certain of the Rift Valley's jungles.

I hope you agree that they must have had such a gene and that we can reasonably add a spatial-awareness archetype to the others whose origins we have sought to unearth.

Mathematical Consistency: the Module

We can declare, as an axiom, that anything which fits together perfectly or is precisely symmetrical is mathematically consistent. If it weren't it wouldn't fit together or the symmetry wouldn't be precise. Symmetry and fitting together are not however the only kinds of mathematical consistency to be found in the visual arts. There is another: the module, defined in the *New Shorter Oxford Dictionary* as 'a length chosen as a basis for the dimensions of parts of a building, items of furniture, etc. so that all lengths are integral multiples of it'. The phrase 'a length' is however, in my judgement, too restrictive; modules come in various guises: sometimes as linear dimensions, sometimes as rectangles, sometimes as RAPs, sometimes as squares. The use of a particular module may be the result of cultural or religious convention, as in Egyptian temples, of economy of construction, as in the building of a brick wall, of fitting together, as in the traditional architecture of Japan, of the process of manufacture, as in Persian carpets, and often of two or three of these at once. It might make things easier if we consider each influence on its own. Let's start with convention.

You will remember that in Chapter One we described the classical orders of architecture as the most subtle of artistic conventions. In these circumstances, it seems reasonable to begin our consideration of the module-as-a-result-of-convention with a word or two about its use in the classical orders. Here, however, we encounter a difficulty; the dictionary offers, for the purpose of discussions about the orders, a special definition: 'the unit of length by which proportions are expressed, usually the diameter or semi-diameter of the column at the base of the shaft'. If you refer to the illustration of the ionic order from the Erectheion on the facing page you

85 The Erectheion, Athens: the Ionic order.

will see what this implies. The engraving is carefully dimensioned but the dimensions are not lengths like feet and inches or metres and centimetres, instead they relate to a module – defined in this context as 'half the lower diameter of the column' and which is itself divided into thirty 'minutes'. This is straightforward enough but the dimensions are not all integral multiples of the module or even of the minutes. Thus the figure of 1 Mod 24 for the architrave means that it is one module and twenty-four minutes deep, while other figures, vertical and horizontal, include 1 Mod 21½ for the depth of the frieze and 1 Mod 20 for the upper diameter of the column. The figures are, in fact, ratios, ratios between the dimensions of the order's constituents and half the lower diameter of the column.

This version of the module-as-a-result-of-convention has the effect that whatever the order's size the dimensions of its constituents are all mutually related, thus providing consistency throughout the design while giving the scholarly architect freedom, within the rules, to indulge his whim. (I use the word scholarly because there are many cases in which – no doubt through ignorance – the convention has been disregarded. We may be sure that Lutyens, when he had 'the cheek to adapt' the Doric order did not have the cheek to disregard the convention.)

I don't think we need worry about the fact that the word module has a special meaning in the context of the orders. There it is used with reference to matters of detail, elsewhere it is used with reference to the underlying mathematical structure of the building or piece of craftwork. The commonest of such structures was a square grid upon which the plan was based. Thus analyses of the plans of Egyptian temples indicate that they were designed in accordance with a square grid whose module was defined by some significant feature of the building such as the length of the sanctuary, an arrangement which simplified the task of laying out the building on the site and was almost certainly devised in accordance with some religious or magical canon. (According to the Egyptologist Jean-Louis de Cenival, the Egyptian architect worked in accordance with a strict programme imposed on him by the theologians.)[9] Similar grids appear, also under the influence of religious requirements, in the Hindu temples of northern India (we shall discuss them in more detail later) but it was in renaissance Italy that we find what must be the most elaborate use of the conventionally derived module.

The architects of the Italian renaissance did not seek the module directly, it was the inevitable part of their theory of proportion, a concept which the architectural historian Rudolf Wittkower summarises by declaring that they held, as a conviction, 'that architecture is a science' and that 'each part of a building, inside as well as outside, [had] to be integrated into one and the same system of mathematical ratios',[10] ratios which derived from musical analogies based on Pythagorean and neo-Platonic philosophy. These analogies led them to take the consonant intervals of the musical scale as audible proofs for the beauty of the ratios of the small whole numbers 1:2:3:4; a concept which, when applied to the design of buildings required the use of a module. Thus, Palladio recommended seven shapes of rooms and three sets of ratios for height to width and length. The ratios were either 8 or 9 feet high for a room 6' x 12', and 6 feet high for a room 4' x 9'.[11] The shapes were circular, square (i.e. 1:1), the diagonal of the square for the length of the room, (i.e. 1:$\sqrt{2}$), a square and a third (i.e. 3:4), a square and a half (i.e. 2:3), a square and two thirds (i.e. 3:5), and two squares (i.e. 1:2). All – with the exception of 1: $\sqrt{2}$, an irrational number that was in practice hardly ever employed[12] – are based on a module of one.[13]

To a builder the convenience of fitting together is the greatest advantage bestowed by the use of a module, imagine how difficult it would be to construct a wall with bricks made in odd shapes and varied dimensions. Such convenience is not, however, the only consequence of the standardisation of brick sizes. Traditionally, the dimensions of a brick, allowing a bit for the mortar, were 9" x 4½" x 3" – heaven knows what they are now that everything is measured in millimetres – figures which provided a pair of modules, one horizontal of 4½ inches the other vertical of 3 inches, which controlled the lengths of walls, the positions and dimensions of window and door openings and the heights of eaves or parapets. To ensure economy of materials the architect had to design all these dimensions as integral multiples of one or other of the modules. If he didn't the bricklayer had to cut his bricks, an expedient which was not only wasteful but destroyed the consistent pattern of bricks and mortar-joints on the face of the wall; a pattern which expressed the modular nature of the design.

Bricks have to be small enough to be easily handled so the modules that derived from the standard brick were necessarily short. The traditional

86 The Imperial Villa: Katsura, Japan, plan

architecture of Japan, being one of timber frames, is not so constrained; its module – deriving from the wadded mats which cover the floor – is typically about 3'0" x 1'6"; a double square which, fitted together with others, determines the shapes and sizes of rooms. The accompanying plan of the Imperial Villa at Katsura (c 1650) shows how the system provides variety of space together with mathematical consistency.

Modules don't have to be large like those of seventeenth-century Japan and sixteenth-century Italy or medium-sized like those that derive from the dimensions of a brick, they can be less than a millimetre square. This is exemplified by the illustration of a motive of the great period of Persian classical design by the carpet designer Tahir Zadeh Bihzad. You will notice that the original was drawn on squared paper and that the design is made up not of flowing curves but of straight lines combined with jerky right-angled zigzags, the result of filling in tiny squares on the paper. It was done like this because Persian carpets are woven in knots arranged in a square grid, a technology which is incompatible with flowing curves, and each square on the drawing represents a knot; a modular system which

87 Tahir Zadeh Bihzad: a motive of Persian carpet design.

does much to provide Persian carpets with the consistency of design which we have noted in the orders of classical Greece, the temples of ancient Egypt, the brickwork of northern Europe, and the villas of both renaissance Italy and Tokugawa Japan.

We should, if there is anything in our theory, be able to find something in nature of which our ancestors must have been aware and whose form possesses such mathematical consistency without the symmetries that we have already encountered. Something which is, in a word, at once random and mathematically consistent.

What about trees? They are mathematically consistent – the buds, flowers and leaves of an oak are all similar – but it grows randomly as the result of external influences. Peter S Stevens sums it up in three sentences: 'Trees generate their parts in a regular and uncompromising manner and only end up looking random after disease and competitive struggle have taken their toll. Trees grow in a repetitive or modular manner. In any particular species every bud is like every other bud and at the time of its propagation every bud is related to its neighbours in the same way.'[14]

'Trees grow in a repetitive or modular manner'. Need we say more? Only, I think, to point out that if today's western townsman can distinguish an oak from an ash our environmentally-conscious ancestors must surely have possessed an innate capacity to recognise a tree's 'repetitive or modular manner' of growth; and that this capacity, passed on to ourselves, explains the presence of IAC in works, whether of architecture or the crafts, which likewise possess a modular structure.

88 T Medland: *The Panshanger oak, near Tewin, Hertfordshire, 1814.*

89 Oak leaves, flowers, acorns and a twig.

Proportion

The statement that an open space, a room, a building or a piece of craftsmanship is well-, or perhaps ill-, proportioned must be one of the commonest remarks in any critical discussion of architecture or the crafts, but what – apart from the idea that the speaker likes or dislikes the shape of the object concerned – do the words well- or ill-proportioned mean?

Euclid, a mathematician, wasn't concerned with *good* proportion, just with proportion itself. He defined it as the equality of two ratios. A phrase which can be expressed algebraically as $a/b = c/d$. This gives us a useful starting point; it indicates that proportion is both a matter of relationships – a to b and c to d as well as a/b and c/d – and an aspect of mathematics.

The most comprehensive study of the subject that I have encountered appears in P H Scholfield's *The Theory of Proportion in Architecture*. He points out that:

> 'in a building where all the parts are of different shapes the visual effect is one of the greatest possible disorder, indeed chaos. Order can be introduced by the repetition of similar shapes, and the highest degree of order results when comparatively few shapes are used, repeated as often as possible. This sort of order is one

which the eye can recognize. It is not a purely mathematical order which has to be consciously understood before it can be appreciated. We can therefore reasonably define the object of architectural proportion as the creation of visible order by the repetition of similar shapes'. To which he adds 'once we decide to use a restricted number of shapes for all the parts of a design the choice of these shapes is no longer an arbitrary affair. The smallest parts of a design add together to form larger parts, these larger parts form still larger ones and eventually we come to the largest parts which add together to form the whole. If we select a limited group of shapes for the smaller parts quite arbitrarily, we have no reason to expect that the shapes of the larger parts will belong to the same limited group. We must therefore select a group of shapes which can be added together in the most varied ways without reproducing any new ones.'[15]

Scholfield's definition is at first sight disappointing; it hardly gets us any further than we are anyway. 'The creation of visible order by the repetition of similar shapes' is very closely related to our own findings about mathematical consistency, while his statement 'the smallest parts of a design add together to form larger parts, these larger parts form still larger ones and eventually we come to the largest parts which add together to form the whole' might, perhaps should, have come out of our discussion of fitting together. There must be more to proportion than that.

Wittkower didn't think so. After devoting a hundred and fifty pages to the most terrifyingly erudite account of theories of the subject during the renaissance, he concluded that proportion was simply a matter of individual sensibility. In support of this opinion he quoted the French authority Julien Guadet who, after declaring that authors of the past had invoked science in order to establish a theory of proportion, added "elle n'a rien à voir ici; on a cherché des combinaisons en quelques sortes cabalistiques, je ne sais quelles propriétés mystérieuses des nombres ou, encore, des rapports comme la musique en trouve entre des nombres de vibrations qui déterminent des accords. Pures chimères…Laissons là ces chimères ou ces superstitions…Il m'est impossible, vous le concevez bien, de vous donner des règles à cet égard. Les proportions, c'est l'infini."[16]

"Les proportions, c'est l'infini." Is this enough for us? Can we, shrugging our shoulders, declare with Wittkower that proportion is no more than a matter of individual sensibility? Surely not, apart from anything else this idea merely shifts the problem. If proportion is a matter of individual sensibility what is individual sensibility?

Perhaps we should return to our theory. If there is anything in it, we should be able to demonstrate that there is a parallel between proportion in nature and proportion in the visual arts or, to put it the other way round, if we conclude that no general system of proportion exists in nature there can be no such parallel. In that case, Guadet's conclusion would match our theory.

I don't see how anyone can argue that a general system of proportion exists in nature. Are the trunk of the elephant, the neck of the giraffe or the powerful hind legs and exiguous fore limbs of the kangaroo proportionate to the bodies of the creatures concerned? Perhaps they are if you consider them individually but I defy you to propose a system that would accommodate their proportions as well as those of every other mammal to be found on this planet, not to mention birds, insects, fishes, plants or crystals. Whatever may be the case in the visual arts, 'Les proportions, c'est l'infini' is certainly true of nature.

And, in that case, a system of proportion cannot be something of which our ancestors were innately aware, we cannot have inherited such awareness as an archetype in the collective unconscious and the phrase 'well proportioned' is, in terms of our theory, meaningless.

But is it? I don't think so. We have already declared, with Euclid, that proportion is not only a matter of relationships but also an aspect of mathematics and we have noted that Scholfield's definition is very closely related to our own findings about mathematical consistency, while his addendum might have come out of our discussion of fitting together. 'Well proportioned' seems to be a catch-all; a phrase which is used indiscriminately about any of the means by which mathematics provides internal order in architecture and the crafts. We have discussed several of them so far. You may be able to think of others but there is at least one more and, to make things easier, it accords with Euclid's definition. We shall consider it in the next section.

A Puzzle: the Golden Ratio

Here is an oblong. It may not look very much but I can assure you that it's unusual. It is a 'golden rectangle', something of which Christopher Alexander declared – in the article whose opening paragraph I quoted at the beginning of this chapter – that 'it is an unaccountable empirical fact that *this* particular shape pleases the eye'.[17] Can we, by means of our theory, account for the unaccountable? We can try, but first we must get a few details out of the way and adduce evidence concerning Alexander's assertion.

THE DETAILS:

(i) The sides of the rectangle are, as near as I can draw them, in the ratio 1:1·6180339. This is the so-called golden ratio, known to mathematicians as ϕ, the solution to the equations

$$x^2 - x - 1 = 0 \quad \text{or} \quad x = (1+\sqrt{5})/2$$

(ii) ϕ is, like π, an irrational number. I have written it to eight significant figures, the most that my pocket calculator can manage, but you can go on for as long you like. I suggest that we stop at four significant figures, 1·618. That should be ample for our purposes.

(iii) ϕ is the only number which, when diminished by one becomes its own reciprocal. Thus $\phi - 1$ or $1·618 - 1 = 0·618$ which is $1/\phi$. It is often written as ϕ'.

(iv) Any straight line or any rectangle can of course be divided in accordance with the ϕ ratio. The line that makes such a division is called 'the golden cut'.

(v) If you have a line which is divided into two parts at the golden cut and you call the length of the long part a and the length of the short part b you will find that $\frac{a}{b} = \frac{a+b}{a}$

(vi) The human eye is, as we have seen, good at recognising similarities of shape but it isn't perfect. Experiments have shown that in general people cannot distinguish between two rectangles whose height-breadth ratios are 6 per cent apart or less.[18] This means that while the mathematical golden rectangle is one whose sides are in the ratio of 1 : 1·618 the visually effective golden rectangle can be anything between 1 : 1·57 and 1 : 1·67 or ± 3% in each direction.

(vii) $(1+\sqrt{5})/2$ isn't the only way that ϕ can be calculated. If you take the sequence of numbers in which each number is the sum of the two which preceded it, e.g.

$1+1 = 2 \quad 2+1 = 3 \quad 3+2 = 5 \quad 5+3 = 8 \quad 8+5 = 13 \quad 13+8 = 21...$
(You can start with any two numbers but it's convenient to start with 1+1)

the ratio between the numbers in any one of these pairs gets closer and closer to ϕ the further you proceed in the sequence. This may sound complicated but it's easy. Look at this:

$1/1 = 1 \quad 2/1 = 2 \quad 3/2 = 1·5 \quad 5/3 = 1·67 \quad 8/5 = 1·6$
$13/8 = 1·625 \quad 21/13 = 1·615...$

And we have got quite a long way after only seven of these equations; 1·615 is 0·19% less than ϕ. Furthermore, any rectangle whose sides are beyond 5/3 in the series is visually if not mathematically golden.

(viii) The fact that the ratio between the numbers in any one of these pairs gets closer and closer to ϕ the further you proceed in the sequence applies

whatever numbers one may start with. Thus starting with 2 and 5 the sequence is

$$2+5 = 7 \quad 5+7 = 12 \quad 7+12 = 19 \quad 12+19 = 31$$

...and we get

$$7/5 = 1 \cdot 4 \quad 12/7 = 1 \cdot 71 \quad 19/12 = 1 \cdot 58 \quad 31/19 = 1 \cdot 63...$$

(ix) This sequence of numbers has a name. It is called the 'Fibonacci series' after the thirteenth-century Italian mathematician, Leonardo of Pisa, nicknamed Fibonacci (filius Bonacci), who rediscovered it, believe it or not, in the course of an enquiry into the breeding of rabbits.[19]

(x) The Fibonacci series is only one of a remarkable set of mathematical phenomena that involve ϕ. There is no need to consider them all here, our subject is not mathematics, but six of them – one concerning an angle, two the golden rectangle, one a spiral, one a star, and one a progression – relate to our enquiry and should be mentioned.

(xi) The angle:

We all remember that a triangle whose sides are in the ratios of 3:4:5 is right-angled with 5 as the hypotenuse. The angle between the hypotenuse and the side whose length is three is 53° 13′. According to my table of trigonometrical ratios, which does not include seconds, the secant of this angle is 1·67, pretty close to ϕ. An angle of 51° 50′ is closer still: 1·6183. (In case you have forgotten your school trigonometry the secant of an angle is the ratio of the hypotenuse of a right-angled triangle to the side adjacent to the angle concerned.)

(xii) Whirling squares:

If we divide a golden rectangle into two parts one of which, based on its shorter side, is also a golden rectangle the area which remains, called the gnomon, is a square. This process

can be repeated indefinitely. The pattern which results so mesmerised the American museum curator Jay Hambidge that he named it 'whirling squares'.[20]

(We should note that this property – though important for our enquiry – is a special case of a general phenomenon. Similar nesting patterns can be created with rectangles of any proportion but the golden rectangle is the only one in which the gnomon is a square.)[21]

(xiii) The whirling square rectangle:

Hambidge used the phrase 'whirling square rectangle' to describe a golden rectangle which is divided in this way. The phrase, though somewhat bizarre, is briefer than 'a golden rectangle which is divided into a square and another golden rectangle' and because I like brevity I have chosen to follow his example.

(xiv) The spiral:

It is clear that if we went on making smaller and smaller whirling squares we should end up with a point. This point is the pole of a spiral – of a type known to mathematicians as logarithmic – which passes through the opposite corners of the sequence of squares and golden rectangles which make up the pattern. The diagram should make this clear. (For the sake of clarity I should perhaps mention that there are two kinds of spiral. One the 'equable spiral' is exemplified by the spiral made by a rope coiled upon the deck of a ship. The rope is uniform in thickness so in the whole spiral each whorl is of the same breadth as that which precedes or follows it. The other, the 'logarithmic spiral' is exemplified by a snail shell. Here the whorls gradually increase in breadth in a constant and unchanging ratio. Logarithmic spirals are not all identical – the ratio may vary from one spiral to another – but they all have the same characteristic.)

(xv) The pentagram:

This is a pentagon whose sides are extended to form a five-pointed star and which includes a pair of concentric circles, one of which circumscribes the pentagon and the other the star. According to the mathematician, H E Huntley,[22] it provides 'a rich source of golden ratios'.

We need only mention one of them, the fact that the ratio between the radii of the two circles, is 1 : 2·618, a number which, as we show below, is both ϕ^2 and $1 + \phi$.

(xvi) The progression:

The progression 1, ϕ, ϕ^2, ϕ^3, ϕ^4, ϕ^5 ...(usually known as the ϕ progression) is not only a geometrical progression like 1, 2, 4, 16, 32 but is also a Fibonacci series staring with 1 and ϕ, thus:

$1 = 1$
$\phi = 1·618$
$\phi^2 = 2·618 = 1 + 1·618$
$\phi^3 = 4·236 = 1·618 + 2·618$
$\phi^4 = 6·854 = 2·618 + 4·236$
$\phi^5 = 11·090 = 4·236 + 6·854$
etc.

This characteristic of being at once additive and geometrical is unique to ϕ.

I must apologise for inflicting these morsels of mathematics upon you but they are a necessary foundation to the next few pages. Without them you could well find difficulty in understanding what follows – unless, of course, your mind is more mathematical than mine.

THE EVIDENCE: A NOTE ON DIMENSIONS

Unless otherwise specified, the dimensions that appear on the illustrations to this sub-section are dimensions, not lengths.)

ANCIENT EGYPT

I said earlier in this section that Fibonacci *rediscovered* the series that bears his name. It was known, thousands of years before he was born, to the temple-builders of ancient Egypt. Alexander Badawi demonstrates, from his analyses of numerous plans of Egyptian buildings mostly temples, that 'many cases show the use of the Fibonacci series'.[23] (I counted twenty.) He adds, however,[24] that the use of the series by the Egyptians has been contested by other authorities. In these circumstances it seemed wise to confirm his opinion with a sample study so I reworked one of his analyses – that of the plan of the mortuary temple adjoining the Pyramid of Chephren, a building which, in Badawi's opinion 'probably marks the apex of Egyptian culture'.[25] The result, set out on the next page, shows that his analysis was incomplete; the Egyptian priests of the third millennium BC were not only aware of the Fibonacci series, they also knew about the golden rectangle – look at the dimensions of the central courtyard, 0·74% above ϕ – and how to arrange a pair of whirling square rectangles so that they overlapped.

This, however, isn't all. I mentioned earlier that the secant of 51° 50′ is 1·6183 – 0·0003 away from ϕ. The angle of slope of the pyramid of Kheops (rounded to the nearest minute) is 51° 51′ (secant 1·619) while that of Mykerinus is 51° 20′ (secant 1·6) So not only were many temples laid out in accordance with the Fibonacci series but two of the three greatest pyramids have angles of slope whose secants lie within a whisker of ϕ (the third pyramid, that of Chephren, with an angle of slope of 53° 10′ is evidently based on a 3:4:5 triangle).[26] For this, the priests had no need for trigonometry; a right-angled triangle with its base and hypotenuse in the ratio of 1 to ϕ would have provided a model.

We may conclude that the Egyptian priests knew enough about the Fibonacci series, whirling square rectangles and ϕ to be able to use them as elements of design. In this, they knew what they were talking about; except that they didn't talk about it. The secret was jealously guarded, apparently for some two thousand years.

CLASSICAL GREECE

Greek geometry came, initially, from Egypt. It was brought to Greece by Thales, the master of Pythagoras[27] and then, perhaps, by Pythagoras

90 *The mortuary temple adjoining the pyramid of Chephren, Egypt: Plan and analysis.*

Plan after de Cenival: Fibonnaci series after Badawi but reversed (figures in Egyptian Royal cubits): figures for the ratio of the central couryard calculated after Maragigolio and Rinaldi, scaled from their drawing.

himself. Little is known of Pythagoras and what there is does not touch his mathematics but there is some evidence that he studied in Egypt. According to the historian of mathematics D E Smith tradition declares that Thales initiated him into the secrets of Zeus and then told him that if he would have further light he must seek it in Egypt. Smith adds that 'we now lose all definite knowledge of Pythagoras for a considerable period'.[28] He does, however mention two writers – Isocrates who lived a century after Pythagoras and Callimacus, librarian of the Alexandrian library who lived in the third century BC – both of whom declared that Pythagoras spent some years in Egypt. Smith adds that according to Pliny, writing in the first century of our era, he was in Egypt in the time of Psammetichus III by which time he was about forty-six years old. Perhaps he spent part of Smith's 'considerable period' among the Egyptian priests.

91 The Parthenon, an analysis of the façade.

He may have obtained from them the secret of the golden ratio; for knowledge of ɸ – though not so far as I have discovered the Fibonacci series – seems to have been fairly common among the philosophers, mathematicians and artists of fifth century Athens. Plato knew about it,[29] Ictinus and Callicrates, the architects of the Parthenon knew about it – they must have, look at this analysis. According to Hambidge it appears – together with other incommensurable numbers, in particular $\sqrt{5}$ – in the profiles of Greek vases so whoever designed them knew about it,[30] and the Pythagoreans, the followers of Pythagoras, used the pentagram as their emblem, something which they would hardly have done unless they knew something of its mathematical significance and liked its combination of rotational and bilateral symmetry. (I have to add, however, that other authorities have analysed the Parthenon's façade differently from that which I illustrate; Wittkower, in an essay, *The Changing Concept of Proportion*, lists five such analyses of which only one involves the golden ratio.[31])

THE SCHOOL OF ALEXANDRIA

Smith declares that the period from 300 BC to 500 AD marks 'approximately the period of influence of the greatest mathematical school of ancient times, the School of Alexandria'.[32] Alexandria was not, however, only a centre of mathematics, it became also the hub of Mediterranean commerce, and it was the home both of the first international university and of the greatest of ancient libraries.

It seems hardly possible that the scholars who lived and worked in this well-spring of intellectual activity, situated in Egypt, lasting for eight hundred years should have been unaware of the golden ratio and the Fibonacci series. They certainly knew about the ratio – Euclid, he was one of them, dealt with its geometrical properties in his *Elements* – but I have found only one reference to the series and that appears in what seems to have been a popular study; the *Introduction to Arithmetic* written about 100 AD by Nichomacus of Gerasa[33] – a late Pythagorean who, according to Heath, 'was not really a mathematician' and whose interests lay in the 'mystic rather than the mathematical side of the theory of numbers'.[34] I probably failed to find anything more about the series because I didn't look hard enough but the material may not be there to be discovered. Information about it must surely have been held in the library and between BC 46 and

AD 646 the library was the subject of several devastating fires. Of these the last occurred following the capture of Alexandria by the Arabs; an event which was part of the expansion of the caliphate throughout North Africa and the Near East following the death of Mohammed in 632. Of the library nothing remains. Its loss was surely the greatest disaster in the history of scholarship, perhaps of civilisation.

IMPERIAL ROME, BYZANTIUM

Much of Alexandria's intellectual eminence occurred during the Roman and Byzantine empires, but neither of them had much interest in mathematics. According to Smith, Rome 'showed no originality [in mathematics] and possessed no high ideals', while Byzantium 'did little for mathematics for a period of five centuries'.[35]

Nevertheless aspects of mathematics including both the golden ratio and the Fibonacci series did spread into Syria and Palestine where a number of churches and synagogues were laid out in accordance with the ratio – in one case with both the ratio and the series – during the Byzantine period. There were enough for Doron Chen, an Israeli archaeologist who has specialised in this field, to postulate a school of architects who were imbued with such ideas and who passed them on to their new masters after the Arab conquest.[36]

ISLAM

Chen based his argument on similarities of design between these buildings – notably the Rotunda Anastasis, The Church of the Holy Sepulchre in Jerusalem – and that of The Dome of the Rock, a building which was started only a few decades after the destruction of the Alexandrian Library. He shows[37] that its plan is based on two concentric circles – one which circumscribes the exterior of the building, the other which defines the inner circumference of the drum – and that the radii of these circles are in the ratio of 1 : 2·636, very close to 1 : 2·618, ϕ^2, the ratio between the radii of the concentric circles in the pentagram. Evidence surely of Pythagorean influence upon the design.

The concentric circles are not, however, the only place where ϕ appears in this building; the internal dimensions of the central space are very close to the golden ratio (the figures are 1· 0, its diameter, to 1·615, the height

92 The Dome of the Rock, Jerusalem: axonometric projection and elevation of the outer octagon.

from the floor-level to the centre of the dome),[38] while the dimensions of the octagon's sequence of stories give the Fibonacci series 3, 3, 6, 9 and 15.[39]

The Dome of the Rock dates from 688. During the next fifty years the Arab Caliphate established by conquest an empire which stretched from the Pyrenees through North Africa, Palestine, Mesopotamia and Iran to beyond Samarkand; an area which, except for Spain, has remained Muslim to the present day. It seems reasonable to suppose that the architects and craftsmen of this vast, culturally coherent region, adept at mathematics and with the precedent of the Dome of the Rock behind them, would have made use of ϕ and the Fibonacci series in their designs. Did they?

Perhaps, but there is little information. Apart from Chen's studies of the Dome of the Rock and Edwards' of the Persian carpet industry (discussed below) nobody, to my knowledge, has studied Islamic buildings and artefacts as Badawi analysed Egyptian temples, and Hambidge studied Greek vases. If we are to go further we are on our own, using as evidence measurements of published illustrations typically at a small scale. The results are necessarily inaccurate but I hope that you will consider them sufficient for our purposes.

The obvious place to start is the Alhambra. Anyone who could devise works of such extraordinary mathematical ingenuity as its tile mosaics and ceiling domes must surely have been aware of both ϕ and the series. Furthermore it has been measured and drawings have been published so we have something to go on.

I have found two sets of drawings; one of them by a Frenchman, Jules Goury and – from his name I suppose a Welshman – Owen Jones, which were published in two volumes in 1842 under the title *Plans, Elevations, Sections and Details of the Alhambra*. They include a plan, at too small a scale to be useful, some superbly drawn elevations and sections as well as many details of wall-patterns. The other, which consists only of a plan, appears in *L' Architecture de l'Islam, de l'Atalantique au Gange* by a Swiss, Henri Stierlin.

I could find nothing in this material that related to the Fibonacci series. Perhaps this was because it had been forgotten during the six-hundred years which passed between the completion of the Dome of the Rock and the building of the Alhambra, or perhaps because the regular geometry of the

93 The Alhambra, Granada: plan.

Alhambra's decoration could not accommodate the series' gradually increasing progression. But if the series isn't there, the golden rectangle is. You don't, admittedly, see it all over the place, I found only four examples of which two – a niche and a panel of tile mosaic – are not particularly important. The other two are, however, critical to the design. The palace is built around two courtyards. One, the Court of the Lions – so called from

94 The Alhambra, Granada: the west pavilion in the Court of the Lions.

the lions that decorate its central fountain – is, in plan, a double square. The arcade which surrounds it is punctuated by pavilions in the centre of each short side and one of these, the focus of this part of the space, the link

with the remainder of the palace is, in elevation, a visually effective golden rectangle (its ratio is 1:1·6). The other courtyard, the Court of the Myrtles, is simpler, with plain walls and an arcade at each end. It too is a visually effective golden rectangle, this time in plan. (Its ratio is 1:1·59.) We may conclude that the Alhambra's architects not only knew about the golden rectangle, they knew how to use it both as an aspect of space and as the basis of an elevation.

The architecture of Mughal India is highly mathematical and we might have expected it to include φ. In fact φ seems to have been used occasionally, but not often. The plans of Mughal tombs and mosques were almost always based on squares or double squares and in Mughal architecture's most typical feature, a pointed arch set within a rectangle, the rectangle was seldom golden. Thus there seems to have been only one in the palace of Fathepur Sikri, Mughal architecture's most elaborate complex, built by the emperor Akbar in the early sixteenth century. (Most of the other nine golden rectangles in the palace appeared in relatively unimportant details like door openings or veranda screens.)[40] It seems that the architects of the time either didn't know about φ or, if they did know, were not specially interested. A pity, they missed something.

There doesn't seem to be much point in looking for φ in Islamic pottery; for all their charm and vigour neither the copper-lustre dishes of Moorish Spain nor the slip-ware bowls of medieval Persia possess the mathematical purity of Greek vases. Persian carpets are a different matter. They are the finest examples of their kind and they are always rectangular. Perhaps some of them are, in shape, golden rectangles.

Here we have a well-documented piece of evidence. In his book, *The Persian Carpet*, A Cecil Edwards gives details of the approximate dimensions of seven types of carpet. One of them, called variously *dozar, khalicheh or sedjadeh*, is described as being 7'0" x 4'6" (1·35 x 2·10 mtrs.) in size.[41] These dimensions are in a ratio of 1:1·556. He emphasises that they are approximate but it is evident that the proportions of the dozar (we'll call it that for short) lie just outside the range of a visually effective golden rectangle. (To remind you the range lies between 1:1·57 and 1:1·67.)

All but one of the carpet dimensions which Edwards mentions are given either in whole numbers of feet or in feet and six inches (the odd one is 2'3"). This seems strange; why should Persian weavers have worked to

British imperial units? The puzzle is explained if we realise that Edwards was writing not about the traditional Persian carpet industry but about the industry during the first half of the twentieth century; one in which carpets were woven for export in accordance with specifications prepared by western, frequently British or American, agents. These people would, naturally, have used their own measuring systems. Perhaps equivalent dimensions using the original Persian system would give a shape for the dozar which was even closer to the golden rectangle than that given by Edwards' figures.

I have tried to confirm this possibility but without success. Perhaps you can do better than I.

HINDU INDIA

The eleventh-century temples of northern India often consisted of a rectangular platform upon which various buildings, a tower (known as the garbha-griha) an assembly hall (known as the mukhashala) and four shrines, were disposed symmetrically in accordance with a square grid.[42] Thus, in the Brahmeshvara temple at Bhuvaneshvar in Orissa (illustrated on the next page), the sides of the platform are in the ratio of twenty-one squares east and west to fourteen north and south; so forming, at one end of the platform, a large square of fourteen units in each direction and at the other end a double square of seven units east and west by fourteen north and south. The garba-griha is placed at the centre of the large square while the mukhashala lies partly in the large square and partly in the double square.

All this is evident from the plan. What is, perhaps, less obvious is that the sides of the platform are in the ratio of two to three, that the north-south axis of the mukhashala lies on the dividing line between the grid's eighth and thirteenth squares and that the focal point of the mukhashala – the image of Nandi, the bull, Shiva's mount – lies not in the centre of the space but a little to the west.

Two to three and eight to thirteen are Fibonacci ratios, and the line between the eighth and thirteenth squares on the grid is its golden cut. Furthermore, the golden cut of the mukhashala's internal space occurs across the image of Nandi. These things could not have been accidental; the priest-architects of this and similar Hindu temples must have been aware of both ϕ and the series.

The golden cut of the Mukhashala

The golden cut of the grid

Nandi

The Garba Griha

The Mukhashala

N

95 *The Brahmeshvara temple Bhuvaneshvar, India: elevation, section and plan.*

In southern India the principles seem to have been the same but their application was different. Here we find neither platform, garbha-griha nor mukhashala. Instead there is a sequence of nearly concentric walled rectangles dedicated to different activities; activities which become more sacred as one approaches the centre. This is the brahma-sthana, the domain of Brahma, the holy of holies;[43] an arrangement which is exemplified in the temple-city of Srirangam. Its brahma-sthana lies on the temple's golden cut, while the measurements between the walls of its concentric rectangles accord with the Fibonacci series.

We may conclude that the priest-architects of southern India must, like their colleagues in the north, have been aware of both ɸ and the series.

96 The temple-city of Srirangam, India: plan.

97 *Teotehuacan, Mexico: The sacred complex, plan.*

This concept is supported by Andreas Volwasen's account of the codes which determined the design of Hindu temples. He says that 'the proportion between the length, breadth and height of the various parts is the subject of detailed, hardly comprehensible rules',[44] rules which were based on religious or magical requirements and were designed not only to correlate the various parts of a temple in an aesthetically pleasing manner but also to 'bring the entire building into a magical harmony with time and space'.[45] The extraordinary mathematics of ϕ would surely have accorded with this magical harmony.

ANCIENT MEXICO

The 'Way of the Dead' in the ancient city of Teotehuacan – two and a half kilometres long, culminating in a pyramid with a forecourt almost a hundred and forty meters square – is certainly one of the grandest processional ways ever devised (for comparison the Champs Elysées is about 2·1 kilometres long and the Place Charles de Gaulle about 200 meters in diameter). But its grandeur isn't all; the pyramid at the end – The Pyramid of the Moon – is small by comparison with its companion, The Pyramid of the Sun and, as you can see from the illustration, the apex of the Pyramid of the Sun lies virtually on the golden cut of the line between the centre line of the citadel and the apex of the Pyramid of the Moon.

So the Toltec priests of the second and third centuries must have known about the golden ratio.

CHINA AND JAPAN

In this they were more aware than the scholars and architects of China or Japan. Neither ϕ nor the Fibonacci series is mentioned in the volume of Joseph Needham's massive *Science and Civilization in China* which deals with mathematics; Michael Sullivan assures me, in response to an enquiry, that the golden ratio doesn't appear in any aspect of Chinese art; while traditional Japanese architecture is based, as we have seen, on the proportions of the double square not on those of the golden rectangle. All this seems to be pretty conclusive.

Nevertheless, close approximations to ϕ do appear – though I am sure not deliberately – in the arts of both cultures. If we examine Chinese landscapes and Japanese woodcuts we find that the most striking element

in the picture often lies on or close to the line of the golden cut. Thus an investigation of the illustrations in *Symbols of Eternity*, Sullivan's immensely erudite study of the history of Chinese landscape painting, shows that this happens in more than half of his sixty-six illustrations of complete pictures (i.e. omitting those which only show details). To take as an example a picture which we have already mentioned elsewhere: in Fan K'uan's *Travelling amid Mountains and Gorges* the coincidence occurs at the tips of the pine trees in the middle distance where a line would divide the picture in the ratio of 1 : 1·66; The same occurs in half of the one hundred and forty-seven illustrations in Matthi Forrer's *Hokusai Prints and Drawings*.[46] (In the example which I illustrate, *Farmers Crossing a Suspension Bridge*, the kink in the bridge is at a ratio of 1 : 1·55 across the picture.) We may conclude that φ lay, unconsciously, in the minds of these masters.

98 Hokusai: Farmers Crossing a Suspension Bridge.

MEDIEVAL EUROPE

I must apologise for bouncing you around from ancient Egypt to classical Greece, from Arab Palestine to Moorish Spain, from Hindu India to Toltec

Mexico, from Sung dynasty China to Tokugawa Japan. You must by now be a bit dizzy. Don't worry. We are coming back to Europe and we shall stay there.

I don't know whether it was a result of the destruction of the Alexandrian library or of the ravages of the Goths, the Huns and the Vandals, but, apart from Fibonacci, medieval Europe didn't go in for mathematics. The only aspect of ϕ that interested the seers of the time was the pentagram. This – as we have seen the emblem of the Pythagorean brotherhood – was transmitted, perhaps by Boetius, across the dark ages to the medieval period.[47] It was used as a magical symbol by alchemists and astrologers,[48] it was one of the esoteric recognition symbols of the guild of stonemasons[49] and, according to the Swedish architect F M Lund,[50] it provided the basis for the sections and certain details of several gothic cathedrals. I confess to finding his concept improbable and his argument unconvincing but that may be my fault; his analytical drawings are not easy to interpret and I may have got them wrong.

THE ITALIAN RENAISSANCE

Fibonacci was the only great mathematician of the medieval period but for all its mathematical importance his study of the breeding of rabbits had little effect on architecture. The interest of the gothic masters in theories of proportion was limited to the repetition of simple geometrical figures like equilateral triangles[51] and, though the architects of the Italian renaissance were profoundly concerned with mathematics, their concepts – based as we have seen on musical analogies derived from Pythagorean and neo-Platonic philosophy – could not relate to the golden ratio or the findings of Fibonacci.

The pictorial artists of the time were less inhibited about these matters than were the architects. Thus Michelangelo arranged *The Creation of Man* in the Sistine Chapel so that the point where the fingers of God and of Adam almost meet lies within one per cent of the panel's golden cut (though I have not discovered whether this remarkable accuracy was no more than apparent, a consequence of the unavoidable error that results from measuring a photograph), the mathematician Luca Pacioli wrote an essay about the golden ratio – entitled *De Divina Proportione* – which was illustrated by his friend Leonardo da Vinci, while Piero della Francesca,

99 Piero della Francesca: *The Baptism of Christ*.

100 Michelangelo: *The Creation of Man.*

also a friend of Pacioli, based that extraordinary masterpiece *The Baptism of Christ* in the National Gallery on a grid of golden rectangles. Such ideas were not, however, acted upon by architects. They kept to the musical analogy.

THE BAROQUE

We think of the baroque as the time of Bach and Handel, of the palaces of St Petersburg, of elaborate German, and still more elaborate Spanish churches, but it was also, at least at first, the golden age of mathematical discovery. It was, to mention only the best known names, the time of Galileo, Leibniz, Halley, Newton, Descartes, Kepler and Pascal; but apart from Kepler – who was so fascinated by ϕ that he called it, copying Pacioli, the 'divine proportion' – these masters don't seem to have paid much attention either to the Fibonacci series or to ϕ itself; they had other, more important, things on their minds. The artists and architects of the time were similarly preoccupied; Rembrandt and Vermeer were too concerned with light, Rubens and Bernini with movement, Cuvilliés and Fechtmayer with rococo ornament, Poussin and Le Nôtre with classical formality – to bother with the mathematics of the golden ratio.

There were occasional exceptions. Wren, as we have seen a mathematician as well as an architect, designed the north, east and west façades of Oxford's Sheldonian Theatre in the ϕ proportion and some of the baroque painters focussed an occasional picture on the line of its golden cut. Thus in Rembrandt's *Night Watch* it lies across the man in profile (in the original dressed in bright yellow) in the foreground, the face of the pikeman behind him and the escutcheon on the wall above. I'm sure that you can find others.

Meanwhile fashions were changing. By the middle of the eighteenth century, and particularly in England, people had begun to question the musical analogy. Hogarth in his *Analysis of Beauty*, published in 1763, commented on 'the strange notion [that because] certain uniform and consonant distances upon one string produce harmony to the ear...similar distances in lines belonging to form, would, in like manner, delight the eye'.[52] At almost the same time Lord Kames declared in his *Elements of Criticism* that 'to refute the notion of a resemblance between musical proportions and those of architecture, it might be sufficient to observe in general that one is addressed to the ear, the other to the eye and that objects

101 Rembrandt: *The Night Watch*.

of different senses have no resemblance, nor indeed any relation to each other'.[53] And when, with the start of the romantic movement, the Reverend William Gilpin mourned the demise of classicism – 'the secret is lost. The ancients had it…if we could only discover their principles of proportion'[54] – the way was open for studies of ϕ not only as part of mathematics but also as an aspect of design.

THE NINETEENTH AND TWENTIETH CENTURIES

We have already referred to a number of these analyses –Hambidge's of Greek vases, Badawi's of Egyptian temples, Chen's of the Dome of the Rock – and there doesn't seem to be much need to discuss them further. There was however one, by Sir Theodore Cook, an Edwardian scientist, that should be mentioned though I find it only partly convincing.

Cook gave an account of plants like houseleeks and molluscs like nautilus shells which are generally agreed to be beautiful and which grow in logarithmic spirals in accordance with the ϕ progression. On this basis he proposed a hypothesis: that the relationship between these three phenomena: beauty, the logarithmic spiral and ϕ, indicates the existence of a correspondence between the principles of growth and those of beauty. To test this concept he prepared, on tracing linen, a scale of the ϕ progression and set it against reproductions of 'familiar pictures by great artists'. He found, as he expected, that important features in the pictures were often distributed in accordance with the scale. He concluded that the hypothesis appeared to be valid but emphasised that it must not be pushed too far. To illustrate his argument he showed three examples among, he said, many: Frans Hals' *The Laughing Cavalier*, Turner's *Ulysses Deriding Polyphemus* and a Botticelli *Venus*.[55]

I tried to do the same but I couldn't make his system work. I found that even with the examples which he illustrated I did not always share his opinion about which of the picture's features were the most important and when I went on to apply his technique to Persian miniatures, Chinese landscapes and Japanese woodcuts any such decision appeared quite arbitrary. This, of course doesn't mean that his hypothesis is mistaken, only that I don't seen how it can be applied to pictures. In other contexts it could well be valid.

This, however, is not all.

During the late nineteenth century a number of experimental psychologists carried out studies of ϕ, investigating how it appeared not in monuments of past civilisations but in phenomena of their own time. The first of these was by a German, Gustav Fechner, who seems to have been stimulated by a study carried out by his compatriot, Adolf Zeising. In an effort to establish whether people liked the golden rectangle for its own sake he made literally thousands of measurements of rectangular objects like book-covers, window-panes, sheets of writing paper and playing-cards. He took their average and found that it was close to the golden rectangle. From this, he went on to prepare a set of ten rectangles varying in shape from a square through a golden rectangle to one whose proportions were in the ratio of 2:5. He showed the rectangles to a number of respondents and asked them to say which shape they liked the best. The results, shown

102 Gustav Fechner: Graph showing people's preferences for various rectangles.

on the accompanying graph, indicate that thirty-five per cent preferred a mathematically exact golden rectangle, and over forty per cent preferred one which was visually though not mathematically golden – 75.6 per cent in all.

Fechner's experiments were made in 1876, since they have been repeated elsewhere. Results varied but rectangles that were most nearly golden were selected by more subjects than any other though in three cases the curves had peaks some distance away from ϕ.

Another experimenter, R P Angier, asked his respondents to move a dividing strip along a horizontal line to the position that produced the most pleasing division other than at the mid-point – an experiment which I have repeated many times but using a rectangle rather than a horizontal line. My own results matched Angiers'; there was a scatter of judgements but most respondents chose a division close to the golden cut.

These experiments have been much criticised and discussed. Huntley was positive: 'if Fechner's figures mean what they seem to mean, they point unambiguously to a popular preference for a rectangular shape closely approximate to that of the golden rectangle.'[56] D E Berlyne, in common with most commentators, accepted the theory but with some hesitation: 'the occurrence in so many experiments of a central tendency coinciding with the golden rectangle is at least suggestive'.[57] Scholfield concluded grudgingly that 'the series of experiments seems on the whole to have provided fairly faint praise for the golden section', adding however that 'the main objection to the whole theory is that the results of the experiments

103 A man, a woman and the golden ratio.

are so very slight and inconclusive'.[58] Katherine Gilbert and Helmut Kuhn were even more dubious: 'the slightness of the emotional reaction gives rise to another objection. How can these hardly noticeable feelings contribute in any considerable degree to the exuberant delight often awakened by works of art?'[59], while H Osborne dismissed it completely: 'the aesthetic stimuli used in these experiments are so elementary…as to be subliminal for all, or all but an abnormally sensitive, aesthetic sense and it is probable that no purely aesthetic response could be obtained from them…There is inadequate complexity for perception in constructions of this kind.'[60]

Many reasons have been offered for people's liking for the golden ratio but, with one exception they don't relate to our hypothesis and I can see little need to mention them here. (The dedicated student will find summaries in Berlyne, and in Gilbert and Kuhn who also provide a bibliography.) The exception is a suggestion, by Zeising, that we like φ because the ratio appears in our own bodies. Specifically, because in a standing figure the average ratio between the height of the figure and the distance from the navel to the soles of the feet is 1·625 in men and 1·6 in women – or, as I show in the illustration, the navel occurs very close to the figure's golden cut.

Zeising reached this conclusion as the result of what must have been a disagreeable and tedious piece of research; he measured over a thousand human bodies and analysed the results. His findings were picked up some seventy years later by Matila Ghyka and thence became a feature of Le Corbusier's *Man with his Arm Outstretched*, the logo for his *Modulor*.

This, a set of preferred dimensions, is the best known attempt to relate the findings of Zeising and his successors to the practice of architectural design. It consists of a pair of interlocking Fibonacci series – both of them φ progressions – whose controlling dimensions are based on those of the human figure. The controlling dimension of one, which Le Corbusier called the red series, is 183 cms – the height of a standing man, the controlling dimension of the other, the blue series, is 226 cms – the height of the man with his arm outstretched. In order that the two series should interlock they are arranged so that each number in the red series equals half a corresponding number in the blue series. Thus half the controlling dimension of the blue series – 113 cms – matches a dimension in the red series. And, as you can see from the diagram, the dimension concerned

neatly coincides with the position of the man's navel and hence with the line of his golden cut.

For all its ingenuity, the Modulor is somewhat limited as a design tool for the architect. Its preferred dimensions only give golden rectangles when

104 Le Corbusier: *The Modulor* – After F D K Ching: *Architecture, Form Space and Order.*

they are taken from the same series and, even when the series are mixed, the restricted set of dimensions which its use involves may produce inconvenient spaces or clumsy structures. Even Le Corbusier only used fifteen of them in the design of the *Unité d'Habitation* at Marseilles and that is quite a big and complex building. I can't imagine it being used in a field like low-cost housing where every centimetre counts.

Moreover, it isn't germane to our problem. Le Corbusier considered that the golden ratio and the Fibonacci series, when related to the human figure, provided an agreeable set of proportions and devised a means by which they might be used in the process of design. We, on the other hand, are investigating Alexander's assertion and, if we find that it is confirmed, hoping to account for it. Le Corbusier begged the question that we seek to answer.

AN ANALYSIS

What are we to make of all this?

First, that we have encountered two linked but very different numerical phenomena. One, the Fibonacci series, is an infinite progression of pairs of usually whole numbers, the other, ϕ, is a single irrational number. In the case of the latter the number can't be exact; an exact irrational number is a contradiction in terms. (Our own figure for ϕ of 1·618 is of course a convenient approximation.)

Secondly, that in order to be used, the series had to be carefully calculated and, until the twentieth century, seems only to have been employed because the numbers concerned were believed to possess religious or magical significance. By contrast, though the use of ϕ must frequently have been the result of calculations – we can't imagine that the angles of slope of the pyramids, the east front of the Parthenon, the pavilions of the Alhambra, the Baptism of Christ, the controlling circles of the Dome of the Rock, the plan of the Brahmeshvara temple and the position of the Pyramid of the Sun were defined without mathematics – its use was often approximate, evidently unconscious, and frequently without religious or magical significance. It seems that in many cases the artists, architects and craftsmen who used the ϕ proportion did so simply because they liked it.

This conclusion matches the findings of the experimental psychologists: Angier's that people chose to divide a rectangle or a horizontal line roughly in accordance with the golden cut and Fechner's that people like the shape of the golden rectangle.

We may also conclude that the dismissive attitudes of Osborne and of Gilbert and Kuhn to Fechner's findings can be explained by the historical circumstances that caused ϕ to be forgotten in western Europe. Had it been part of the cultural baggage of medieval Christendom and renaissance Italy

– as it evidently was of ancient Egypt, classical Greece, Hellenistic Alexandria, Byzantine Syria, Hindu India, Moorish Spain and Toltec Mexico – their attitudes to Fechner's and Angier's studies would surely have been different; though in that case the research probably wouldn't have been done anyway.

I hope you agree that Alexander's remark '*this* particular shape pleases the eye' is fully confirmed; the evidence is surely overwhelming. He, however, only referred to the golden rectangle. There are also the pentagram and the proportions that result from the golden cut. All three appear, in their different ways, in the story. What pleases the eye is not a shape, it is a proportion. It is, in different manifestations, ϕ.

Furthermore ϕ pleases not just our own eyes nor even the eyes of those whose cultures derived from Egypt, Greece and Byzantine Syria. It pleased the eyes of Tokugawa Japanese, of Toltec Mexicans, of Sung dynasty Chinese, and of eleventh century Hindus – people whose cultures arose independently of Mediterranean influence. For this to have happened ϕ must lie innately in the minds of us all.[61]

But what about the Fibonacci series? Is that innate also?

This seems less likely. In the first place, its appearance in the visual arts is infrequent and – apart from Hindu India which we discussed in the last note – seems to be limited to cultures with Mediterranean origins; and, secondly, its application involves an awareness of mathematics and if it were innate we should expect mathematics to be one of the activities of Brown's universal people. In fact it isn't; the list includes the ability to express the measure of things, as we have seen, but does not include mathematics.

It seems therefore that ϕ is innate in our minds but that the series is not.

And if ϕ is innate in our minds this extraordinary phenomenon is, by Jungian theory, an archetype. For that it should, by our theory, derive from some innate environmental awareness possessed by our remote ancestors. It can't do that unless it appears in nature, unless they knew about it and unless it was the subject of a genetic mutation. Does it so appear? And are the other criteria reasonably probable?

It certainly appears in nature, both directly as Zeising discovered in the proportions of our own bodies and indirectly as Cook showed in the logarithmic spirals exhibited by molluscs like the nautilus and plants like houseleeks – and not only houseleeks, he used them as an illustration because

they show the spiral arrangement very clearly but the great majority of plants grow in the same way. Botanists call it spiral phyllotaxis, its details are somewhat complicated and I don't think there is any need to describe them here except to say that they involve the Fibonacci series and, for ϕ, the link between it and the series. (For those who may be interested, I include an account in Appendix Six.) If, as we have just argued, our ancestors didn't know about mathematics they could not have spotted the link. It follows that an awareness of ϕ could not have come about as a by-product of an awareness of spirals.

We are left with it as an aspect of the proportions of the human body.

Here a question arises: why should our ancestors have paid such attention to the navel? Why not the chin? The nipples? The knees? The genitalia? Logically we might have expected the genitalia; not only are they the centre of sexual activity, there is a mathematical relationship between their position and the height of the standing figure – typically they lie at the mid-point – and to a man a blow in the testicles is agonisingly painful. A mutation that led to an awareness of the danger inherent in such a blow would have been genetically useful and might, at the same time, have involved a recognition that a one-to-one proportion is not limited to circumstances of bilateral symmetry.

Perhaps the same applies to the navel; it is of obvious importance as the site of the umbilical cord, it is the focal point of the abdomen, a blow there – especially after a meal – is hardly less debilitating than one in the testicles, and, most importantly, to a pregnant woman a blow in the abdomen could well induce an abortion and might be fatal. A mutation which led to an awareness of the dangers inherent in such a blow would certainly have been genetically beneficial and might reasonably have included a recognition of the navel as the centre of attention for that part of the body.

This, however, isn't enough. An appreciation of the importance of the navel doesn't necessarily imply a recognition of the proportions of the body which lie above and below it. Can we explain this also? Perhaps. We have suggested, following Griffin, that our ancestors could recognise similarities, and if they could recognise similarities they would, as a corollary, have been able to recognise anomalies including those in the proportions of the human body. (Even we can recognise a pregnant abdomen or a Jewish nose.) And if they could spot such anomalies they

would, as a corollary, have had to know about the body's normal proportions including the amounts that lie above and below the navel. Could such knowledge have been innate? Only, I think, as part of the huge and unexpected amount of variation whose presence in our genes is considered by the neutralists to be the result of genetic drift. And why not?

Finally, assuming that our ancestors knew about the body's normal proportions, why did they like them? Here, surely, we can follow Freud and attribute the liking to sex.

I confess that I'm not very keen on these explanations. The relationships between the human body, sex and enjoyment is self-evident but it does seem somewhat far-fetched to postulate a link between our liking for the proportion of 1:1·618 and an innate awareness on the part of our ancestors of those proportions of their anatomy that lay above and below the navel. On the other hand the alternative: a link between our innate liking for those proportions and an innate awareness by our ancestors of spiral phyllotaxis – with the understanding of mathematics which that implies – seems even less probable.

But surely the fact that ϕ appears not only in the arts but also in both spiral phyllotaxis and in the proportions of the human body provides the strongest argument for the theory that it lies in our unconscious minds as the result of two or three mutations that concerned our ancestors' awareness of one of these aspects of nature. Its presence must be the result either of multiple coincidences or of such mutations and the idea that it is the result of coincidences is even less probable than the theory. There must be a link somewhere and if it isn't an archetype in the collective unconscious what else is it? And where else, apart from the navel, did it originate?

OTHER IRRATIONAL NUMBERS

What about ratios like $1 : \sqrt{2}$, $1 : \sqrt{3}$, and $1 : \sqrt{5}$?

I don't think they matter much. If people liked these ratios, we should expect to encounter them in the studies of the experimental psychologists. In fact of course we don't. So far as architecture and the crafts are concerned we do find $\sqrt{2}$ here and there, $\sqrt{3}$ very rarely and $\sqrt{5}$ only, so far as I have discovered, in ancient Greece. Perhaps we should say a little about the circumstances of their appearance.

One of the few studies of this subject was provided by Hambidge's assistant, L D Caskey, who later became curator of Greek antiquities in the Boston Museum. He found that, of the 120 Greek vases in the museum, eighteen fitted within a $\sqrt{2}$ rectangle, six within a $\sqrt{3}$ rectangle and all the rest within rectangles based either on ϕ or $\sqrt{5}$ – evidence of preferences for ϕ and $\sqrt{5}$ among the Greek potters – while Hambidge himself found $\sqrt{5}$ in the façade of the Parthenon. The presence of $\sqrt{5}$ in these examples can hardly be a matter of a liking for the shape of the $\sqrt{5}$ rectangle; if so Fechner would have noted it. Perhaps the Greek potters and architects made use of $\sqrt{5}$ either because of its mathematical relationship with ϕ or because $\sqrt{5}$, being a diagonal of a double square, provided a rectangle which could be fitted, relatively easily, into a design based on squares.

The $\sqrt{2}$ rectangle was, as we have seen, recommended by Palladio but was hardly ever used, either by him or by other architects of the Italian renaissance. Its great advantage is that it accommodates the square's rotational symmetry and so provides opportunities for developing squares into octagons and star octagons like those which we found in the Alhambra. Among more recent western architects I have found only one, Lutyens, who used it in this way though there must have been others. We should realise, however, that its employment is a matter of convenience in fitting together rather than of any inherent attractiveness in the shape of the $\sqrt{2}$ rectangle.

There is however one very widespread example of its use: the A range of paper sizes. They are all $\sqrt{2}$ rectangles. There is a practical reason for this circumstance. If you divide a $\sqrt{2}$ rectangle into two you get a pair of smaller $\sqrt{2}$ rectangles, divide one of them and you get two more…etc., etc. Thus an A2 sheet is half the size of an A1 sheet, an A3 sheet is half the size of an A2 sheet, an A4 sheet is half the size of an A3 sheet and so on. All very convenient and economical but not a matter of aesthetic preference.

The Yin Yang Symbol

We started this chapter with a reference to Leonardo's drawing of a man in a square and a circle, describing it as 'surely the most celebrated expression of the mathematics of form in art'. I conclude with a reference to the Yin Yang symbol, an ancient Chinese device whose combination of rotational symmetry – in its form of a circle –, of translational symmetry – in the

rhythmical relationship of its two comma-shaped units –, of fitting together – in the way in which they snuggle into one another – and of geometry –, in the fact that the diameters of the smaller semi-circles together constitute the diameter of the whole circle – contribute to making it the most comprehensive, if not in the West the most celebrated, expression of the mathematics of form in art that I have encountered.

There is, however, more to it than that; the Yin Yang symbol is an expression not only of the mathematics of form in art but of a profound philosophical concept. Toynbee, after suggesting that hominid and human history can be seen as an alteration between a static condition and a dynamic activity, declares that Yin and Yang are the most apt among the symbols in which this idea has been expressed by different observers in different societies 'because they convey the measure of the rhythm direct and not through some metaphor derived from psychology or mechanics or mathematics'.[62] A view which places the Yin Yang symbol firmly – if for a philosophical concept unexpectedly – among Peirce's icons. (Remember what he said: 'A great distinguishing property of the icon is that by direct observation of it other truths concerning its object can be discovered than those which suffice to determine its construction.')

105 The Yin-Yang symbol.

I think, however that there is still more. The Yin Yang symbol is surely three images in one: the first of art and mathematics, the second of an alternation between a static condition and a dynamic activity and the third of unity in diversity. That is to be the topic of our next chapter.

1 Christopher Alexander, 'Perception and Modular Co-ordination', *RIBA Journal*, October 1959, p 428.
2 d'Arcy Wentworth Thompson, *On Growth and Form*, Cambridge University Press, 1917, p 8.
3 J D Bernal, 'Art and the Scientist' in *Circle: International Review of Constructive Arts*, J L Martin, Ben Nicholson and N Gabo, eds, Faber and Faber, 1937, p 120.
4 For an account of this design, see Edwards, *op cit*, pp 41-42.

5 To test this improbable concept I spent an afternoon in the Pitt-Rivers Museum in Oxford looking, in that great collection of ethnographic artefacts, for asymmetrical objects. I found about six of which two were made of animal horn, an inescapably asymmetrical material.

6 See Wentworth Thompson, *op cit*, p 457.

7 See Peter S Stevens, *Patterns in Nature*, Penguin Books 1976, pp 3-4.

8 *ibid*, p 4.

9 See in this connection Alexander Badawi, *Ancient Egyptian Architectural Design*, University of California Press, 1965, pp 35-36 and Jean-Louis de Cenival, *Egypt*, in Architecture of the World Series, Benedikt Taschen, Lausanne, pp 95-97.

10 Rudolf Wittkower, *Architectural Principles in the Age of Humanism*, Norton, 1971, p 101.

11 For an explanation of the theory behind these dimensions see *ibid*, pp 108-111.

12 'It is probably right to say that rarely did Palladio or any other renaissance architect use irrational numbers in practice', *ibid*, p 108.

13 For full accounts of the musical analogy, see Wittkower, *op cit*, pp 110-150 and P H Scholfield, *The Theory of Proportion in Architecture*, Cambridge University Press, 1958, pp 55-75.

14 Peter Stevens, *op cit*, p 123.

15 Scholfield, *op cit*, p 6.

16 Wittkower, *op cit*, p 154, quoting Julien Guadet, *Eléments et théorie de l'architecture*, 4th ed, 1915, Vol 1, p 138.

17 See Alexander, *op cit*, p 428.

18 *ibid*, p 426

19. For an account of ϕ and the Fibonacci series see H E Huntley, *The Divine Proportion*, Dover Books, 1970, *passim*. He discusses the rabbit problem on p 158.

20 Jay Hambidge, *Dynamic Symmetry, the Greek Vase*, Yale University Press, 1920, p 18.

21 See, in this connection, Lionel March and Philip Steadman, *The Geometry of Environment*, RIBA Publications, 1971, p 231.

22 Huntley, *op cit*, p 28.

23 Badawi, *op cit*, p 54.

24 *ibid*, p 53.

25 *ibid*, p 70.

26 Different authorities give different figures for the angles of slope. These are from Maragigolio and Rinaldi, *L'Architectura delle Piramide Menfite*, Turin 1964-5, the most recent and comprehensive account that I have found.

27 See Sir Thomas Heath, *A History of Greek Mathematics*, Oxford University Press, 1921, Vol 1, p 128.

28 D E Smith, *History of Mathematics*, Ginn and Co, 1923, Vol 1, p 71.

29 See Heath, *op cit*, Vol 1, p 304.

30 For Hambidge's analyses of Greek vases see *Dynamic Symmetry, The Greek Vase*.

31 Daedalus, American Academy of Arts and Sciences, Vol 89, 1960, p 209. The diagram is after an unreferenced illustration in D K Ching, *Architecture, Form, Space and Order*, 2nd ed, John Wiley & Sons Inc, 1996, p 228.

32 Smith, *op cit*, p 102.

33 See in this connection Doron Chen, 'The Ancient Synagogue at Horvat Ammudim: Design and Chronology', *Palestine Exploration Quarterly*, 1986, p 135.

34 Heath, *op cit*, p 98.

35 *ibid*.

36 Doron Chen has written several papers on this subject. See in particular 'A Note Pertaining to the Design of the Rotunda Anastasis in Jerusalem', *Zeitschrift des Deutschen Palästina Vereins*, 95/2, pp 178-181 and 'The Design of the Dome of the Rock in Jerusalem', *Palestine Exploration Quarterly* 1980, p 50.

37 *ibid*, pp 43-46.

38 These figures are measured from the drawing in K A Cresswell's *Early Muslim Architecture*, Oxford University Press, 1932-40.

39 The dimensions upon which Chen's ratios are based are given in the Byzantine foot, rounded to make them into whole numbers. Thus the distance from the ground to the height of the octagon's window sills, shown on the diagram as 15, is in fact 14·897 feet, rounded up to 15. The difference is 0·7%.

40 See in this connection Henri Stierlein ed, *Islamic India*, Benedikt Taschen, Lausanne, undated and Edmund W Smith, 'The Moghul Architecture of Fatehpur Sikri' Allahabad, 1894-98. (In *The Archaeological Survey of India*.)

41 Edwards, *op cit*, p 374.

42 See Andreas Volwahsen, *India*, in Architecture of the World Series, Henri Steirlin ed, Benedikt Taschen, undated, pp 145-6 and 152-3.

43 *ibid*, p 56.

44 *ibid*, p 50.

45 *ibid*.

46 Royal Academy of Arts, London and Prestel-Verlag Munich 1991.

47 According to the *Encyclopaedia Britannia*, 11th ed, Vols 3-4, p 117, the influence of Boetius upon medieval thought was 'exceedingly powerful'. The author mentions in particular that his translations of Greek texts, especially of Aristotle, provided the schools of the time with manuals on arithmetic, music, geometry and astronomy.

48 See Smith, *op cit*, Vol 1, p 203.

49 See Matyla Ghika, *The Geometry of Art and Life*, Dover Publications, 1977, p 147.

50 *Ad Quadratum, a Study of the Geometrical Bases of Classic and Medieval Religious Architecture*, Batsford, 1921, *passim*.

51 See Scholfield, *op cit*, p 87.

52 William Hogarth, *The Analysis of Beauty*, 1763, p 76 *et seq*.

53 Lord Kames, *Elements of Criticism*, 2nd ed, Blake, 1839, p 456.

54 Gilpin, *op cit*, p 32.

55 See Cook, Theodore Andrea, *The Curves of Life*, Constable, 1914, pp 461-469.

56 Huntley, *op cit*, p 65.

57 D E Berlyne, *Aesthetics and Psychobiology*, Appleton-Century-Crofts, 1971, p 226.

58 Scholfield, *op cit*, p 100.

59 Katherine Everett Gilbert and Helmut Kuhn, *A History of Esthetics*, New York, 1939, p 532.

60 H Osborne, *Theory of Beauty, an Introduction to Aesthetics*, London, 1952, pp 183-4.

61 I'm not quite sure about eleventh-century Hindus. Their priest-architects' knowledge of φ and of the Fibonacci series might have come from the eastern Mediterranean. The remarkable school of sculpture that flourished from the first to the end of the fifth century in Gandhara on the borders of what is now Pakistan and Afghanistan shows strong Hellenistic influence, north India is known to have had business contacts with Alexandria, and Pliny bewailed the adverse balance of trade between Rome and what he called India. Hellenistic geometry might have come with these links. On the other hand Hindu mathematics was very advanced and their priest-architects were probably capable of working out both φ and the Fibonacci series for themselves. I am happy to leave this question to the architectural historians. I have to thank Dr Vladimir Zwolf for information about links between north India and the eastern Mediterranean.

62 Arnold Toynbee, *A Study of History*, One Volume Edition, Oxford University Press, 1972, p 89.

Chapter Eight

Unity in Diversity

The idea that unity in diversity is essential to a work of art has been part of aesthetic theory from the fourth century BC to the present day; from Aristotle, who held that 'the fable, being an imitation of an action should be an imitation of an action that is one and entire, the parts of it being so connected that if any one of them be either transposed or taken away, the whole will be destroyed or changed; for whatever may be either retained or omitted, without making any sensible difference is not properly a part',[1] to John Dewey who declared that 'the characteristic of artistic design is the intimacy of the relations that hold the parts together' and 'only when the constituent parts of a whole have the unique end of contributing to the consummation of a conscious experience do design and shape lose superimposed character and become form'.[2] Berlyne goes further. According to him: 'The aim of all intellectual pursuits, including science, philosophy, and art, is to seek unity in the midst of diversity or order in the midst of complexity. Their ultimate task is to fit multifarious elements into some kind of compact, cohesive, apprehensible scheme.'[3]

Where did mankind's desire to seek this highly abstract concept originate?

The achievement of unity in diversity in any intellectual pursuit is, evidently, a part of cognition; 'the use or handling of knowledge' and cognition is, as we have seen, specific to the culture concerned. We have however also seen that *cognitive capacity*, as opposed to cognition, is innate. If the achievement of unity in diversity is a part of cognition, we may reasonably infer that the ability to achieve it is an aspect of cognitive capacity

and is, accordingly, innate. Berlyne's 'aim of all intellectual pursuits, including science, philosophy, and art' is, however, more than just an ability, it is, in Jungian language, a predisposition. Could a predisposition to achieve unity in diversity be an archetype? Why not? It is certainly 'a typical situation in life', it is certainly 'an unconscious image that is altered by becoming conscious and by being perceived' and it certainly 'takes its colour from the individual consciousness in which it happens to appear'. But if it is an archetype it's pretty comprehensive; think of all the different 'colours' and 'individual consciousnesses' which are implied by Berlyne's 'all intellectual pursuits'. If, however, it is an archetype it must, by Jungian theory and our evidence, derive from our remote ancestors' awareness of nature. What aspects of nature are there which possess this highly abstract, highly comprehensive characteristic, and which can, on the basis of common sense or independent evidence, be assumed not only to have been part of our remote ancestors' environmental awareness but also to have been the subject of a genetic mutation, passed on through the millennia to us, their descendants.

I can think of several. I hope you will agree that there is no need to support our argument with illustrations from the visual arts. If all the sages from Aristotle onwards have considered unity in diversity to be essential to a work of art that characteristic can be taken as read; we need only consider it as a putative aspect of our ancestor's environmental awareness.

Here then are a few examples:

Unity in Diversity in Nature, Some Examples

A SINGLE, ISOLATED, THREE DIMENSIONAL OBJECT

Any such object, in nature a mountain, a rock, a tree, an animal, a person, is, by definition, a unity; but looking at it from different directions and in varied conditions of light we perceive it in an infinite variety of ways; from the front, from the back, from both sides and if we can get there from above; as well as – if outdoors – under grey skies, in sunshine, in shadow, in dusk, in mist, in rain, under snow, at night and – if indoors – under many kinds of natural or artificial illumination. We know, nevertheless, that despite this multitude of perceptions the object is one thing only. Our

experience of it is diverse, our knowledge of it is unitary. Moreover, we may be sure that the ability to recognise such unity in diversity is innate. We cannot imagine that our hominid ancestors with their profound environmental awarenesses would have lacked such competence. Without it they would hardly have been able to return to base after a scavenging expedition and even a bee can do that.

THE SKY

At night, indigo, spangled with stars or black with clouds, dimly illuminated by the changing moon; in daylight hazy or bright with sunshine, sometimes blue-grey, sometimes clear azure, sometimes brushed with thin cirrus, loaded with white cumulus or heavy with rain; at dawn and dusk blue, grey, yellow, crimson or two or three together.

But, despite such diversity, always the sky.

THE SYMMETRIES

Anything symmetrical must possess unity; it wouldn't be symmetrical if it didn't. Do the various symmetries which we discussed in the last chapter also possess diversity? And if they do, can we reasonably assume that our ancestors were innately aware of it? Let's see.

We pointed out that bilateral symmetry is characteristic of every mammal, every bird, every reptile, every insect, the great majority of fishes and many flowers. We didn't however mention that we can only appreciate such symmetry when we see the object concerned in unusual circumstances. It must be motionless, it must adopt, like Leonardo's man, a symmetrical position and we must see it directly – whether from above, from below, from in front, or from behind. In every other case – whether we see it in movement, from the side, at an angle or curled up like a sleeping puppy – it appears asymmetrical. We know that its shape possesses symmetry – and hence unity – but our everyday experience of it is one of asymmetry – and hence of diversity.

What about rotational symmetry?

We noted that flowers provide the prototype for rotational symmetry. Think, since I am writing this in March, of daffodils. Any group of daffodils from a bunch to the whole species is, necessarily, a unity – it wouldn't be a group if it weren't – but the group's constituents are diverse. Every daffodil,

though recognisably similar to the rest, has individual characteristics: a short or long stem, a narrower or more open trumpet, flatter or more wavy petals, a paler or darker colour. The same is true of apple blossom, sunflowers, irises...any others which you care to suggest. So flowers, though symmetrical are also diverse. Is there an exception? I can't think of one.

GROUPS

Animals also? Here Jeeves had the answer. He declared, in the *Episode of the Dog Macintosh*, that 'except to the eye of love, one Aberdeen terrier looks very much like another Aberdeen terrier'.[4] The breed of Aberdeen terriers is a unity but it is made up of individuals who, to the eye of love, are distinguishable and necessarily diverse. And it isn't only true of Aberdeen terriers; selective breeding has created such diversity among farm animals and pets but many other creatures possess similar characteristics in a less obvious form; thus zebras don't, as I understand, all sport the same pattern of stripes but they are all recognisably zebras, while swallows assembling for migration may all look the same but they aren't. Each one must be a distinct individual, if it weren't it would neither be recognisable to its mate nor be able to find its way back to last year's nesting place.

In each case we encounter unity of the group together with diversity of its members. Can we reasonably suppose that our environmentally conscious ancestors would not have been innately aware of the unity of the sky combined with its variety of brightness, stars, moon phases and cloud patterns, of the symmetry of animals combined with the multiplicity of the ways in which we perceive them, of the similarity of members of a particular species combined with the diversity of individuals within it?

I can't; particularly as the last concept applies even more evidently to mankind. We are conscious not only of ourselves as human beings and of the social groups to which we belong but also of the characteristics of particular individuals. Early man must surely have possessed such consciousness. You will remember Dunbar's conclusion that heidelbergensis lived in groups of about 150. A group of this size cannot operate effectively unless its members have quite detailed knowledge of their colleagues' personal characteristics. An awareness of this unity in diversity must have been innate among our ancestors, without it their groups would not have been established, they would not have survived and we should not be here.

We have considered a few examples of unity in diversity as it appears among some of the more obvious natural phenomena. Perhaps we should supplement them by considering another, less evident but hardly less important aspect of the subject, ecosystems.

ECOSYSTEMS

You must have decided, if you have managed to get thus far, that I have finally lost my marbles. The idea that the west fronts of basilican churches are equipped with screens or twin towers because their architects possessed in their minds archetypes of the African flesh-fly is pretty far-fetched. The notion that our remote ancestors were aware of the ecosystems in which they lived and that we have inherited that awareness is, quite simply, preposterous.

Preposterous though it seems, we have already discussed the idea in our consideration of scale and have recognised it, albeit by implication, in what we have noted about the environmental awareness of the Kalahari bushmen. They can hardly have known that there was 'not a tree, expanse of sand or bush that were alike' unless they saw the trees, expanses of sand or bushes not just as discrete phenomena but also in relation to each other and hence as part of an ecosystem. Moreover, in another context, van der Post and his colleague Jane Taylor are quite positive about the bushmen's ecological awareness; they declare that the bushmen 'understood the ways of nature in the most complete manner for they knew themselves to be part of its intricate and divinely ordered system'.[5]

The bushmen, however, were not the only 'primitive' people who have been found by anthropologists to possess such ecological awareness. Here are four others:

(i) Hugh Brody, writing of his experience of fifteen years living in many parts of arctic and sub-arctic Canada, quotes the Canadian Indian Richard Neyrisoo as follows:

> "It is very clear to me that it is an important and special thing to be an Indian. Being an Indian means being able to understand and live with this world in a very special way. It means living with the land, with the animals, with the birds and fish, as though they were your sisters and brothers. It means saying the land is

an old friend and an old friend your father knew, your grandfather knew, indeed your peoples have always known...We see our land as much, much more than the white man sees it. To the Indian people our land really is our life."'[6]

(ii) The anthropologist D F Thompson gives the following account of the detailed environmental awareness possessed by the Wik Munkan; a tribe who live in the valley and estuary of the Archer River on the West coast of the Cape York peninsula in northern Queensland:

'The natives are acutely aware of the characteristic trees, underscrub and grasses of each distinct "association area", using this term in its ecological sense. They are able to list in detail and without any hesitation, the characteristic trees of each, and also to record the string, resin, grasses and other products used in material culture, which they obtain from each association as well as the mammals and birds characteristic of each habitat. Indeed so detailed and so accurate is their knowledge of these areas that they note the gradual changes in marginal areas...My informants were able to relate without hesitation the changes in fauna and in food supply in each association in relation to seasonal changes.'[7]

(iii) According to the anthropologist Roy A Rappaport, who studied them in the 1960s, similar ecological awareness was displayed by the Tsembaga Mareng, a remote New Guinea tribe who combined slash-and-burn farming and hunter-gathering. He showed that their belief in their ancestors' insatiable demand for pigs, together with certain rituals and linked periodic outbreaks of warfare, constituted an adaptive mechanism for ensuring a suitable ecological balance. He wrote as follows:

'The Tsembaga ritual cycle has been regarded as a complex homeostatic mechanism operating to maintain the values of a number of variables within "goal ranges" (ranges of values that permit the perpetuation of a system, as constituted through indefinite periods of time). It has been argued that the regulatory function of ritual among the Tsembaga and other Mareng helps

to maintain an undegraded environment, limits fighting to frequencies that do not endanger the existence of the regional population, adjusts man-land ratios, facilitates trade, distributes local surpluses of pig in the form of pork throughout the regional population and assures people of high-quality protein when they most need it.'[8]

(iv) A more elaborate version of the idea is given by another anthropologist, G Reichel-Dolmatoff, in his description of the Tukano, a tribe of Indians from the Amazonian rain forest. He declares that in Tukano culture

> 'the individual person is conscious that he forms part of a complex network of interactions which include not only society but the entire universe. Within this context of an essential interrelatedness of all things a person has to fulfil many functions that go beyond his or her social roles and that are extra-societal extensions of a set of adaptive norms. These rules and norms, then, guide a person's relationships not only with other people…but also with animals, plants, as a matter of fact with all biotic and non-biotic components of the environment. The rules the individual has to follow refer, above all, to co-operative behaviour aimed at the conservation of ecological balance as the ultimately desirable quality.'[9]

He goes on:

> 'The cosmological myths which express the Tukano world-view do not describe man's place in nature in terms of dominion, of mastery over a subordinate environment, nor do they in any way express the notion of what some of us might call a sense of "harmony with nature". Nature in their view is not a physical entity apart from man and, therefore he cannot confront it or oppose it or harmonise with it as a separate entity. Occasionally he can unbalance it by his personal malfunctioning as a component, but he never departs from it. Man is taken to be a

part of a set of supra-individual systems which – be they biological or cultural – transcend our lives and within which survival and the maintenance of a certain quality of life are possible only if all other life forms too are allowed to evolve according to their specific needs as stated in cosmological myths and traditions.'[10]

All of which proves nothing; the ecological awarenesses of Reichel-Dolmatoff's Tukano, Rappaport's Tsembaga Mareng, Thompson's Wik Munkan, Neyrisoo's Indians and van der Post's bushmen may all be due to local cultural influences. This however implies that these highly sophisticated ideas developed independently among the inhabitants of the Amazon rain forest, the Kalahari desert, the Canadian Arctic and the region of the Arafura Sea. An unlikely concept; these places are too environmentally varied and too geographically dispersed for such a theory to seem plausible. Alternatively, we may consider that some or all of the hundred and fifty or so individuals who emerged from Africa 90,000 years ago carried an archetype for the awareness of ecology and that they passed it on to their descendants. Such a theory would not only explain the existence of ecological ideas among these widely dispersed peoples, it would also provide further support for the idea that there is a unity-in-diversity archetype in the collective unconscious.

Perhaps, but what about mutations, natural selection and the accidental inheritance of genetic variation?

An innate awareness of the ecosystem in which he lived would surely have helped early *homo* to find food and avoid predators. Remember Thompson's account of the Wik Munkan: 'My informants were able to relate without hesitation the changes in fauna and in food supply in each association in relation to seasonal changes.' Natural selection would have favoured those who possessed such awareness. Those who lacked it would have been in danger of eating the wrong berry or providing a meal for a crocodile.

※ ※ ※

There is one other thing: any stable ecosystem involves decomposition; look at the bottom half of the jigsaw-puzzle diagram on the facing page. The conclusion, that we have an awareness of ecology archetype in our

unconscious minds – typically expressed as unity in diversity – enables us to retrieve pleasing decay from the back-burner where it has stood ever since the end of Chapter Six. That's nice, isn't it?

106 Unity in diversity in an ecosystem.

Conclusion

Have we adduced sufficient evidence to support our argument? Let's see.

We discussed, in chapters six and seven, a total of twenty-five varieties of images. Under preliminaries there were four: eyes, jaws, claws and spirals (we can't include circles, they appear as rotational symmetry in the mathematics of form). In the miscellany there were eleven: representational art with its vast number of examples, profiles, serpents, sex, the basilical section, tactile examples such as floorscape, three kinds of outdoor space (prospects, refuges and views from cover), scale, and pleasing decay (completed later). Under the mathematics of form there were nine: three kinds of symmetry, rhythm, fitting-together, including – as a separate image – indoor space, as well as the module, the golden ratio and the Yin Yang symbol. Under unity in diversity there was one, together with the completion of pleasing decay.

This doesn't, however, mean that we have defined twenty-five archetypes; we decided that one recognising-of-similarities archetype would

cover the three kinds of symmetry, we showed that the Yin Yang symbol embodies two of the symmetries and fitting-together as well as, more generally, geometry and we suggested, in our discussion of *Les Demolselles d'Avignon*, that the collective unconscious includes, as an archetype, an image of a naked woman. Allowing for these, we have a net figure of twenty-two archetypes apart from any more that you would like to add from representational art.

Enough? I hope so, so far as it goes; but the enquiry is incomplete; we have hardly considered qualitative judgement.

Why did Gibbon declare, in a letter to his stepmother, that 'of all towns in Italy I am the least satisfied with Venice. Old and in general ill-built houses, ruined pictures and stinking ditches, dignified with the pompous denomination of canals...and a large square decorated with the worst architecture I have ever seen'?[11] while we described it, on page 180, as possessing what is 'surely the most splendid cityscape to be found anywhere' – both can't be right. Why do I, I don't know about you, find *Travelling amid Mountains and Gorges* profoundly impressive? the west front of Santa Maria Novella awkward? that of St Pancras Church dull? *Les Demoiselles d'Avignon* inconsistent? *The Marriage at Cana* delightful? A proper investigation ought, surely, to offer answers to such questions.

Of course it ought, but that means another book and in my eighties I can't see myself writing it.

Why not you?

1 Aristotle, *Poetics*, J M Dent, Everyman Edition, pp 19-20.

2 John Dewey, 'Art as Experience' in *Philosophies of Art and Beauty*, Albert Hofstadter and Richard Kuhns, University of Chicago Press, 1976, pp 621-622.

3 Berlyne, *op cit*, p 296.

4 P G Wodehouse, *Very Good Jeeves*, Herbert Jenkins, 1930, p 140.

5 Laurence van der Post and Jane Taylor, *Testament to the Bushmen:* Viking 1984, p 11.

6 Hugh Brody, *Living Arctic, Hunters of the Canadian North*, Faber and Faber, 1987, p 9.

7 D F Thompson, 'Names and naming in the Wik Munkam Tribes', *Journal of the Royal Anthropological Institute*, Vol 76, Part 2, 1946.

8 Roy A Rappaport, *Pigs for the Ancestors, Ritual in the Ecology of a New Guinea People*, Yale University Press, 1968, p 224.

9 G Reichel-Dolmatoff: 'Cosmology as Ecological Analysis, a View from the Rain Forest', *Man*, 11 1976, p 311.
10 *Ibid*, p 318.
11 Quoted by Kenneth Clark, *The Gothic Revival*, Constable, 1928, pp 267-268.

Part Four

This Side of the Looking Glass

Part Four

Introduction

You will remember what I said in the foreword: 'To investigate beauty directly involves serious problems, chiefly because the word eludes definition. Accordingly this enquiry…adopts an indirect approach to the investigation of beauty, a strategy which has enabled me to avoid, so far as possible, the use of the word.' If this strategy has worked so far it is because I have taken care to confine the enquiry to works of art, regarding them as devices of communication between the mind of the artist and the mind of the experiencer. Such an approach cannot, however, apply to natural phenomena, the topic of Part Four; they aren't devices of communication. In these circumstances I cannot avoid using the word. You will encounter it here.

Chapter Nine

The Beauties and Uglies of Nature

The Beauties

Can we extend our theory to include the beauties of nature?

Let's try, beginning with a return to Peirce.

You will remember that according to him 'anything which startles us is an index, in so far as it marks the junction between two portions of experience. Thus, a tremendous thunderbolt indicates that *something* considerable happened, though we may not know precisely what the event was. But it may be expected to connect itself with some other experience.' We are not startled by a may-tree in bloom, a sunset, a nautilus shell, a daisy, a cloudscape, a butterfly, a quartz crystal, a breaking wave, a galloping horse or a mountain; we have seen such things many times, but they certainly excite us and they certainly mark a junction between two portions of experience; our experience after encountering one of them is different from our experience before we encountered it. Such natural phenomena are evidently indexes and if they are indexes we should be able to figure out the connection between them and the 'other experiences' to which Peirce referred.

And what are these other experiences?

It seems reasonable to suggest, in terms of Jungian theory and our conclusions so far, that they are complexes that reside in the individual's personal unconscious. If this is so the sequence of operations involved in our excitement on beholding such things should be the same for a

phenomenon of nature as for a work of art and it should be possible to demonstrate this by reference to some examples. But do we need several such demonstrations? We listed ten of nature's beauties in the last paragraph, to go over them all would be tedious, one good case should be sufficient. On this basis I offer an analysis of the psychological impact of a view of the Matterhorn. It is based on our study of an encounter with *Les Demoiselles d'Avignon* on page79

The mountain archetype, a typical situation in life, an aspect of our ancestors' environmental awareness, lies in the experiencer's share of the collective unconscious. He, on seeing the Matterhorn, responds to it consciously via his ego while at the same time his experience of it is transmitted unconsciously – via the ego-self axis – to the self whence it is passed to one of his complexes. This was, of course, originally an archetype which had been activated to become a complex in his personal unconscious and which had, in the process, accrued to itself ideas, percepts and emotional experiences associated with the people and things with which he had been

107 The Matterhorn.

in contact. We can have no idea what these were but we may be sure that if he were to respond favourably to his view of the Matterhorn they must have been agreeable and would have been such as to provide him with experience of mountains generally and perhaps with examples similar to the Alps in particular. With such familiarity he can respond unconsciously to his view of the mountain as well as consciously to its symbolic and iconic attributes; without it his complex would not have been appropriately activated and he would be unable to respond, except perhaps with dislike, to the view.

You will have noticed that this analysis of the Matterhorn, like that of *Les Demoiselles d'Avignon* emphasised the importance of familiarity. This was not unconsidered. I chose the Matterhorn as an example partly because its pyramidal shape is almost mathematical in its clarity but chiefly because a liking for mountains is, at least in England, a recent phenomenon; one which dates only from the second half of the eighteenth century (continental Europe seems to have been similar, pre-columbian America and the Far East were certainly different). Until then mountains were regarded as thoroughly disagreeable. Thus Captain Burt, an intelligent English officer serving in the Highlands after the '45 rebellion wrote of the 'stupendous bulk, frightful irregularity and horrid gloom' of the Scottish mountains, characteristics which he contrasted with a 'poetical mountain, smooth and easy of ascent, cloth'd with a verdant silvery turf where shepherds tend their flocks sitting under the shade of poplars…in short, Richmond Hill'.[1] A taste for mountain landscapes seems, like a taste for cubist painting, to be the result of familiarity; a familiarity which, in England, came in with the romantic movement.

But if mountains were unfamiliar to the pre-romantic movement, upper-class Englishman his common experience must have included the examples of nature's beauties which we listed at the beginning of this section as well as any others which you care to name. (Perhaps not nautilus shells, but certainly the shells of other spiral molluscs like snails.) The archetypes of such things must have been freshly activated with each individual at least since the emergence from Africa. It follows that we need not worry about the establishment of familiarity so far as their archetypes are concerned. It happened with the business of growing up and they came to be regarded as beautiful without any consideration of why this should be.

The Uglies

The same argument can, of course be applied to nature's uglies – flies, spiders, reptiles, all kinds of creepy-crawlies – though in such cases the ideas, percepts and emotional experiences would surely have been unpleasant and the response not one of enjoyment but of loathing. We had, as you will remember, an example of such a response in Chapter Six when we explained the almost universal masking of the basilical west front by noting the similarity of its profile to that of the African flesh-fly.

A Bonfire

I hope you will consider that these fragments of evidence are sufficient to support an extension of our theory. If, however, you remain unconvinced, think of a bonfire. We have all gazed warm, silent and entranced at its fitful, lively flames. Whence, apart from some innate recollection of our ancestors' awareness of such things, could this entrancement have originated?

I rest my case.

1 See in this connection Peter Bicknell, *British Hills and Mountains*, Collins, 1947, pp 26-29, an account from which these quotations are taken.

Afterword

(i) We have seen that primitive man lived in the savannahs of East Africa.
(ii) We have noted Toynbee's opinion that the most momentous event to date in human history was the dawn of consciousness in the biosphere.
(iii) We have seen that serpents have been made into 'one of the most important of cult animals' and that they 'provoke phobic responses in human and non-human primates alike'.
(iv) We have seen that that all mankind outside sub-Saharan Africa is descended from a tiny group of people who left their native continent about 90,000 years ago.

On this evidence we may interpret the Genesis story as a myth of primitive man with Eden as the East African savannah, the eating of the apple as the catalyst for the dawn of consciousness, the serpent as the symbol of evil and the expulsion from Eden as the departure from man's native continent.

Perhaps the sensations which we call beauty and ugliness are, at least in part, the result of matching events in somebody's conscious experience with images in his unconscious mind – images of certain aspects of Adam's awareness of Eden.

Appendices

Appendix One

Wissler's Culture Scheme[1]

Speech
Languages, writing systems, etc.

Material traits
Food habits
Shelter
Transportation and travel
Dress
Utensils tools, etc.
Weapons
Occupations and industries

Art
Carving, painting, drawing, music, etc.

Mythology and Scientific Knowledge

Religious Practices
Ritualistic forms
Treatment of the sick
Treatment of the dead

Family and Social Systems
Forms of marriage
Methods of reckoning relationship
Inheritance
Social control
Sports and games

Property
Real and personal
Standards of value and exchange
Trade

Government
Political forms
Judicial and legal procedures

War

Appendix Two

Murdock's Universal Culture Pattern[2]

Age grading, athletic sports, bodily adornment, calendar, cleanliness training, community organisation, cooking, co-operative labour, cosmology, courtship, dancing, decorative art, divination, division of labour, dream interpretation, education, eschatology, ethics, ethnobotany, etiquette, faith healing, family, feasting, fire making, folklore, food taboos, funeral rites, games, gestures, gift giving, government, greetings, hair styles, hospitality, housing, hygiene, incest taboos, inheritance rules, joking, kin-groups, kinship nomenclature, language, law, luck, superstitions, magic, marriage, mealtimes, medicine, modesty concerning natural functions, mourning, music, mythology, numerals, obstetrics, penal sanctions, personal names, population policy, postnatal care, pregnancy usages, property rights, propitiation of supernatural beings, puberty customs, religious ritual, residence rules, sexual restrictions, soul concepts, status differentiation, surgery, tool-making, trade, visiting, weaning, and weather control.

Appendix Three

The Activities of Brown's 'Universal People': an Abbreviated Version[3]

Language

Use of symbolic language.
Use of abstractions.
Value placed on articulateness.
Use of timing, tone etc. to express more than the mere words indicate.
Gossip.
Lying.
Misleading.
Verbal humour.
Verbal insults.
Phonemes, the basic speech sounds, form a series of contrasts; e.g. contrasts between one vowel and another.
Change of language over time.
Grammar including some redundant information; thus in English both subject and verb indicate number: e.g. 'we are'.
Poetic and rhetorical speech forms.
Narrative and storytelling.
Onomatopoeic words.
Figurative speech, including metaphor and metonymy (the use of a word for that with which it is associated e.g. crown for king).
Poetry with repetition of linguistic elements and lines separated by pauses.
Use of words for units of time, e.g. days, months, seasons, years.

Use of words for undefined periods of time, e.g. past, present, future.
Use of words for parts of the body.
Use of words for inner states (emotions, sensations, thoughts).
Use of words for behavioural propensities.
Use of words for flora.
Use of words for fauna.
Use of words for weather conditions.
Use of words for tools.
Use of words for space (by which directions are given).
Use of words for physical properties, e.g. motion, speed, location, dimension.
Use of words for actions, e.g. giving, lending, and affecting things and people.
Use of synonyms and antonyms.
Use of proper names.
Pronouns.
Use of numerals (at the very least 'one' 'two' and 'many').
In grammar the possessive, e.g. my axe.
Distinctions between mother and father.
Kinship categories, defined by relationships inherent in procreation – i.e. mother, father, son, daughter – and age sequence.
Use of taxonomy, including both binary discriminations – e.g. black and white, male and female, good and bad – and where appropriate, gradations between them and ranked orders in their classification.
The ability to express the measure of things and distances, though not necessarily with uniform units.
Logical relationships including 'not', 'and', 'same', 'equivalent and opposite', 'general and particular', 'part and whole'.
Conjectural reasoning (inferring the presence of absent and invisible entities from their perceptible traces).

Non-verbal Communication

Non-linguistic vocal communication such as cries and squeals.
Interpreting intention from behaviour.
Recognised facial expressions, e.g. happiness, sadness, anger, fear, surprise,

disgust, contempt.
Use of smiles as friendly greeting.
Crying.
Coy flirtation with the eyes.
Masking, modifying and mimicking facial expressions.
Displays of affection.

Self-awareness

Sense of self versus other.
Responsibility.
Voluntary versus involuntary behaviour.
Intention.
Private inner life.
Memory.
Decision making.
Normal versus abnormal mental states.
Empathy.
Sexual attraction.
Powerful sexual jealousy.
Childhood fears, especially of loud noises and, at the end of the first year, of strangers, together with its counterpart; a strong attraction of a child to its carer.
Fear of snakes.
'Oedipal feelings' (possessiveness of mother, coolness towards her consort).
Recognition of individuals including face recognition.

Tool Usage

Manufacture of, and dependence upon, tools, e.g. cutters, pounders, containers, string, levers, weapons.
Right-handedness.
Use of fire for comfort and security as well as to cook food.
Drugs, both medicinal and recreational.

Shelter

Shelter

Birth

Patterns of pre-natal preparation, birth and post-natal care.
A standard pattern and time for weaning.

Group-living

Living in groups, which claim a territory and have a sense of being a distinct people.
Maintenance of the unity of a group even though its members may be dispersed.
Recognition of the family as a group.

The Family

Family life, built around the mother and children, usually the biological mother and one or more men.
Institutionalised marriage.
Socialisation of children (including toilet training) by senior kin.
Children copying their elders.
Learning some things by trial and error.
Distinguishing of close kin from distant kin, and favouring of close kin.
Sexual regulations including the avoidance of incest
Great interest in the topic of sex.

Society

Status and prestige, both assigned (by kinship, age, sex) and achieved.
Recognition of individual and collective social identities.
Some degree of economic inequality.
Division of labour by sex and age.
Child care by women rather than men.
Aggression and violence by men rather than women.

Acknowledgement of differences between male and female natures.
Dominance by men and submissiveness of women and children, particularly in the public, political sphere.
Customs of co-operative labour.
Exchange of labour, goods and services.
Gift giving.
Sharing of food.
Reciprocity including retaliation.
Attempts to predict and plan for the future.
Social reasoning including awareness of relationships between others.
Coalitions.
Government, in the sense of binding collective decisions about public affairs.
Existence of leaders, almost always non-dictatorial, perhaps ephemeral.
Government by a *de facto* oligarchy.
Laws, rights and obligations including laws against violence, rape and murder.
Punishment, including censure, of acts that threaten, or are believed to threaten the unity of the group.
Conflict, which is deplored, including customary means of dealing with it; thus violence, including rape, is proscribed but not eliminated.
Seeking of redress for wrongs.
Mediation in conflicts.
In-group/out-group conflicts. Co-operation expected within a group rather than between one group and another.
Envy, together with means of coping with its consequences.
Sense of right and wrong.
Etiquette.
Hospitality.
Feasting.
Daily routines.
Sexual modesty, even though people may customarily go about naked.
Sex normally in private.
Discreteness in elimination of bodily wastes.
Food taboos.
Fondness for sweet tastes.

Religion, Myth and Magic

Religious or supernatural beliefs.
Belief in things that are demonstrably false.
Magic, including devices to sustain life and to attract the opposite sex.
Theories of fortune and misfortune.
Explanation of disease and death.
Divination.
Attempts at weather control.
Medicine.
Rituals, including rites of passage.
Mourning the dead.
Having a view of the world and of the individual's place in it as a part of his religious or supernatural beliefs.
Folklore.
Dreaming, interpreting dreams.

Property

Property.
Inheritance of property.

Sexual Attractiveness and Visual Art

Adornment of bodies and arrangement of hair.
Sexual attractiveness, based in part on signs of health and, in women, youth.
Hygienic care.
Decoration of artefacts.

Non-visual Art

Dance.
Music.
Conjunction of music and poetry.
Play, including play fighting.

Appendix Four

The Activities of Brown's 'Universal People' with the Three Capacities, Certain Instincts and Belief in the Supernatural

The ticks in the table that follows demonstrate correspondences between the activities of Brown's universal people, shown horizontally, and the three capacities, certain instincts and belief in the supernatural, shown vertically. I have entered the ticks where, in my judgement, certain correspondences are either essential – the activity of gossip requires both social awareness and communication – or normal – the activity of music, including conjunction of music and poetry, normally involves the playing of instruments (tool usage) though people do occasionally sing unaccompanied. In marginal cases, I have preferred to omit the tick rather than to include it.

| ACTIVITY | THE THREE CAPACITIES ||||| INSTINCTS |||| BELIEF IN SUPER-NATURAL |
|---|---|---|---|---|---|---|---|---|---|
| | AWARENESS ||| TOOL USAGE | COMMUN-ICATION | SEX | HUNGER THIRST | FEAR | AGGRESS-ION | |
| | Env | Social | Self | | | | | | | |
| **LANGUAGE** | | | | | | | | | | |
| Use of symbolic language | √ | √ | | | √ | | | | | |
| Use of abstractions | | √ | | | √ | | | | | |
| Value placed on articulateness | | √ | | | √ | | | | | |
| Use of timing, tone etc to express more than the words alone indicate | | √ | | | √ | | | | | |
| Gossip | √ | √ | | | √ | | | | | |
| Lying | | √ | √ | | √ | | | | | |
| Misleading | √ | √ | √ | | √ | | | | | |
| Verbal humour | | √ | | | √ | √ | | | | |
| Verbal insults | | √ | | | √ | | | | √ | |
| Phonemes, the basic speech sounds, form a series of contrasts; e.g. contrasts between one vowel and another | | √ | | | √ | | | | | |
| Change of language over time | | √ | | | √ | | | | | |
| Grammar includes some redundant information; thus in English both subject and verb indicate number: e.g. 'we are' | | √ | | | √ | | | | | |
| Poetic and rhetorical speech forms | | √ | | | √ | | | | | |
| Narrative and storytelling | √ | √ | √ | | √ | | | | | |
| Onomatopoeic words | √ | | | | √ | | | | | |
| Figurative speech, including metaphor and metonymy (the use of a word for that with which it is associated e.g. crown for king) | √ | √ | | | √ | | | | | |

Poetry with repetition of linguistic elements and lines separated by pauses	✓	✓	✓
Use of words for units of time, e.g. days, months, seasons, years	✓	✓	✓
Use of words for undefined periods of time, e.g. past, present, future	✓		✓
Use of words for parts of the body		✓	✓
Use of words for inner states, (emotions, sensations, thoughts)		✓	✓
Use of words for behavioural propensities	✓		
Use of words for flora	✓		✓
Use of words for fauna	✓		✓
Use of words for weather conditions	✓		✓
Use of words for tools	✓		✓
Use of words for space (by which directions are given)	✓		✓
Use of words for physical properties, e.g. motion, speed, location, dimension	✓	✓	✓
Use of words for actions, e.g. giving, lending, and affecting things and people	✓	✓	✓
Use of synonyms and antonyms	✓	✓	✓
Use of proper names	✓	✓	✓
Pronouns	✓	✓	✓
Use of numerals (at the very least 'one' 'two' and 'many')	✓	✓	✓
In grammar the possessive; e.g. my axe	✓	✓	✓
Distinctions between mother and father	✓		✓
Kinship categories, defined by relationships inherent in procreation — i.e. mother, father, son, daughter — and age sequence		✓	✓

| ACTIVITY | THE THREE CAPACITIES ||||||| INSTINCTS ||| BELIEF IN SUPER-NATURAL |
| --- | --- | --- | --- | --- | --- | --- | --- | --- | --- | --- |
| | AWARENESS ||| TOOL USAGE | COMMUN-ICATION | SEX | HUNGER THIRST | FEAR | AGGRESS-ION | |
| | Env | Social | Self | | | | | | | |
| Use of taxonomy, including both binary discriminations – e.g. black and white, male and female, good and bad – and where appropriate gradations between them and ranked orders in their classification | √ | √ | | | √ | | | | | |
| The ability to express the measure of things and distances, though not necessarily with uniform units | √ | | | | √ | | | | | |
| Logical relationships including 'not', 'and', 'same', 'equivalent and opposite', 'general and particular', 'part and whole' | √ | √ | | | √ | | | | | |
| Conjectural reasoning (inferring the presence of absent and invisible entities from their perceptible traces) | √ | √ | | | √ | | | | | |
| NON-VERBAL COMMUNICATION | | | | | | | | | | |
| Non-linguistic vocal communication such as cries and squeals | √ | √ | √ | | √ | √ | | √ | √ | |
| Interpreting intention from behaviour | | √ | | | √ | √ | | √ | √ | |
| Recognised facial expressions, e.g. happiness, sadness, anger, fear, surprise, disgust, contempt | | √ | | | √ | √ | | √ | √ | |
| Use of smiles as friendly greeting | | √ | | | √ | √ | | | | |
| Crying | | √ | √ | | √ | √ | √ | | | |
| Coy flirtation with the eyes | | √ | √ | | √ | √ | | | | |
| Masking, modifying and mimicking facial expressions | | √ | √ | | √ | | | | | |
| Displays of affection | | √ | √ | | √ | √ | | | | |

SELF-AWARENESS

Sense of self versus other		✓						
Responsibility		✓	✓					
Voluntary versus involuntary behaviour		✓	✓					
Intention		✓	✓	✓				
Private inner life			✓					
Memory	✓	✓	✓					
Decision-making	✓	✓	✓					
Normal versus abnormal mental states		✓	✓					
Empathy		✓	✓	✓				
Sexual attraction		✓	✓	✓				
Powerful sexual jealousy		✓	✓	✓		✓		
Childhood fears, especially of loud noises, and, at the end of the first year of strangers; together with its counterpart, a strong attraction of a child to its carer	✓	✓	✓		✓			
Fear of snakes	✓		✓			✓		
'Oedipal feelings' (possessiveness of mother, coolness towards her consort)		✓	✓			✓		
Recognition of individuals including face recognition		✓	✓	✓				

TOOL USAGE

Manufacture of, and dependence upon, tools, e.g. cutters, pounders, containers, string, levers, weapons	✓		✓	✓				
Right-handedness		✓	✓	✓				
Use of fire for comfort and security as well as to cook food	✓	✓	✓	✓				
Drugs, both medicinal and recreational		✓	✓	✓				

ACTIVITY	THE THREE CAPACITIES					INSTINCTS				BELIEF IN SUPERNATURAL
	AWARENESS			TOOL USAGE	COMMUNICATION	SEX	HUNGER THIRST	FEAR	AGGRESSION	
	Env	Social	Self							
SHELTER										
Shelter	√	√	√	√						
BIRTH										
Patterns of pre-natal preparation, birth and post-natal care		√		√						
A standard pattern and time for weaning,		√					√			
GROUP LIVING										
Living in groups, which claim a territory and have a sense of being a distinct people	√	√			√			√	√	√
Maintenance of the unity of a group even though its members may be dispersed		√			√			√		√
Recognition of the family as a group		√			√					
THE FAMILY										
Family life, built around the mother and children, usually the biological mother and one or more men		√			√	√				
Institutionalised marriage		√			√	√				
Socialisation of children (including toilet training) by senior kin		√			√					
Children copying their elders		√			√					
Learning some things by trial and error	√	√								
Distinguishing of close kin from distant kin, and favouring of close kin		√			√	√				
Sexual regulations including the avoidance of incest		√				√				
Great interest in the topic of sex		√	√		√	√				

304

SOCIETY

Status and prestige, both assigned (by kinship, age, sex) and achieved	✓			✓			
Recognition of individual and collective social identities	✓	✓		✓			
Some degree of economic inequality	✓	✓		✓			
Division of labour by sex and age	✓				✓		
More child care by women	✓				✓		
More aggression and violence by men	✓				✓		✓
Acknowledgement of differences between male and female natures	✓			✓	✓		
Dominance by men and submissiveness of women and children, particularly in the public, political sphere				✓	✓		
Customs of co-operative labour	✓			✓			
Exchange of labour, goods and services	✓			✓			
Gift giving	✓			✓			
Sharing of food	✓			✓		✓	
Reciprocity including retaliation	✓			✓			
Attempts to predict and plan for the future	✓	✓		✓			✓
Social reasoning including awareness of relationships between others	✓			✓			
Coalitions	✓			✓			
Government, in the sense of binding collective decisions about public affairs	✓			✓			
Existence of leaders, almost always non-dictatorial, perhaps ephemeral	✓			✓			
Government by a *de facto* oligarchy	✓			✓			
Laws, rights and obligations including laws against violence, rape and murder	✓			✓			

305

| ACTIVITY | THE THREE CAPACITIES ||||| INSTINCTS |||| BELIEF IN SUPER-NATURAL |
|---|---|---|---|---|---|---|---|---|---|
| | AWARENESS ||| TOOL USAGE | COMMUN-ICATION | SEX | HUNGER THIRST | FEAR | AGGRESS-ION | |
| | Env | Social | Self | | | | | | | |
| Punishment, including censure, of acts which threaten, or are believed to threaten the unity of the group | | ✓ | | | ✓ | | | ✓ | | |
| Conflict, which is deplored, including customary means of dealing with it; thus violence, including rape, is proscribed but not eliminated | | ✓ | | ✓ | ✓ | ✓ | | | ✓ | |
| Seeking of redress for wrongs | | ✓ | | | ✓ | | | | | |
| Mediation in conflicts | | ✓ | | | ✓ | | | | | |
| In-group/out-group conflicts. Co-operation expected within a group rather than between one group and another | | ✓ | | ✓ | ✓ | | | | ✓ | |
| Envy, together with means of coping with its consequences | | ✓ | ✓ | | ✓ | | | | | |
| Sense of right and wrong | | ✓ | ✓ | | | | | | | |
| Etiquette | | ✓ | | | ✓ | | | | | |
| Hospitality | | ✓ | | | ✓ | | ✓ | | | |
| Feasting | | ✓ | | | ✓ | | ✓ | | | |
| Daily routines | | ✓ | | | | ✓ | ✓ | | | |
| Sexual modesty, even though people may customarily go about naked | | ✓ | | | | ✓ | | | | |
| Sex normally in private | | ✓ | | | | ✓ | | | | |
| Discreteness in elimination of bodily wastes | ✓ | ✓ | ✓ | | | | | | | |
| Food taboos | | ✓ | | | | | ✓ | | | |
| Fondness for sweet tastes | | ✓ | ✓ | | | | ✓ | | | |

306

RELIGION, MYTH AND MAGIC

Religious or supernatural beliefs	✓	✓	✓		✓		✓
Belief in things that are demonstrably false	✓	✓			✓		✓
Magic, including devices to sustain life and to attract the opposite sex	✓	✓		✓	✓		✓
Theories of fortune and misfortune	✓	✓					✓
Explanation of disease and death	✓	✓			✓		✓
Divination	✓	✓	✓				✓
Attempts at weather control	✓						✓
Medicine		✓			✓		✓
Rituals, including rites of passage		✓			✓		✓
Mourning the dead		✓			✓		✓
Having a view of the world and of the individual's place in it as a part of his religious or supernatural beliefs	✓	✓			✓		✓
Folklore	✓	✓			✓		✓
Dreaming, interpreting dreams	✓	✓			✓		✓

PROPERTY

Property	✓	✓			✓		
Inheritance of property	✓	✓			✓		

SEXUAL ATTRACTIVENESS AND VISUAL ART

Adornment of bodies and arrangement of hair		✓	✓			✓	
Sexual attractiveness, based in part on signs of health and, in women, youth		✓				✓	
Hygienic care	✓	✓	✓			✓	
Decoration of artefacts	✓	✓	✓				

| ACTIVITY | THE THREE CAPACITIES ||||| INSTINCTS |||| BELIEF IN SUPER-NATURAL |
|---|---|---|---|---|---|---|---|---|---|
| | AWARENESS ||| TOOL USAGE | COMMUN-ICATION | SEX | HUNGER THIRST | FEAR | AGGRESS-ION | |
| | Env | Social | Self | | | | | | | |
| **NON-VISUAL ART** | | | | | | | | | | |
| Dance | | √ | √ | √ | | | | | | |
| Music, including conjunction of music and poetry | | √ | √ | √ | | | | | | |
| Play, including play fighting | | √ | √ | √ | | | | | √ | |

Appendix Five

Toynbee, Consciousness and Cognitive Capacity

On page 117, I referred to homo sapiens' cognitive capacity, adding that Toynbee described its development as 'the dawn of consciousness in the biosphere'. He is my guru and it behoves a disciple to hesitate before doubting the words of his master. I did so because I can't believe that he intended us to interpret consciousness in its everyday sense. Think, as an example, of having an operation: you are conscious before you're given the anaesthetic, unconscious while the surgeon is carving you up and conscious again when the anaesthetic wears off. I'm no biologist but I'm certain that we share such consciousness at least with the mammals, creatures which, according to Tudge,[4] have been part of the biosphere for the last sixty-five million years. Toynbee's subject was man's history and the dawn to which he referred could not possibly have occurred a minimum of sixty-three million years before homo erectus appeared on the scene. But if he didn't intend us to interpret consciousness in this way how did he intend us to interpret it? Here I could only guess, recognising that consciousness is, like intelligence, a topic which sends philosophers and psychologists into a maze. I saw no need join them but it seemed to be worth illustrating the matter with a quotation. The following definition appears among the eight closely printed columns which *The Oxford Companion to the Mind* devotes to the subject:

> '[Consciousness is] a process in which information about multiple individual modalities of sensation and perception is combined into a unified multidimensional representation of the state of the system and its environment, and integrated with information

about memories and needs of the organism generating emotional reactions and programs of behaviour to adjust the organism to its environment'.[5]

An account which, if I understand it correctly, not only relates consciousness to Darwinian evolution 'generating emotional reactions and programs of behaviour to adjust the organism to its environment' but is also close to the *Oxford Companion's* definition of cognition: 'the use or handling of knowledge'.

To which Toynbee provides us with a clue. He describes the dawn as being 'followed by a million or half a million years of torpor before man began to exercise actively the spiritual and material power with which his awakening to consciousness had endowed him'.[6] This active exercise of spiritual and material power must be the explosion of creativity, an event which started, as we have seen, some thirty thousand years ago with the cave paintings of our paleolithic ancestors. So Toynbee's consciousness occurred a million or half a million years before that, a date which – if we accept his half a million years – equates roughly with the emergence of heidelbergensis and the rapid development of cognitive capacity.

These two bits of evidence suggest that we may translate Toynbee's 'consciousness' as 'cognitive capacity'. I do this, using the phrase in accordance with my own interpretation of the *Oxford Companion's* definition of cognition: the intertwining of awareness, tool-usage (where appropriate) memory and thought - chiefly language based.

Appendix Six

Spiral Phyllotaxis

In the great majority of plants, the leaves are arranged in the form of a helix. Such a helix can be expressed by a fraction whose numerator refers to the number of turns before a leaf appears vertically above the starting point, and whose denominator refers to the number of leaf bases passed excluding the first; thus the plant in the diagram opposite has a fraction of $2/5$. Every species of plant has its characteristic fraction. Thus common grasses have a fraction of $½$, sedges $1/3$, apple trees $2/5$, plantains $3/8$ and leeks $5/13$. And, if we take the numerators and denominators of these fractions in sequence we get 1, 1, 2, 3 and 5 for the first numbers and 2, 3, 5, 8 and 13 for the second numbers. Both Fibonacci series.

If, however, instead of looking at a range of plants we look at one species only we find another connection with the Fibonacci series. New stems always grow from leaf axils, so not only are the leaves of the 'first' stem arranged in a spiral but the leaves of the 'second' stem, which sprouts from the axil of the lowest leaf does the same – except that it spirals in the opposite direction – and so do the leaves of the 'third' stem, and so on. And, since the old and new stems are added together, the number of leaves in each horizontal plane is a Fibonacci number and collectively they constitute a Fibonacci series. The diagram of the sneezewort (achillea ptarmica) shows how this occurs.

But the real fun comes when we look at plants such as pineapples, pines, daises and sunflowers whose scales, fruits or florets form two intermeshed spirals, of which one goes clockwise, the other widdershins and within which each unit plays a double role, belonging to both. If we count the number

108 Left: A diagram of spiral phyllotaxis.

109 Above: A diagram of a sneezewort.

110 Below: A diagram of a sunflower's florets.

111 A pineapple.

112 A daisy.

of spirals in any example we find, astonishingly, that they are in the ratio of adjacent Fibonacci numbers. Thus in the accompanying illustration the pineapple has eight scales going in one direction and thirteen in the other (an arrangement which is called a phyllotaxis of $8/13$) while the daisy's florets are in the ratio of $21/34$. The diagram of the sunflower's spiral pattern has the same though phyllotaxes of $55/89$ and $89/144$ are common in sunflowers and one has been found, yes honestly, with a phyllotaxis of $144/33$.

We aren't botanists and I don't think there is any need for us to seek an explanation for these phenomena. If you want an explanation I suggest you refer to Peter Stevens' *Patterns in Nature,* pages 155-166 or, if you are more scientifically inclined than I, to Chapter Fourteen of D'Arcy Wentworth Thompson's *On Growth and Form,* 1917 edition. It was edited out of later editions so go for that one.

1 Clark Wissler, *Man and Culture*, Harrap, 1923, p 74.
2 Murdock, *op cit*, pp 124-125.
3 In the original Brown's list of activities occupies nine and a half pages, hardly suitable for a table. Pinker, *op cit*, pp 413-415, boils down the list to just under two pages. The list in the table is based on Pinker's version, modified here and there in an attempt to achieve brevity and, I hope, clarity. The grouping of topics relates to Brown's account. The headings are mine. Brown's account appears in his book, *Human Universals*, pp 131 – 140.
4 Tudge, *op cit*, p 6.
5 R W Thatcher and E R John, *Foundations of the Cognitive Processes*, Hillsdale New Jersey, 1977 p 294. Quoted by Daniel C Dennet, *The Oxford Companion to the Mind*, p 162.
6 Toynbee, *Mankind and Mother Earth*, p 26

Bibliography

Adam, L,
Primitive Art, Allen Lane, Penguin Books, 1940
Allman, William F,
The Stone Age Present, Simon and Schuster, 1994
Appleton, Jay,
The Experience of Landscape, John Wiley, 1975
Aristotle,
Poetics, J M Dent, Everyman Edition, 1934
Arnheim, Rudolf,
Towards a Psychology of Art, Faber and Faber, 1967
Badawy, Alexander,
Ancient Egyptian Architectural Design, University of California Press, 1965
Barkow, Jerome H, **Cosmides**, Leda, and **Tooby**, John eds,
The Adapted Mind, Evolutionary Psychology and the Generation of Culture, Oxford University Press, 1992
Batley, Claude,
Indian Architecture, St Martin's Press, 1973
Beach, Milo Cleveland,
The New Cambridge History of India, Mughal and Rajput Painting, Cambridge University Press, 1992
Bell, Clive,
Landmarks in Nineteenth Century Painting, Chatto and Windus, 1927
Berger, Arthur Asa,
Media Analysis Techniques, Sage Publications, 1982
Berlyne, D E,
Aesthetics and Psychobiology, Appleton-Century-Crofts, 1971

Bertram, Anthony,
Manet, Studio, 1931
Bickerton, Derek,
Language and Species, University of Chicago Press, 1990
Bisbee, Ruth C,
'The Wonder of Heredity', in *Wonders of Animal Life*, J A Hammerton, ed, Amalgamated Press, pp 1727-1732, undated, c 1930
Bicknell, Peter,
British Hills and Mountains, Collins, 1947
Blumenschine, Robert J and **Cavallo**, John A,
'Scavenging and Human Evolution', *Scientific American*, October 1992
Boas, Franz,
The Mind of Primitive Man, Revised Edition, The Free Press, 1968
Boardman, John,
Greek Sculpture, The Archaic Period, Thames and Hudson, 1991
Bodmer Walter and McKie, Robin,
The Book of Man, Little, Brown and Company, 1994
Bouchard, Thomas J Jnr,
'Genes, Environment and Personality', *Science*, Vol 264, 17th June 1994
Bouchard Thomas J Jnr, et al,
'Sources of Human Psychological Differences: The Minnesota Study of Twins Reared Apart', *Science*, Vol 250, 12 October 1990
Bourdieu, Pierre,
Distinction, a Social Critique of the Judgement of Taste, trans Richard Nice, Routledge and Kegan Paul, 1984
Brody, Hugh,
Living Arctic, Hunters of the Canadian North, Faber and Faber, 1987
Brown, Donald E,
Human Universals, McGraw-Hill, 1991
Bryan, J and **Sauer**, R, eds,
'Structures Implicit and Explicit', in *VIA, Publications of the Graduate School of Fine Arts*, Vol 2, University of Pennsylvania
Bullock, Alan, **Stallybrass**, Oliver and **Trombley**, Stephen, eds,
The Fontana Dictionary of Modern Thought, Second Edition, Fontana Press, 1988
Cavalli Sforza, Luigi Luca,
'Genes, Peoples and Languages', *Scientific American*, November 1991

Cenival, Jean Louis de, **Stiertin**, Henri ed,
Egypt, Benedikt Taschen, Lausanne, undated
Chen, Doron,
'A Note Pertaining to the Rotunda Anastasis in Jerusalem', *Zeitscrift des Deutschen Palästina Vereins*, 95/2
'The Design of the Dome of the Rock in Jerusalem', *Palestine Exploration Quarterly*, 112
'The Ancient Synagogue at Horvat 'Ammudim', *Palestine Exploration Quarterly*, 118
'On Planning Churches in Palestina: A Comparison Between Syria and Illyricum, Christian Archaeology in the Holy Land: New Discoveries', *Essays in Honour of V C Corbo*, G C Bottini et al eds, Jerusalem, 1990
Ching, Francis D K,
Architecture, Form, Space and Order, John Wiley & Sons, 1996
Chomsky, Noam,
Language and Mind, Harcourt Brace and World, 1968
Clark, Ronald W,
The Survival of Charles Darwin, Weidenfeld and Nicolson, 1984
Clark, Kenneth,
Civilization, British Broadcasting Corporation and John Murray, 1969
The Gothic Revival, Constable, 1928
Leonardo da Vinci, Penguin, 1959
The Nude, Penguin, 1956
What is a Masterpiece?, Thames and Hudson, 1989
Cobban, Alfred, ed,
The Eighteenth Century, Thames and Hudson, 1969
Cole, Bruce,
Giotto, The Scrovegni Chapel Padua, K Brazillier, 1993
Cook, Theodore Andrea,
The Curves of Life, Constable, 1914
Le Corbusier,
The Modulor, Faber and Faber, undated
Craven, Roy C,
Indian Art, Thames and Hudson, 1976
Cull, P, ed,
The Sourcebook of Medical Illustration, The Parthenon Publishing Group, 1989

Dawkins, Richard,
The Blind Watchmaker, Penguin 1991
The Extended Phenotype, Oxford University Press, 1989
The Selfish Gene, Oxford University Press, 1989
Dewey, John,
'Art as Experience', in Hofstadter and Kuhns eds, *Philosophies of Art and Beauty*, University of Chicago Press, 1976
Dickinson, Terence,
Exploring the Sky by Day, Camden House, 1989
Dobzhansky, Theodosius,
Mankind Evolving, Yale University Press, 1962
Donald, Merlin,
Origins of the Modern Mind, Harvard University Press, 1991
Doyle, A Conan,
The Case Book of Sherlock Holmes, Penguin, 1931
Dunbar, Robin,
Grooming, Gossip and the Evolution of Language, Faber and Faber, 1996
'Neocortex Size as a Constraint in Group Size in Primates', *Journal of Human Evolution*, June 1992
Durkheim, Emile,
The Elementary Forms of the Religious Life, trans J W Swain, George Allen and Unwin, 1976
Edwards, A Cecil,
The Persian Carpet, Duckworth, 1953
Eco, Umberto,
A Theory of Semiotics, Indiana University Press, 1976
'Function and Sign: Semiotics of Architecture', in Bryan and Sauer, eds, Structures Implicit and Explicit in VIA, *Publications of the Graduate School of Fine Arts*, Vol 2, University of Pennsylvania
Ehrenzweig, Anton,
The Psychoanalysis of Artistic Vision and Hearing, Sheldon Press, 1975
The Hidden Order of Art, London, 1953
Eibl-Eibesfeldt, Irenäus,
Love and Hate, trans Geoffrey T Strachan, Methuen, 1971
Ellenberger, H F,
The Discovery of the Unconscious, Basic Books, 1970

Fagg, William,
Divine Kingship in Africa, British Museum, 1970
Fletcher, Banister,
A History of Architecture on the Comparative Method, B T Batsford, 1931
Forrer, Matthi,
Hokusai Prints and Drawings, Royal Academy of Arts, London and Prestel-Verlag Munich, 1991
Fox, Robin,
Encounter with Anthropology, Penguin, 1975
Freud, Sigmund,
Complete Psychological Works, Standard Edition, Vols 13 (1913-1914) and 23 (1937-39) Hogarth Press, 1955 and 1964
Leonardo da Vinci and a Memory of his Childhood, Penguin, 1963
Complete Letters of Sigmund Freud to Wilhem Fliess, 1887-1904, Belknap Press of Harvard University Press, 1985
Ghiselin, Brewster,
The Creative Process, University of California Press, 1952
Gibson, K R and **Ingold**, T eds,
Tools, Language and Cognition in Human Evolution, Cambridge University Press, 1993
Gilbert, Katherine Everett and Kuhn, Helmut,
A History of Esthetics, New York, 1959
Gilpin, William,
Three Essays on Picturesque Beauty, 1792
Ghyka, Matila,
Esthetique des Proportions dans la Nature et dans les Arts, 1927
The Geometry of Art and Life, Dover Publications, 1977
Gombrich, E H,
Art and Illusion, Phaidon, 1977
Meditations on a Hobby-horse Phaidon, 1963
The Sense of Order, Phaidon 1994
Symbolic Images, Studies in the Art of the Renaissance, Phaidon, 1972
'Freud's Aesthetics', *Encounter*, January 1966
Greenberg, Clement,
Art and Culture, London, 1973

Gregory, Richard L ed,
The Oxford Companion to the Mind, Oxford University Press, 1987
Griffin, Donald R,
The Question of Animal Awareness, Evolutionary Continuity of Mental Experience, Rockefeller University Press, 1976
Goury, Jules and **Jones**, Owen,
Plans, Elevations, Sections and Details of the Alhambra, Vol 1, Owen Jones, 1842
Hall, Marion and **Halliday**, Tim eds,
Biology: Brain and Behaviour, Book 1, Behaviour and Evolution, Open University, 1992,
Hambidge Jay,
Dynamic Symmetry, The Greek Vase, Yale University Press, 1920
The Parthenon and Other Greek Temples, Yale University Press, 1924
Harada, Jiro,
The Lesson of Japanese Architecture, Studio, 1936
Harris, Marvin,
The Rise of Anthropological Theory, Routledge and Kegan Paul, 1968
Hayakawa, Masao,
The Garden Art of Japan, Weatherhill/Heibonsha, 1973
Heath, Sir Thomas,
A History of Greek Mathematics, Oxford University Press, 1921
Hedley, R H, et al,
Nature at Work, British Museum (Natural History) and the Cambridge University Press, 1978
Hege, Walter and **Barthel**, Gustav,
Barokkirchen in Altbayern und Schwaben, Deutscher Kunstverlag, 1938
Hix, John,
The Glass House, Phaidon, 1974
Hockett, C F,
Man's Place in Nature, McGraw Hill, 1973
Hofstaedter, Albert and **Kuhns**, Richard eds,
Philosophies of Art and Beauty, University of Chicago Press, 1976
Hogarth, William,
The Analysis of Beauty, 1763
Hölscher, U V O,
Das Grabendenkmal der Königs Chephren, Leipzig, 1912

Honour, Hugh and **Fleming**, John,
A World History of Art, Laurence King, fourth ed, 1995
Hood, le Roy,
'Genes, Genomes and Society', in *Genetic Secrets: Protecting Privacy and Confidentiality in the Genetic Era*, Mark A Rothstein ed, Yale University Press, 1997
See also Kevles, Daniel J,
Hookway, Christopher,
Peirce, Routledge and Kegan Paul, 1985
Hume, David,
Four Dissertations, A Millar, London, 1757
Huntley, H E,
The Divine Proportion, a Study in Mathematical Beauty, Dover Publications, 1970
Hyams, Edward,
Capability Brown and Humphry Repton, J M Dent, 1971
Isaac, Glyn,
'The Food Sharing Behaviour of Protohuman Hominids', *Scientific American*, April 1978
Itoh, Teiji,
Space and Illusion in the Japanese Garden, translated and adapted by Ralph Friederich and Masajiro Shimamura, Weatherhill/Tankosha, 1973
James, Philip,
Henry Moore on Sculpture, Macdonald, 1966
Janson, H W,
A History of Art, Thames and Hudson, 1977
Jones, Steve,
'Genes and the Economics of Eden', The *Independent*, December 4th, 1991
The Language of the Genes, HarperCollins, 1993
'We are all Cousins under the Skin', The *Independent*, December 12th, 1991
'Was Eve an African?', *The Cambridge Encyclopaedia of Human Evolution*, Cambridge University Press, 1992
et al ed, *The Cambridge Encyclopaedia of Human Evolution*, Cambridge University Press, 1992
with van **Loon**, Borin,
Genetics for Beginners, Icon Books, 1993

Jordanova, L J,
Lamarck, Oxford University Press, 1984

Jung, Carl G,
The Archetypes and the Collective Unconscious, 2nd edition, Routledge, 1980
Collected Works, trans, R F C Hall, Kegan Paul, 1953-79
Four Archetypes, Mother, Rebirth, Spirit, Trikster, Ark Paperbacks, 1986
et al, *Man and His Symbols*, Aldus Books, 1964

Kames, Lord,
Elements of Criticism, 2nd edition, Blake, 1839

Kaplan, Stephen,
'Environmental Preference in a Knowledge-Seeking, Knowledge-Using Organism' in *The Adapted Mind, Evolutionary Psychology and the Generation of Culture*, Jerome H Barkow et al eds, Oxford University Press, 1992

Kevles, Daniel J and Hood, Leroy,
The Code of Codes, Scientific and Social Issues in the Human Genome Project, Harvard University Press, 1992

Kimura, Motoo,
The Neutral Theory of Molecular Evolution, Cambridge University Press, 1983

Koch, Ebba,
Mughal Architecture, Prestel, 1991

Koestler, Arthur,
The Act of Creation, Hutchinson, 1964

Kosslyn, S M,
Ghosts in the Mind's Machine, Creating and Using Images in the Brain, Norton, 1983

Krautheimer, Richard,
Early Christian and Byzantine Architecture, Penguin Books, 2nd ed, 1975

Kris, Ernst,
Psychoanalytic Explorations in Art, George Allen and Unwin, 1953

Lane, Richard,
Hokusai, Life and Work, Barrie and Jenkins, 1989

Lauer, Jean-Phillipe,
Le Problème des Pyramides d'Egypte, Payot, Paris, 1948

Leach, Edmund,
Lévi-Strauss, Fontana, 1974

Leakey, Richard and **Lewin**, Roger,
Origins, Macdonald and Janes, 1978
Origins Reconsidered, Abacus, 1992
People of the Lake; Man, his Origins Nature and Future, Collins 1979,
Levi-Strauss, Claude,
Structural Anthropology, Penguin 1972
A World On the Wane (Tristes Tropiques, trans John and Doreen Weightman), Cape, 1973
Lewin, Roger
Principles of Human Evolution, A Core Textbook, Blackwell Science, fourth ed, 1998
Linton, Ralph, ed,
The Science of Man in the World Crisis, Columbia University Press, 1945
Lumsden, C and **Wilson**, E O,
Promethean Fire, Reflections on the Origin of Mind, Harvard University Press, 1983
Lund, F M,
Ad Quadratum, a Study of the Geometrical Bases of Classic and Medieval Religious Architecture, Batsford, 1921
McFarland, David,
Animal Behaviour, third ed, Longman, 1999
Maragigolio, V and **Rinaldi**, C,
L'Architettura delle Pyramide Menfite, Turin, 1964-5
March, Lionel and **Steadman**, Philip,
The Geometry of Environment, RIBA Publications, 1971
Margetts E L,
'Concept of the Unconscious in the History of Medical Psychology', *Psychiatric Quarterly*, 27 (1953), 1
Masuda, Tomoya, **Stierlin**, Henri, ed
Japan, Benedikt Taschen, undated
McGuire, W Ed,
The Freud-Jung Letters, London, 1974
Merlin, Donald,
Origins of the Modern Mind, Harvard University Press, 1991
Midgely, Mary,
Beast and Man, the Roots of Human Nature, Methuen 1979

Miller, Geoffrey and **Arden**, Rosalind,
'Natural Born Genius? The Search for the Genes of Intelligence', *Equinox* (*Equinox* – ITV Channel 4), 1997
Miller, Mary Ellen,
The Art of Mesoamerica from Olmec to Aztec, Thames and Hudson, 1986
Mithen, Steven,
The Prehistory of the Mind, Thames and Hudson, 1996
Mundkur, Balaji,
The Cult of the Serpent, an Interdisciplinary Survey of its Manifestations and Origins, State University of New York Press, 1983
Murdock, George Peter,
'The Common Denominator of Cultures', in Linton ed, *The Science of Man in the World Crisis*, Columbia University Press, 1945
'Anthropology's Mythology', *Proceedings of The Royal Anthropological Institute of Great Britain and Ireland*, 1971
Neumann, Erich,
Art and the Creative Unconscious, Routledge and Kegan Paul, 1959
Noll, Richard,
The Jung Cult, Origins of a Charismatic Movement, Princeton University Press, 1995
Odum, E P,
'Ecosystems', *Encyclopaedia Britannica*, 15th edition, Vol 17
O'Hare, David,
Pyschology and the Arts, Harvester Press, 1986
The Open University,
Science: A Second Level Course, SD 206 Biology, Brain and Behaviour, Book 1, Behaviour and Evolution 1992
Science: A Second Level Course, S 298 Genetics, Units 1, 2, 3, 4, 5 ,9, 10, 11 and 12, 15, and History 1987
Osborne, H,
Theory of Beauty, an Introduction to Aesthetics, London, 1952
Peirce, C S,
Peirce, Collected Papers, Harvard University Press, 1931-58
The Philosophy of Peirce, Selected Writings, Justus Buckler, ed, Kegan Paul, Trench Trubner and Co, 1940

Pevsner, Nikolaus,
The Englishness of English Art, Architectural Press, 1956
Pfeiffer, John, E,
The Creative Explosion, Cornell University Press, 1985
Phillips, William, ed,
Art and Psychoanalysis, The World Publishing Company, 1963
Pinker Steven,
The Language Instinct, Penguin, 1994
How the Mind Works, Alan Lane, 1998
Pitts, Michael and **Roberts**, Mark,
Fairweather Eden, Century, 1997
Popper, Karl R,
Objective Knowledge, Oxford University Press, 1979
Post, Laurence van der,
The Lost World of the Kalahari, Penguin, 1963
with **Taylor**, Jane,
Testament to the Bushmen, Viking, 1984
Premack, K D,
Gavagai, MIT Press, 1986
Radford Tim,
'Excavation at Boxgrove, West Sussex', *Guardian*, September 14th, 1995
Rappaport, Roy A,
Pigs for the Ancestors: Ritual in the Ecology of a New Guinea People, Yale University Press, 1968
Reichel-Dolmatoff, G,
'Cosmology as Ecological Analysis: a View from the Rain Forest', *Man* 11, 1976
Repton, Humphry,
Observations on the Theory and Practice of Landscape Gardening, London, 1805
Revett, Nicholas,
see Stuart, James
Richards, Graham,
Human Evolution, an Introduction for the Behavioural Sciences: Routledge and Kegan Paul, 1987

Richardson, John,
A Life of Picasso, Volume 2, 1907-1917; The Painter of Modern Life, Jonathan Cape, 1996

Rouhani, Shahin and **Jones**, Steve,
'Bottlenecks in Human Evolution', in the *Cambridge Encyclopaedia of Human Evolution*, Cambridge University Press, 1992, pp281-283

De Saussure, Ferdinand,
Cours de Linguistique Général, Payot, 1916

Scholfield, P H,
The Theory of Proportion in Architecture, Cambridge University Press, 1958

Scruton, Roger,
The Aesthetics of Architecture, Methuen, 1979

Segal, Nancy S,
'The Nature vs Nurture Laboratory', *Twins*, University of Minnesota, July/August 1984

Skaife, S H,
African Insect Life, Country Life Books, 1979

Smith, D E,
A History of Mathematics, Ginn and Co, 1923

Smith, Edmund,
'The Moghul Architecture of Fathepur Sikri', four volumes, in *The Archaeological Survey of India*, Allahabad, 1894-8

Spector, Jack J,
The Aesthetics of Freud, a Study in Psychoanalysis and Art, Allen Lane, The Penguin Press, 1972

Spies Werner,
Picasso Sculpture, Thames and Hudson, 1972

Sternberg Robert J, ed,
The Nature of Creativity, Contemporary Psychological Perspectives, Cambridge University Press, 1988

Stevens, Anthony,
Archetype, A Natural History of the Self, Routledge, 1982
On Jung, Penguin, 1990

Stevens, Peter S,
Patterns in Nature, Penguin, 1974

Stierlin, Henri,
Architecture de l'Islam de l'Atlantique au Gange, Office du Livre, Fribourg, 1979
Living Architecture: Ancient Mexican, ed, Macdonald, 1968
Architecture of the World Series (See Masuda, Tomoya, *Japan*, Vohlwasen, Andreas, *India* and *Islamic India*, and Cernival, Jean Louis de, *Egypt*)

Stocking, George W Jnr,
Victorian Anthropology, The Free Press, 1987

Stollnitz, Jerome, ed,
Aesthetics, Macmillan, 1965

Storr, Anthony,
Jung, Fontana Press, 1995
The Dynamics of Creation, Penguin, 1976
Freud, Oxford University Press, 1989
Music and the Mind, HarperCollins, 1992
ed, *The Essential Jung*, Princeton University Press, 1983

Stringer, Chris,
'The Emergence of Modern Humans', *Scientific American*, December 1990
with **McKie**, Robin, *African Exodus*, Jonathan Cape, 1996

Stuart, James and **Revett**, Nicholas,
Antiquities of Athens, Vol 2, London, 1787

Sullivan, Michael,
The Arts of China, fourth ed, University of California Press, 1999
Chinese Art: Recent Discoveries, Thames and Hudson, 1973
An Introduction to Chinese Art, Faber and Faber, 1961
Symbols of Eternity, the Art of Landscape Painting in China, Clarendon Press, 1979,
The Three Perfections, Chinese Painting, Poetry and Calligraphy, Thames and Hudson, 1974

Summerson, John,
Architecture in Britain, 1530 to 1830, Penguin, 1953
The Classical Language of Architecture, Thames and Hudson, 1980

Talbot Rice, David,
Islamic Art, Thames and Hudson, 1975

Taylor, Gerald,
Silver, Penguin, 1956

Thompson, d'Arcy, Wentworth,
On Growth and Form, Cambridge University Press, 1917
Tooby, John, and **Cosmides**, Leda,
'The Psychological Foundations of Culture', in **Barkow**, Jerome H, **Cosmides**, Leda, and **Tooby**, John eds
The Adapted Mind, Evolutionary Psychology and the Generation of Culture, q v
Toynbee, Arnold,
A Study of History – Revised and Abridged by the Author and Jane Kaplan, One Volume Edition, Oxford University Press in association with Thames and Hudson, 1972
Mankind and Mother Earth, Oxford University Press, 1976
Tudge, Colin,
The Day Before Yesterday, Jonathan Cape, 1995
Unattributed,
Art Treasures of the World, Hamlyn, 1964
Leonardo da Vinci, Phaidon, 1948
Vaillant, G C,
The Aztecs of Mexico, Penguin, 1950
Vernon, M D,
The Psychology of Perception 2nd ed, Penguin, 1961
Villa-Real, Ricardo,
The Alhambra and the Generalife, Miguel Sanchez, 1989
Volmar, Alice,
'Together Again', *Friendly Exchange*, Winter 1984, p 28
Volwahsen, Andreas: ed **Steirlin**, Henri,
India, Benedikt Taschen, undated
Islamic India, Benedikt Taschen, undated
Waetzoldt, Wilhelm,
Dürer und Seine Zeit, Phaidon-Ausgabe, 1936
Weyl, Hermann,
Symmetry, Princeton University Press, 1952
Wilson, E O and **Lumsden**, C J,
Promethean Fire, Harvard University Press, 1981
Whyte, Lancelot Law,
The Unconscious Before Freud, Tavistock Publications, 1962

Wissler, Clark,
Man and Culture, Harrap, 1923
Williams, Iolo A,
Flowers of Marsh and Stream, Penguin, 1946
Wills, Christopher,
The Runaway Brain, HarperCollins, 1994
Wittokwer, Rudolf,
Architectural Principles in the Age of Humanism, Norton, 1971
'The Changing Concept of Proportion', *Daedalus*, American Academy of Arts and Sciences, Vol 89, 1960
Wodehouse, P G,
Very Good Jeeves, Herbert Jenkins, 1930
Wollheim, Richard,
Freud, Fontana/Collins, 1971
'Freud and the Understanding of Art', *British Journal of Aesthetics*, Vol 10
Woodcock D M,
A Functionalist Approach to Environmental Preference, Unpublished Doctoral Thesis, University of Michigan, 1982
Woodworth, R S, in association with **Sheeham**, M R,
Contemporary Schools of Psychology, Methuen, 1965
Wright, R,
The Moral Animal, Evolutionary Psychology and Everyday Life, Pantheon 1994
Wymer, John,
Lower Palaeolithic Archaeology in Britain as Represented by the Thames Valley, Humanities Press, 1968
Yanagi, Munemoto et al,
Byzantium, Cassell, 1978
Zangwill, O L,
'Freud and Mental Structure', *The Oxford Companion to the Mind*, Oxford University Press, 1987
Zannier, Italo,
Venezia, imagini del XIX secolo degli Archivi Alinari con un scritto di Italo Zannier, Alinarti, 1985
Zeising, Adolf,
Neue Lehre von den Proportionen des Menschlichen Körpers, Leipzig, 1854

Zervos, Christian,
'Conversations with Picasso', in Brewster Ghiselin, *The Creative Process*, University of California Press, 1952

Index

Entries, which are arranged alphabetically, cover all sections of the book, apart from the notes, from the foreword to the appendices. Names in italics refer either to titles of publications or to formally entitled works of art. Page numbers in italics indicate illustrations.

Aboriginal Australian art 191
abstract art 28, 38-9
Adam and Eve (Dürer) *192*, 198
The Adapted Mind 54-5, 109
aesthetic communication 5, 8, 28, 31
 see also IAC
aesthetic response 5, 8, 28, 35-37,
 79-80, 274
 blind compulsion 12, 27-8
 Freud's lack of 64-5
 negative 17, 158, 162, 164, 284
 shock 10, 17-18, 79-80
 to decay and ruins 185, 186
 to landscapes 172-3, 283,
 to nature's beauty 281
 to order in architecture 189
 to proportion 250-53, 256
 see also experiencer
aesthetics 1, 63, 265
The Aesthetics of Freud 63
Africa 102, 104-5, 131, 141, 285
 DNA studies in 106-7

environment 102, 116, 163, 169, 175,
 184, 214, 272
hominid emergence from 105, 106-
 7, 108, 124, 131, 272, 285
Kalahari bushmen 140, 141, 184, 269,
 272
African art *see* Benin, art
African flesh fly 163-4, *163*, 269, 284
aggression 300-308
Alaska, painted skin tunic *191*
Alberti, Leon Battista 158, *162*, 274
Alexander, Christopher 189, 224, 255,
 256
Alexandria 231, 232-3
Alhambra, Granada 235-8, *236*, 255, 259
 Court of the Myrtles 238
 Court of the Lions 237-8, *237*,
 Hall of the Two Sisters, dome in the
 206, *207*, 209, 210
 tile mosaics 202-4, *203*
Allman, William F 109, 111
Amazonian Indians 271-2

INDEX

Amerindian art 191, *191*
Amiens Cathedral *160*
Analysis of Beauty 248
anatomical awareness 207-8
angles 206-7, 226, 229
 right-angles 206-7, 208-9
Angier, R P 251, 255, 256
animal behaviour
 awareness 111-2
 communication 114-6, 119-20
 reproduction, cats 204
 rhythms 205-6
 social 116-7, 119-20
 tool-making and usage 113, 116
anthropology 46-7, 53-6, 124, 269-72
Anthropology's Mythology 55
Appleton, Jay 172-3, 174, 175-7
archetypes 74-9, 87-90, 131-2, 266, 273-4
 awareness of
 anatomy 207-8
 bonfires 284
 decay 185-7, 272-3
 fitting together 207, 208-9, 210
 flesh fly 164
 golden ratio 256
 motives, decorative 141-2
 mountains 282
 profiles, 150-2
 proportion 223, 258
 rhythm 205-6
 scale 184
 serpents, movement 153
 sex 164-7
 shells 200, 283
 similarities, recognising 204-5, 273-4
 space 177, 210, 214, 273
 symmetry 191, 200, 204
 texture 168, 169
 unity in diversity 266
 collective unconscious 74-5, 77-8
 Jung's concept 72, 73, 74-7, 78, 79, 86, 87-90, 109
 predisposition 89-90, 164, 266
architecture 7, 19-21, 40
 see also under specific cultures, eg Greek architecture
 bilateral symmetry *195-7*, 198-9, *201*, 202
 classical orders 15-16, 40, 42, 214-6, *215*
 Fibonacci series 229, *230*, 233-7, 239-42, 253
 fitting together 206, *207*, 209, 217
 geometric shapes 206, 245
 golden ratio 229, *230*, 232, 233-8, 239-43, 253-4
 musical analogies 217, 245
 order 189, 221-2, 223
 proportion 221-2 245, 249
 rhythm 205
 rotational symmetry 200, *201*, 202
 ruins 185, 186
 scale 180-83, 184
 sexual references *166*, 167
 space within 156, 171, 209-10, *211-13*, 238, 243
 symbolism 20-21
 texture 168-9
 transitional symmetry 201, 202
 variety within 183-4, 210, 222
 Wotton's three conditions 40
L'Architecture d'Islam, de l'Atalantique au Gange 235
Ardepithecus ramidus 102, 109-11, 112, 113, 116, 117, 119, 120, 121

Aristotle 265
Arnheim, Rudolf 42
Art and Illusion 21
artefacts 20-21 *see also* architecture; craftworks as visual art
artists' creativity *see* creativity
Asam, Egid Qurin *144*
The Assumption of the Virgin (Asam) *144*
Assyrian reliefs 145-6, *145*
Atlantaean column *144*, 145, 198
Australopithecus afarensis 104, 113
Australopithecus anamensis 102-4
awareness 110-12, 117-19, 126-7, 130, 131, 145, 284
 see also archetypes, awareness of
 Brown's universal activities and 300-308
 definition 111
 ecology 269-73
 environmental 118, 139-43, 151, 162-3, 168, 172, 184, 186-7, 189, 210-11, 258, 266, 267, 282, 300-8
 self 118, 119, 140-1, 295, 300-308
 social 118, 119, 140-1, 268, 296-7, 300-308
 spatial 177, 210, 214, 273
Aztec art 146, *149*, *154*, 155

Badawi, Alexander 229
The Baptism of Christ (Piero della Francesca) *246*, 248, 255
Barkow, Jerome 54-5, 109
Barlow, Horace B 110
baroque art and architecture *144*, 145, 158, 248-9
Barthes, Roland 8
Bartholdi, Frédéric 35

basilical section 156-64, 269, 284
Baudelaire, Charles 77, 79
Bayeux tapestry 18, 146
beauty 1, 279
 in nature 250, 279, 281-3
behaviour *see* animal behaviour; human behaviour
beholder *see* experiencer
belief in supernatural 127-30, 131, 298, 299-308
Bell, Clive 17, 28
Benin, art 155
 Queen Mother head 44, *45*, 145, 198
Berger, Arthur Asa 13
Berger's matrix 13-15, 18-19, 21-2, 24
Berlyne, D E 251, 265-6
Bernal, J D 189-90, 199, 200
Bihzad, Tahir Zadeh 218-19, *219*
Birth of Venus (Botticelli) 18, 198
blind compulsion 12, 27-8
Blumenschine, Robert J 124, 176
Boas, Franz 54
Bodmer, Walter 57-9
Boetius 245
bonfires 284
The Book of Man 57
Bosch, Hieronymus 18, 145, plate 2
Botticelli 18, 198, 250
Bouchard, Thomas J 58, 59-60, 99, 100, 112, 131
 findings in relation to Freud's model 68
 findings in relation to Jung's archetypes 75, 76, 77, 90
Boucher, François 164, *165*
Bourdieu, Pierre 23, 44, 80
Boxgrove excavation 208
Brahmeshvara temple, Orissa 239, *240*, 255

333

brain size *see* hominids, brain size
brickwork 217, 219
Brody, Hugh 269
Brown, Donald E 47-8
Brown's universals 47-8, 50, 55, 56, 68-9, 127, 129, 131, 164
 of classification 47-50, 56, 75-7, 80
 of content 48
 Freud and 68, 69
 list 47, 293-8
 list analysis 127, 299-308
Brown, Lancelot (Capability) 15, 41
The Buddha Fasting, Gandhara *193*
Buddhist art 167, *193*, 198
Buffon, George-Louis 91
Bull Ritual (Minoan) *146*
A Bull's Head (Picasso) *193*, 198
Burt, Captain 283
Byzantine art and architecture *157*, 191, *191*, 233

Callicrates 232
Callimacus 231
Canadian Indians 269-70, 272
caryatids 202
Caskey, L D 259
Cavallo, John A 124, 176
cave paintings 44, *45*, 105, 108, 143, 145, 149
Cenival, Jean-Louis de 216
Centre for Twin and Adoption Research 57-8
Certosa di Pavia 158, *159*, 180
The Changing Concept of Proportion 232
Charles IV and his Family (Goya) 43, 44, 126, plate 8 (detail)
Chartres Cathedral 182-3, *183*, 184
Chehil Situn Pavilion, Isfahan *194*, 198

Chen, Doron 233-5
Cheops *see* Kheops
Chephren, pyramid and mortuary temple 229, *230*
Chinese art and architecture 39
 artists' inscriptions 39-40, 41-2
 golden ratio 243-4, 256
 Imperial Palace, Peking *195*, 199
 landscape painting 23-5, 36, 39-40, 44, 55, 145, 177, 243-4, 250, *plate 4*
 ouroboros 155, *156*
 pottery jug *166*, 167
 Sung dynasty 19, 24, 69, 77
 Yin Yang symbol 259-60, *260*, 273-4
Chomsky, Noam 125
Church of the Holy Sepulchre, Jerusalem 233
Churchill, Winston 98
circles 141-2 199, 233, 259, 273
cityscapes *see* townscapes
Clark, Kenneth 17, 27
Claude Lorrain 15
claws 141, 273
The Code of Codes 99
cognition 116-17, 124, 129-31, 265
cognitive capacity 117, 131, 265-6, 309-10
collective unconscious 72, 74-7, 80, 85-6, 90, 117, 131-2, 282
 see also archetypes, awareness of
The Common Denominator of Cultures 53-4, 55
communication 8-10, 115-16, 117, 299-308
 see also aesthetic communication; IAC; language
 non-human 114-16, 119-20
 non-verbal 48, 126, 294-5, 302

334

complexes 72, 73-4, 79, 281, 282-3
consciousness 72, 139, 266
 and cognitive capacity 309-310
 and the ego 73
 dawn of 117, 124, 285
consistency *see* mathematical consistency
Constable, John 25, 26, 27, 44, 145, 177, *plate 5*
conventions 10, 14, 15-18, 20
 in architecture 17, 214-6, *215*
 in painting 24
 profiles 145-9, *145-5/*191
Cook, Sir Theodore 249-50, 256
The Cornfield (Constable) 25, 26, 27, 44, 145, 177, *plate 5*
Cosmides, Lena 54, 109
craftsmanship 121-3, 131, 190-91, 214
craftworks as visual art 7, 14, 15, 19-21
 as statements 19-21
 carpets and rugs, Persian 15, 69, 77, *198*, 199, 214, 218-9, *219*, 238-9
 initial impetus for 40
 jug, Chinese pottery *166*
 proportion 223
 sexual references *166*, 167, *167*
 Sung dynasty dish 19, 69, 77
 symmetry 199, 200
 teacups, Wedgewood 19
 teapots, English, silver 167, *167*
 texture 168
 weathervane at Lords cricket ground 14, *14*, 28
The Creation of Man (Michelangelo) 245, *247*
creationism 90-91
The Creative Process 42-3
creativity 42, 77-80, 108, 122, 125-6, 131, 139
 artists' inability to explain 41-2, 80
 Freud's silence on 63, 65
 initial impetus 38-9, 40-41, 79
 intention 32-4, 37-43, 64-5, 77
 and the unconscious mind 37, 42-3, 50, 78-9
 see also genius; IAC
crescent 13-14, *13*
Cro-Magnon art *see* cave paintings
cross-cultural similarities *see* universalities of culture
The Crucifixion from the Isenheim Altarpiece (Grünewald) 26, *26*, 28, 31-2, 34-5, 145, 198, *plate 6 (detail)*
Crystal Palace *197*, 199
cubist painting 283 *see also* Les Demoiselles d'Avignon
The Cult of the Serpent 152-3
cultural development 109, 128-9 *see also* social groups
cultural universalities *see* universalities of culture

daisies 311, *313*, 314
Dali, Salvador 68
Darwin, Charles 91-2
Darwin, Erasmus 91
Darwinism 85, 91-2, 110, 125, 142, 172, 200, 205-6, 272
 validation 94
David (Donatello) *20*, 19, 145
Dawkins, Richard 95, 137
De Divina Proportione 245
De Vries, Hugo 93
decay 185-7, 272-3
The Declaration of Independence 54
decomposition *see* decay
Delacroix 35

INDEX

Demeunier, J N 46
Les Demoiselles d'Avignon (Picasso) 10, 77-79, *78*, 145, 274, 283
Descartes 61, 62
detached copies 201
Dewey, John 265
diamond python 155, *155*
dimensions 214, 216, 217
 bricks 217
 Persian carpets 238-9
 preferred 253-4
dish, Sung Dynasty 19, 69, 77
DNA 94, 96, 98-9, 106
Dobzhansky, Theodosius 94
Dome of the Rock, Jerusalem 233-5, *234*, 255
domes 200, 206, *207*, *213*, 233-5, *234*
Donatello *20*, 19, 145
Doric order 15-16, 40, 42, 216
drosophilia (fruit fly) 93-4
Dunbar, Robin 106, 107-8, 114, 115, 116, 119-20, 268
Dürer, Albrecht *192*, 198
Durkheim, Emile 128-9
Dyke, Sir Anthony van 180, *181*, 182, 184

Easter Island heads 198
ecosystems 269-73, *273*
 mankind's place in nature 271
Eden 285
Edwards, A Cecil 235, 238-9
ego
 Freud's ego and super-ego 66, 67
 Jung's ego 72, 73, 75, 79, 282
Egyptian art and architecture
 bilateral symmetry in 198
 conventions 15, 21,
 Fibonacci series 229, *230*

 golden ratio 229-32, *231*
 modules in 214, 216
 painting of vintage scene 145, p*late 3*
 pyramids, Giza 229, 255
 reliefs 202
 sculpture, head of Nefertiti 198
 temples 214, 216, 229, *230*
 mortuary temple of Chephren, Giza 229, *230*
 temple of Horus, Edfu *166*, 167
Egyptian cobra deity 153, *153*, 155
Ehrenzweig, Anton 36
Einstein, Albert 125-6, 139
Elamite civilisation 155
Elements 232
Elements of Criticism 248-9
emigration *see* Africa, hominid emergence from
English art and architecture
 Crystal Palace *197*, 199
 diamond python 155, *155*
 King's College Chapel *201*, 202, 205
 landscape architecture 15, 41
 landscape painting 25, 26, 27, 44, 145, 177, *plate 5*
 Peterborough Cathedral 158, *159*, 180, *182*
 portrait painting 180, *181*, 184
 sculpture 38
 St Andrew's, Heckington 158, *161*
 St Paul's 158
 Wren's favourite design, 209-10, *211-13*
 Wells Cathedral 158, *159*
Enlightenment 54, 62
The Entry into Jerusalem (Giotto) 146, *151*

336

Episode of the Dog Macintosh 268
Erectheion 17, 199, 202, 214-16, *215*
L'Esprit des Usage et des Coutumes des Peuples Différents 46
Essay Concerning Human Understanding 54
Euclid 221, 223, 232
eugenics 98
evolution 85, 90-92
 human, 101, 102-9, 117
 timescale 101, 102-6, *103*
 theories of 85, 91-2
experience 44, 49, 54, 78, 85, 281, 282-4
 see also familiarity
The Experience of Landscape 172-3
experiencer 8, 9, 19, 79, 282-3
 unconscious mind 35-7, 43, 44, 50, 281, 282, 285
 see also aesthetic response; familiarity
experimental art 39
eyes 141, 273

familiarity 22-5, 31, 44, 46, 50, 80, 283
 see also experience
Fan K'uan 24-5, 44, 145, 177, 244, *plate 4*
Farmers Crossing a Suspension Bridge (Hokusai) 244, *244*
Fathepur Sikri 238
fear 152-33, 164, 300-308
Fechner, Gustav 250-51, *251*, 255, 259
Festive Lovers (Hokusai) *165*
Fibonacci 226, 229, 245
Fibonacci series 225-6, 228, 243, 255, 256-8, 311-14
 architecture 229, *230*, 233-7, 239-42, 253
fire 105, 284

Fischer, Johann Michael *160*
fitting together 206-7, 208-9, 217, 222, 259, 260, 273
 mathematical consistency 214
The Five Eldest Children of Charles I (van Dyke) 180, *181*, 182, 184
flesh fly 163-4, *163*, 269, 284
flowers 189, 199, 267-8, 311-314, *313*
The Food Sharing Behaviour of Protohuman Hominids 176
forests *see* rain forests; woodlands
form 189, 206-9, 219
Forrer, Matthi 244
Fowler, Henry Watson 152
Fox, Robin 47
Freud, Sigmund 36, 60-62, 70
 attitude to art 62-5, 68-9
 ego and super-ego 66, 67
 error 62
 historical context 61-2
 model of the mind 66-9, 70
 relationship with Jung 69-71
 sexual theory 70, 71
fruit fly 93-4

Gainsborough, Thomas 180, *181*, 184
Galton, Francis 98
gamelin band 202, *203*, 204
gardens 7
 bilateral symmetry in *194*, 198
 cottage 69, 77
 Japanese 18, 169, *169*
 landscape 41
 Japanese dry *166*, 167
gene-culture co-evolution 109
genes 93, 95, 96-9
 archetypes and collective unconscious 137, 141-2

genes cont.
 human genome project 98-9
 intelligence 99-100
genetics 85,
 genetic drift 96, 97, 200, 205, 258
 genetic variation *see* mutation
 human genetics 96-9
 eugenics 98
 genetic diseases, 95, 98-9
 genome project 98-9
 race 54
 research 92-4, 98-9
Genesis 285
genius 55, 63, 98, 99
geometry 153-6, 189, 199-200, 206, 260
Ghiselin, Brewster 42
Ghyka, Matila 253
Gibbon, Edmund 274
Gibbs, James 16-17
Gilbert, Katherine 253, 255
Gilpin, William 185, 249
Giotto 146, 149, *151*
A Girl Playing the Bagpipes with a Herd of Deer 146, *150*
Girls playing in a gamelin band 202, 20*3*, 204
Gogh, Vincent van 168, *170*, 171
golden cut 225, 251, 255, 256
 baroque 248, *249*
 China and Japan 244, *244*
 Hindu India 239, *240*, 241 *241*
 and human body *252*, 253-4
 Italian Renaissance 245, *246*
 Mexico *242*, 243
golden ratio 224-8, 250, 255
 Alexandria, School of 232-3
 baroque 248-9, *249*
 Byzantium 233

China and Japan 243-4, *244*
Egypt 229, *230*
Fibonacci series 225-6, 228, 243, 255, 256-8, 311-4
Greece 229-32, *231*
Hindu India 239-43, *240*, *241*
human body *252*, 253-4, 257-8
innateness 256-8
Islam 233-9, *234*
Italian Renaissance 245-8, *246*, *247*
medieval Europe 244-5
Mexico *242*, 243
preferences, aesthetic 251-5, 256
spiral phyllotaxis 250, 256-7, 258, 310-14, *312*
Gombrich, Ernst 21, 32-5, 42, 62-3, 65, 69, 71, 141
Gothic architecture 189, 245
Goya 43, 44, 126, 145, *plate 8*
Greek art and architecture
 Athenian 17, 77, 167, 185, 199, 202, 214-6, *215*, *231*, 232
 Byzantine mosaics 191, *191*
 Doric order 15-16, 40, 42, 216
 golden ratio in 229-32, *231*
 Ionic order 17, 214-6, *215*
 vases 146, *147*, 149, 155, 232, 238, 259
Greeves, Tom *4*, 5
Griffin, Donald R 111, 112, 117-18, 126, 151, 204, 257
Grooming, Gossip and the Evolution of Language 107
Grünewald 26, *26*, 31-2, 34, 44, 145, 198, *plate 6*
Guadet, Julien 222-3
Guatemala *see* Mayan architecture

Hambridge, Jay 227, 232, 259

hand-axe design 122-123, *122*, 190-91
 see also tool-making and usage
Heathrow airport 182
helices 153-5, *154*, 311-14
Herakles and Cerberus, on Greek vase 146, *147*, 155
heraldic conventions 15
heredity 92-3, 95 see also genetics
hexagons 199, 206, 209
The Hidden Order of Art 36
Hindu India 167, 216, 239-41, *240*, *241*, 243
Hitler 98
Hockett, C F 47
Hogarth, William 248
Hokusai *165*, 167, 244, *244*
Holbein, Hans 43, 168
Holmes, Sherlock 22
hominids 102-8, *103*
 brain size 104, 105, 106, 107, 124, 125
 cognition 116-17, 124, 130, 131
 communication 115-16, 117
 diet 104, 106, 121, 124, 125
 language 117, 119-20, 131, 142
 and thought 125, 126
 religion, myth and magic 127-9, 131, 298, 300-308
 scavenging and hunting 123-4, 125, 163-4, 175-6, 208
 survival 109-117, 126-7, 128-9, 141-2, 151, 172, 184, 208, 214
 see also awareness; tool-making and usage
Homo erectus 104-5, 117, 120, 123, 124, 125, 142, 163-4, 208
Homo habilis 104, 121, 123, 124
Homo heidelbergensis 105, 120, 125, 208, 268, 310

Homo sapiens 105, 106-7, 117, 124, 141, 142, 208, 309
The Horrors of War (Rubens) 32-4, *33*
human behaviour 55-6, 109 see also social groups
 accumulative modifications 49, 50
 child behaviour 177
 drives 55
 environmental influences 56, 60, 74
 genetic influence 56, 57-60
 innateness 55-60, 75-7, 115-6, 119-20, 127, 130-31 see also awareness
 instincts 127, 164, 300-308
 interactionism 56
 learned 55, 56
 predisposition 89-90, 164, 266
 social influences 54-5, 57
 twins, identical 57-60
human figure see also nudes; portraits
 anatomy awareness 207-8
 proportions *190*, 191
 golden ratio *252*, 253-5, *254*, 257-8
 sculpture *20*, 19, 145, *192*, 202
human genome project 98-9
Human Universals 47
Hume, David 22-3, 44, 80
hunger 300-308
hunter-gatherers 107,108, 140-41
hunting 123-4, 125, 172-3, 175
 in art 145, *145*,
Huntley, H E 228, 251

IAC 28
 archetypes and 77-8, 79, 85, 273-4
 creativity and 77-80
 example 77-80, *78*
 Freud's model of the mind, 65, 68, 69
 iconography and iconology 31-5

339

INDEX

IAC cont
 Jung 's model of the psyche 75-7, 80
 three-stage process 43, 50
 unconscious mind, artist's 37-43, 50, 78-9
 unconscious mind, experiencer's 35-7, 50, 79-80
 universal system 44-50, 143
iconography and iconology 31-5
icons
 in Berger's matrix 13
 definition from Peirce 10-11
 examples 13-14, 21, 24-8, 38-9, 260
Ictinus 232
id 66-67 *see also* unconscious
illustrations of stories 18-19, 26 *see also* symbols
images, mental 125-6, 131-2, 151-2, 153, 204
impasto 168
Imperial Palace, Peking *195*, 199
Imperial Villa, Katsura (Japan)
 garden 169, *169*
 plan 218, *218*
indexes 10, 18, 21-3, 27-8, 32, 35-7, 281
 in Berger's matrix 13-14
 definition from Peirce 11-12
 examples 12, 13-14,
 paintings 24, 25, 26-8, *26*, 39,
 plates 4-7
 learning to interpret 14, 21-3
indexical aestheic communication (IAC) *see* IAC
Indian art and architecture 146, *150*, 167, *193*, 198, 216, 238
 golden ratio in 238, 239-41, *240*, *241*, 243

palace of Fathepur Sikri 238
Rajput paintings 146, *150*
sculpture, 167, *193*, 198
temples 216, 241, 243
 Brahmeshvara 239, *240*, 255
 Srirangam 241, *241*
tombs and mosques 238
innateness 55-60, 75-7, 115-6, 119-20, 127, 130-31 *see also* awareness
insects *see* flesh fly; fruit fly
instincts 127, 164, 300-308
intelligence 99, 110, 121 *see also* genius
interactionism 56
interpretant 9
Introduction to Arithmetic 232
Inwood, H W 16-17, *16*
Ionic order 17, 214-6, *215*
Iranian *see* Persian
Isaacs, Glynn 176
Isaacs, Susan 176-7
Isenheim Crucifixion *see* The Crucifixion from the Isenheim Altarpiece
Islamic art and architecture
 fitting together in 206, *207*, 210
 golden ratio 233-9, *234*, *236*, *237*, 255
 irrational numbers in 259
 Persian carpets 15, 69, 77, *198*, 199, 214, 218-9, *219*, 238-9
 Persian embroidery 205, *205*
 Persian miniatures 19, 250
 rhythm in 205, *205*
 space in 209, 210
 symmetry in *194*, 198, 202-4, *203*
 tile mosaics 202-4, *203*
Islands in the sea *166*, 167
Isocrates 231

Italian art and architecture
 churches *157*, 158, *159*, *161*, 162, *162*, 274
 golden ratio 245-248, *246*, *247*
 ouroboros 155
 Pisa 158 202
 Renaissance 16-17, 189, 216-7, 245-8, *246*, *247*, 259
 Romanesque architecture 156, 158, 202
 Venice 158, *161*, 177-80, *178*, *179*, 274
Italianate landscapes 15

Japanese art and architecture
 gardens 18-19, 41, 166, 167,*169*, *169*
 golden ratio 243-4, *244*
 Imperial Villa, Katsura 169, *169*, 218, *218*
 Islands in the Sea *166*, 167
 landscape pictures 198, 244, *244*
 modules in 214, 218, *218*
 sexual references in *165*, 167
 symmetry in *195*, 199
 texture in 169, *169*
 woodcuts 18, *165*, 167, 243-4, 250
jaws 141, 273
Jefferson, Thomas 54
The Joke 69
Jones, Steve 54, 60, 96, 98, 107, 108
Jung, Carl 69-72
 archetypes 72, 73, 74-7, 86, 87-90, 109
 example in IAC 77-80
 see also archetypes, awareness of
 collective unconscious 72, 74-7, 79-80, 85-6, 90, 117, 131-2, 282, 285
 see also archetypes, awareness of
 complexes 72, 73-4, 79, 281, 282-3

ego 72, 73, 75, 79, 282
ego-self axis 72, 79, 282
error 85-6
instincts and instinctual behaviour 164
model of the mind (psyche) 72-3, *72*, 80
mysticism 71
personal unconscious 72, 73, 74, 78-9, 88, 126, 281, 282-3
psyche 70, 74-5
relationship with Freud 69-71
self 73, 75, 79, 282

Kalahari bushmen 140-1, 184, 269, 272
Kames, Henry Home, Lord 248-9
Kheops pyramid 229
Kidd, Ken 106-7, 108
Kimura, Motoo 96, 129, 142, 200, 205-6
King's College Chapel, Cambridge 201-2, *201*, 205
kitsch art 28
Klee, Paul 143, *143*
Klimt, Gustav 39
Kris, Ernst 36, 69
Kuhn, Helmut 253, 255

Lamark, Jean Baptiste, Chevalier de 85, 91
Lamarckism 85-6, 89, 91, 142
landscape architecture 7, 41
 conventions 15
 space in 171
 texture in 168, 169, *169*
landscapes 145, 172-7, *173*, *174*, *175*
 in art 23-5, 36, 39-40, 44, 55, 145, *170*, 177, 198, 243-4, *244*, 250, plates *4*,*5*

language 47-8, 56-7, 76-7, 164, 293-4, 300-302
 development 117, 119-20, 124, 142
 learning 123, 125
 and thought 124-6, 130
 universal grammar 125
 see also communication
Lascaux stag 44, *45*, 143, 145
Le Corbusier 253-5, *254*
Leonardo da Vinci 65, *190*, 191, 245
Leonardo da Vinci and a Memory of his Childhood 63, 65
Leonardo of Pisa *see* Fibonacci
Liberty Leading the People (Delacroix) 35
The Life of Picasso 77
light conditions 266, 267
Lightfoot, James 90
Lipps, Theodore 62
loch on the west coast of Scotland *173*
Locke, John 54, 70, 71, 109
Lord's cricket ground, weathervane 14, *14*, 28
Lumsden, Charles J 109
Lund, F M 245
Lutyens, Sir Edwin 15-16, 40, 42, 216
Lyell, Charles 91

McKie, Robin 57, 58, 59-60, 106-7
Madonna and Child (Moore) 38
magic 127, 129, 131, 298, 300-308
Magritte 39
Malthus, Thomas 91, 204
Man with his Arm Outstretched (Le Corbusier) 253-4, *254*
Manet 17-18, *plate 1*
maps 14, 21
market forces 37-8

Marly garden, near Versailles *194*, 198
The Marriage at Cana (Bosch) 18, 274, *plate 2*
mathematical consistency *see* modules
Matterhorn 282-3, *282*
Mayan architecture *196*, 199
measurement 206
Medland, T *220*
Memory 116, 118-9, 130
Mendel, Gregor 92-3
mentalese 125, 131-2, 142
Mesoamerica *see* Mayan architecture; Mexico; Pre-Columbian art and architecture
Mexico
 Atlantean column *144*, 145, 198
 Aztec stone rattlesnake *154*, 155
 golden ratio *242*, 243
 Teotehuacan, Way of the Dead *242*, 243
 Texcatlipoca 146, *149*
 Toltec sculpture *144*, 145, 198, 202
Michelangelo 65, 245, *247*
The Mind of Primitive Man 54
Minoan bull ritual 146, *146*
Miss O'Murphy (Boucher) 164, *165*
Mithen, Steven 116-17
modules 214-20, 222, 273
Modulor (Le Corbusier) 253-4, *254*
Mogul India *see* Mughal India
Monet 39
Moore, Henry 38, 41
Morgan, Lewis Henry 46
Morgan, Thomas Hunt 93-4
mortuary temple, Chephren 229, *230*
The Moses of Michelangelo 63-4
motives, decorative 141-2, 190, 200-204, 218-9

mountains 24, 25, 282-3, *282*
movement 7
 and space 171, 183
 in space *see* symmetries
 reptilian 153
Mr and Mrs Andrews
 (Gainsborough)180, *181*, 184
Mughal India 146, 238
Mundkur, Balaji 152-3, 164
Murdock, Peter 47
 psychic unity of mankind 53-6, 75-6
 Universal Culture Pattern 47, 48-9, 291
mutations 93-4, 96,123, 125, 128, 141, 162, 184, 206, 257
 neutral 129,142, 258
myth 127, 129, 131, 285, 298, 300-308

natural selection *see* Darwinism
nature *see also* ecosystems
 beauty in 250, 279, 281-83
 fitting together in 206-7, 209, 219
 golden ratio in 250, 256-8, 310-14, *312*, *313*
 proportions *221* 223
 rhythms in 205-6
 symmetry in 189, 199-200, 267-8
 ugliness in 284
 unity in diversity in 266-9
navel 257-8
Neanderthalers 105, 121
Needham, Joseph 243
neocortex 106, 107, 125
Neolithic revolution 105, 106
New Guineau tribespeople 270-71, 272
Neyrisoo, Richard 269-70, 272
Nichomacus of Gerasa 232
The Night Watch (Rembrandt) *248*, 249

No title (T A Greeves) *4*
nudes 10, 17-18, 27, 77-80, *78*, 164, *165*, 274, *plates 1,7*
numbers, irrational 258-9

Olduvai, Tanzania 105
Olympia (Manet) 17-18, *plate 1*
On Inspiration 42
Ordnance Survey 21
The Origin of Species 92
Osborne, H 253, 255
Ottobeuren Church and Bendictine Abbey, Bavaria *160*
ouroboros 155-6, *156*

Pacioli, Luca 245, 248
painted skin tunic, Alaska *191*
palaeoanthropology 102, 106-8, 112-3
Palaeolithic art *see* cave paintings
Palladio 158, *161*, 217, 259
The Panshanger Oak (Medland*)* *220*
Pantheon, Stourhead *174*
parks 8 *see also* gardens; landscape architecture
parallelepipeds *see* RAPs
Parthenon 19, 77, 185, 202, *231*, 232, 255
patronage, effects on artist 37, 43
Paxton, Joseph *197*
Le Peintre de la Vie Moderne 77, 79
Peirce, C S 9-14, 18, 21, 27, 37, 281
pentagrams 228, 232, 233, 245, 256
perception 36, 65, 118, *118*,139, 266
Persepolis, reliefs 146, *148*
Persian art and architecture
 carpets 15, 69, 77, *198*, 199, 214, 218-9, *219*, 238-9
 Chehil Situn Pavilion, Isfahan *194*,198
 embroidery 205, *205*

343

Persian art and architecture cont
 golden ratio 238
 miniatures 19, 250
 Persepolis, reliefs 146, *148*
 The Poems of Nizami 19
 rhythm in 205, *205*
 Sassian palaces 202
 symmetry in *194*, 198
The Persian Carpet 238-9
Persian carpets 15, 69, 77
 design *198*, 199, 218-9, *218*
 dimensions 238-9
personal unconscious 72, 73, 74, 88, 126, 281,282-3, 285
perspective 149
Peterborough Cathedral 158, *159*, 180, 182
phi *see* golden ratio
philosophy 1
phobic responses 152-3, 164, 285
Piazza San Marco, Venice 177-80, *178*, *179*, 180, 183-4
Picasso 10, 38-9, 40-41, 77-80, *78*, 145, *193*, 198
Piero della Francesca 245, *246*, 248
pineapples 311, *313*, 314
Pinker, Stephen 114, 115, 125-6, 131-2, 164
Pisa 158, 202
Place Royale, Nancy *195*, 199
Plans, Elevations, Sections and Details of the Alhambra, 232
Plato 61, 87, 232
Pliny 231
Plomin, Robert 99
The Poems of Nizami 19
poetry, rhythm 205
poisonous water snake (Sarawak) 153-5, 154

Pope, Alexander 41, 186
portraiture 38, 43 *see also* profiles
 painting 43, 44, 126, 145, 149, 180, *181*, 184, plate 8
 sculpture 44, *45*, 145,198
pottery jug, Chinese *166*, 167
Pre-Columbian art and architecture
 acropolis and temple, Tikal *196*, 199
 Atlantean column, Tula *144*, 145, 198
 Texcatlipoca 146, *149*
 wall paintings 146
 Way of the Dead, Teotehuacan *242*, 243
predisposition 89-90, 164, 266
profiles 145-52, 191, 273
progressions, mathematical 228 *see also* Fibonacci series
proportion *190*, 217, 221-3, *254*, 255, 256, 257-8
The Theory of Proportion in Architecture 221-2
The Proportions of the Human Figure (Leonardo) *190*, 191
prospects, 173-5, *173*, *174*, *179*, 180, 273, 282-3, *282*
psyche 70, 74-5
 evolution of 108-9
 Jung's model 72-5, *72*, 80
psychic unity of mankind 53-6, 75-6
Psychoanalytic Explorations in Art 36, 69
The Psychoanalysis of Artistic Vision and Hearing 36
psychology
 and aesthetics 1,5, 36, 43, 49
 and anthropology 55-6
 and art 42-3

collective unconscious 72, 74-7,
 80, 85-6, 90, 117, 131-2, 282
 see also archetypes, awareness of; IAC
 models of the mind 53-6, 66-9, 72-80
 personal unconscious 72, 73, 74, 88,
 126, 281, 282-3, 285
pyramids 200, 255, 283
 Egypt 229, *230*, 255
 Guatemala *196*, 199
 Mexico *242*, 243, 255
Pythagoras 217, 229, 231-2
Pythagoreans 232, 233, 245

qualitative judgements 274
Queen Mother head (Benin) 44, *45*, 145, 198

race 54, 60, 73, 76
Radford, Tim 208
rain forests 102, 173-4, *175*
 Tukano tribe, Amazon 271-2
Rajput paintings 146, *150*
Rappaport, Roy A 270-71
RAPs 206-7, 209, 214
ratios 258-9 *see also* golden ratio
rectangles, preferred shape, 251-5, *251*
Red Square, Moscow 182
refuges 173-7, 273
Reichel-Dolmatoff, G 271-2
religion 127-9, 131, 298, 300-308
Rembrandt 24, *25*, 177, 248, *249*
Renaissance *see* Italian art and architecture, Renaissance
Renoir 27, 44, 145, 164, *plate 7*
repetitions 205, 221-2
 linked repetitions 201-4, *201*, *203*
representational art 18-19, 143-56, *143-51* 153-6, 273, 274

Repton, Humphrey 15, 41, 42
rhythm 205-6, *205*, 260, *260*, 273
Richardson, John 77
right-angled parallelepipeds *see* RAPs
right angles 206-7, 208-9
Roman architecture
 basilicas 156,
 ruins 186
Romanesque architecture 156, 158, 202
Rose, Richard 59-60, 68, 69, 76, 77, 131
Rotunda Anastasis 233
Rouhani, Shahin 107-8
Royal Crescent, Bath 202
A Royal Lion Hunt (Assyria) 145-6, *145*
Rubens, Peter Paul 32-4, *33*, 145, 164, 248
ruins 185-6, 272-3

sacred procession, Persepolis 146, *148*
Salmon, André 77
San *see* Kalahari bushmen
San Giorgio Maggiore, Venice 158, *161*
San Zeno, Verona *157*, 158
Sant'Apollinare in Classe, Ravenna *157*
Santa Maria Novella, Florence 158, *162*, 274
Sarawak, poisonous water snake 153-5, *154*
Saussure, Ferdinand de 8, 9, 10
savannah 102, 173, 174, 175, 184
scale 180-84, 273
scavenging 123, 124, 163-4, 175-6, 208, 267
Scavenging and Human Evolution 124, 176
Scholfield, P H 221-2, 223, 251, 253
Science and Civilization in China 243
Scrovegni chapel, Padua 146, 149, *151*

345

sculpture 7, *20*, 19, 38, 44, *45*, 143-5, *144*,
 sexual references in 167
 symmetry in *192*, *193*, 198
 texture 168
Segal, Nancy S 57-8
self 73, 75, 79, 282
semi-detached houses 19-21
semiology 8-10
semiosis 9
semiotics 8-10
sensory experience 118, 130
 seeing 118
 touch 168-9
serpents 152-6, 273, 285
 diamond python 155, *155*
 Egyptian cobra deity 153, *153*
 fear of 152-3, 164
 ouroboros 155-6, *156*
 poisonous water snake, Sarawak 153-5, *154*
 stone rattlesnake (Aztec) *154*, 155
sex 164-7, 208, 258, 273, 300-308
shape 221-2 *see also* geometry; proportion; symmetry
 aesthetic response 17, 158, 162, 164, 250-4, 256
 manifest 150, 152
Sheldonian Theatre, Oxford 248
shells 200, 227, 250, 256, 283
shock 10, 17-18, 79-80
signs 8-10
 definition, Peirce 10, 37
 definition, Saussure 10
 interpretation 9, 13-14
 Peirce's theory of 10-15, 28, 35-6
similarities, recognising 204-5, 273-4
Sistine Chapel 245, *247*
Skaife, S H 163

sky 267
Sleeping Woman (Renoir) 27, 44, 145, plate 7
Smith, D E 231
snakes *see* serpents
sneezewort 311, *312*
social groups, human 116, 117, 118, 119, 268
 behaviour 128-9, 296-7, 304-7
 size 107-8, 117
social science model, standard 53-6, 112, 115
space, mathematics of 189, 209-14
spatial experience 7, *170*, 171-2, 177-80, *178*, *179*, *184*, 273
 environmental preferences 172-7
 security 173, 175, 176-7, 210
 variety 182-3, 210-14, *211*, *212*, 213, 218
Spector, Jack J 62, 63-4
Spencer, Herbert 46-7
spiral phyllotaxis 250, 257, 258, 311-14, *312*,*313*
spirals 141-2, 227, 250, 256, 273
Srirangam temple 241, *241*
St Andrew's, Heckington 158, *161*
St John Chrysostom, Mosaic *191*
St Martin-in-the-Fields 16-17
St Pancras Church 16-17, *16*, 274
St Pancras Station 182, *182*
St Paul's (Cathedral) 158
 Wren's favourite design, 209-10, *211-13*
standard social science model 53-6, 112, 115
Statue of Liberty (Bartholdi) 35
Stevens, Anthony 70, 72-6, *72*, 87, 89-90, 164

Stevens, Peter S 208-9
Stierlin, Henri 235
stone rattlesnake (Aztec) *154*, 155
stone rubbing from Bali 202, *203*, 204
Storr, Anthony 66
Stringer, Chris 106-7
Sullivan, Michael 23-4, 39-40, 41, 243-4
Sumerian civilisation 105, 106
Summerson, Sir John 15, 17
sunflowers 311, *312*, 314
Sung Dynasty
 artistic conventions 24
 dish 19, 69, 77
supernatural 127-8, 129, 131, 299-308
surrealism 39, 68
survival, hominid 109-117, 126-7, 128-9, 141-2, 151, 172, 184, 208, 214
 see also awareness; hominids; tool-making and usage
Symbolic Images, Studies in the Art of the Renaissance 32-5
symbols 10, 12, 13, 15, 28, 32
 in Berger's matrix 13-14
 definition from Peirce 12
 examples 13-14, 18-21, 24, 26, 28
 paintings 18, 24, *25*, 26, *26*, 27, 28, 35, 39, *78*, *79*, *plates 2, 4-7*
 learning to interpret 14, 22, 35
 semiotics 8-10
Symbols of Eternity 244
symmetry 153, *153*, 163, 189-90, 267-8
 awareness of 123, 273-4
 bilateral 190-99, *190-99*, 232, 257, 267
 rotational 199-200, 232, 259-60, *260*, 267-8
 translational 200-204, *201*, *203*, 259-60

Taylor, Jane 269
teapots, English, silver 167, *167*
Teotehuacan, Way of the Dead *242*, 243
Texcatlipoca 146, *149*
texture 168-9, 273
Thales 229, 231
The Theory of Proportion in Architecture 221-2
They're Biting (Klee) *143*
thirst 300-308
Thompson, D F 270, 272
Thompson, Sir D'Arcy Wentworth 189, 199
Three Essays on Picturesque Beauty 185
The Three Trees (Rembrandt) 24, *25*, 177
Tiger, Lionel 47
Tikal, north acropolis and temple *196*, 199
tile mosaics 202-4, *203*, 235, 237
Tishkoff, Sarah 106-7
Titian 63
Toltec art and architecture
 golden ratio in 242, 243
 sculpture *144*, 145, 198, 202
Tooby, John 54-5, 109
tool-making and usage 104, 111, 112-3, 117, 121-3, 208
 Brown's universal activities and 295, 300-308
tools 120-23, *122*, 190-91
townscapes 7, 184
 bilateral symmetry *195-7*, 198-9
 scale 180, 182, 183-4
 space 171, 177-80, *178*, *179*, 184
 texture 168, 169
 Venice 177-80, 183-4, 274
Toynbee, Arnold 117, 131, 260, 285, 309-10

Travelling amid Mountains and Gorges (Fan K'uan) 23-4, 27, 28, 145, 177, 244, 274, *plate 4*
trees 220
Tribute Money (Titian) 63
Tsembaga Mareng 270-71, 272
Tudge, Colin 113
Tukano (Amazonian Indians) 271-2
twins, identical, research 57-60, 68, 76, 129
 procedure 57-8
Tylor, Edward 46-7

unconscious 50, 61-2 *see also* creativity, unconscious mind; IAC, unconscious mind
 collective 72, 74-7, 79-80, 85-6, 90, 117, 131-2, 282, 285 *see also* archetypes, awareness of
 personal 72, 73, 74, 78-9, 88, 126, 281, 282-3
The Unconscious Before Freud 61-2
Unité d'Habitation, Marseilles 254
unity in diversity 265-6, 273-4, *273*
 ecosystems 269-73, *273*
 groups 268-9
 sky 267
 symmetries 267-8
 three-dimensional objects 266-7
universal people, activities *see* Brown's universals
universalities in culture 44, 46-50, 60
 Brown's universals 47-8, 50, 55, 56, 127, 129, 131, 164
 of classification 47-50, 56, 75-7, 80
 of content 48
 Freud and 68, 69

 list 47, 293-8
 list analysis 127, 299-308
 IAC and 46, 49, 50, 77
 Jung 70-71, 75-7, 80
 Murdock's Universal Culture Pattern 47, 48-9, 291
 psychic unity of mankind 53-6, 75-6
 Wissler's Culture Scheme 47, 289-90
urban design *see* townscapes
Ussher, James 90-91
Utamaro 18

van der Post, Sir Laurens 140-1, 184, 269
van Dyke 180, *181*, 182, 184
van Gogh 168, *170*, 171, 201
Varadarajaswamy Temple, Kanchipuram *197*
vaults
 fan 69, 77
 gothic 206
Venice 177-80, *178*, *179*
 Gibbon's opinion of 274
 San Giorgio Maggiore 158, *161*
The 'Venus of Willendorf' *192*, 198
vintage scene (Egypt) *plate 3*
vistas 173-5, *173*, *174*, *179*, 180, 273, 282-3, *282*
visual arts 7-8, 126, 298, 307
Volwasen, Andreas 243

Way of the Dead, Teotehuacan *242*, 243
weathervane at Lord's cricket ground *14*, *14*, 28
Wells Cathedral 158, *159*
Western art 32-5, 39, 44, 49, 198
whirling squares 226-7

rectangle 227, 229
Whyte, Lancelot Law 61-2
Wik Munkan, Queensland native people 270, 272
Willow-wood and Shepherd (van Gogh) *170*, 171
Wilson, Edward O 109
Wissler, Clark 47
Wissler's Culture Scheme 47, 289-90
Wittkower, Rudolf 217, 222-3, 232
Wodehouse, P G 268
Woodcock, D M 173-5
woodcuts 18, *165*, 167, 243-4, 250
woodlands 102, 173, 174
Wotton, Sir Henry 40, 42, 156, 206, 209
Wren, Christopher 169, 209-210, *211-13*, 248

Yin Yang symbol 259-60, *260*, 273-4

Zangwill, O L 67
Zeising, Adolf 250, 253, 256